LIFE IN THE DARK

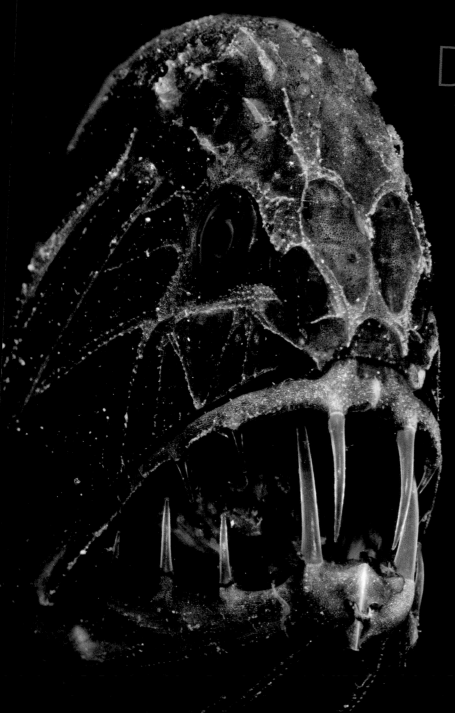

Danté Fenolio

Johns Hopkins University Press *Baltimore*

life IN THE DARK

Illuminating Biodiversity in the Shadowy Haunts of Planet Earth

© 2016 Johns Hopkins University Press
All rights reserved. Published 2016
Printed in China on acid-free paper
9 8 7 6 5 4 3 2 1

Johns Hopkins University Press
2715 North Charles Street
Baltimore, Maryland 21218-4363
www.press.jhu.edu

Library of Congress Cataloging-in-Publication Data
Names: Fenolio, Danté B. (Danté Bruce)
Title: Life in the dark : illuminating biodiversity in the shadowy haunts
 of planet earth / Danté Fenolio.
Description: Baltimore : Johns Hopkins University Press, 2016. | Includes
 bibliographical references and index.
Identifiers: LCCN 2015010640 | ISBN 9781421418636 (hardcover : alk. paper) |
 ISBN 9781421418643 (electronic) | ISBN 1421418630 (hardcover : alk. paper)
 | ISBN 1421418649 (electronic)
Subjects: LCSH: Adaptation (Biology) | Habitat (Ecology) | Deep-sea animals.
 | Cave animals. | Parasites.
Classification: LCC QH546 .F46 2016 | DDC 578.4—dc23
LC record available at http://lccn.loc.gov/2015010640

A catalog record for this book is available from the British Library.

*Special discounts are available for bulk purchases of this book. For more information,
please contact Special Sales at 410-516-6936 or specialsales@press.jhu.edu.*

Johns Hopkins University Press uses environmentally friendly book materials,
including recycled text paper that is composed of at least 30 percent post-
consumer waste, whenever possible.

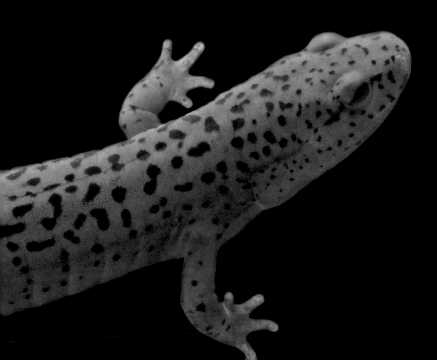

This book is dedicated to three individuals who have profoundly influenced me, Bart Fenolio, Jerry Balistreri, and Terry Freitas.

My father, Bart Fenolio, supported my interests at every turn, providing a foundation for learning and for investigating the natural world.

My closest childhood friend's father, biologist Jerry Balistreri, allowed his son and friends, including myself, to tag along as he taught field courses. These early experiences profoundly shaped my career.

My undergraduate friend, biologist Terry Freitas, taught me a deeper appreciation for the struggles that wildlife faces because of human activities. Terry went on to help the U'wa people of Colombia in their struggle against an American oil company that drilled for oil on their land and against their will; he was abducted and murdered by FARC, one of the leftist rebel groups that once controlled much of Colombia, in 1999.

Thank you for everything each of you did to enrich my life.

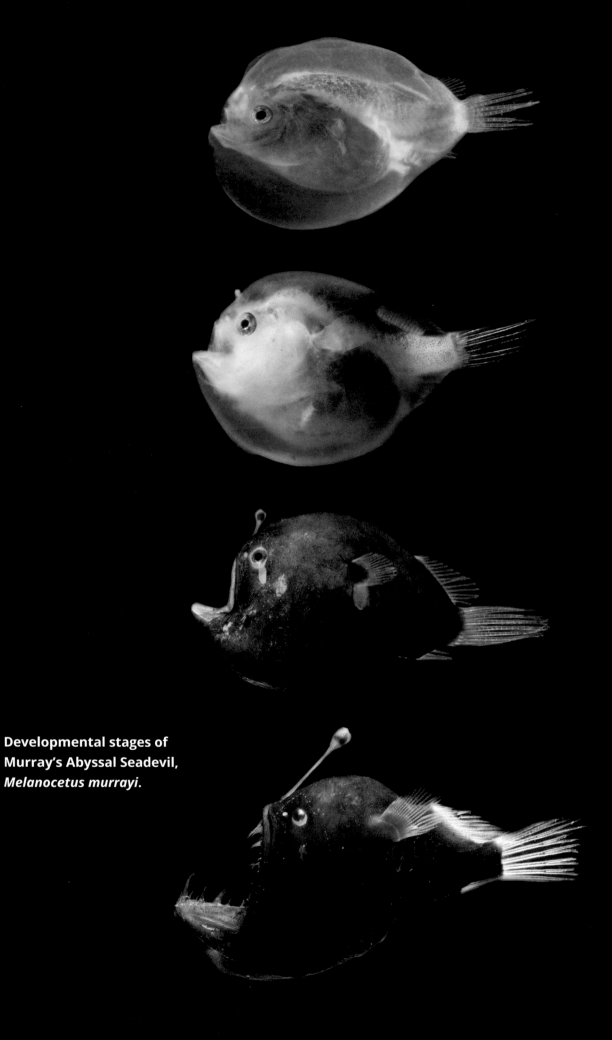

Developmental stages of Murray's Abyssal Seadevil, *Melanocetus murrayi*.

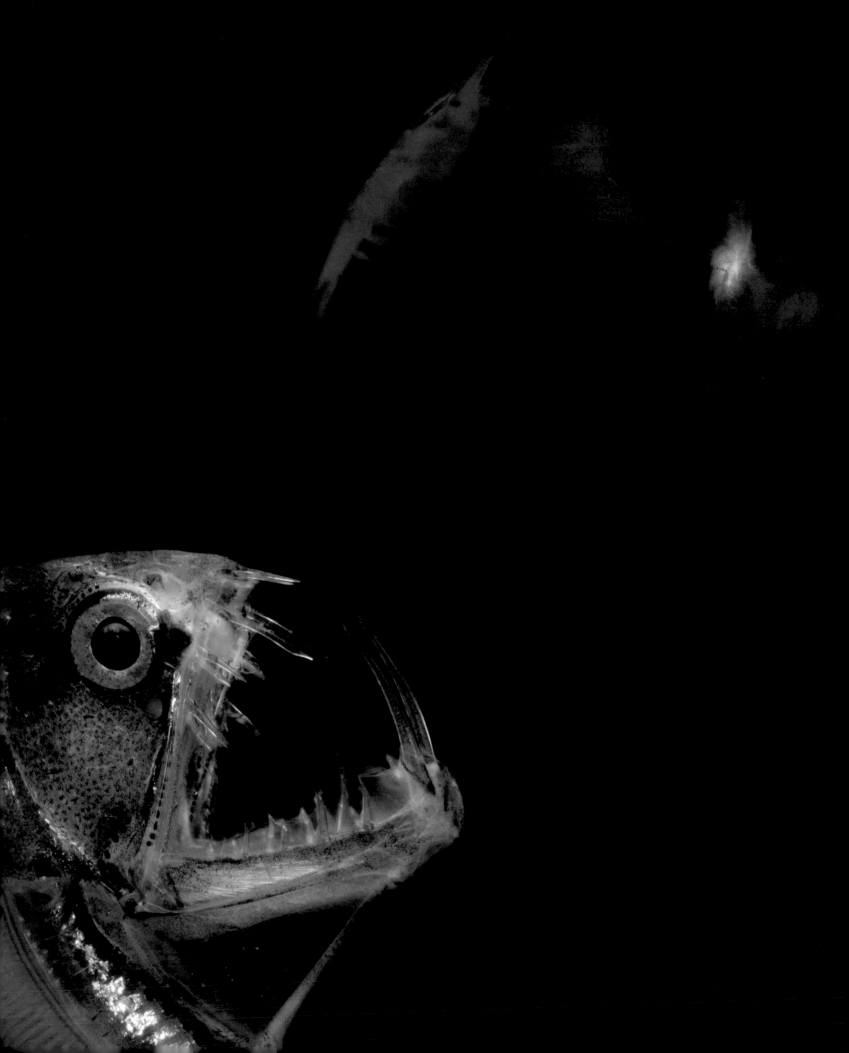

*t*his book is a collection of images depicting the magical creatures that I have spent my career studying. Whenever possible, the photos show them in their natural habitats, an exception being deepwater wildlife. Many of the subterranean life forms, fossorial animals, and inhabitants of termite mounds were photographed in situ, as I found them. Each of these creatures is part of a larger ecosystem. They cannot survive if their habitats are destroyed. Protecting these unique organisms requires conservation of their habitats. Conserving wildlife that spend their time in the dark will require humanity to recognize the value of biodiversity and work to protect it.

The book is intended to aid naturalists. At the end of some captions, I have included citations to encourage further reading. Many of the captions highlight interesting points of biology and ecology. Some of the information refers to indigenous peoples in the areas where I have worked and discusses links between these cultures and wildlife. I respect people who live close to nature; they are our best teachers with regard to the environment and wildlife. Indigenous peoples and belief systems are vanishing along with our fauna, as forests and other wild areas evaporate. Much will be lost if we lose the knowledge of the environment that these people command.

The general and chapter introductions are intended to be basic rather than exhaustive summaries of each subcategory of community living in the dark. A more comprehensive undertaking would be beyond the scope of a book of photographs. My hope is that these images will lead you to question what you know of nature and how you feel about the state of the environment. Ask yourself how you want your children's and your grandchildren's life experience with the natural world to be.

Please celebrate biodiversity with me as you look through this book, and consider supporting any environmental movement with which you connect.

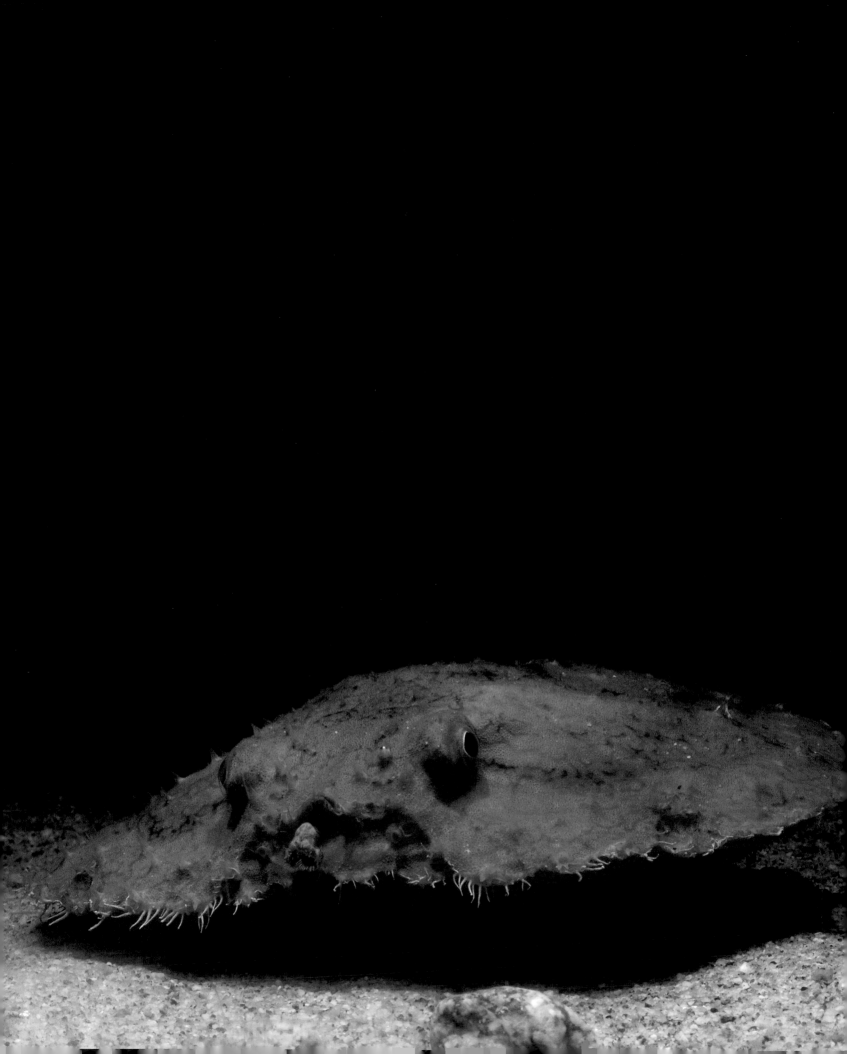

*f*or helping me collect the subjects of the images included in this book, I am deeply indebted to dozens of biologists, ecologists, naturalists, field companions, locals, governments, and organizations. I've listed their names at the end of the book.

I thank Ronald Javitch for his unwavering support. Without his generosity, this book would never have been published. The San Antonio Zoo and the Atlanta Botanical Garden allowed me the time to take many of the trips that produced the images, for which I am most grateful.

My grandfather and father, both avid outdoorsmen, provided me with early opportunities to interact with wildlife. My father, who signed up for SCUBA certification with me when I was quite young, supported my interest in wildlife. As I finished high school and throughout my undergraduate program at the University of California, Santa Cruz, I spent summers working with and learning from herpetologist William W. Lamar in the tropics. After Bill's tutelage, I became a graduate student of Janalee Caldwell, and my days of working in caves began with her encouragement. I thank Vic Hutchison, who never tired of discussing my passion for salamanders.

I have been enormously influenced by biologists, cavers, naturalists, and photographers, including Andy Charrier, Marty Crump, Mauricio Fabry, Andy Gluesenkamp, G. O. Graening, Andy Harris, Meg Lowman, Matt Niemiller, José Nuñez, Tim Paine, Michael Ready, Henry Robison, Michael Slay, Daphne Soares, Jim Stout, Marcela Tirado, and Yahui Zhao. I learned a tremendous amount from these people and had opportunities to photograph some remarkable wildlife with them. I thank Nelson Jorge da Silva Jr. and his team for teaching me about the wonders of Brazil. Jim O'Reilly spent countless hours with me talking about caecilian captive care and biology while I was guided through my PhD work by Kathryn Tosney--many thanks to both.

I owe a debt of gratitude to the marine biologists who have given me access to their deep-sea cruises, including José Torres, Greg Cailliet, and Tracy Sutton. Time spent on research ships with these professionals rank among my fondest memories.

This book was made possible by the generous support of:

Inspiring our world to conserve wildlife and wild places
through science, action, fun, and education.

The exceptional generosity of Ronald Javitch made this project possible.

The mission of the Atlanta Botanical Garden is to develop and maintain plant
collections for display, education, research, conservation, and enjoyment.

This research was made possible in part by a grant from BP / The Gulf
of Mexico Research Initiative.

The Shared Earth Foundation is committed to the tenet that all creatures have
an enduring claim to sustainable space on this planet. It believes that today's
human beings have the responsibility to share Earth's resources with other
creatures and future generations by limiting their adverse impact on the planet,
and by enriching and protecting Earth's wild life and the places they inhabit.

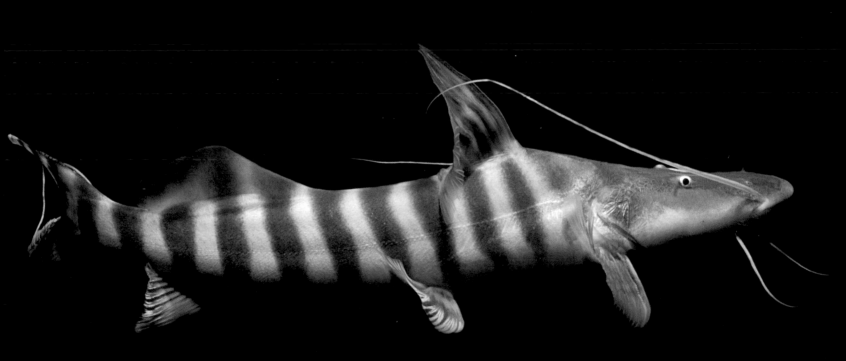

AN INTRODUCTION TO LIFE IN THE DARK

\mathcal{M}ost humans rely on vision to decipher the world around them. Indeed, vision plays a key role in nearly every facet of our interactions with the environment. Darkness takes away that key sense; not surprisingly, most humans have an aversion to dark places. Dark places are mysterious—perhaps even sinister—in our collective consciousness. The opposite of fearing the dark is nyctophilia, or a love of the dark, and countless organisms fall into this category.

Regardless of how we feel about dark places, life forms of all sorts eke out a living in the darkest reaches of our planet's biosphere (the thin layer encircling the globe where life is found). Most people don't realize just how many habitable places there are on Earth with little or no light. The inky black depths of our oceans are the largest habitat on Earth. The dark bottoms of rivers and lakes also host special deepwater communities. Underground rivers and lakes as well as dry or damp caves, large and small, have their own special inhabitants. Other lightless habitats include spaces within the soil and sand, burrows, compartments within structures such as termite mounds and rotting logs, pockets beneath leaf litter, and even the spaces inside other organisms. All of these habitats receive little or no light, yet life persists and even thrives within them.

Dark habitats have played important roles in the evolution of species. Some species even persisted and continued to evolve in subterranean habitats long after conditions on the surface became unfavorable for them. In such cases, dark habitats served as microhabitats. Biologists Robison and Allen (1995, p. 23) define microhabitats as "special places within larger habitats that may provide just the right environmental conditions for a species to live. Throughout time, microhabitats have no doubt been important in preserving many species as climates waxed and waned and glaciers came and went."

Entire communities of organisms can and do make a living in low light or complete darkness, although many rely on energy produced by photosynthesis—the process in plants in which light is converted to

The internal environment of a cave is buffered from the outside by the rock around it. Caves may have served as refugia (that is, refuges important to a population's survival) or even as critical microhabitats for some species as surface conditions changed.

This groundwater salamander from south Texas has become the subject of much study. Is it a form of the Texas Blind Salamander, *Eurycea rathbuni*, or is it a new species? The groundwater- and spring-dwelling salamanders of Texas occupy subterranean habitats that serve as microhabitats within a much larger, inhospitable environment. Surface conditions in Texas, above the Edwards Aquifer, are now too dry and routinely too hot for most salamanders. One hypothesis holds that as Texas dried out over hundreds to thousands of years, salamanders moved underground or into springs. The contemporary biodiversity of groundwater- and spring-inhabiting salamanders in Texas is unrivaled.

chemical energy in the form of organic matter. Therefore, the energy that sustains a dark habitat is often produced outside that habitat. Scientists call these "foreign imports" of energy allochthonous inputs.

In surface environments, photosynthesis sustains nearly all life around it, directly or indirectly. Even most deep-ocean and subterranean communities rely on photosynthesis in the form of decomposing organic matter such as corpses and waste that find their way into dark communities and sustain them. And there are marine communities that rise closer to the surface to feed on the photosynthesis-driven plankton communities after dark. There are exceptions. For example, the communities that surround hydrothermal vents on the sea floor (openings where hot, mineral-rich water spouts into the ocean) do not require continued sunlight on the surface to persist through time. All energy produced by hydrothermal vent communities is derived from chemosynthesis, a process carried out by bacteria in which they take up chemicals that spew from the sea floor and break them down to produce chemical energy. These bacteria form the base of the vent food webs—that is, bacteria serve as food for other creatures. Were photosynthesis on the planet's surface to stop entirely, hydrothermal vent communities could, in theory, continue for as long as chemical compounds flowed from the sea floor.

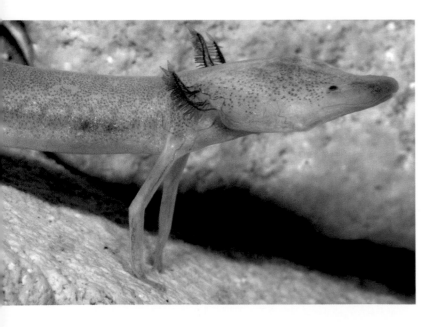

Subterranean habitats range from tiny cracks in rocks to massive chambers that humans can enter. Subterranean lakes and rivers add to the diversity of possible habitats. Cracks in rocks (water-filled, damp, or dry) are a distinct habitat type known as epikarst.

Worldwide, caves have long served
as places of mystery and adventure.

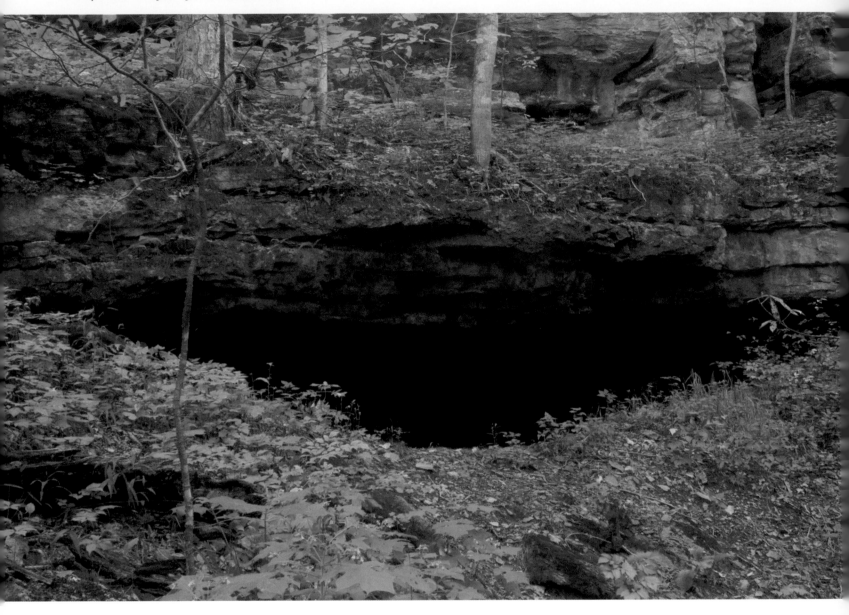

Hydrothermal vent communities remain largely unstudied, because
they are so recently discovered and so difficult to reach. Caves, how-
ever, have long intrigued humans. They have been used both as ref-
uges and as sites for adventure, and we are beginning to understand
quite a lot about them and their inhabitants.

The life forms that call caves home never fail to astonish people who are familiar only with surface creatures; often, these cave organisms are alien in appearance. Animals that live exclusively in caves or in groundwater are known, respectively, as troglobionts (or troglobites) and stygobionts (or stygobites). Troglobionts live on the land, stygobionts in the water. The terms are associated with species that are highly adapted for life in subterranean habitats and are found nowhere else.

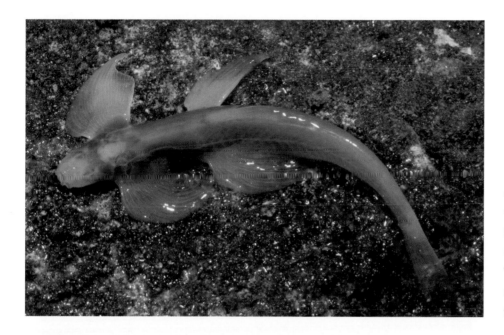

A fish known as the Waterfall Climbing Loach, *Cryptotora thamicola*, lives in only a handful of caves along the border of Thailand and Myanmar and is among the most alien-looking life forms on Earth.

The lack of eyes and pigment and the shovel-shaped head of the Georgia Blind Salamander, *Eurycea wallacei*, are common adaptations for life underground in salamanders.

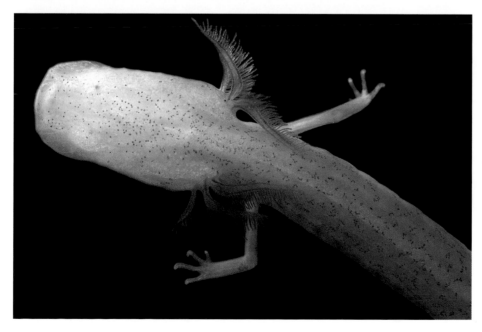

Some subterranean species develop structures not found in their relatives that live aboveground, and scientists are not always certain of the function of these structures. The Chinese Barbels, for example, inhabit both surface streams and subterranean waters. The cave-inhabiting species exhibit varying degrees of adaptation for that environment, and some have mysterious structures. The Horned Golden Line Barbel, *Sinocyclocheilus tileihornes*, has a structure protruding from its forehead that looks like a horn. Other cave-inhabiting species have massive bumps on their forehead or a flattened, duck-billed mouth. We assume that the structures have something to do with life in the dark, but we do not know for sure. Just as with the other characters mentioned above, these structures exist on a continuum; that is, they are expressed more strongly in some species than in others.

Among the obvious differences between surface and subterranean habitats is the lack of light. Without light, there is no photosynthesis. Without input from resident plants, subterranean food webs must receive energy from photosynthesis indirectly, in the form of animal waste, corpses, and other organic materials from surface food webs. For example, cave crickets, which inhabit caves in enormous numbers, feed on the surface at night but return to the cave by day. While in the cave, they defecate. This "frass" is a key nutrient and energy input in some subterranean food webs. The food the crickets eat comes from a surface habitat powered by photosynthesis; the crickets carry that energy into the cave and then defecate, depositing energy into the subterranean food web. In other words, there are entire communities of subterranean organisms that depend on the regular input of cave cricket frass to survive. As another example, Oilbirds, *Steatornis caripensis*, and Grey Swiftlets, *Collocalia spodiopygia*, are two species of birds that live and roost in dark caves. Both species deposit waste within the subterranean habitat. That waste is another example of external energy (allochthonous input), from the foraging of the birds on the surface, making its way into subterranean ecosystems. The waste is then decomposed by cave species.

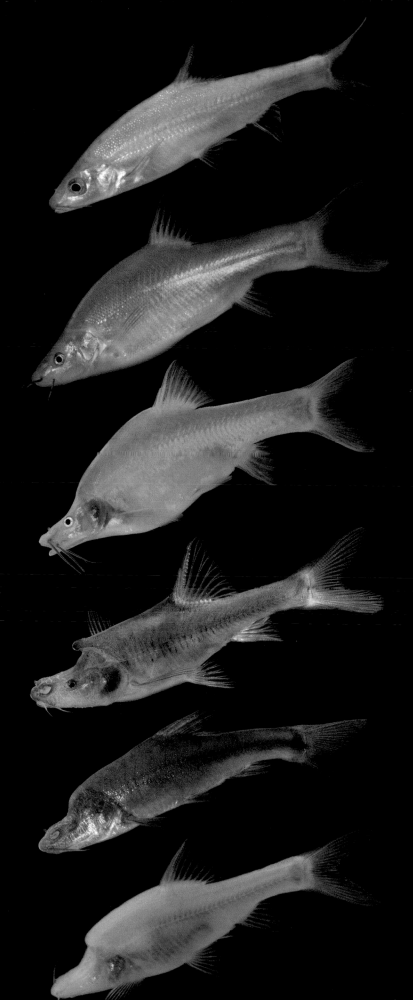

The Barbels are endemic to China. Some species live in surface streams and have pigment, eyes, and few troglomorphic features (*top two: Sinocyclocheilus angustiporus* and *S. brevis*). Others live in subterranean waters and have numerous troglomorphic features (*third to sixth down: S. hugeibarbus, S. tileihornes, S. anopthalmus,* and *S. furcodorsalis*).

Some species are found below-ground in subterranean habitats and nowhere else on Earth. Brazil has a rich subterranean fish fauna. *Ituglanis passensis*, a subterranean catfish, is a relative of the infamous Amazonian *candirú*. Most obligate subterranean species show some adaptations to life underground, but they are not always the same adaptations, nor are they always expressed to the same extent.

As materials such as frass and bird and bat guano are decomposed by life forms in caves, then, they supply the energy for the food webs. Decomposition-based food webs have far less energy flowing through them than direct, photosynthesis-based food webs, and this often translates to fewer individuals than are found in surface habitats. I discuss the circumstances and challenges of the subterranean environment in more detail in chapter 5.

So we know that there are species that make use of both subterranean and surface habitats, but how do they navigate in the dark? Bats and some birds that use dark caves for living space use echolocation to find their way in the dark. Echolocation is a means of navigating by bouncing sound off surfaces in the surrounding environment and using that reflected sound to determine aspects of the habitat. The abilities of

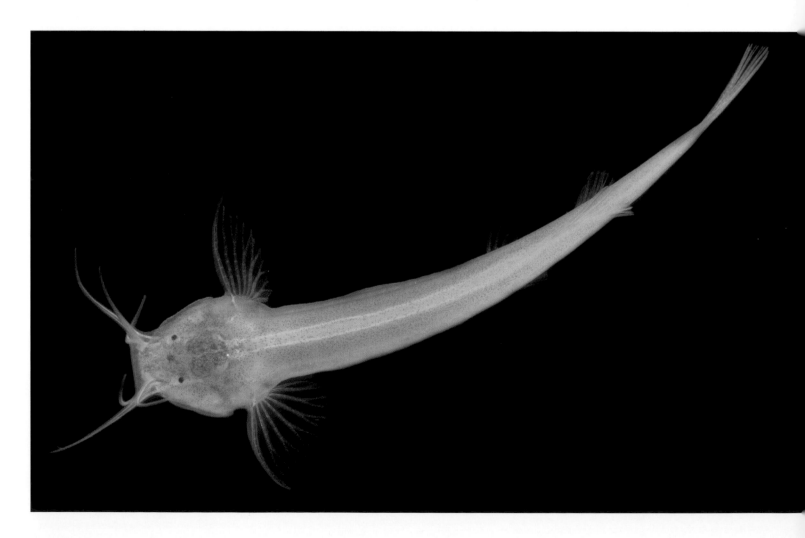

birds and bats are not necessarily comparable, but for both, the basics of the navigation system are derived from sound. Bats can use echolocation to determine such things as where a cave wall is, how far they are from another animal, how big the objects around them are, and even the direction and speed of moving objects. All of these determinations happen in milliseconds (thousandths of a second) and through the use of (usually) high-pitched sounds.

The inhabitants of deep-ocean habitats are similar in many respects to their subterranean counterparts (Poulson, 2001). This applies to some freshwater communities as well (chapter 3). The waters of many of the world's rivers are dark below the first couple of meters because of the turbidity caused by particles of dirt, clay, or other suspended materials. These particles block light and blacken the water column below, leaving

The Mammoth Cave Crayfish, *Orconectes* (*Cambarus*) *pellucidus* (this specimen is from Kentucky, USA), is among the many species of crayfish that inhabit subterranean waters. Many are threatened as a result of humans' overexploitation of groundwater, contamination of groundwater by agricultural runoff and illegal chemical dumping, and destruction of associated cave habitats, where bat colonies have been eradicated. Bat guano can be a significant energy input into groundwater communities.

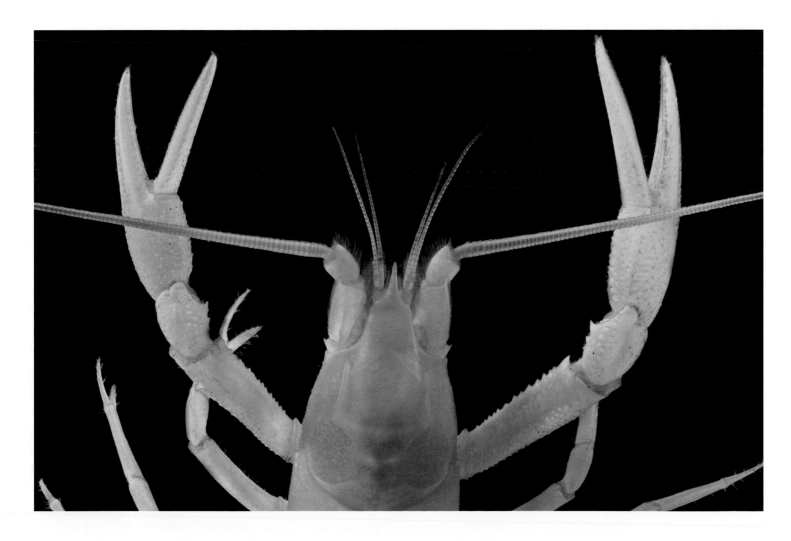

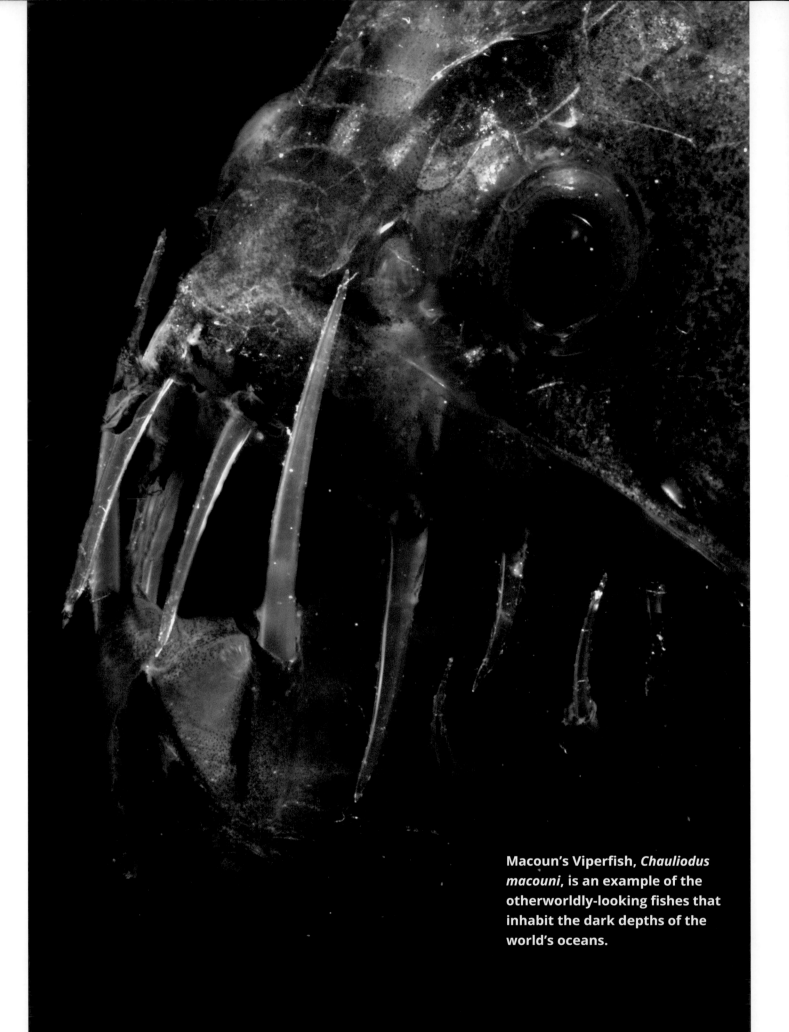

Macoun's Viperfish, *Chauliodus macouni*, is an example of the otherworldly-looking fishes that inhabit the dark depths of the world's oceans.

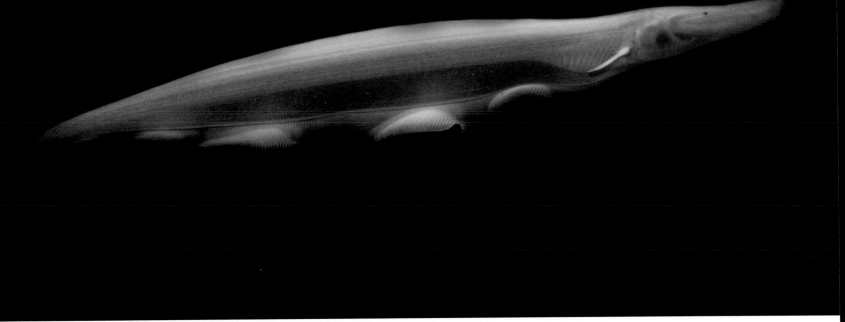

the depths as dark as deep-ocean habitats. The bottoms of deep lakes are dark because light is filtered out in the water column, as in the ocean. Consequently, many fishes of the world's turbid river systems and deep lakes do not rely on vision to find food and mates. Because the deep-freshwater habitats are dark, photosynthesis is not always directly involved in the food webs in these places. In fact, deep-freshwater habitats, just like many deep-sea communities, often rely on organic materials sinking from surface waters as an energy source. However, these organic materials were produced via photosynthesis. Some deepwater species move closer to the surface at night to exploit the energy-rich food webs there.

Rivers and lakes often have dark lower levels, due to depth or to high turbidity that can remove light from the water column just several feet below the surface. The Amazon River has sections that are more than 300 feet (90 meters) deep. The Pink Knifefish, *Orthosternarchus tamandua*, is among the fishes that thrive in the darkness.

(*Facing page*)
**The Square Pink Anthias,
Pseudanthias pleurotaenia, can be
found at depths down to 540 feet
(180 meters). This species lives in the
tropical waters of the Indo-Pacific
Ocean, typically inhabiting drop-offs
and deepwater reefs. Such habitats
are good examples of dimly lit
places that are home to spectacu-
larly colored and patterned species.
The colors cannot be seen at these
depths ("hot colors" in the spectrum,
such as red and yellow, drop out
even at shallow depths), but the
patterns that they form are visible.**

Not all deepwater communities are found far out at sea or at the
bottoms of lakes and rivers; they can exist close to shore. For example,
the Monterey Canyon off the coast of California comes within a few
hundred meters of the shore and drops off to depths of 2 miles (about
3 kilometers) below the surface. The net result is that deepwater
species can be found close to the coast. These "drop-offs," as they are
sometimes referred to, are found around the world and may include
both tropical and cold-water communities. The faces of these subma-
rine canyons are habitats where light dwindles yet biological communi-
ties persist. They are interesting for a variety of reasons, not the least
of which is that, descending the canyon walls, one can trace the grad-
ual reduction of light into the depths. The animals that persist in these
low-light habitats often still have eyes and rely on vision. Stark patterns,
rather than colors, may help convey messages (see chapter 2 for
examples of these species).

Subterranean and deep-ocean communities differ in the incidence of
bioluminescence (that is, the biological production of light). In some
deep-sea communities, up to 90 percent of the species can produce
light (Smith and Douglas, 1987). Bioluminescence can serve as a means
of same-species communication (such as mate attraction), avoiding
predators (by counterillumination), and attracting prey (such as the
bioluminescent lure used by anglerfishes). This form of light production
has also been called "cold light" owing to its efficiency and the lack of
heat released as a by-product. There are at least two known examples
of bioluminescence in caves (glow worms and a centipede), yet it
abounds in deep-ocean communities.

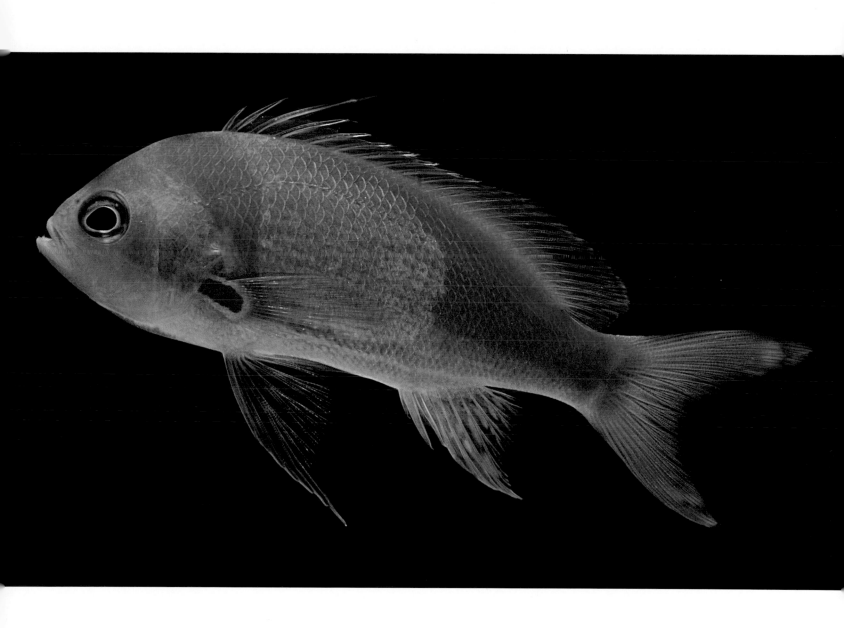

Hatchetfishes are deepwater fishes that use counterillumination to "hide in plain sight." Light-producing organs called photophores line the bottom of their bodies (the oval-shaped photophores are featured in the close-up image) and produce a dim blue light that matches the intensity of the surface light above, thus obscuring the fish's silhouette from a predatory fish looking up from below. Other organisms, including the Firefly Squid, *Watasenia scintillans*, also use counterillumination as a defense strategy.

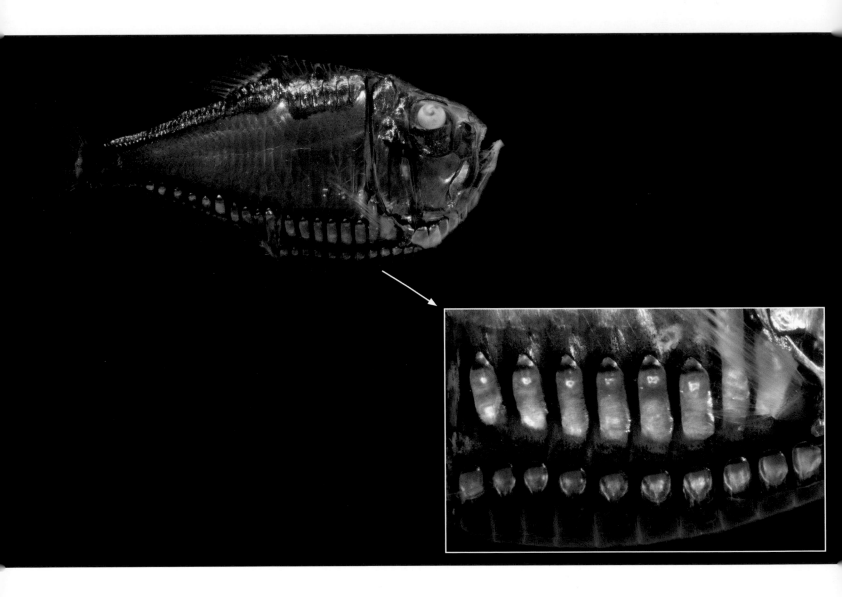

Bioluminescence is relatively uncommon on land, but several dozen species of terrestrial fungi produce light. The purpose of the light is unclear. One hypothesis holds that the light attracts nocturnally active beetles: the insects are drawn to the light, are covered with fungal spores, and disperse the spores when they move on.

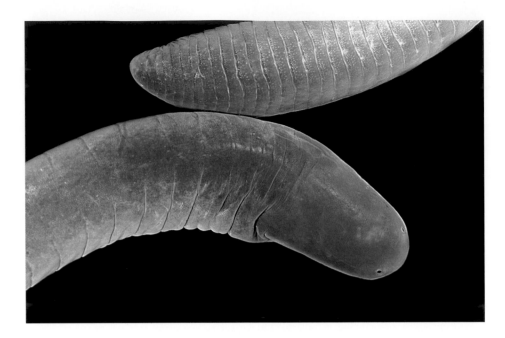

Fossorial animals usually spend their lives belowground in burrows. The caecilians are classic representatives of the fossorial community. They mostly live underground in the world's tropics. The *Caecilia* species shown here is from Amazonian Peru. These amphibians burrow into the soil, leaf litter, and even rotting logs. It is no accident that caecilians look like earthworms. The shape of an earthworm facilitates burrowing through the soil—something caecilians also do well. Ironically, many caecilians eat earthworms. Caecilians have potent skin toxins, but little is known of their biochemistry.

The Mexican Mole Lizard, *Bipes biporus*, is a burrowing reptile that spends much of its life in the darkness belowground. This species crawls at impressive speed through the sandy soils of the western portion and southern half of Baja Mexico.

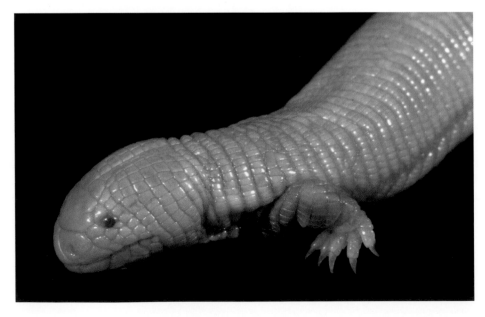

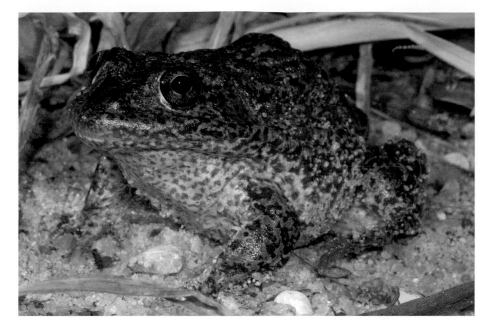

A Gopher Frog, *Lithobates capito*, spends most of its life in the dark confines of Gopher Tortoise, *Gopherus polyphemus*, burrows in the southeastern United States. The Gopher Frog is a frog-eating frog that dines on its kin, given the opportunity. Changes in their habitat have driven the decline of both the tortoise and the frog across much of their range.

Animals that burrow into surface soils are collectively referred to as fossorial animals. For the most part, they live in darkness. Fossorial communities include a variety of worms, insects, arachnids, amphibians, reptiles, birds, and mammals (chapter 4). Fossorial amphibians range from frogs that live in seasonally dry habitats and spend long periods underground to salamanders that live in burrows and caecilians (wormlike amphibians), which live in the soils, leaf litter, and rotting logs of the world's tropics.

Termite mounds also provide a dark refuge for many life forms. Mounds are common components of grassland habitats ranging from Africa to South America and Australia. Entire communities of animals inhabit termite mounds along with the termites that make them. Some of these animals leave the mounds from time to time; others spend their entire lives there.

Deeper still lies the "terrestrial deep subsurface layer" of our planet's landmasses, constituting all habitats deeper than roughly 24 feet (8 meters) below the surface. Biologists have long known that this habitat is home to countless bacteria and fungi. The conditions in these habitats can be as harsh as those in the deep sea, including low

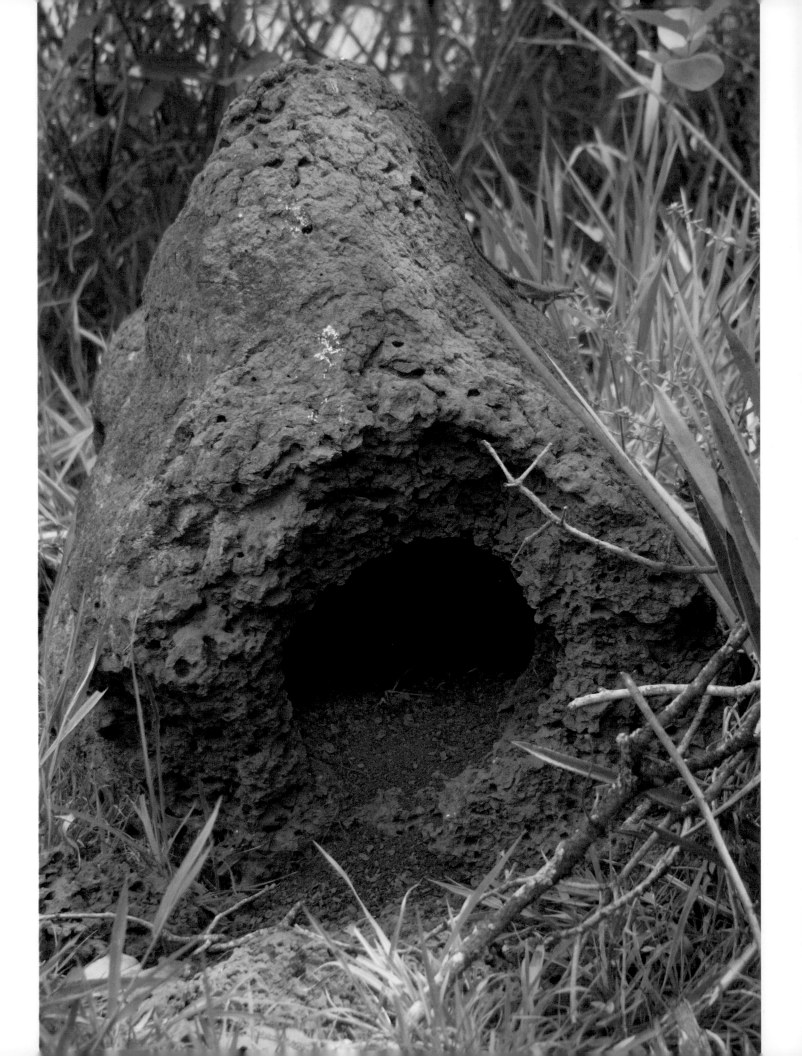

Termite mounds have unoccupied pockets and corners that offer cooler temperatures and higher humidity than the external environment and provide refuge from harsh external conditions for countless small animals. The Cerrado, a Brazilian grassland habitat where termite mounds abound, can experience temperature swings within one day of 35 °C. As many as 14 species of termites may inhabit the same mound, along with ants, roaches, beetles, scorpions, spiders, opilionids (harvestmen or "daddy longlegs"), and mites. A mammal has excavated the base of this termite mound, exposing its hollow center. Further Reading: Domingos and Gontijo, 1996; Baptista, 1998; Moreira et al., 2009.

Termite mound communities include fascinating assemblages of wildlife. A group of reptiles called amphisbaenians are common within the mounds. Similar to lizards and snakes, amphisbaenians are squamate (scaled) reptiles that, with exceptions, lack legs and arms. Most are powerful creatures, and some can deliver an exceedingly painful bite. A research group that I was part of found half a dozen species within the termite mound communities of central Brazil. The colorful *Amphisbaenia fuliginosa* shown here is a juvenile; as the animal ages, the blue will change to white.

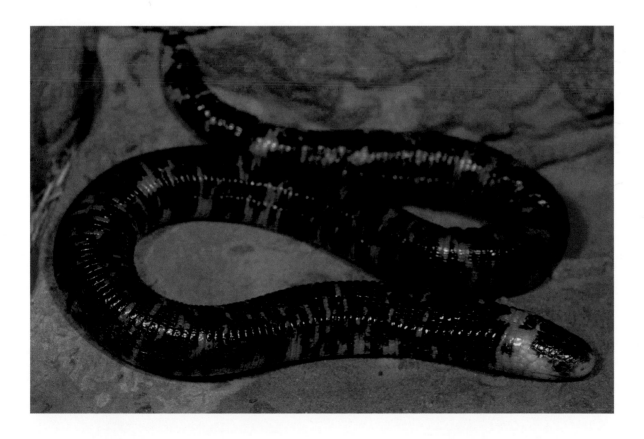

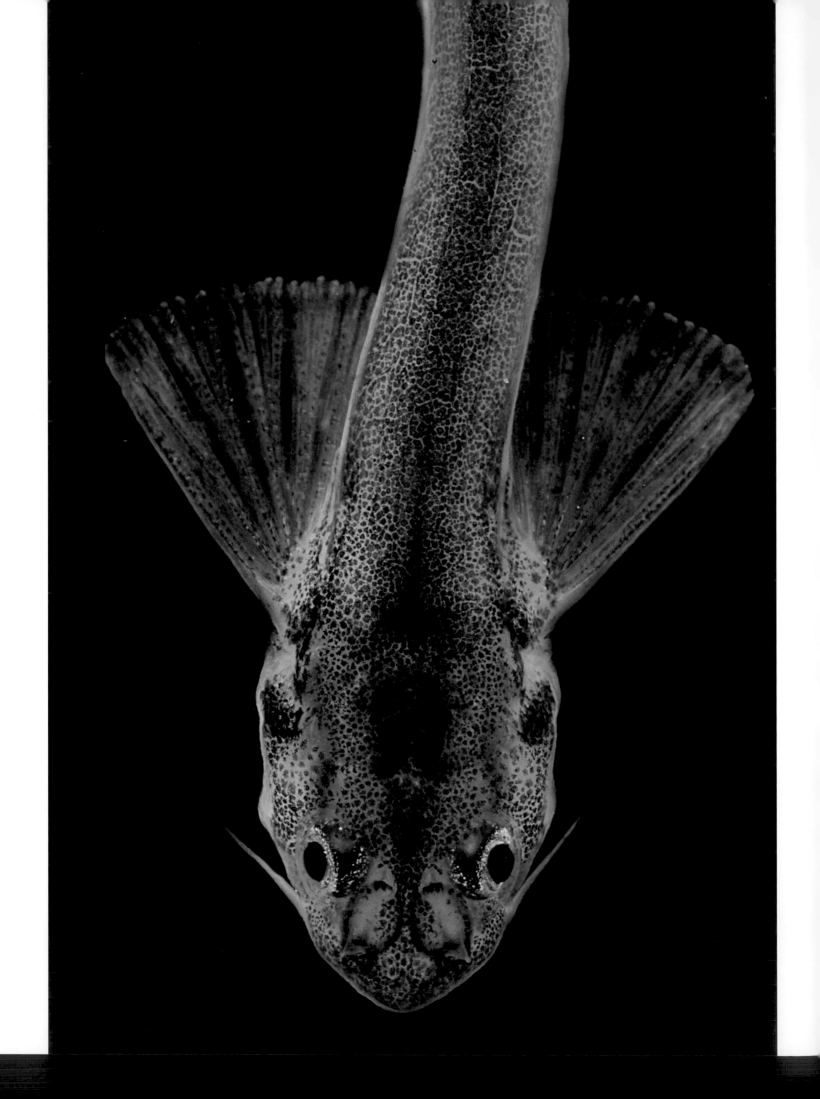

oxygen levels, complex gas mixtures, adverse temperatures, little open space, pressure, and few nutrients. In 2011, a team of scientists reported the discovery of a kind of roundworm in samples taken from 2.24 miles (3.6 kilometers) below the surface (Borgoine et al., 2011), at the bottom of a gold mine in South Africa. The discovery of complex life forms inhabiting such a challenging and inhospitable habitat may give some insight into where and how life forms might exist on other planets.

There are life forms on this planet that are as alien to us as life forms on other planets would be, including some parasites (chapter 6). We do not often think of parasites as creatures that lurk in the dark. But many parasites live within other organisms; some of them even move freely between hosts. The South American parasitic catfishes collectively known as *candirú*, for example, enter the dark gill chambers of larger fishes and chew on their blood-filled gills.

In this book, I focus on wildlife that spends the majority of time in the dark or in low-light conditions, whether on the dimly lit walls of marine canyons or in places where they will never be exposed to sunlight. These communities of organisms are some of the least familiar to the public, and yet also some of the most fascinating. I have always wanted to bring wildlife to public attention, particularly the deepwater and subterranean communities that people rarely see. As a scientist and photographer, I find them intriguing because they include some of the most alien-looking life forms on our planet. For example, dragonfishes have a "fishing pole" dangling off their chin, with a bioluminescent lure at the end of it. The same fish has a number of glowing spots down the sides of its body that are believed to be used for recognition between individuals of the same species. The glowing spots and organs on the fish produce some incredibly strange appearances . . . something like a Dr. Seuss character blended with a Christmas tree.

Parasites come in a variety of shapes and sizes. Some fishes are parasites, such as the *candirú*, *Vandellia* cf. *sanguinea*, a typical Amazonian Basin species from the Río Napo, Loreto, Peru.

Deep-sea dragonfishes display many of the characters that make deep-sea wildlife appear alien. The long chin structure, called a barbel, has a luminescent lure that the dragonfish can wiggle like a worm. Creatures that come in too close to investigate fall prey by way of the dragonfish's giant teeth. Further Reading: Sutton and Hopkins, 1996a, 1996b.

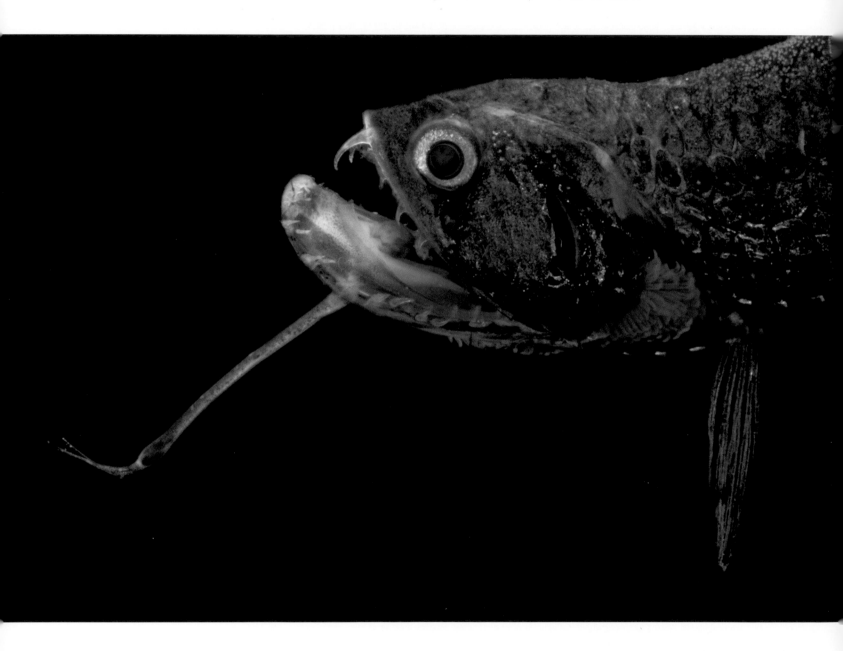

Deep-sea crustaceans definitely fit the bill for alien-looking life forms. This crustacean (shrimplike animal of the order Lophogastrida), a species of *Gnathophausia*, was collected at a depth of 1,350 feet (450 meters) in the Gulf of Mexico in 2010.

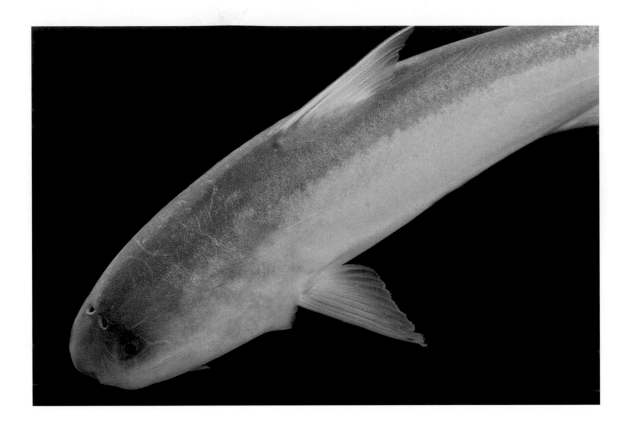

Catfishes of the genus *Cetopsis* live in the murky Amazon River and do not require vision to effectively hunt or find mates. These voracious fishes are responsible for many, if not most, of the so-called attacks on humans that are mistakenly attributed to piranhas.

(*Facing page, top*)
Unlike the aboveground salamanders familiar to us, some cave salamanders lack functional eyes and have little pigment. This Grotto Salamander, *Eurycea spelaea*, is from the Ozark Mountains of the United States.

(*Facing page, bottom*)
The Crossed-fork Back Golden-line Barbel, *Sinocyclocheilus furcodorsalis*, is a highly specialized cavefish endemic to Guangxi Province, China. Little is known about the structure that protrudes from its forehead. The long barbels have taste buds that the fish uses to find food in the dark caves where it lives.

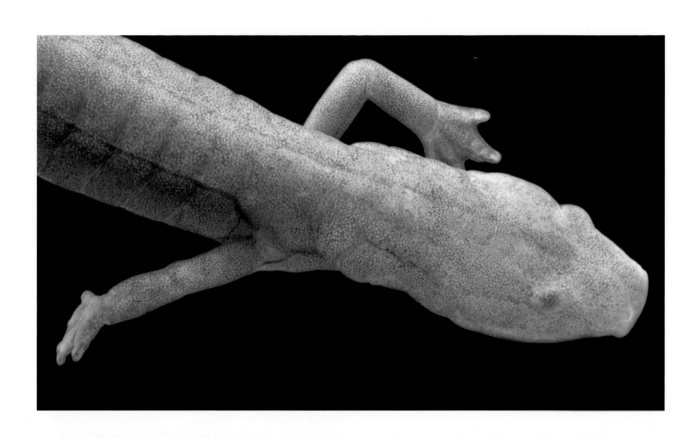

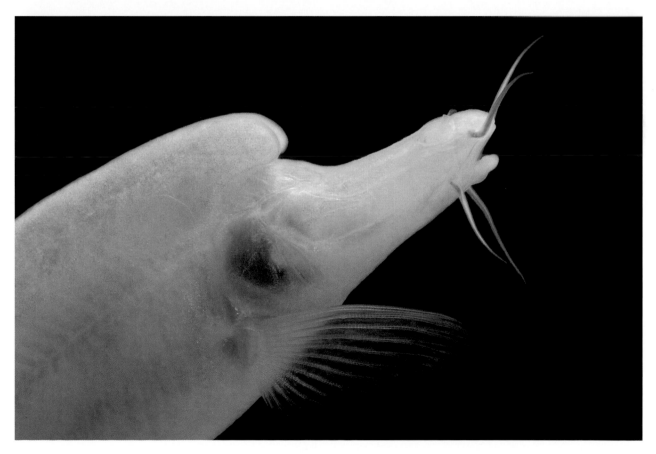

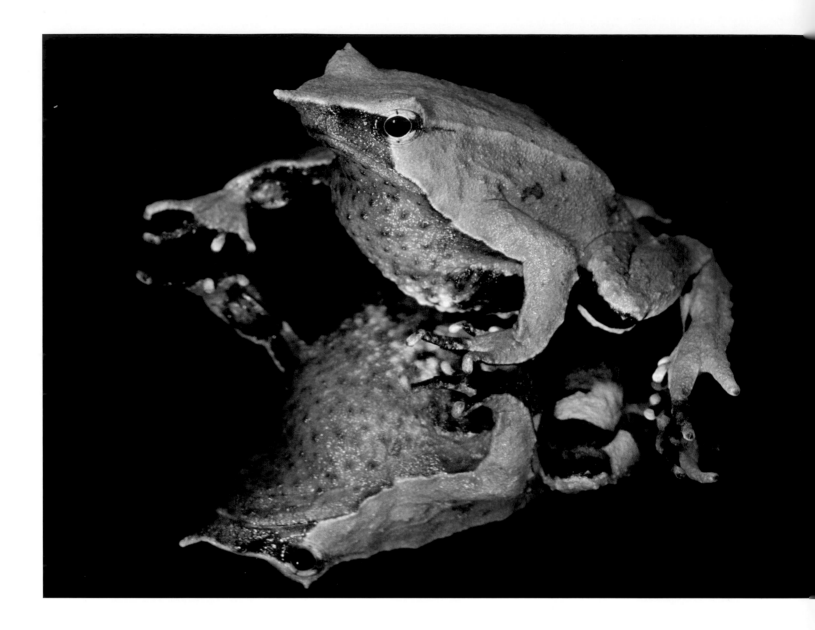

Darwin's Frogs, *Rhinoderma darwinii*, are unique in keeping their developing young within their bodies (inside the male's vocal sac).

Further Reading: Howes, 1888; Cei, 1962, 1980; Busse, 1970, 1989, 1991, 2003; Busse and Werning, 2002; Crump, 2002, 2003; Crump and Veloso, 2005; Rabanal and Nuñez, 2008; Fenolio, 2012; Fenolio et al., 2012b.

When I think of animals living in the dark, I include another species, one that may not be obvious at first glance. Darwin's Frogs, *Rhinoderma darwinii*, live on the dimly lit floor of temperate Austral forests (that is, forests of the southern hemisphere) in Chile and Argentina. Adult males call to attract females that are ready to breed. When an interested female approaches, a rowdy courtship ensues. The female is aggressive, even kicking the head and body of the male. The female ultimately deposits a small clutch of eggs among the debris of the forest floor, and the male fertilizes them. Then she leaves, her contribution to the reproductive process finished. The male remains in the area of the clutch of

eggs and keeps careful watch on their development. When the tadpoles begin hatching, the male takes them into his mouth and manipulates them through an opening below his tongue (called the vocal slit) and into his vocal sac. There, within the dark confines of the male's body, the tadpoles complete their development. After 50 to 65 days, depending on the prevailing temperatures, the male begins to "cough up" fully formed baby frogs. By keeping his developing young within his vocal sac, the father provides a stable environment, safe from would-be predators. It is a huge energetic investment on his part, but it gives his offspring a better chance at surviving to adulthood to pass on their (and his) genes. Only two species on Earth are known to enact this kind of parental care, both of which are Darwin's Frogs. Sadly, Chile's Darwin Frog, *Rhinoderma rufum*, hasn't been seen in more than 30 years. Darwin's Frogs, *R. darwinii*, have declined across their range, and there is concern about their conservation.

Who knows how many ages passed before the Appalachian Cave Crayfish, *Orconectes* (*Cambarus*) *packardi*, evolved into the white, blind form that we find in a few cave streams today? I had the privilege of meeting this one in its home.

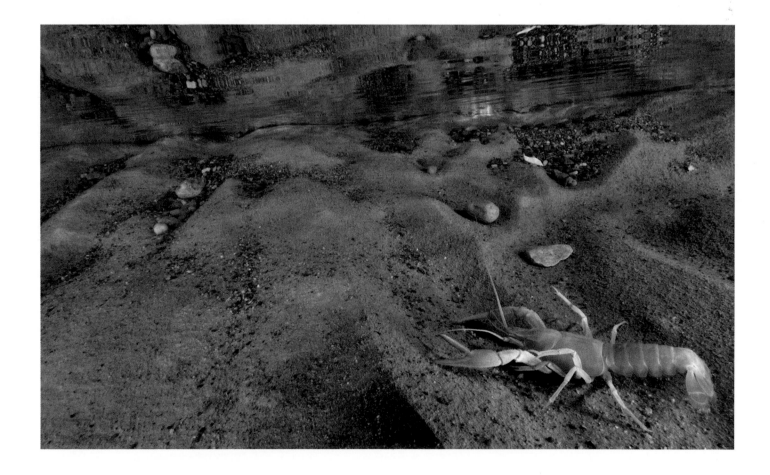

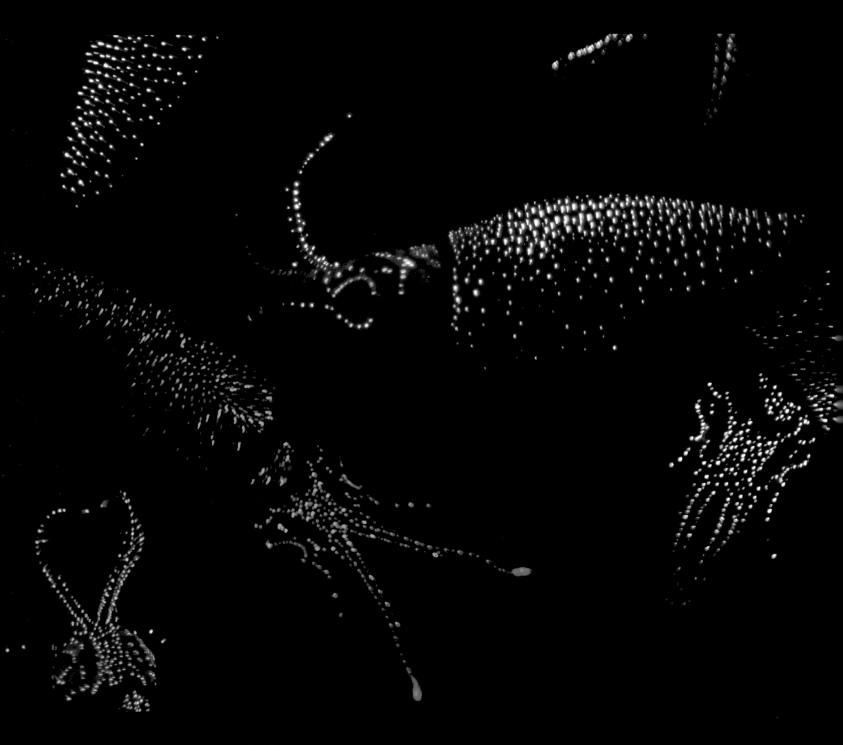

Firefly Squid, *Watasenia scintillans*, are among the many deep-ocean squid that can produce light.

*O*ceanic habitats are divided into zones of increasing depth, starting with the epipelagic and mesopelagic zones, followed by the bathypelagic, abyssopelagic, and hadopelagic zones. Sunlight penetrates the epipelagic and mesopelagic zones. The bottom portion of the mesopelagic zone is where most surface light drops off, and no sunlight penetrates into the bathypelagic and lower zones. The hadopelagic zone includes the waters of deep-sea trenches and craters. The deep-sea creatures, those living below the surface waters of the epipelagic zone, occupy the largest habitat on Earth, with the greatest number of individual animals.

Like subterranean life forms, animals in dark, deepwater environments may go longer between meals than their surface counterparts. Also like subterranean animals, many deepwater animals are capable of detecting movement and chemical cues using senses other than vision. But vision is still important for many deepwater oceanic species, for one very good reason: bioluminescence—the biological production of light. Humans often find it difficult to grasp that the largest habitat on our planet is dependent on a communication mechanism that is rare in terrestrial environments.

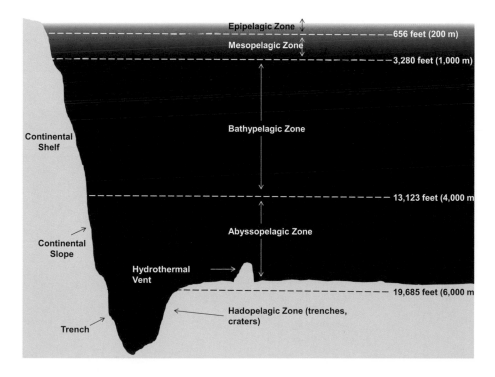

Epipelagic Zone
Mesopelagic Zone
—656 feet (200 m)
—3,280 feet (1,000 m)

Continental
Shelf

Bathypelagic Zone

13,123 feet (4,000 m)

Continental
Slope

Abyssopelagic Zone

Hydrothermal
Vent

19,685 feet (6,000 m)

Hadopelagic Zone (trenches,
craters)

Trench

The ocean is divided into zones by depth. This depiction shows all of the depths in meters and feet.

Communicating through Bioluminescence

Bioluminescence plays a critical role in the lives of countless species. Organisms use bioluminescence to communicate with potential mates, as camouflage, to frighten potential predators, even to attract prey, as well as for reasons that biologists have yet to determine. Here I want to consider bioluminescence as a way for animals to communicate in the dark.

Most of the earth's bioluminescent creatures live in the oceans. Up to 90 percent of the species in some deepwater oceanic communities can produce light (Smith and Douglas, 1987). Even though most bioluminescence occurs in the depths of the oceans, long-hidden from human eyes, its existence in terrestrial environments has not gone unnoticed. More than 2,000 years ago, Aristotle wrote about "foxfire" in rotting wood. Aristotle's foxfire is actually a bioluminescent fungus that decomposes wood. When Charles Darwin was on his *Beagle* voyage around the world, he wrote of a night when the ship was sailing through a bioluminescent sea.

> While sailing in these latitudes on one very dark night, the sea presented a wonderful and most beautiful spectacle. There was a fresh breeze, and every part of the surface, which during the day is seen as foam, now glowed with a pale light. The vessel drove before her bows two billows of liquid phosphorus, and in her wake she was followed by a milky train. As far as the eye reached, the crest of

The eerie corpse of this grub glows in the dark. Science has no answer yet for why the bacteria that are digesting this moth larva produce light. This is one example of bioluminescence found outside deep-ocean habitats.

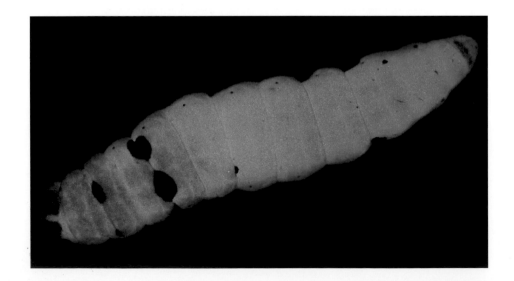

every wave was bright, and the sky above the horizon, from the reflected glare of these livid flames, was not so utterly obscure as over the rest of the heavens. (Darwin, 1989 [1839], p. 151)

The glowing waters resulted from the light produced by small, single-celled aquatic organisms called dinoflagellates that generate light in response to physical stimulation. As a ship plows through the water, it agitates millions of dinoflagellates, which light up and outline the boat, its wake, and the crests of nearby waves. This phenomenon is also responsible for "Bioluminescent Bay" in Puerto Rico, beloved by both locals and visitors. The bay accommodates a much greater concentration of bioluminescent dinoflagellates than are usually found in seawater. Everything moving in the bay at night glows: fishes and humans alike.

Thor Heyerdahl often saw bioluminescence when he and his companions were crossing the Pacific on their raft, the *Kon-Tiki*.

> When night had fallen, and the stars were twinkling in the dark tropical sky, the phosphorescence flashed around us in rivalry with the stars, and single glowing plankton resembled round live coals so vividly that we involuntarily drew in our bare legs when the glowing pellets were washed up round our feet at the raft's stern. When we caught them we saw that they were a brightly shining species of shrimp. On such nights we were sometimes scared when two round eyes suddenly rose out of the sea right alongside the raft and glared at us with an unblinking hypnotic stare—it might have been the Old Man of the Sea himself. These were often big squids which came up and floated on the surface with their devilish green eyes shining in the dark like phosphorus. But sometimes they were the shining eyes of deep-water fishes which only came up at night and lay staring, fascinated by the glimmer of light before them. Several times, when the sea was calm, the black water round the raft was suddenly full of round heads two or three feet in diameter, lying motionless and staring at us with great glowing eyes. On other nights balls of light three feet and more in diameter would be visible

down in the water, flashing at regular intervals like electric lights turned on for a moment. (Heyerdahl, 1950, pp. 117–18)

Bioluminescence for Hunting

The feces and decaying organic materials that fall to the depths from the ocean's surface communities have been described as raining down in a bioluminescent shimmer. The organic materials from the surface are covered in bioluminescent bacteria that break down the decaying matter on its way to the deep ocean, where it provides nutrients for deep-sea food webs. Predators exploit this glowing phenomenon for their own gain. Dragonfishes, anglerfishes, some cephalopods, and other predators exploit the circumstances by deploying bioluminescent lures (Young, 1983; Pietsch, 2009), which they dangle and wiggle in the darkness to attract hungry organisms looking for glowing organic food bits, only to become food themselves.

Bioluminescence may also be used to induce confusion in prey. For example, a mesopelagic octopod with glowing suckers on its arms may be using them to lure or to confuse prey—the suckers no longer work for gripping things (Johnsen et al., 1999). One species of squid waves its glowing arms around in a confusing light show as it tries to capture prey (Kubodera et al., 2007). Special light-producing organs near the eyes of some predators can illuminate the area in front of them as they cruise the depths looking for a meal (Young, 1983). While it is rare, certain fish species produce and can see red light—apparently gaining this ability, at

Anglerfishes are famous for their glowing lures dangling from a "rod" attached to their head. The lures attract prey to within striking distance. This is the Ghostly Seadevil, *Haplophryne mollis*.

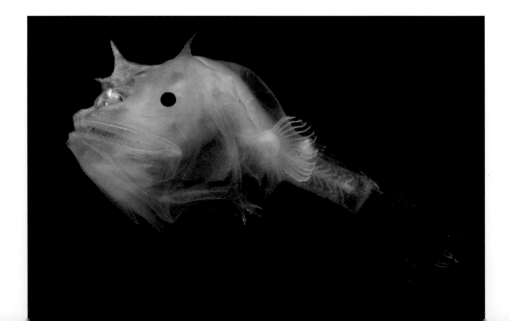

Photophores, shown in close-up on two deep-sea fishes, are structures that produce light. The arrangement of these structures across the body of a given species might be used for species recognition or for recognition between males and females in the ocean darkness.

least in part, through their diet (Douglas et al., 2000; Sutton, 2005). Their prey can't see red light and don't realize that they are being illuminated by the hunting predator (Denton et al., 1970; O'Day and Fernandez, 1974; Douglas et al., 2000; Sutton, 2005). But bioluminescence in the depths has many more purposes than just attracting and locating prey.

Bioluminescence for Same-Species Recognition

The many bioluminescent organs that decorate the bodies of some animals can serve in species recognition and in identification of the opposite sex (Herring, 1977, 1990, 2000, 2007; Young, 1983; Herring et al., 1990; Widder, 2002, 2010). Some form of clear signal is necessary for potential mates to recognize one another down there in the dark, and the various sizes, shapes, and patterns of bioluminescent spots can serve as a beacon to members of the same species and the opposite sex.

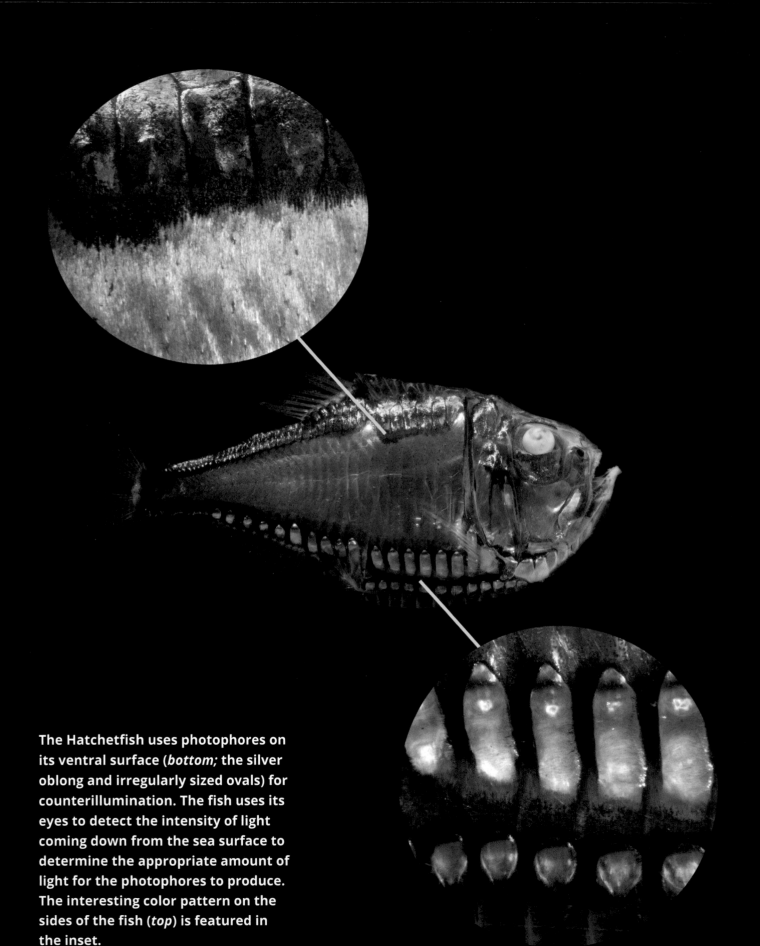

The Hatchetfish uses photophores on its ventral surface (*bottom;* the silver oblong and irregularly sized ovals) for counterillumination. The fish uses its eyes to detect the intensity of light coming down from the sea surface to determine the appropriate amount of light for the photophores to produce. The interesting color pattern on the sides of the fish (*top*) is featured in the inset.

Bioluminescence for Hiding in Plain Sight

Hungry predators often look upward to spot potential prey items silhouetted against the dim surface light. Many midwater species have light-producing organs called photophores lining the lower (ventral) surface of their body. They also have light detectors on their upper (dorsal) side that detect the color and intensity of the dim light streaming down from the surface above. The two systems work together to produce a dim blue light on the underside of the organism that matches the color and intensity of the faint surface glow above them. The light from the photophores makes the body of the animal invisible to an organism looking up from below. This "hiding in plain sight" mechanism is known as counterillumination (Herring, 1977, 1990, 2000, 2007; Latz and Case 1982, 1992; Young, 1983; Herring et al., 1990; Johnsen et al., 2004).

Bioluminescence for Defense, in a Pinch

Some species can squirt out a glowing cloud of liquid when threatened (Young, 1983; Herring, 1990, 2000, 2007). Often, the glowing material is used as a decoy as the producer heads off in another direction. Other species generate elaborate light displays when threatened, perhaps to

Acanthephyra purpurea **is one of many shrimp species that expel a cloud of glowing fluid to try to escape a predator.**

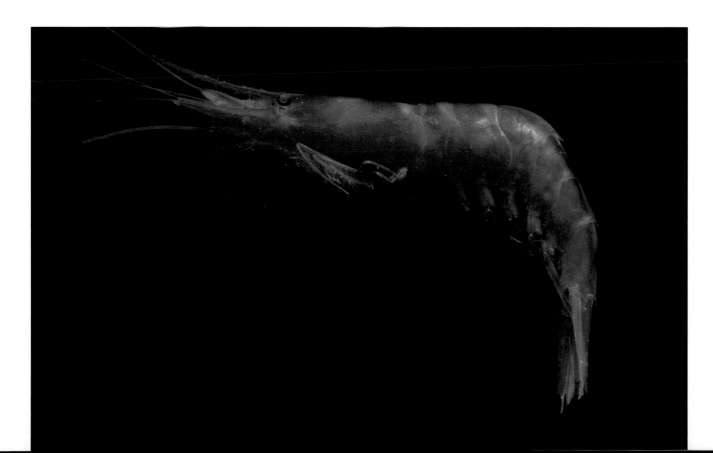

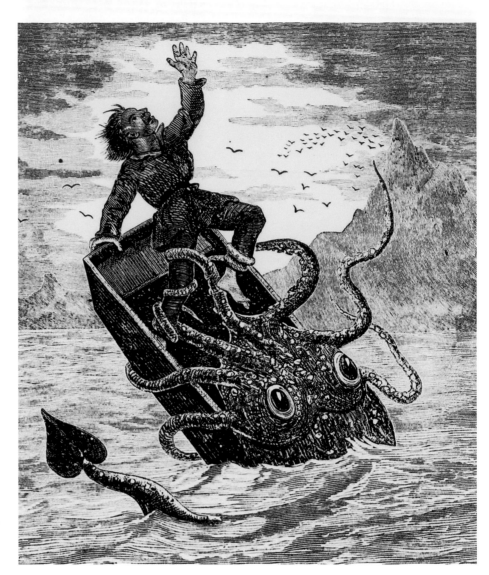

Stories of sea monsters date back as far as humans' first explorations of the world's oceans. This anonymous illustration, published in *Popular Science Monthly* (volume 14, 1878–79), depicts a hybrid creature, part octopus and part squid

There is certainly no need to evoke mythical creatures to find monsters on our planet. They live in our oceans—creatures frightening, amazing, and beautiful, all at the same time. One particular feature draws people who are seeking monsters to the mesopelagic and bathypelagic communities: giant teeth. The denizens of the deep certainly have them. Long teeth ensure that the rare feeding opportunities are not wasted. Recurved (backward-curving) teeth make it easier to snag and ingest passing prey. Glowing lures draw prey within striking distance. Enormous mouths and expandable stomachs ensure space for meals. These characteristics forge the real-life monsters of our day.

The depths are not devoid of color, but most of the creatures that live there cannot see warm colors (reds, oranges, yellows). The nets that bring deep-sea catches to the surface are sometimes splashed with

color. Many crustaceans, for example, are vermillion. There is an adaptive value to being red in the depths. Hot colors like red, orange, and yellow are the first to drop out of the spectrum as one moves to deeper and deeper waters. At depths, if something is red—that is, we would see it as red in sunlight—the color doesn't show up. Red animals in the depths are black when illuminated by the typical blue or green bioluminescence produced by a fish or a squid (Johnsen, 2005). The color allows red creatures of the deep to hide in plain sight.

The biodiversity and ecology of wildlife living in deep oceanic waters remain poorly understood, although new technologies are constantly advancing the science of deep-sea ecology (Robison, 2004, 2009). For example, a newly developed video system that uses bait and/or light to draw deep-sea cephalopods within range has filmed previously unseen

Some dragonfishes produce violet light in the photophores on their face. They presumably can also see violet light. But most other deep-sea species, including the prey the dragonfish seeks, cannot. Prey species can thus be illuminated without knowing it.

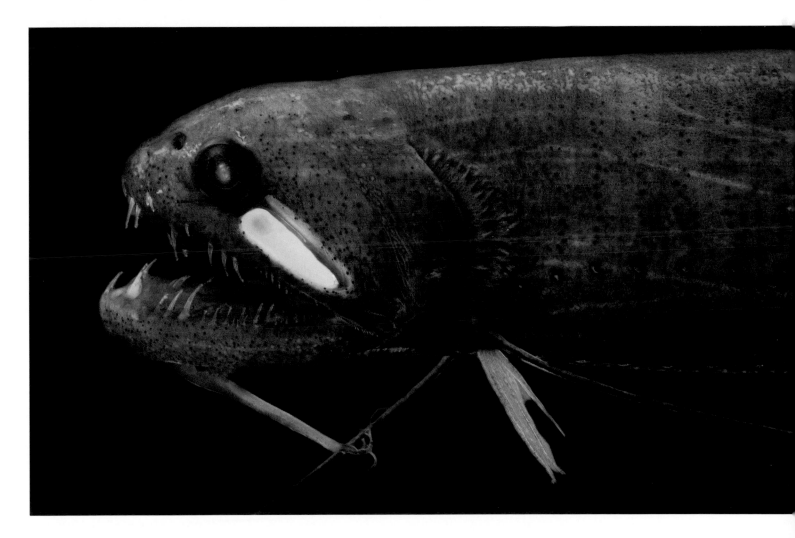

species, including the Giant Squid, *Architeuthis* (Kubodera and Mori, 2005; Kubodera et al., 2007). Nature lovers around the world saw on their televisions the exciting images and video of a giant squid using its elongate feeding tentacles to strike and entangle its prey, caught on film for the first time. These observations challenged early hypotheses of how this squid hunts. Genetic analysis of the stomach contents of the same giant squid revealed that these animals can be cannibals (Deagle et al., 2005; Bolstad and O'Shea, 2010). Stable isotope analysis is shedding light on the movement patterns of *Architeuthis* and the shifts in its diet as it grows from tiny larva to enormous adults, with eyes the size of dinner plates (Cherel and Hobson, 2005; Guerra et al., 2010). [Isotopes are atoms of the same chemical element that differ in the number of neutrons. Stable isotopes do not decay into different isotopes. Stable isotope analysis is a process that looks for the signature of particular stable isotopes in compounds. Because naturally occurring carbon (^{13}C) and nitrogen (^{15}N) isotopes persist and accumulate in food webs, the technique can be used to decipher both diet and trophic (food web) position of a given organism (Peterson and Fry, 1987; Fenolio et al., 2006). An organism can be linked to its diet by the similarity of stable carbon isotope ratios (^{13}C/^{12}C), and the organism's trophic position can be inferred from the characteristic enrichment of the stable nitrogen isotope ratio (^{15}N/^{14}N) of 3.5 percent per trophic level (DeNiro and Epstein, 1981; Fenolio et al., 2006).]

Electronic tagging methods enable scientists to monitor the movements of individuals electronically. The tools have advanced our understanding of the ability of another giant squid species, the Humboldt Squid, *Dosidicus gigas*, to inhabit oxygen-rich surface waters as well as the oxygen-poor depths and, in particular, a deepwater layer known as the oxygen minimum zone (where dissolved oxygen levels are significantly lower than in water layers above and below this zone) (Gilly et al., 2006). Modern technology is allowing us to learn how different communities of mesopelagic fauna have adapted to conditions ranging from cold Antarctic waters to tropical seas (Torres and Somero, 1988a, 1988b;

Stickney and Torres, 1989; Torres et al., 1994; Hopkins and Sutton, 1998). We are also learning which species dominate particular communities (Sutton and Hopkins, 1996a, 1996b; Burghart et al., 2007) and how deepwater communities segregate by depth (Robison et al., 2010).

Deep-sea exploration in manned and unmanned vehicles delivers many exciting new observations. For example, deep-sea trenches are being explored by remotely operated vehicles (ROVs), and the explorations show that the biodiversity of life in these trenches is more diverse than expected and differs in different parts of the trench (Gunton et al., 2015). Formerly unknown or poorly known habitats are being discovered along ocean floors. Newly discovered giant "asphalt mound ecosystems" are being explored in places like the Gulf of Mexico and the Angolan Margin (Jones et al., 2014; Okeanos Explorer, 2014). It turns out that asphalt can be spit out by "asphalt volcanoes" on the floor of the ocean, producing asphalt formed below the floor. The asphalt was produced in the same way that oil and gas were formed. The result is a debris field of asphalt chunks. These rocky reefs are inhabited by an abundance of wildlife, including sulfur-oxidizing bacteria (producing carbohydrates through the breakdown of chemicals).

Other recent discoveries come from the Whillans Ice Stream Subglacial Access Research Drilling Project, or the "WISSARD Team," funded by the National Science Foundation. In 2015, the team drilled through the Whillans Ice Stream, a glacier that flows from the West Antarctic Ice Shelf to the Ross Ice Shelf. The researchers used a hot-water drill to cut through the ice, working around a point where the glacier passes over bedrock, enters the sea, and begins to float—a transitional area referred to as the glacier's grounding zone. They bored down 2,400 feet (731.5 meters) below the ice surface to water along the sea floor. In this habitat, blanketed in darkness and with low nutrient input and under tons of ice and pressure, they made wonderful discoveries. A community of fishes and invertebrates was observed by an ROV—one fish was pale and translucent, similar in appearance to cave-adapted fishes.

The ocean depths harbor communities of fishes that will never see the light of day. Theirs is a world of perpetual darkness, cold temperatures, and unbelievable pressure. Snailfishes have been documented as the deepest-living of all known fish species in the oceans. This Bearded Snailfish, *Careproctus trachysoma*, was photographed in the Sea of Japan.

Drilling and ROV technologies have resulted in the discovery of yet another community living in the dark. I'm proud to say that two of the biologists involved in the WISSARD Team were from my alma mater: Drs. Tulaczyk and Branecky, from the University of California, Santa Cruz. These discoveries teach us much about life's ability to exist in harsh environments here on Earth—and perhaps on other planets.

Modern technology is even helping us learn more about the "fish that time forgot." In 1938, a coelacanth, *Latimeria chalumnae*—a lobe-finned fish thought to have become extinct with the dinosaurs—was caught near the Comoro Islands, off East Africa (Smith, 1956; Thomson, 1991; Weinberg, 2000). In 1997, a second coelacanth species, *L. menadoensis*, was discovered in Sulawesi, Indonesia (first reported by Erdmann et al., 1999). Contemporary coelacanths inhabit waters 300 to 900 feet (90 to 274 meters) deep, in the twilight zone (the depths of the ocean where light from the surface is dim at best and fading with increasing depth). Modern diving techniques that use complex mixes of gases are allowing divers to reach the depths necessary to observe living coelacanths.

A computer process called ecological niche modeling is now showing scientists where additional appropriate habitat is located so that more populations might be discovered (Owens et al., 2011).

Marine biologists predict that a vast number of undescribed species remain hidden in the ocean depths. Studies of communities living around deepwater features such as hydrothermal vents, cold seeps (areas where hydrocarbons leak out of the sea floor), solid methane blocks (known as "methane ice"), and other extreme environments have been particularly productive, and for good reason. It appears that life has thrived around marine hydrothermal vents and thermal springs since the Cambro-Ordovician period, 435 to 570 million years ago (Walter, 2007). Newly discovered species in these habitats are as bizarre as they are numerous. For example, methane ice worms, *Hesiocaeca methanicola*, were discovered inhabiting solid methane ice (also known as methane hydrate) at the bottom of the Gulf of Mexico.

A Japanese direct fish print, or *gyotaku*, of a coelacanth. The California Academy of Sciences was kind enough to give artist Heather Fortner access to one of its specimens.

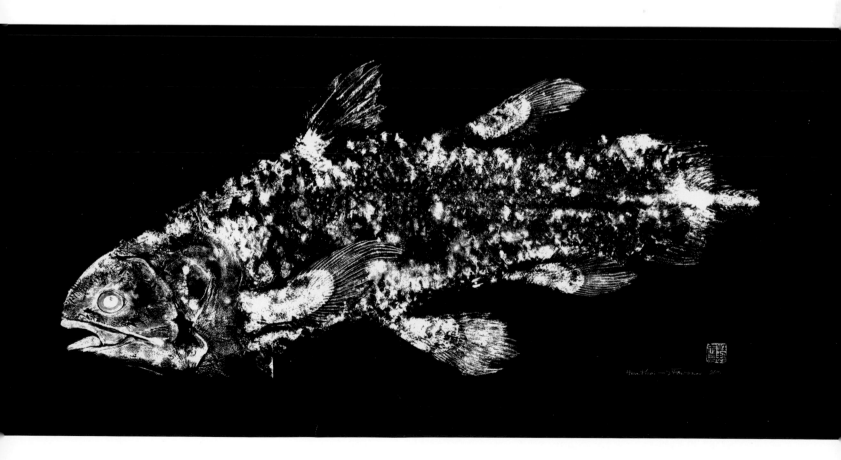

These worms, new to science, have a stable isotope signature suggesting that they live in a chemoautotrophic system—that is, a system where animals acquire energy by eating bacteria that derive energy from chemicals (that is, by chemosynthesis) rather than through photosynthesis (Fisher et al., 2000). In 1998, the largest species of mussel on Earth was discovered in a cold seep on the floor of the western Atlantic Ocean (von Cosel and Olu, 1998). Hydrothermal vents have produced entire communities of organisms previously unknown to science, including a semitranslucent octopus, *Vulcanoctopus hydrothermalis*, which has eyes without irises (Francisco et al., 2002).

The species richness found around hydrothermal vents and cold methane is impressive. Such habitats in Japanese waters accommodate at least 74 mollusk species alone (Sasaki et al., 2005). The biodiversity and productivity in these areas may attract other species that normally do not live in such places. One study documented breeding aggregations of fishes and octopods concentrated around a methane cold seep (Drazen et al., 2003).

But how are creatures surviving at such depths, with massive pressures, difficult temperatures, challenging oxygen concentrations, and variation in salinity and nutrient availability? These truly are extreme conditions. The pressure challenges alone are otherworldly. To calculate the pressure at a given depth, 10 atmospheres of pressure are added for every 328 feet (100 meters) in depth (1 atmosphere is the pressure at sea level). These quickly amount to crushing forces.

We do know a little about some of the extreme biology at depths. Let's consider fishes. The deepest-living fish species that we know of (a Snailfish) was discovered at 26,872 feet (8,190 meters) in Challenger Deep, a portion of the Mariana Trench in the Pacific Ocean. We do not know of any fishes in the deepest ocean depths, 27,600 to 36,089 feet (8,400 to 11,000 meters) (Yancey et al., 2014). We do know that as one surveys fish catches acquired from increasingly greater depths, the fishes contain

increasing levels of a chemical known as trimethylamine *N*-oxide, or TMAO. This chemical helps deep-sea fishes regulate their osmotic balance, helps proteins fold properly under great pressure, and keeps pressurized water from deforming proteins. So what does that mean?

A nice explanation is provided in a *Scientific American* blog by Jennifer Frazer (2015). As she explains, fishes are hypoosmotic to seawater—that is, they have less salt (a lower solute concentration, or osmolarity) in their tissues than the surrounding seawater. This can be a difficult balance to maintain. The process of osmosis, in which water naturally moves from lower to greater solute concentrations, would cause water to move from the fish's body tissues into the surrounding seawater. If this were allowed to follow its normal course, fishes living in seawater would dehydrate and die. But there are tricks to inhibit osmosis. One trick involves TMAO, which, as a solute, increases the osmolarity (the solute concentration) of the fish's tissues and helps prevent dehydration by eliminating the movement of water out of the tissues by osmosis. But TMAO does so much more.

Under high pressure, proteins would not be able to fold normally—a process required for all newly made proteins before they can take up their roles in the cell. TMAO assists the proteins with folding under pressure, and it keeps pressurized water from entering the inner structure of proteins and disrupting their activity. TMAO appears to be one of the great evolutionary tricks that fishes have used in inhabiting the deep depths of the ocean.

Alas, too much of a good thing isn't a good thing; there seem to be limits to the pressures that fishes and their biochemistry can withstand. At a predictable depth (roughly 27,600 feet, or 8,400 meters), the solutes in fishes' bodies (including TMAO) become so concentrated that a fish would become hyperosmotic—having a too-high solute concentration—allowing water to force its way into the fish's tissues and ultimately kill it. No fish species are known to exist below this

depth, and it may be this biochemistry, involving TMAO and osmolarity, that limits the depths at which fishes can live (Yancey et al., 2014).

Creatures living in the ocean depths exhibit another odd condition, known as deep-sea gigantism, or "abyssal gigantism," in which life forms that are relatively small in shallow waters have deep-sea relatives that are far larger—sometimes orders of magnitude larger. In the opposite condition, deep-sea dwarfism, a large shallow-water form has a dwarf deep-sea relative. Let's focus on abyssal gigantism. Some biologists propose that the cold temperatures of deep-sea habitats produce larger cell sizes, resulting in larger life forms. Another hypothesis invokes indeterminate growth, the condition in which an animal continues to grow throughout its life. Indeterminate growth may result in gigantism in the depths because the deep-sea habitat is so cold and the cold may lengthen lifespan, giving the species that live there a longer time to grow. A more recent argument proposes that the stable temperatures of the ocean depths provide an advantage for body temperature control, which may, in turn, affect the dynamics of the body's surface area–to–mass ratio (the bigger the animal, the lower the ratio, and the lower the rate of heat loss from its body). Or perhaps the biological "island rule" comes into play. In this scenario, the food limitation in a deep-sea habitat forces the body size of species to converge on an optimal size for any particular niche (that is, how an organism fits into the biological and nonbiological components of its environment); gigantism or dwarfism may give particular species an inherent advantage in obtaining food (McClain et al., 2006). Regardless of the cause, examples of deep-sea gigantism include the giant marine isopods, supergiant marine amphipods, giant mussel, Japanese spider crab, and colossal and giant squids (Bernard and Ingram, 1986; von Cosel and Olu, 1998; Timofeev, 2005).

Most deep-sea communities are inescapably linked with the sunlit ocean above them (Robison, 2009). For example, a significant component of the mesopelagic community migrates to nutrient-rich shallower

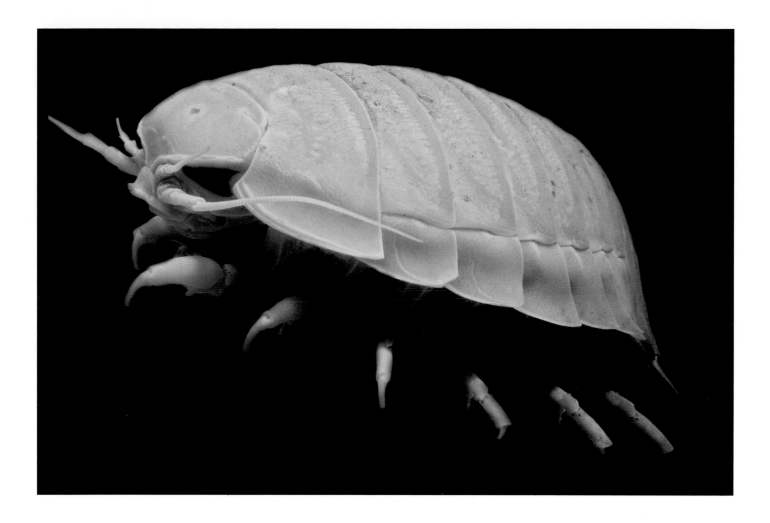

waters each night to feed, then returns to its deeper home waters. The migration is an important mechanism for transporting surface energy into deepwater communities (Hoffman and Sutton, 2010). This continually migrating community—one of the largest animal migrations on Earth (Robison, 2009)—is known as the "deep scattering layer." The deep scattering layer was discovered in the 1950s when navy ships that used sonar routinely picked up a "phantom layer" in the ocean—a false image of the bottom that made water appear much shallower than it really was. Researchers studying this phenomenon discovered that the layer consisted of untold numbers of small creatures that make the daily migration in response to light. Early studies of the deep scattering layer during solar eclipses noted that the layer began to move to shallower depths as the eclipse began.

The Giant Isopod, *Bathynomus giganteus*, the largest known isopod on Earth, lives on the ocean floor

My Experiences with Deep-Sea Communities

My own experiences with deep-sea animals have come through the generosity of marine biologists, including Dr. José Torres from the University of South Florida, who have allowed me to tag along on trawling cruises. One of Dr. Torres's field locations is a spot in the eastern Gulf of Mexico called Standard Station. It takes 18 hours to get there by ship from the docks in St. Petersburg, Florida. Arrival seems almost anticlimactic. There is nothing on the surface to mark this spot, but biologists have studied it since the 1970s, and it is one of the best-understood deepwater communities in the world. Day in and day out, researchers send nets down to the depths, trawl for several hours, and then reel them in. A single trawl can take six or more hours if the net has been sent down to a great depth.

My first time out with José was an exhausting experience. Because the ship was trawling 24 hours a day and I didn't want to miss anything, sleep deprivation soon took its toll. I found that if the net was filled with life forms that I wanted to photograph, it took nearly all of the time between trawls to do it. By the time I was finishing with the organisms from one trawl, the next net was on deck. I learned quickly that if a particular net's catch didn't have much that I wanted to shoot, I needed to run for my bunk and sleep until the next net came up. Energy drinks became my best friends on these trips.

Bringing up a net at night is an enchanting experience. As the load is hoisted above the surface, its contents sparkle and glow with the bioluminescent signals of hundreds of different life forms—green, blue, and even the occasional red flashes, like a Christmas display at a shopping mall. The bright deck lights on the sides of the ship often draw in squid and other nighttime feeders. There is also something calming and hypnotic about the Gulf of Mexico at night. I love to sit on deck and just enjoy the atmosphere. Every now and again, the bright lights of an oil rig decorate the horizon, which is otherwise empty.

It is a place where you can get lost in your thoughts. In fact, I conceived much of the design of this book on the decks of trawling ships in the Gulf of Mexico.

Daytime on a trawler is a different story entirely. The heat and humidity in the Gulf can be overwhelming. The air-conditioned labs are comfortable, but moving from the lab to the open deck is like walking into a wall. The extreme and sudden changes in temperature and humidity are shocking. But it's all worth it. Every time a net lands on the deck, it's like a surprise birthday package: you never know what you're going to see. What crazy species will be pulled from the depths in this net? My trawling experiences are among the most remarkable times I have spent as a professional biologist.

One of the many groups of deep sea fish that regularly turn up in the nets are dragonfish. This is *Astronesthes gemmifer*. These fish employ bioluminescence on their bodies and in their lures to both communicate to members of their own species and to attract prey items respectively.

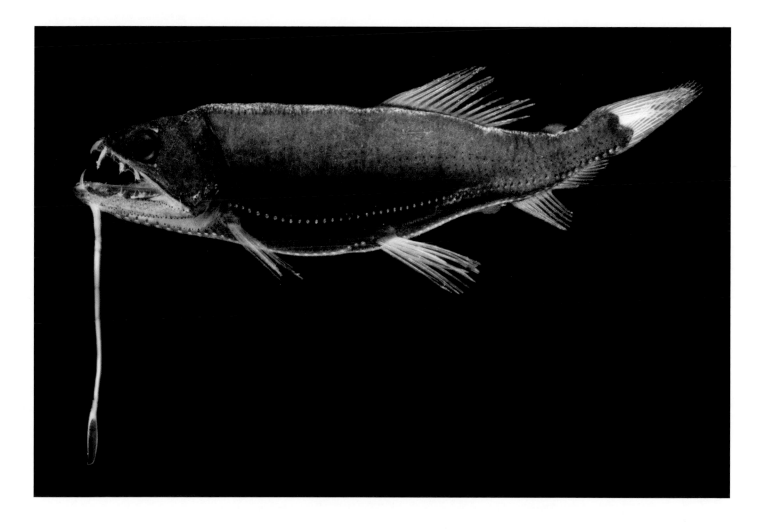

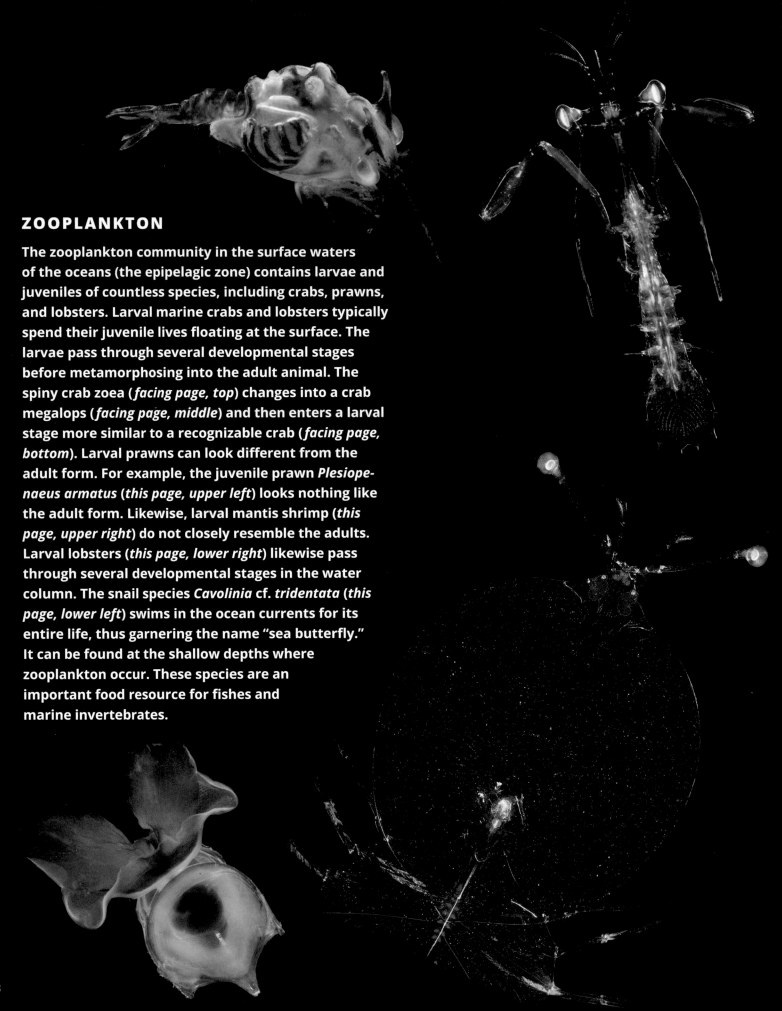

ZOOPLANKTON

The zooplankton community in the surface waters of the oceans (the epipelagic zone) contains larvae and juveniles of countless species, including crabs, prawns, and lobsters. Larval marine crabs and lobsters typically spend their juvenile lives floating at the surface. The larvae pass through several developmental stages before metamorphosing into the adult animal. The spiny crab zoea (*facing page, top*) changes into a crab megalops (*facing page, middle*) and then enters a larval stage more similar to a recognizable crab (*facing page, bottom*). Larval prawns can look different from the adult form. For example, the juvenile prawn *Plesiopenaeus armatus* (*this page, upper left*) looks nothing like the adult form. Likewise, larval mantis shrimp (*this page, upper right*) do not closely resemble the adults. Larval lobsters (*this page, lower right*) likewise pass through several developmental stages in the water column. The snail species *Cavolinia* cf. *tridentata* (*this page, lower left*) swims in the ocean currents for its entire life, thus garnering the name "sea butterfly." It can be found at the shallow depths where zooplankton occur. These species are an important food resource for fishes and marine invertebrates.

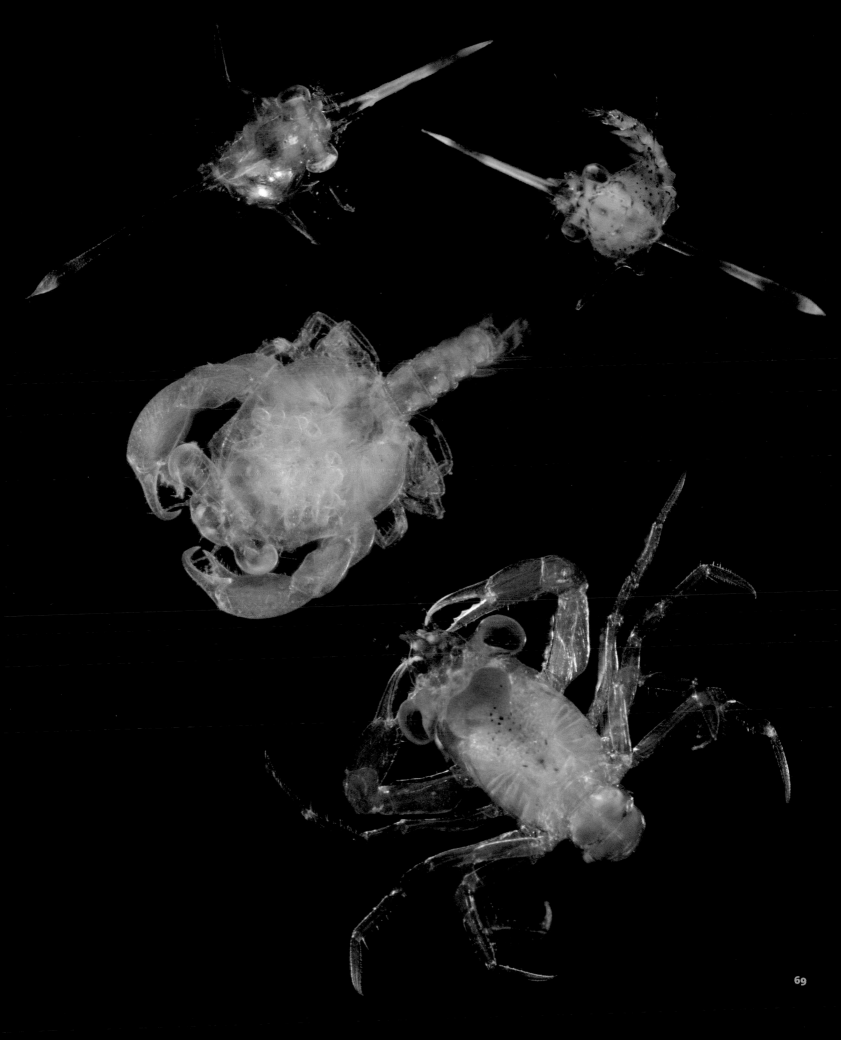

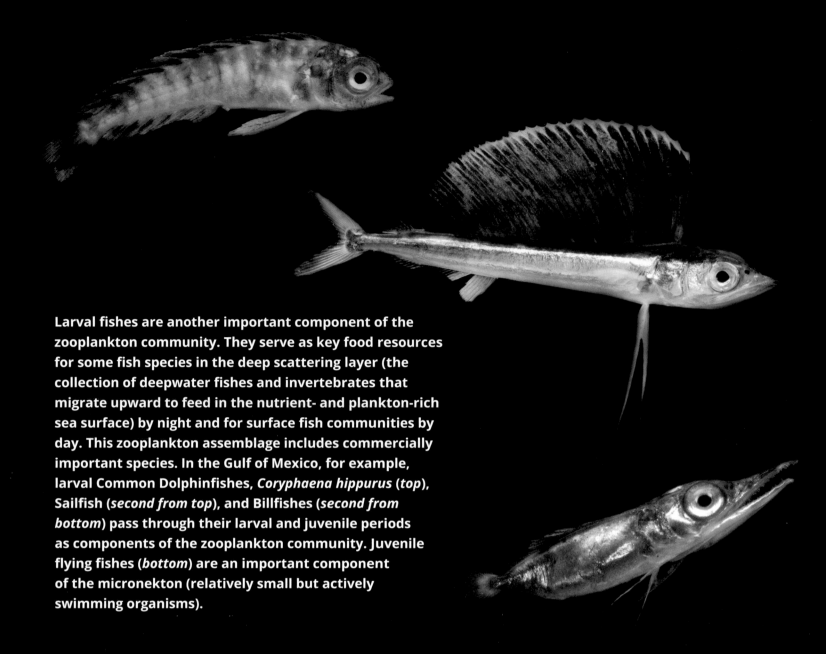

Larval fishes are another important component of the zooplankton community. They serve as key food resources for some fish species in the deep scattering layer (the collection of deepwater fishes and invertebrates that migrate upward to feed in the nutrient- and plankton-rich sea surface) by night and for surface fish communities by day. This zooplankton assemblage includes commercially important species. In the Gulf of Mexico, for example, larval Common Dolphinfishes, *Coryphaena hippurus* (*top*), Sailfish (*second from top*), and Billfishes (*second from bottom*) pass through their larval and juvenile periods as components of the zooplankton community. Juvenile flying fishes (*bottom*) are an important component of the micronekton (relatively small but actively swimming organisms).

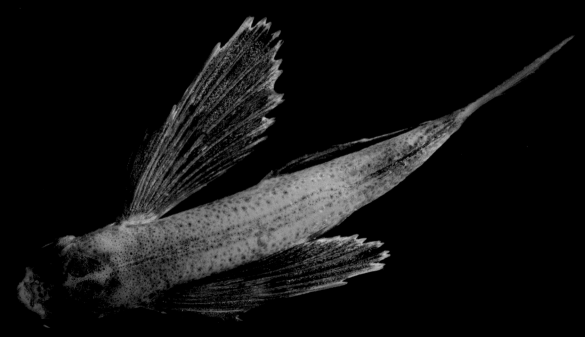

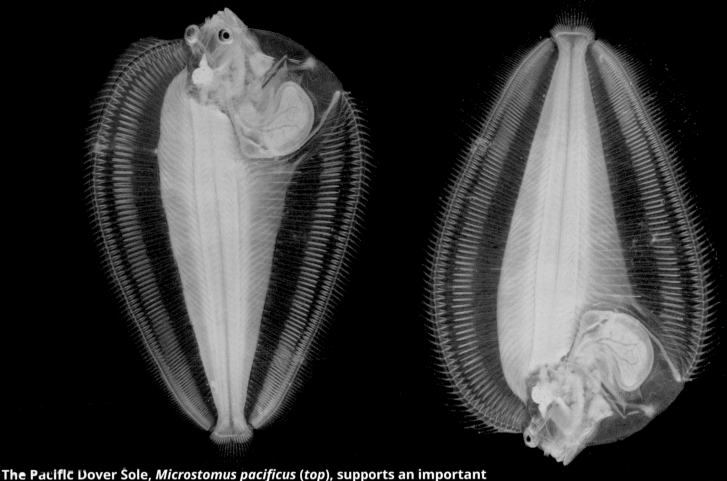

The Pacific Dover Sole, *Microstomus pacificus* (*top*), supports an important
fishery, particularly in the Pacific Northwest of the United States and Canada.
The translucent, larvae live in the water column (above the bottom and
beneath the surface) as zooplankton and are different in appearance from
the adults. As the sole develops, one of its eyes migrates to the dorsal (top)
side of its head. In this specimen, the eye is still in the process of migration.
The larva was trawled from between the surface and a depth of 1,082 feet
(330 meters) off Monterey, California, in 2009. The Deepwater Flounder,
Monolene sessilicauda, ranges through the western Atlantic Ocean. This
larval form was photographed in the Gulf of Mexico in 2015.

(*facing page*). The larvae are translucent and may remain in the water column for as long as three years. For decades, biologists thought that eel larvae were a different species of fish. Typically, leptocephalus larvae are many times smaller than the adults, but exceptions are known. One specimen collected at sea was just shy of 6 feet (1.8 meters) long. The size of the adults of several large leptocephalus specimens that have been collected is unknown because an adult eel associated with these larvae has yet to be described. The oceans undoubtedly hold many more secrets and discoveries. The three larvae here were trawled from between the surface and a depth of 1,640 feet (500 meters) in the Gulf of Mexico in 2011. Leptocephalus larvae that survive their developmental stages become adult eels such as this adult American Eel, *Anguilla rostrata* (*below*).

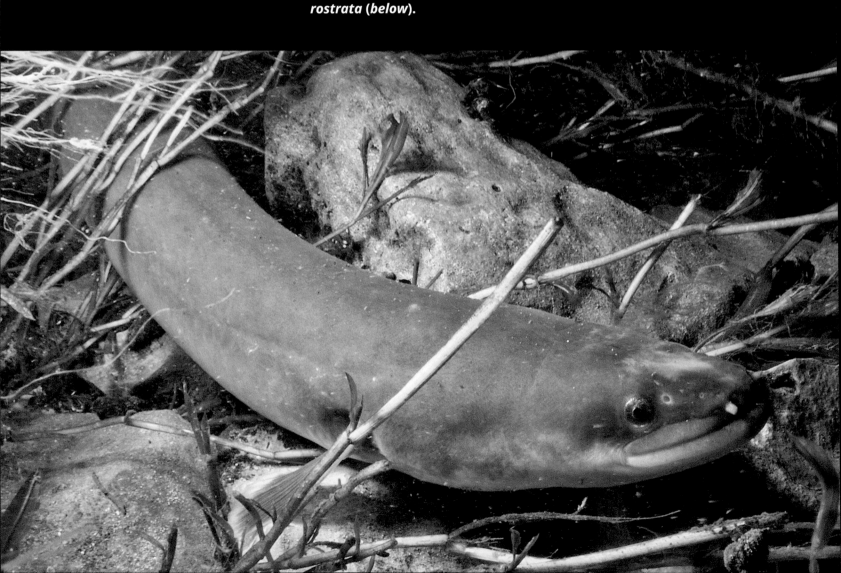

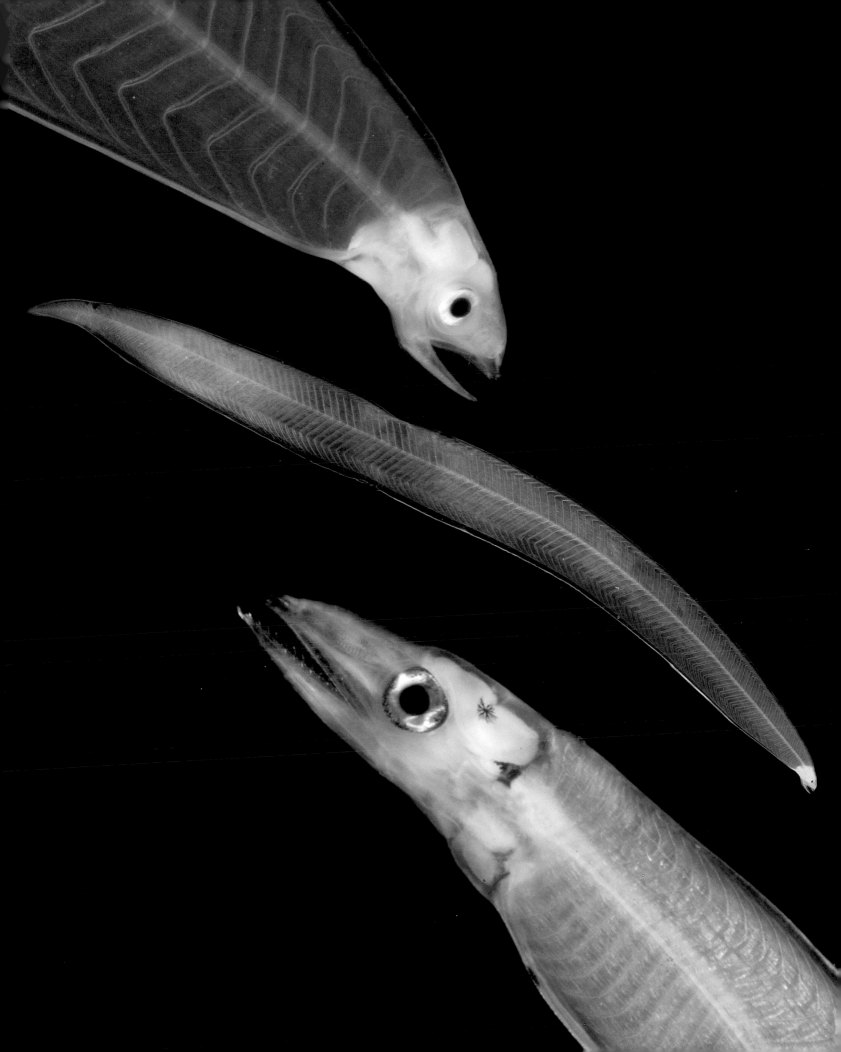

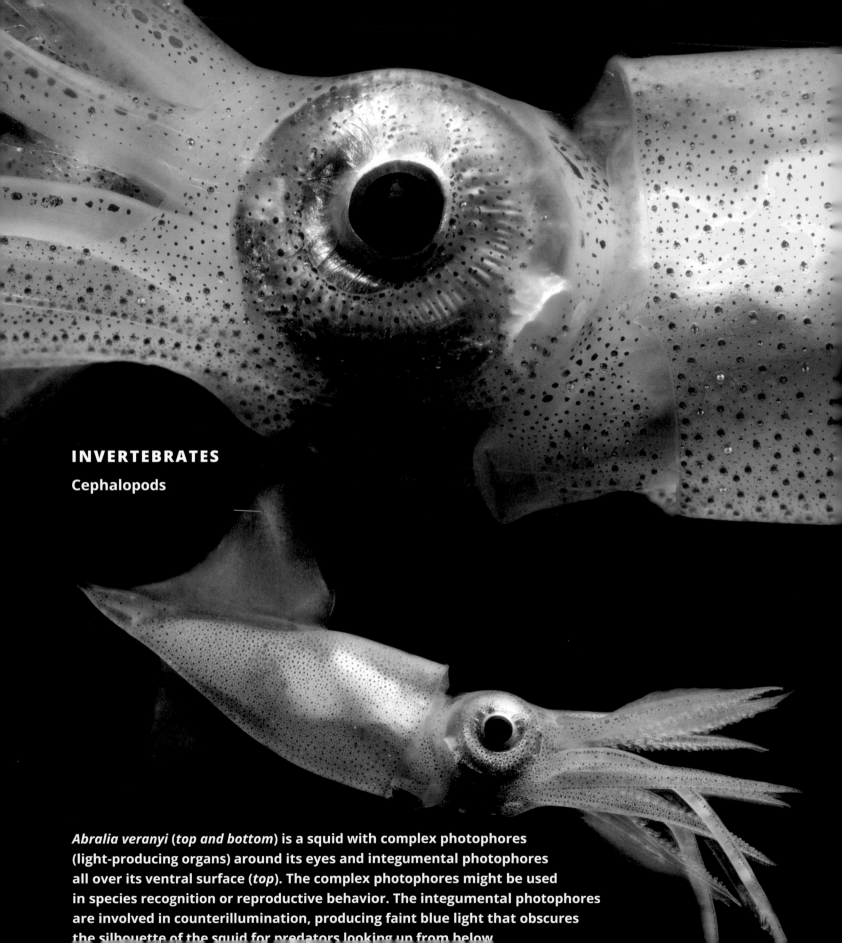

INVERTEBRATES

Cephalopods

Abralia veranyi (*top and bottom*) is a squid with complex photophores (light-producing organs) around its eyes and integumental photophores all over its ventral surface (*top*). The complex photophores might be used in species recognition or reproductive behavior. The integumental photophores are involved in counterillumination, producing faint blue light that obscures the silhouette of the squid for predators looking up from below.

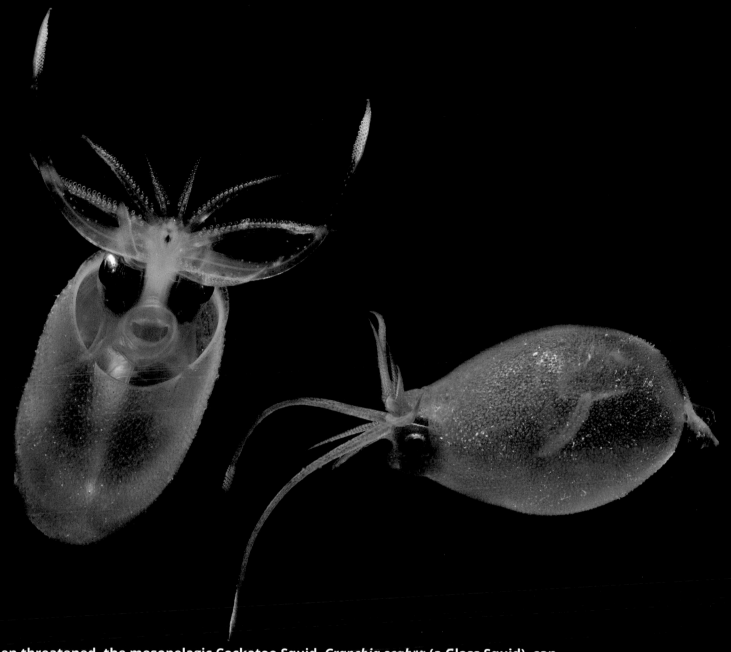

When threatened, the mesopelagic Cockatoo Squid, *Cranchia scabra* (a Glass Squid), can pull its head and tentacles into its mantle and turn into a ball. Sometimes the squid arranges its tentacles into a crest like a cockatoo's (*bottom*)—thus its common name, "Cockatoo Squid." This squid has small, knoblike, cartilaginous tubercles all over its body (seen clearly in the middle image) and has 14 oval photophores on each eye that produce greenish light (bioluminescence). When aggravated, the squid waves its arms back and forth at whatever it perceives as a threat (*top*). This individual was captured in a trawl at a depth between 656 feet (200 meters) and the surface in the Sea of Japan in 2007.

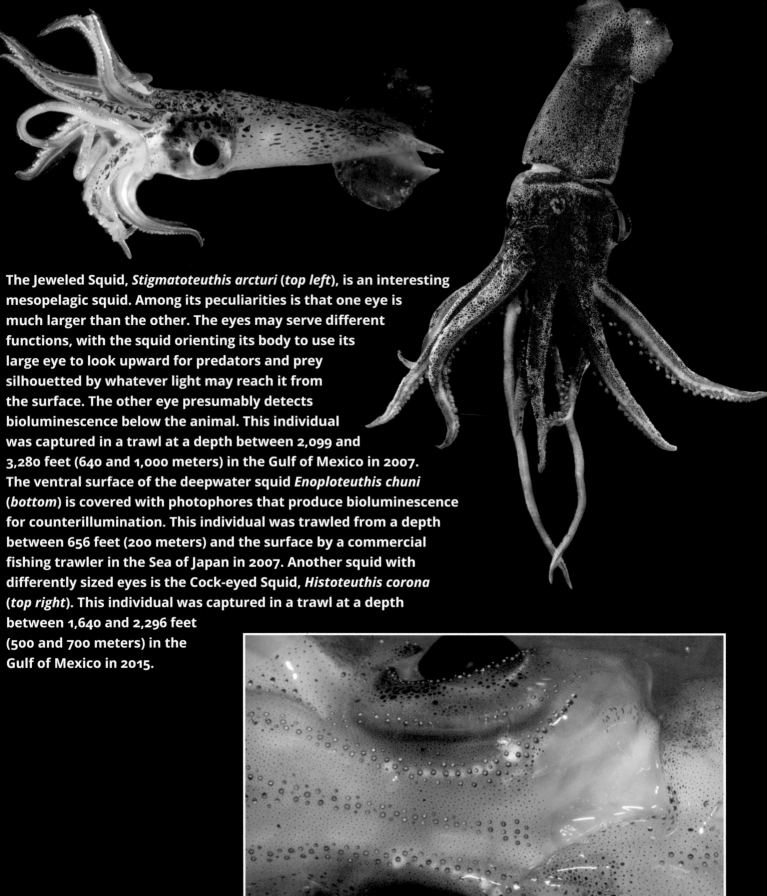

The Jeweled Squid, *Stigmatoteuthis arcturi* (*top left*), is an interesting mesopelagic squid. Among its peculiarities is that one eye is much larger than the other. The eyes may serve different functions, with the squid orienting its body to use its large eye to look upward for predators and prey silhouetted by whatever light may reach it from the surface. The other eye presumably detects bioluminescence below the animal. This individual was captured in a trawl at a depth between 2,099 and 3,280 feet (640 and 1,000 meters) in the Gulf of Mexico in 2007. The ventral surface of the deepwater squid *Enoploteuthis chuni* (*bottom*) is covered with photophores that produce bioluminescence for counterillumination. This individual was trawled from a depth between 656 feet (200 meters) and the surface by a commercial fishing trawler in the Sea of Japan in 2007. Another squid with differently sized eyes is the Cock-eyed Squid, *Histoteuthis corona* (*top right*). This individual was captured in a trawl at a depth between 1,640 and 2,296 feet (500 and 700 meters) in the Gulf of Mexico in 2015.

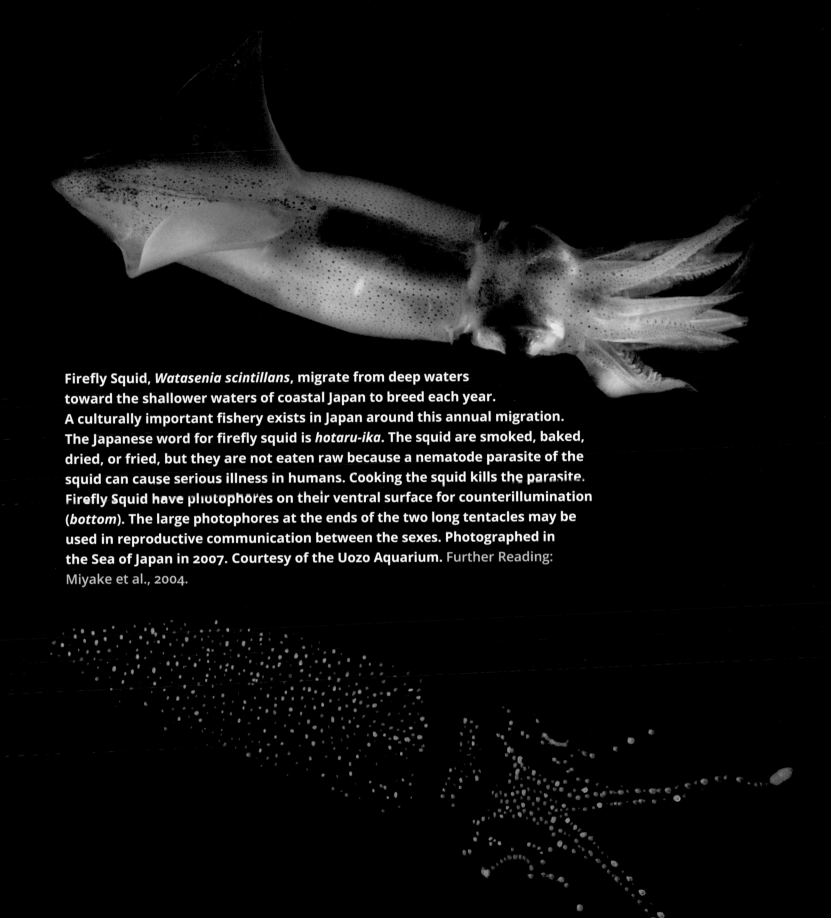

Firefly Squid, *Watasenia scintillans*, migrate from deep waters
toward the shallower waters of coastal Japan to breed each year.
A culturally important fishery exists in Japan around this annual migration.
The Japanese word for firefly squid is *hotaru-ika*. The squid are smoked, baked,
dried, or fried, but they are not eaten raw because a nematode parasite of the
squid can cause serious illness in humans. Cooking the squid kills the parasite.
Firefly Squid have photophores on their ventral surface for counterillumination
(*bottom*). The large photophores at the ends of the two long tentacles may be
used in reproductive communication between the sexes. Photographed in
the Sea of Japan in 2007. Courtesy of the Uozo Aquarium. Further Reading:
Miyake et al., 2004.

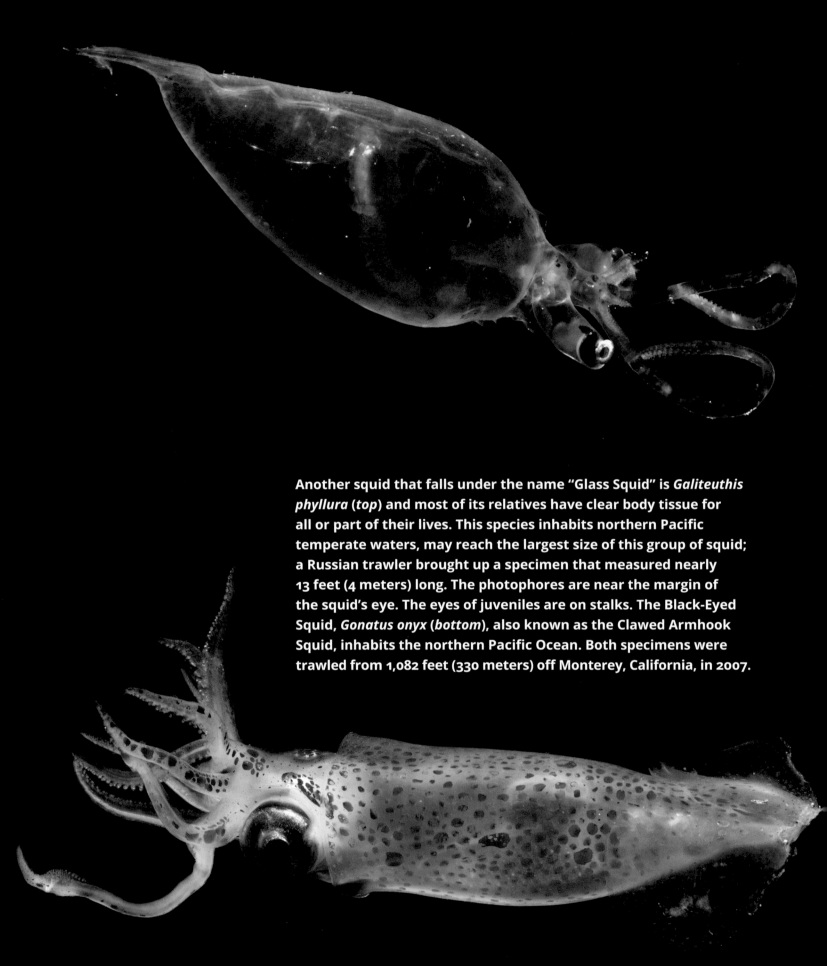

Another squid that falls under the name "Glass Squid" is *Galiteuthis phyllura* (*top*) and most of its relatives have clear body tissue for all or part of their lives. This species inhabits northern Pacific temperate waters, may reach the largest size of this group of squid; a Russian trawler brought up a specimen that measured nearly 13 feet (4 meters) long. The photophores are near the margin of the squid's eye. The eyes of juveniles are on stalks. The Black-Eyed Squid, *Gonatus onyx* (*bottom*), also known as the Clawed Armhook Squid, inhabits the northern Pacific Ocean. Both specimens were trawled from 1,082 feet (330 meters) off Monterey, California, in 2007.

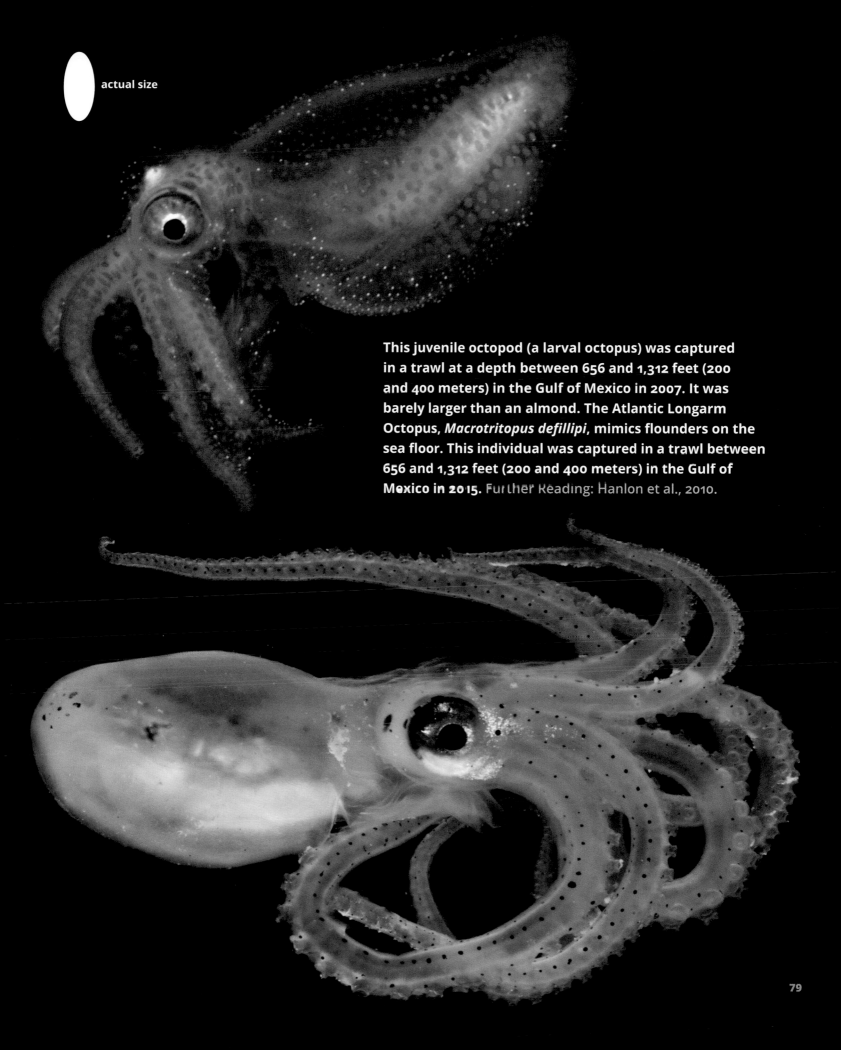

actual size

This juvenile octopod (a larval octopus) was captured in a trawl at a depth between 656 and 1,312 feet (200 and 400 meters) in the Gulf of Mexico in 2007. It was barely larger than an almond. The Atlantic Longarm Octopus, *Macrotritopus defillipi*, mimics flounders on the sea floor. This individual was captured in a trawl between 656 and 1,312 feet (200 and 400 meters) in the Gulf of Mexico in 2015. Further Reading: Hanlon et al., 2010.

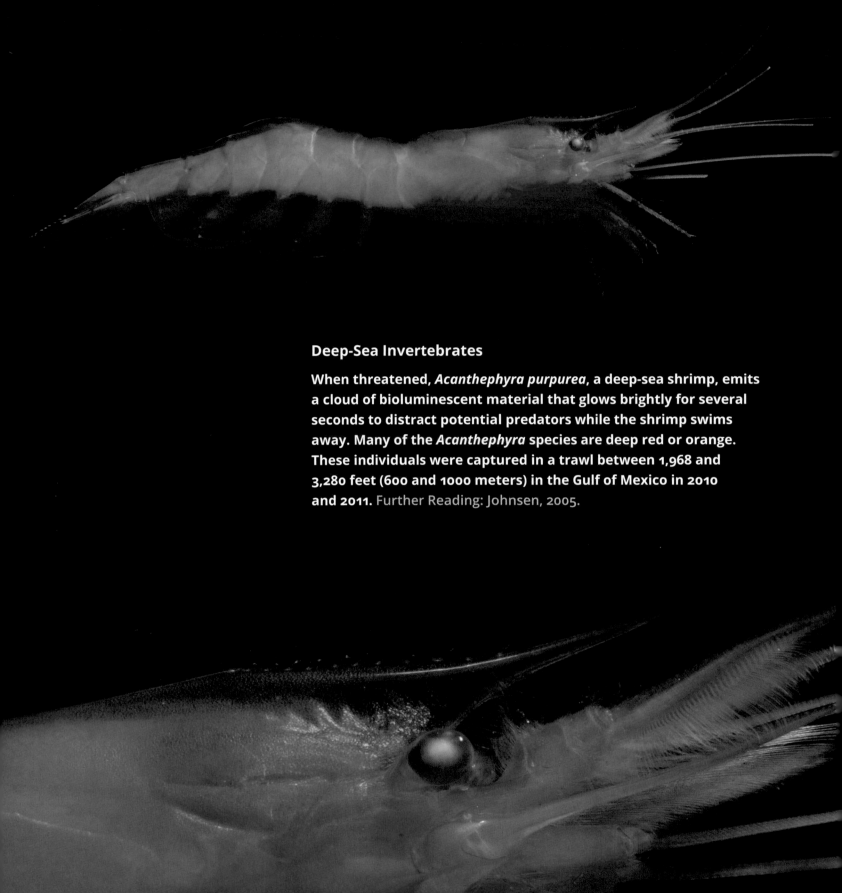

Deep-Sea Invertebrates

When threatened, *Acanthephyra purpurea*, a deep-sea shrimp, emits a cloud of bioluminescent material that glows brightly for several seconds to distract potential predators while the shrimp swims away. Many of the *Acanthephyra* species are deep red or orange. These individuals were captured in a trawl between 1,968 and 3,280 feet (600 and 1000 meters) in the Gulf of Mexico in 2010 and 2011. Further Reading: Johnsen, 2005.

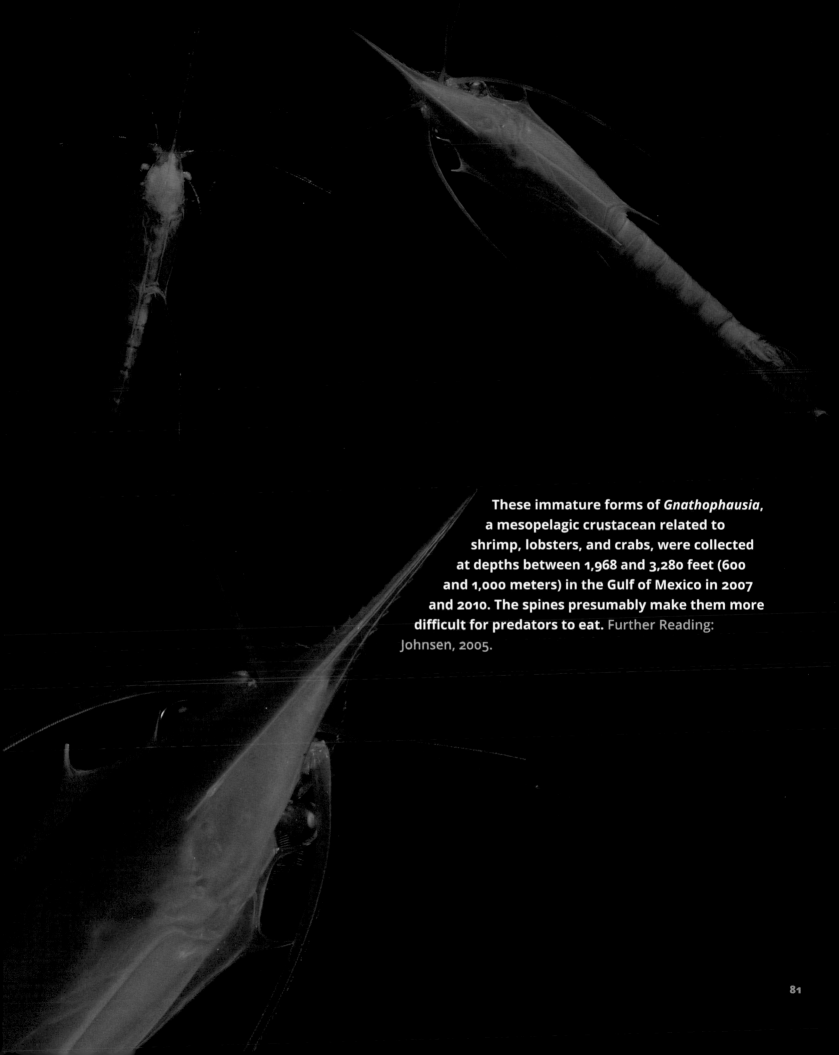

These immature forms of *Gnathophausia*, a mesopelagic crustacean related to shrimp, lobsters, and crabs, were collected at depths between 1,968 and 3,280 feet (600 and 1,000 meters) in the Gulf of Mexico in 2007 and 2010. The spines presumably make them more difficult for predators to eat. Further Reading: Johnsen, 2005.

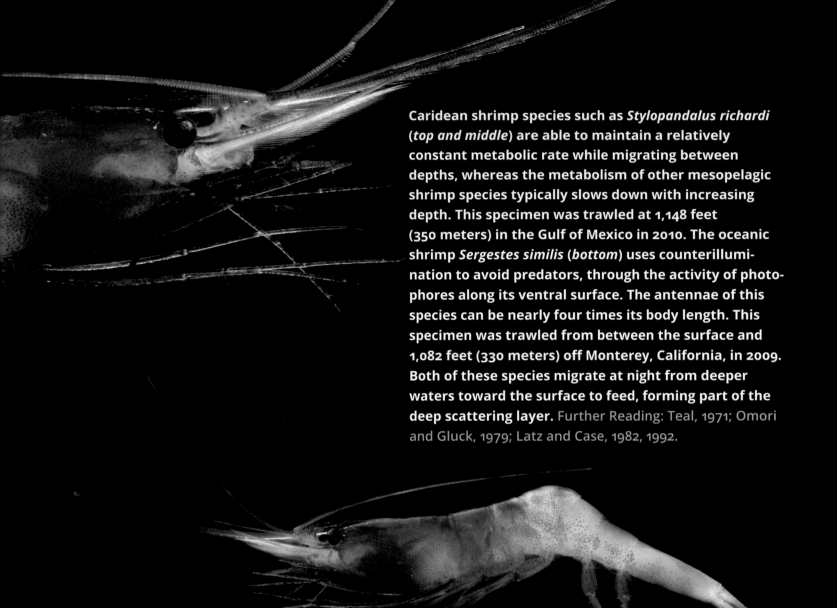

Caridean shrimp species such as *Stylopandalus richardi* (*top and middle*) are able to maintain a relatively constant metabolic rate while migrating between depths, whereas the metabolism of other mesopelagic shrimp species typically slows down with increasing depth. This specimen was trawled at 1,148 feet (350 meters) in the Gulf of Mexico in 2010. The oceanic shrimp *Sergestes similis* (*bottom*) uses counterillumination to avoid predators, through the activity of photophores along its ventral surface. The antennae of this species can be nearly four times its body length. This specimen was trawled from between the surface and 1,082 feet (330 meters) off Monterey, California, in 2009. Both of these species migrate at night from deeper waters toward the surface to feed, forming part of the deep scattering layer. Further Reading: Teal, 1971; Omori and Gluck, 1979; Latz and Case, 1982, 1992.

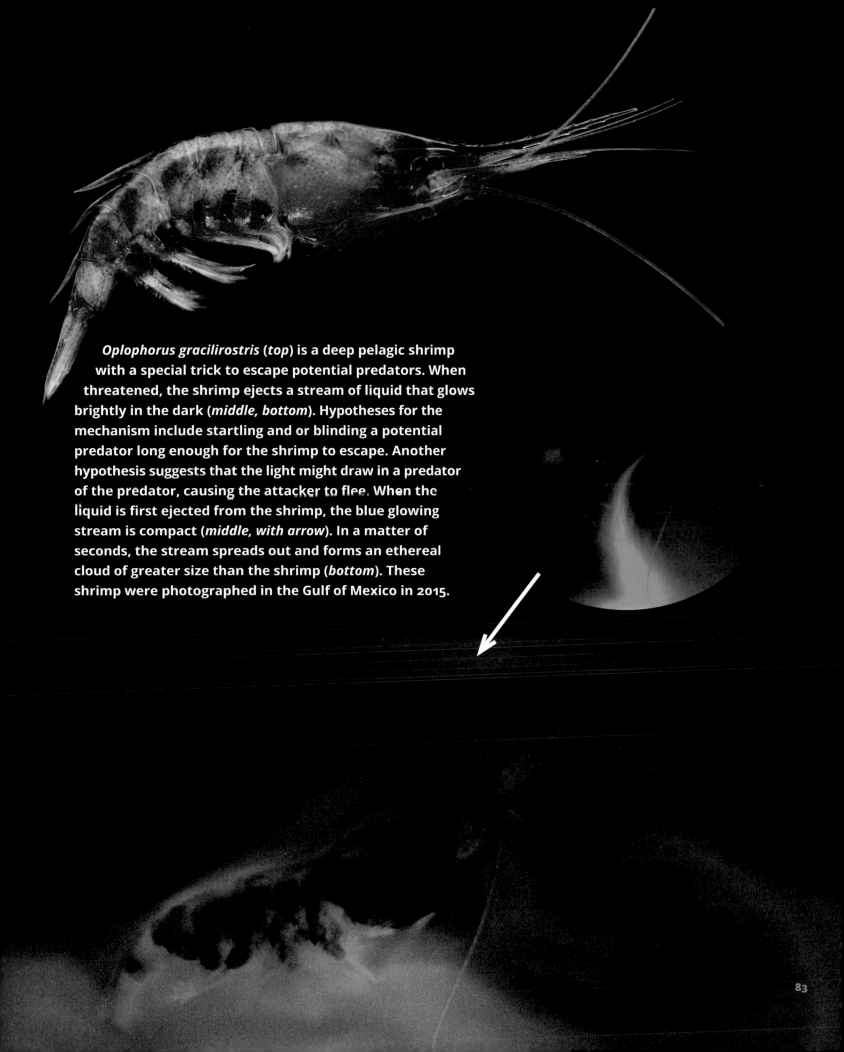

Oplophorus gracilirostris (*top*) is a deep pelagic shrimp with a special trick to escape potential predators. When threatened, the shrimp ejects a stream of liquid that glows brightly in the dark (*middle, bottom*). Hypotheses for the mechanism include startling and or blinding a potential predator long enough for the shrimp to escape. Another hypothesis suggests that the light might draw in a predator of the predator, causing the attacker to flee. When the liquid is first ejected from the shrimp, the blue glowing stream is compact (*middle, with arrow*). In a matter of seconds, the stream spreads out and forms an ethereal cloud of greater size than the shrimp (*bottom*). These shrimp were photographed in the Gulf of Mexico in 2015.

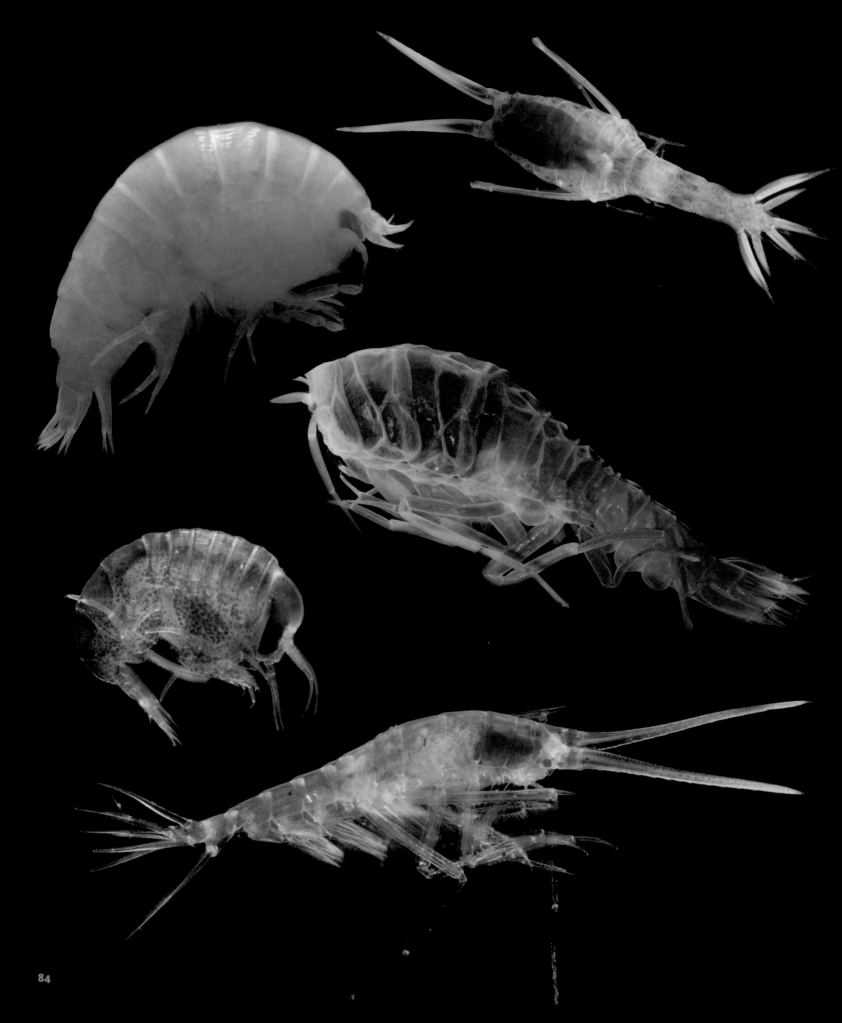

This *Phronima*, an amphipod crustacean, has hollowed out the body of a salp or pyrosome and deposited her eggs within it. Salps and pyrosomes are gelatinous creatures that live in the water column and are related to sea squirts. The adult amphipod guards the eggs until well after they hatch. The bottom image shows the amphipod looking out the end of the salp or pyrosome's body. It is rumored that the idea for the movie *Alien* came from the life history of this amphipod. This individual was collected at a depth between 656 and 1,312 feet (200 and 400 meters) in the Gulf of Mexico in 2007. Further Reading: Idyll, 1964.

(*Facing page*)
Amphipods are important food items for many marine vertebrates and some invertebrates. These crustaceans (related to crabs, lobsters, and shrimp) can serve in the food web as scavengers, as consumers of marine plants, and even as predators. Amphipods often come up in deep-sea trawls, even from hundreds of feet below the ocean's surface.

Crustaceans form a major part of food webs below the ocean's surface. In addition to crabs and lobsters lurking in the depths, some far less recognizable groups play major ecological roles. The mesopelagic copepod *Gaussia princeps* (*top*), commonly referred to as the Black Prince Copepod, is bioluminescent and can be found at depths exceeding 3,280 feet (1,000 meters). Adults migrate to shallower waters at night to feed. This specimen was trawled from between the surface and 1,000 feet (305 meters) off Monterey, California, in 2009. The unidentified shrimp (*middle*) was collected between 328 and 656 feet (100 and 200 meters) in the Gulf of Mexico in 2010. *Gigantocypris agassizii*, a giant ostracod (*bottom right*), is a deepwater seed shrimp that eats copepods and other small invertebrates. The complex eyes of this crustacean can detect the bioluminescence from copepod prey. It is found as deep as 4,265 feet (1,300 meters). This individual was trawled from between the surface and 1,000 feet (305 meters) off Monterey, California, in 2007. Another pelagic ostracod, *Gigantocypris* sp. (*bottom left*), is depicted here brooding purple eggs inside its carapace (shell). This individual was trawled from between 3,280 and 4,921 feet (1,000 and 1,500 meters) in the Gulf of Mexico in 2015. Further Reading: Idyll, 1964.

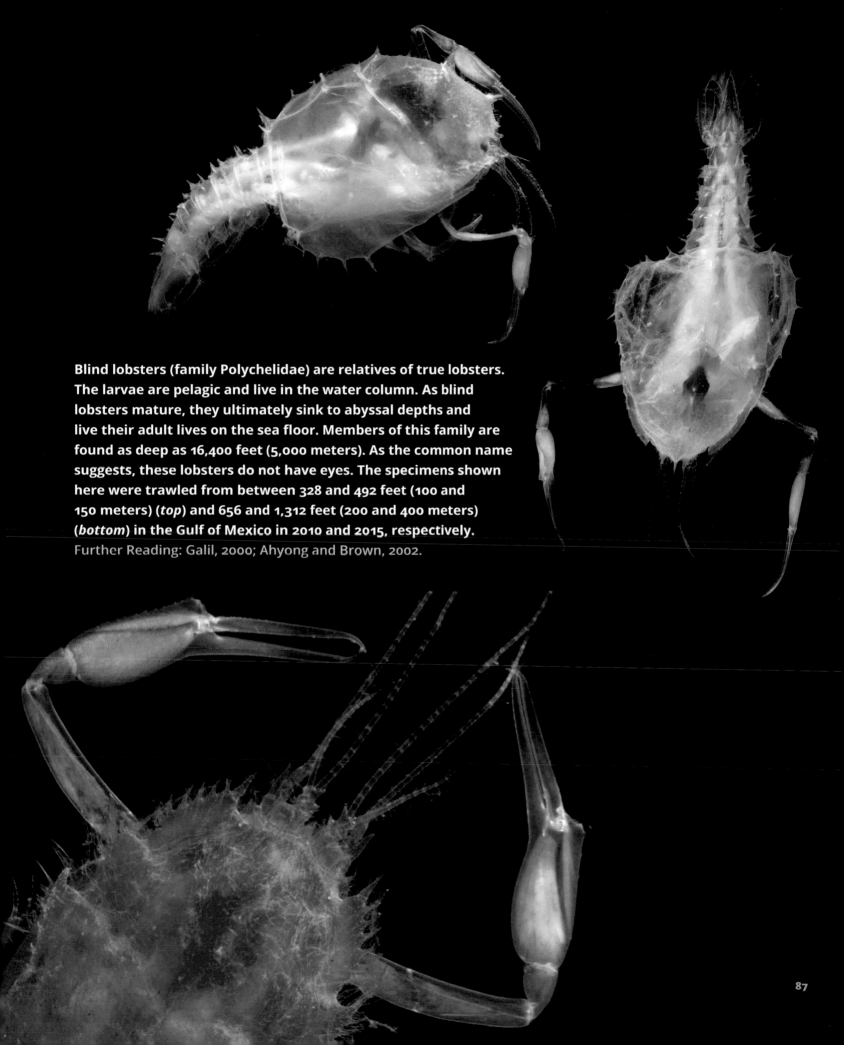

Blind lobsters (family Polychelidae) are relatives of true lobsters. The larvae are pelagic and live in the water column. As blind lobsters mature, they ultimately sink to abyssal depths and live their adult lives on the sea floor. Members of this family are found as deep as 16,400 feet (5,000 meters). As the common name suggests, these lobsters do not have eyes. The specimens shown here were trawled from between 328 and 492 feet (100 and 150 meters) (*top*) and 656 and 1,312 feet (200 and 400 meters) (*bottom*) in the Gulf of Mexico in 2010 and 2015, respectively.

Further Reading: Galil, 2000; Ahyong and Brown, 2002.

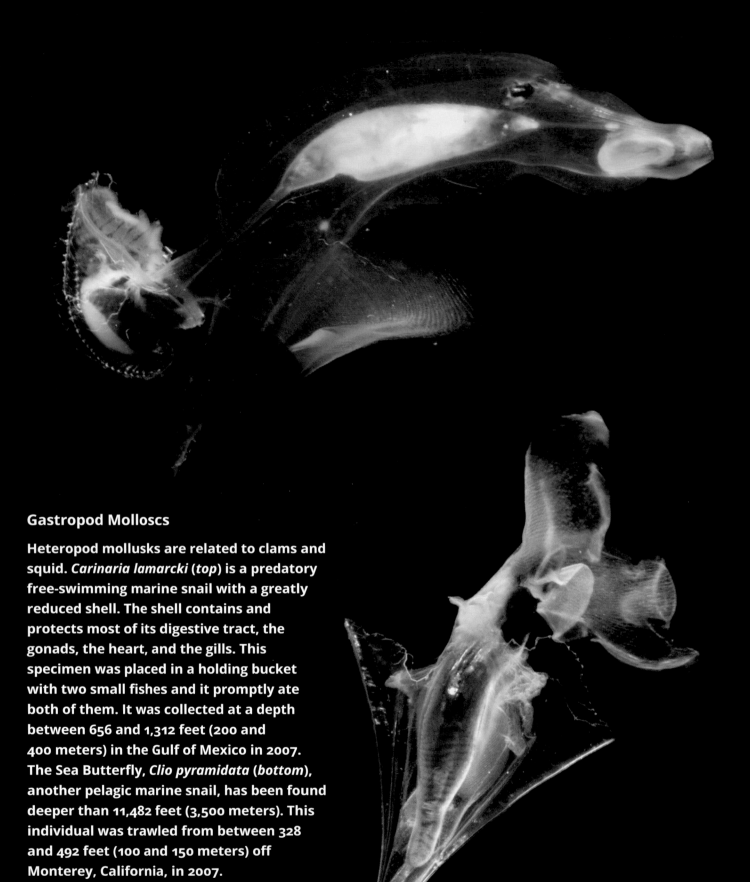

Gastropod Molloscs

Heteropod mollusks are related to clams and squid. *Carinaria lamarcki* (*top*) is a predatory free-swimming marine snail with a greatly reduced shell. The shell contains and protects most of its digestive tract, the gonads, the heart, and the gills. This specimen was placed in a holding bucket with two small fishes and it promptly ate both of them. It was collected at a depth between 656 and 1,312 feet (200 and 400 meters) in the Gulf of Mexico in 2007. The Sea Butterfly, *Clio pyramidata* (*bottom*), another pelagic marine snail, has been found deeper than 11,482 feet (3,500 meters). This individual was trawled from between 328 and 492 feet (100 and 150 meters) off Monterey, California, in 2007.

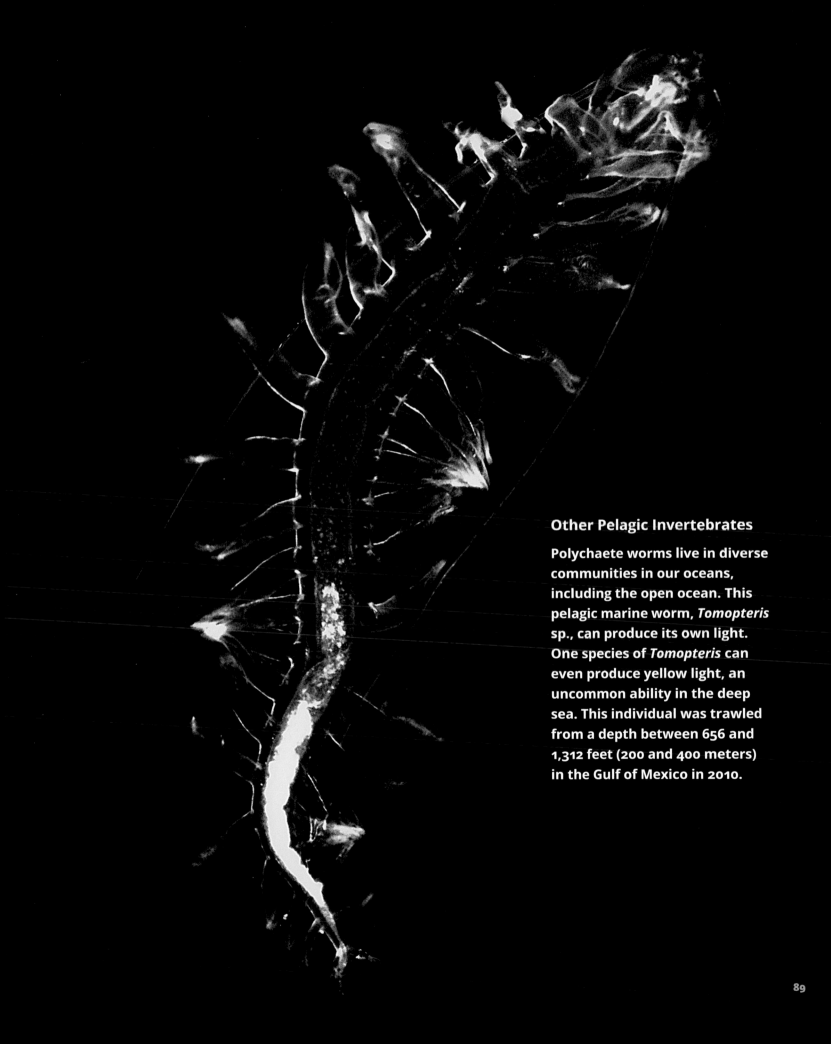

Other Pelagic Invertebrates

Polychaete worms live in diverse communities in our oceans, including the open ocean. This pelagic marine worm, *Tomopteris* sp., can produce its own light. One species of *Tomopteris* can even produce yellow light, an uncommon ability in the deep sea. This individual was trawled from a depth between 656 and 1,312 feet (200 and 400 meters) in the Gulf of Mexico in 2010.

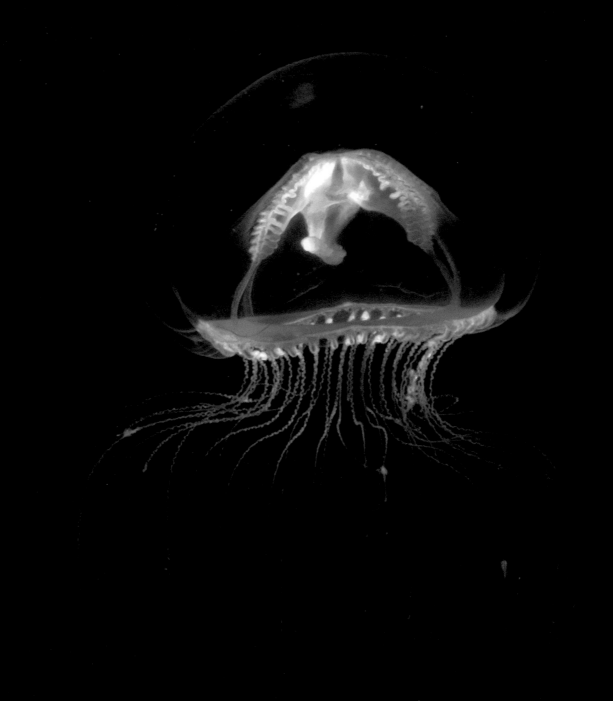

This deeper-water jellyfish, *Ptychogena* cf. *lactea*, feeds on copepods and perhaps even on sergestid shrimp (of the Sergestidae family). Specimens of this jellyfish have been found in the Monterey Bay area from depths of 164 to 3,904 feet (50 to 1,190 meters). This individual was trawled to the surface and photographed in Monterey, California, in 2007.

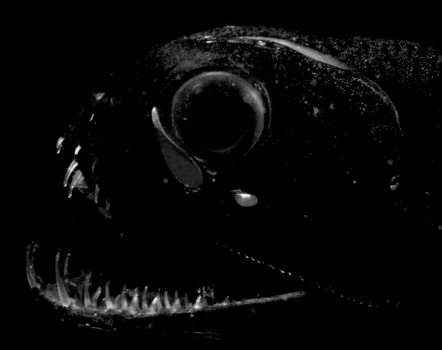

VERTEBRATES

Mesopelagic Vertebrates

Aristostomias cf. *xenostoma* (*top*), known as a Loosejaw, is a predatory dragonfish that lives in deep mesopelagic waters. It has photophores on its face that produce red light, a relatively rare ability in the ocean depths. Most deep-ocean creatures can see only blues and perhaps greens and are unaware that they are being illuminated by a potential predator. The dragonfishes themselves can see red light. In essence, the red photophores below the eyes are like red/violet flash-lights that dragonfishes can use to find prey. This individual was captured in a trawl at a depth between 3,280 and 4,921 feet (1,000 and 1,500 meters) in the Gulf of Mexico in 2007. The dragonfish *Malacosteus niger* (*bottom*) also produces red light from the photophores on its face. This specimen, roughly 6 inches (15.2 centimeters) long, was trawled from between the surface and 2,296 feet (700 meters) in the Gulf of Mexico in 2010. Further Reading: Denton et al., 1970; O'Day and Fernandez, 1974; Sutton and Hopkins, 1996a, 1996b; Hopkins and Sutton, 1998; Douglas et al., 2000; Sutton, 2005; Richards, 2006.

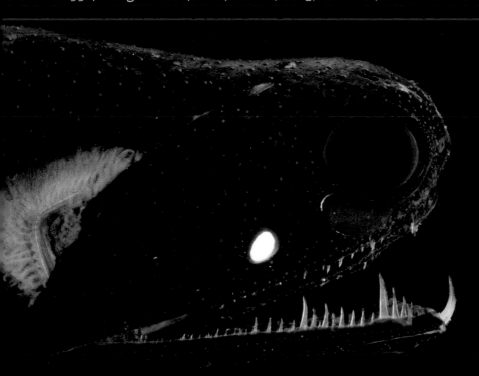

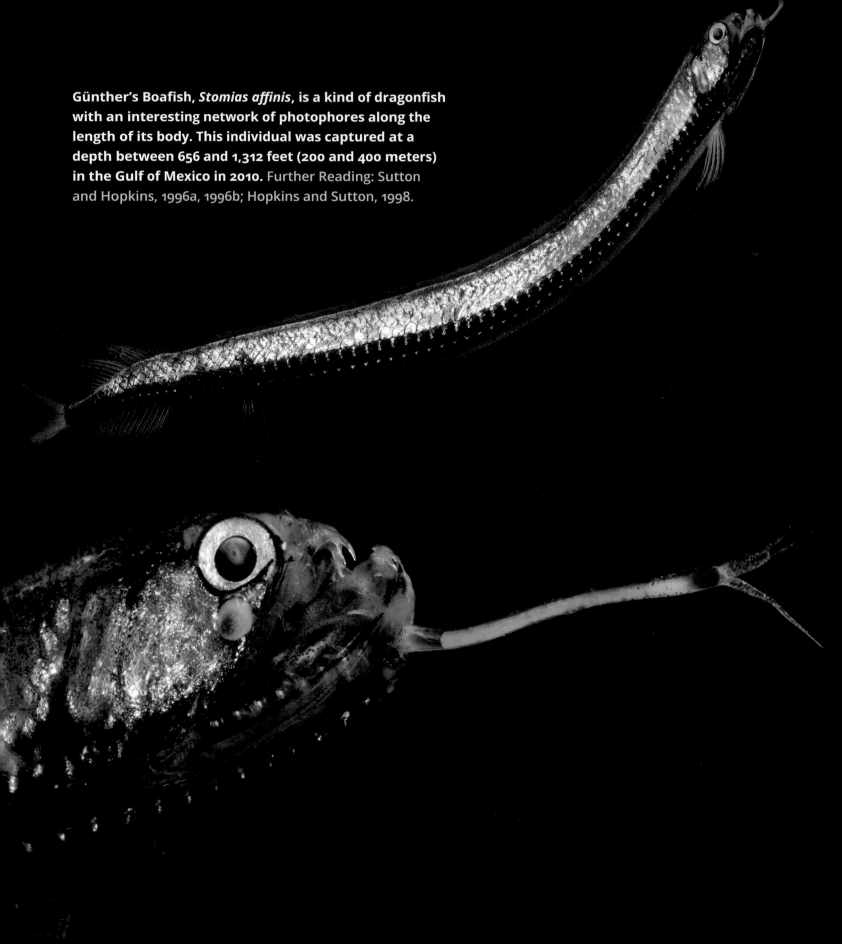

Günther's Boafish, *Stomias affinis*, is a kind of dragonfish with an interesting network of photophores along the length of its body. This individual was captured at a depth between 656 and 1,312 feet (200 and 400 meters) in the Gulf of Mexico in 2010. Further Reading: Sutton and Hopkins, 1996a, 1996b; Hopkins and Sutton, 1998.

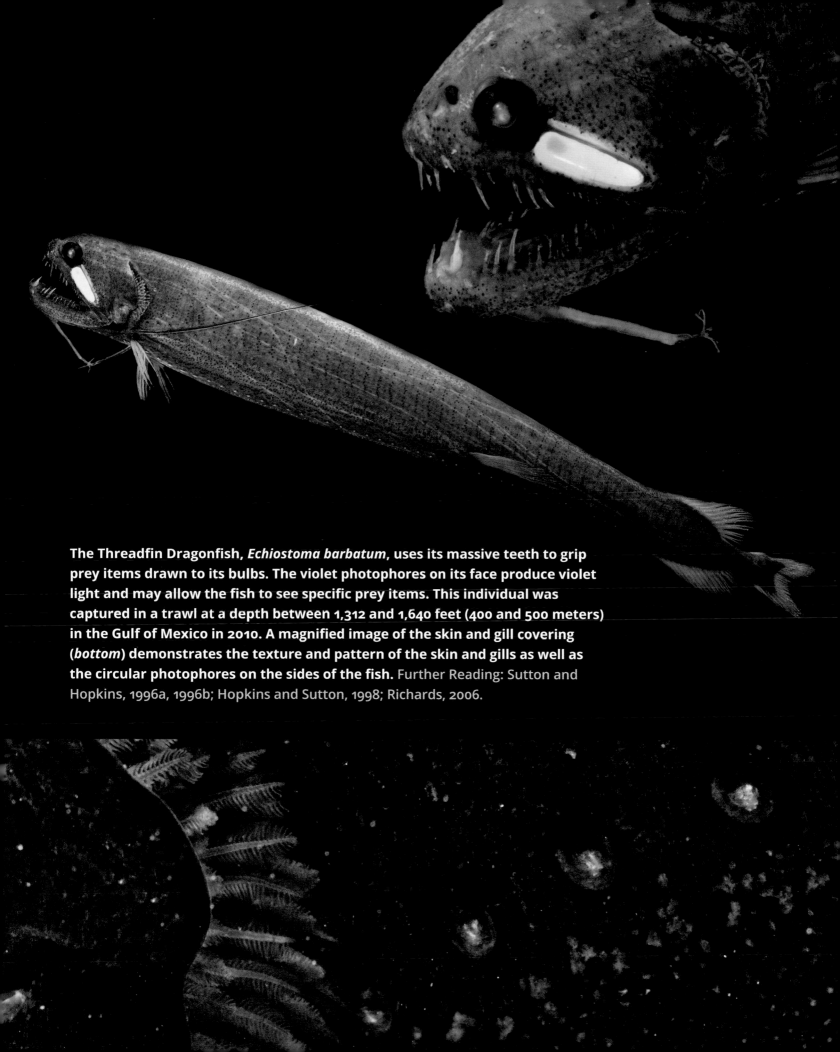

The Threadfin Dragonfish, *Echiostoma barbatum*, uses its massive teeth to grip prey items drawn to its bulbs. The violet photophores on its face produce violet light and may allow the fish to see specific prey items. This individual was captured in a trawl at a depth between 1,312 and 1,640 feet (400 and 500 meters) in the Gulf of Mexico in 2010. A magnified image of the skin and gill covering (*bottom*) demonstrates the texture and pattern of the skin and gills as well as the circular photophores on the sides of the fish. Further Reading: Sutton and Hopkins, 1996a, 1996b; Hopkins and Sutton, 1998; Richards, 2006.

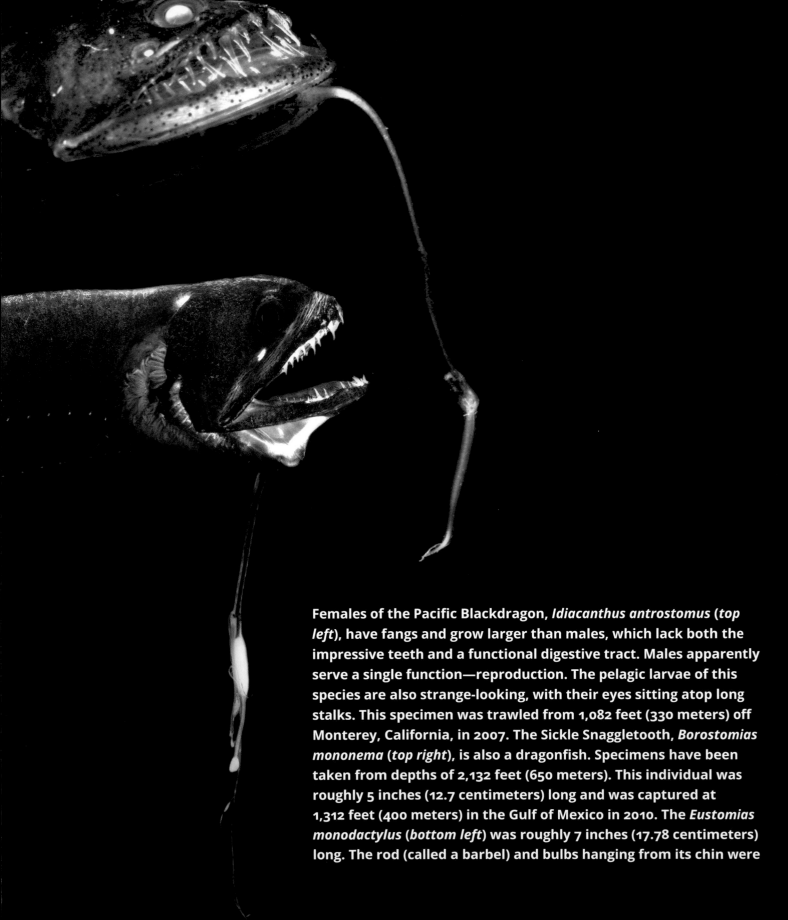

Females of the Pacific Blackdragon, *Idiacanthus antrostomus* (*top left*), have fangs and grow larger than males, which lack both the impressive teeth and a functional digestive tract. Males apparently serve a single function—reproduction. The pelagic larvae of this species are also strange-looking, with their eyes sitting atop long stalks. This specimen was trawled from 1,082 feet (330 meters) off Monterey, California, in 2007. The Sickle Snaggletooth, *Borostomias mononema* (*top right*), is also a dragonfish. Specimens have been taken from depths of 2,132 feet (650 meters). This individual was roughly 5 inches (12.7 centimeters) long and was captured at 1,312 feet (400 meters) in the Gulf of Mexico in 2010. The *Eustomias monodactylus* (*bottom left*) was roughly 7 inches (17.78 centimeters) long. The rod (called a barbel) and bulbs hanging from its chin were

more than half the length of the animal. The bulbs were yellow-green and glowed brightly when the fish was brought to the surface. The light spots on the side of the fish's body are photophores that may help with same-species recognition. This fish was trawled from between the surface and 1,640 feet (500 meters) in the Gulf of Mexico in 2010. The Filamentous Dragonfish, *Astronesthes similis* (*bottom right*), sometimes called a Snaggletooth, is a member of the "Barbeled Dragonfishes" group. The common name is derived from the filaments dangling from the end of its lure. This individual was captured in a trawl between 3,280 and 4,921 feet (1,000 and 1,500 meters) in the Gulf of Mexico in 2007. Further Reading: Fitch and Lavenberg, 1968; Sutton and Hopkins, 1996a, 1996b; Hopkins and Sutton, 1998; Richards, 2006.

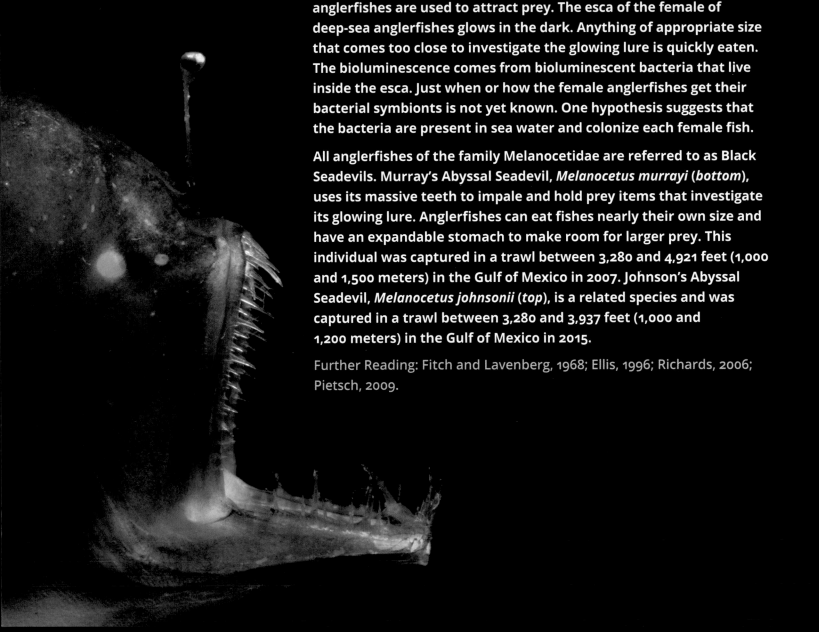

anglerfishes are used to attract prey. The esca of the female of deep-sea anglerfishes glows in the dark. Anything of appropriate size that comes too close to investigate the glowing lure is quickly eaten. The bioluminescence comes from bioluminescent bacteria that live inside the esca. Just when or how the female anglerfishes get their bacterial symbionts is not yet known. One hypothesis suggests that the bacteria are present in sea water and colonize each female fish.

All anglerfishes of the family Melanocetidae are referred to as Black Seadevils. Murray's Abyssal Seadevil, *Melanocetus murrayi* (*bottom*), uses its massive teeth to impale and hold prey items that investigate its glowing lure. Anglerfishes can eat fishes nearly their own size and have an expandable stomach to make room for larger prey. This individual was captured in a trawl between 3,280 and 4,921 feet (1,000 and 1,500 meters) in the Gulf of Mexico in 2007. Johnson's Abyssal Seadevil, *Melanocetus johnsonii* (*top*), is a related species and was captured in a trawl between 3,280 and 3,937 feet (1,000 and 1,200 meters) in the Gulf of Mexico in 2015.

Further Reading: Fitch and Lavenberg, 1968; Ellis, 1996; Richards, 2006; Pietsch, 2009.

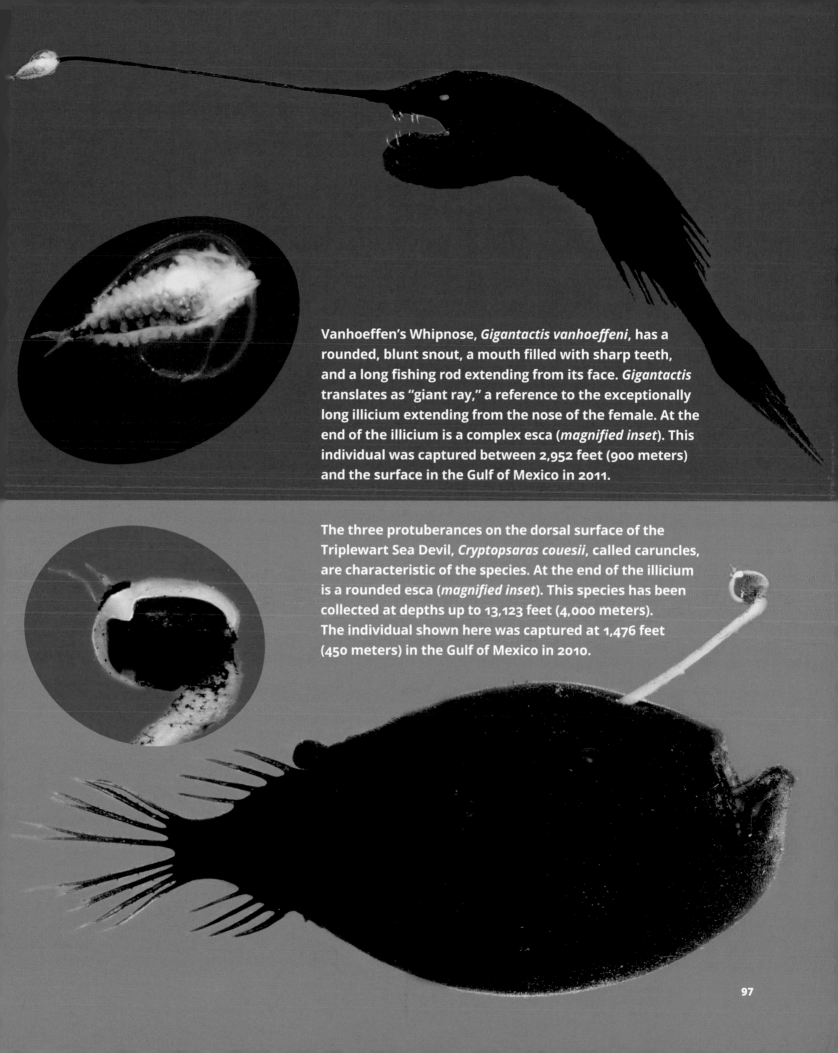

Vanhoeffen's Whipnose, *Gigantactis vanhoeffeni*, has a rounded, blunt snout, a mouth filled with sharp teeth, and a long fishing rod extending from its face. *Gigantactis* translates as "giant ray," a reference to the exceptionally long illicium extending from the nose of the female. At the end of the illicium is a complex esca (*magnified inset*). This individual was captured between 2,952 feet (900 meters) and the surface in the Gulf of Mexico in 2011.

The three protuberances on the dorsal surface of the Triplewart Sea Devil, *Cryptopsaras couesii*, called caruncles, are characteristic of the species. At the end of the illicium is a rounded esca (*magnified inset*). This species has been collected at depths up to 13,123 feet (4,000 meters). The individual shown here was captured at 1,476 feet (450 meters) in the Gulf of Mexico in 2010.

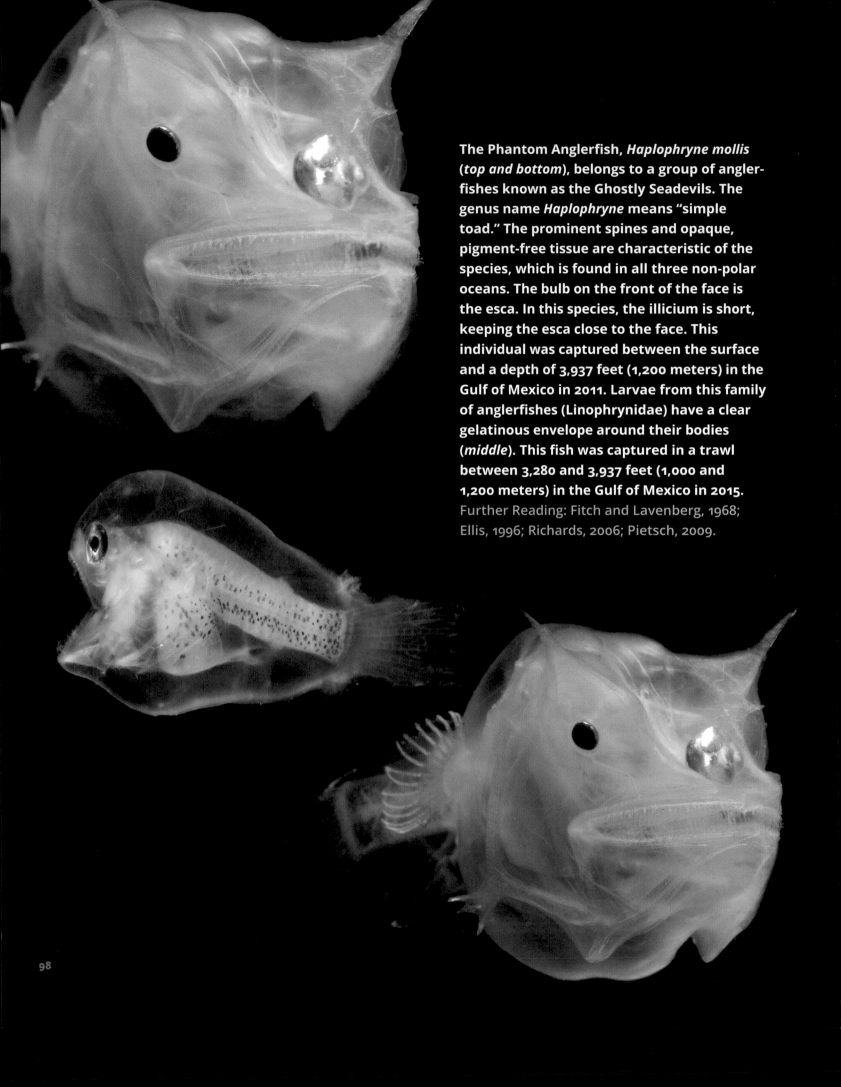

The Phantom Anglerfish, *Haplophryne mollis* (*top and bottom*), belongs to a group of angler-fishes known as the Ghostly Seadevils. The genus name *Haplophryne* means "simple toad." The prominent spines and opaque, pigment-free tissue are characteristic of the species, which is found in all three non-polar oceans. The bulb on the front of the face is the esca. In this species, the illicium is short, keeping the esca close to the face. This individual was captured between the surface and a depth of 3,937 feet (1,200 meters) in the Gulf of Mexico in 2011. Larvae from this family of anglerfishes (Linophrynidae) have a clear gelatinous envelope around their bodies (*middle*). This fish was captured in a trawl between 3,280 and 3,937 feet (1,000 and 1,200 meters) in the Gulf of Mexico in 2015.
Further Reading: Fitch and Lavenberg, 1968; Ellis, 1996; Richards, 2006; Pietsch, 2009.

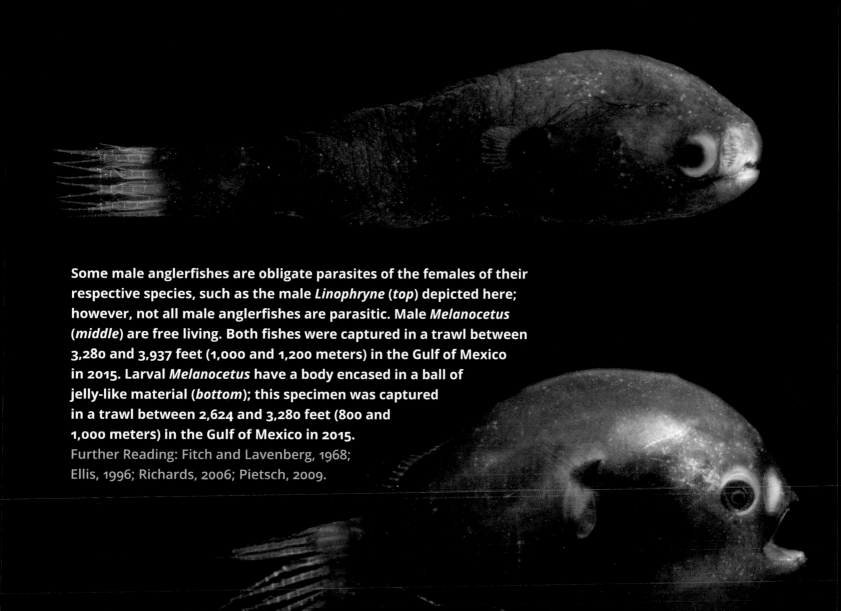

Some male anglerfishes are obligate parasites of the females of their respective species, such as the male *Linophryne* (*top*) depicted here; however, not all male anglerfishes are parasitic. Male *Melanocetus* (*middle*) are free living. Both fishes were captured in a trawl between 3,280 and 3,937 feet (1,000 and 1,200 meters) in the Gulf of Mexico in 2015. Larval *Melanocetus* have a body encased in a ball of jelly-like material (*bottom*); this specimen was captured in a trawl between 2,624 and 3,280 feet (800 and 1,000 meters) in the Gulf of Mexico in 2015.

Further Reading: Fitch and Lavenberg, 1968; Ellis, 1996; Richards, 2006; Pietsch, 2009.

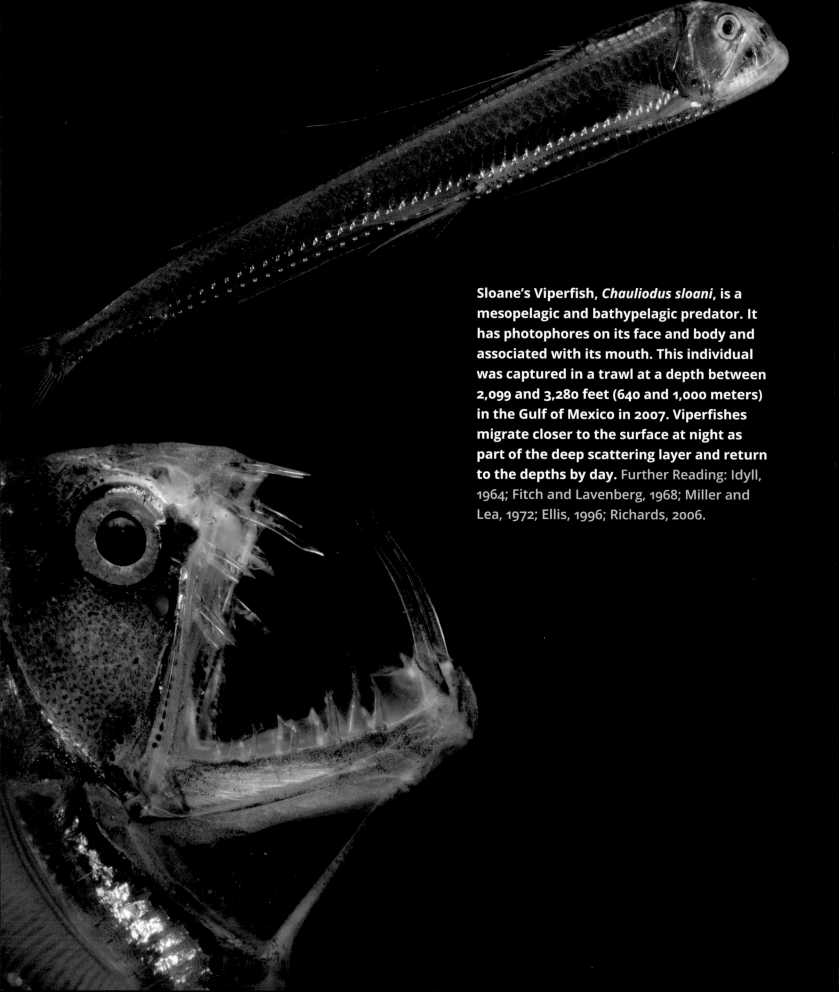

Sloane's Viperfish, *Chauliodus sloani*, is a mesopelagic and bathypelagic predator. It has photophores on its face and body and associated with its mouth. This individual was captured in a trawl at a depth between 2,099 and 3,280 feet (640 and 1,000 meters) in the Gulf of Mexico in 2007. Viperfishes migrate closer to the surface at night as part of the deep scattering layer and return to the depths by day. Further Reading: Idyll, 1964; Fitch and Lavenberg, 1968; Miller and Lea, 1972; Ellis, 1996; Richards, 2006.

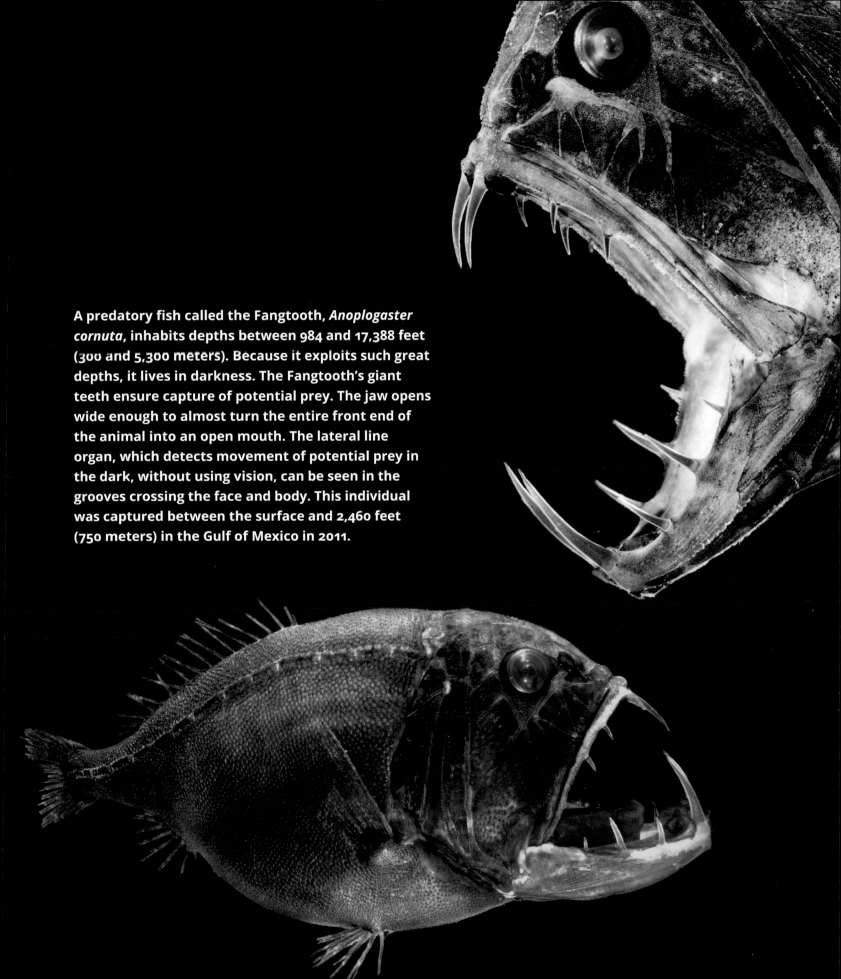

A predatory fish called the Fangtooth, *Anoplogaster cornuta*, inhabits depths between 984 and 17,388 feet (300 and 5,300 meters). Because it exploits such great depths, it lives in darkness. The Fangtooth's giant teeth ensure capture of potential prey. The jaw opens wide enough to almost turn the entire front end of the animal into an open mouth. The lateral line organ, which detects movement of potential prey in the dark, without using vision, can be seen in the grooves crossing the face and body. This individual was captured between the surface and 2,460 feet (750 meters) in the Gulf of Mexico in 2011.

sexes are easily distinguishable by their different body forms. Females retain the long, birdlike beak into adulthood, but males lose the beak as they mature. In fact, adult males and females look so different that they were once thought to be different species. The individual shown here (*top*) was captured between the surface and 3,037 feet (1,200 meters) in the Gulf of Mexico in 2011. Snipe eels, family Nemichthyidae (*this and facing page*), have delicate-looking mouths. The "beak" has miniature backward-facing teeth for grasping and holding small crustaceans. These individuals (*middle and facing page*) were captured in a trawl between 3,280 and 4,921 feet (1,000 and 1,500 meters) in the Gulf of Mexico in 2011.

Further Reading: Fitch and Lavenberg, 1968; Ellis, 1996; Richards, 2006.

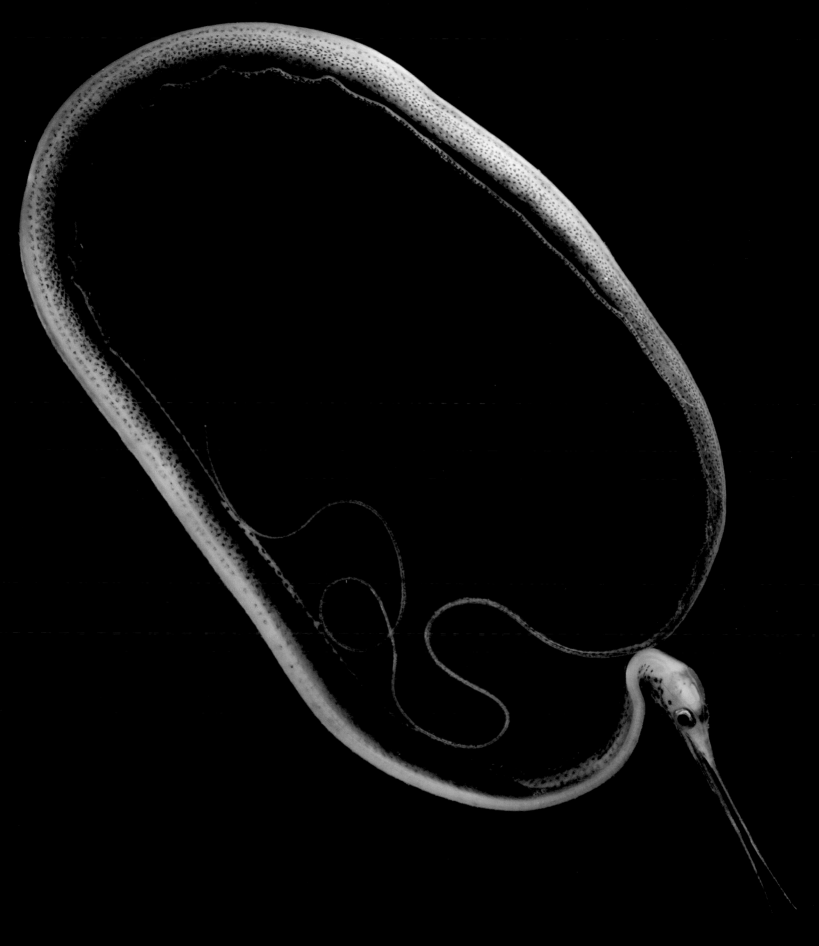

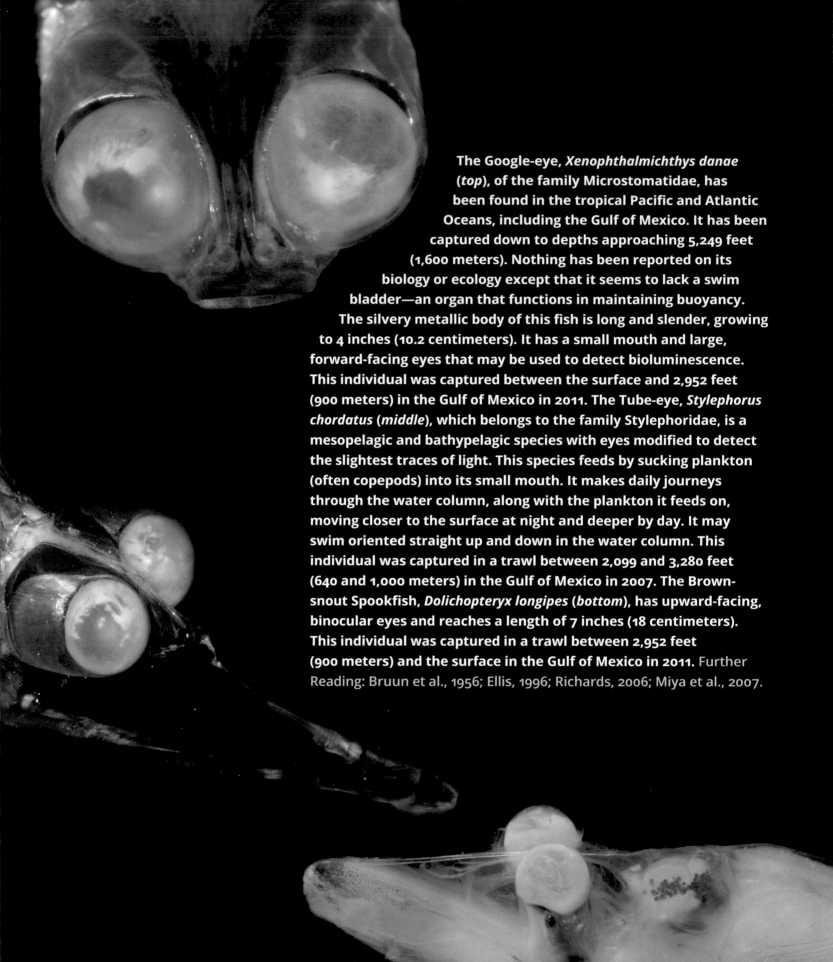

The Google-eye, *Xenophthalmichthys danae* (*top*), of the family Microstomatidae, has been found in the tropical Pacific and Atlantic Oceans, including the Gulf of Mexico. It has been captured down to depths approaching 5,249 feet (1,600 meters). Nothing has been reported on its biology or ecology except that it seems to lack a swim bladder—an organ that functions in maintaining buoyancy. The silvery metallic body of this fish is long and slender, growing to 4 inches (10.2 centimeters). It has a small mouth and large, forward-facing eyes that may be used to detect bioluminescence. This individual was captured between the surface and 2,952 feet (900 meters) in the Gulf of Mexico in 2011. The Tube-eye, *Stylephorus chordatus* (*middle*), which belongs to the family Stylephoridae, is a mesopelagic and bathypelagic species with eyes modified to detect the slightest traces of light. This species feeds by sucking plankton (often copepods) into its small mouth. It makes daily journeys through the water column, along with the plankton it feeds on, moving closer to the surface at night and deeper by day. It may swim oriented straight up and down in the water column. This individual was captured in a trawl between 2,099 and 3,280 feet (640 and 1,000 meters) in the Gulf of Mexico in 2007. The Brown-snout Spookfish, *Dolichopteryx longipes* (*bottom*), has upward-facing, binocular eyes and reaches a length of 7 inches (18 centimeters). This individual was captured in a trawl between 2,952 feet (900 meters) and the surface in the Gulf of Mexico in 2011. Further Reading: Bruun et al., 1956; Ellis, 1996; Richards, 2006; Miya et al., 2007.

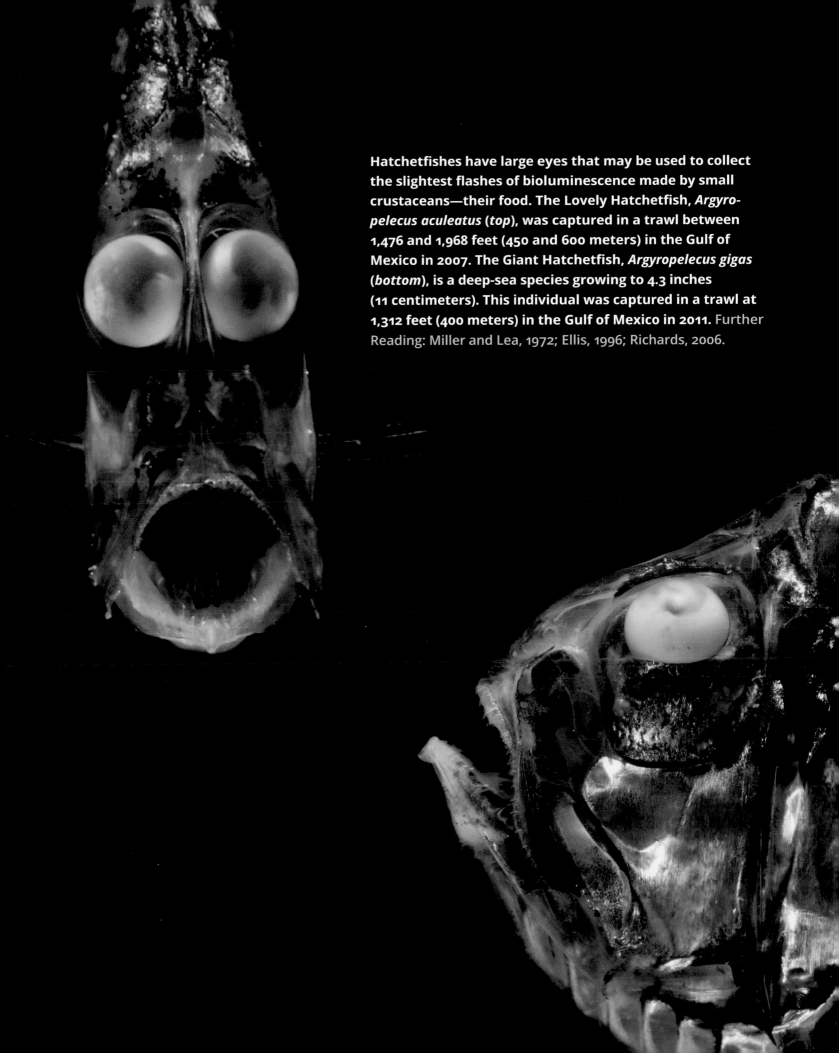

Hatchetfishes have large eyes that may be used to collect the slightest flashes of bioluminescence made by small crustaceans—their food. The Lovely Hatchetfish, *Argyropelecus aculeatus* (*top*), was captured in a trawl between 1,476 and 1,968 feet (450 and 600 meters) in the Gulf of Mexico in 2007. The Giant Hatchetfish, *Argyropelecus gigas* (*bottom*), is a deep-sea species growing to 4.3 inches (11 centimeters). This individual was captured in a trawl at 1,312 feet (400 meters) in the Gulf of Mexico in 2011. Further Reading: Miller and Lea, 1972; Ellis, 1996; Richards, 2006.

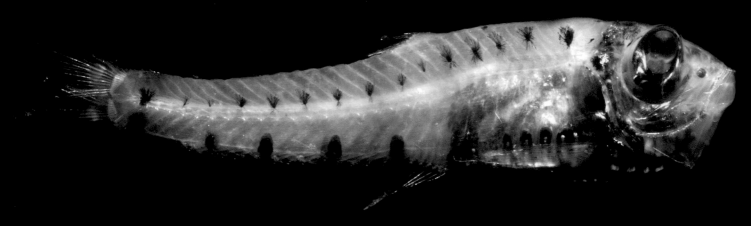

The Constellationfish, *Valenciennellus tripunctulatus* (*top*), has photophores across its body that produce bioluminescence that might be used for species identification in the dark ocean depths. This species consumes crustaceans. The individual shown here was captured in a trawl between 3,280 and 4,921 feet (1,000 and 1,500 meters) in the Gulf of Mexico in 2007. The Red-mouth Whalefish, *Rondeletia bicolor* (*middle*), has specialized teeth that may be used for gripping crustaceans. This specimen was captured in a trawl between 3,280 and 4,921 feet (1,000 and 1,500 meters) in the Gulf of Mexico in 2015. The Waryfish, *Scopelosaurus smithii* (*bottom*), has a lizard-like head and a mouth filled with teeth. Large eyes help it gather faint light for detecting prey. This specimen was captured in a trawl between 2,624 and 3,280 feet (800 and 1,000 meters) in the Gulf of Mexico in 2015.

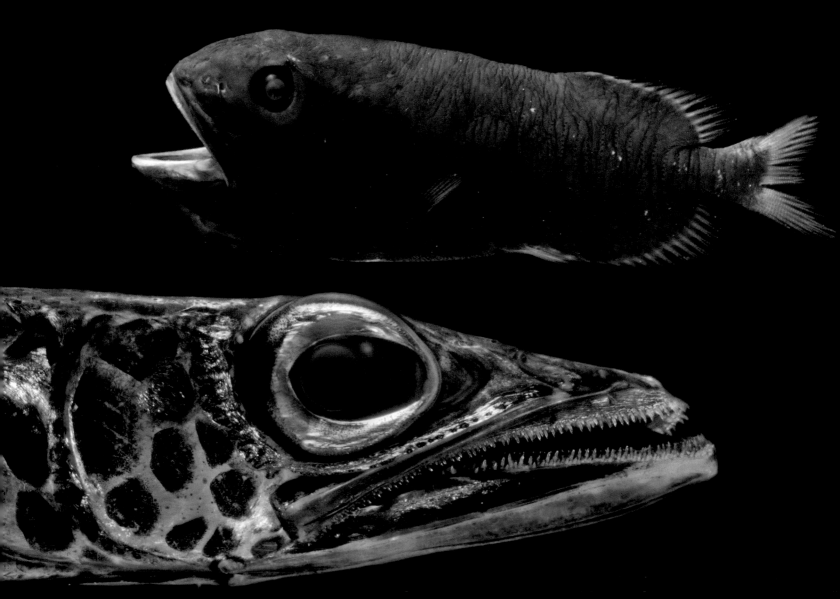

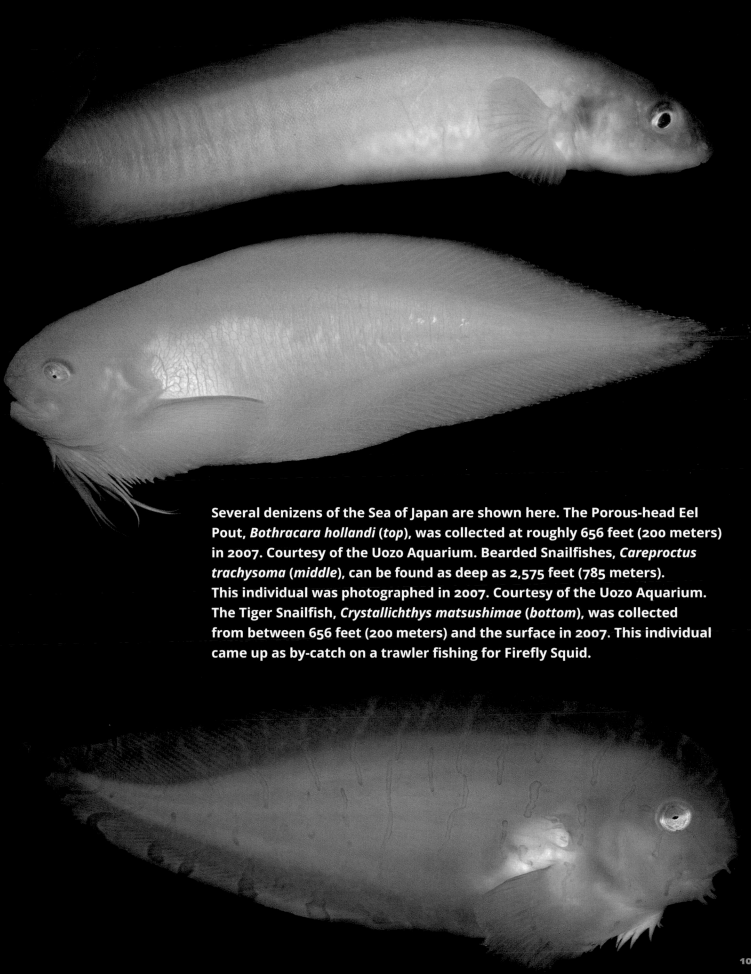

Several denizens of the Sea of Japan are shown here. The Porous-head Eel Pout, *Bothracara hollandi* (*top*), was collected at roughly 656 feet (200 meters) in 2007. Courtesy of the Uozo Aquarium. Bearded Snailfishes, *Careproctus trachysoma* (*middle*), can be found as deep as 2,575 feet (785 meters). This individual was photographed in 2007. Courtesy of the Uozo Aquarium. The Tiger Snailfish, *Crystallichthys matsushimae* (*bottom*), was collected from between 656 feet (200 meters) and the surface in 2007. This individual came up as by-catch on a trawler fishing for Firefly Squid.

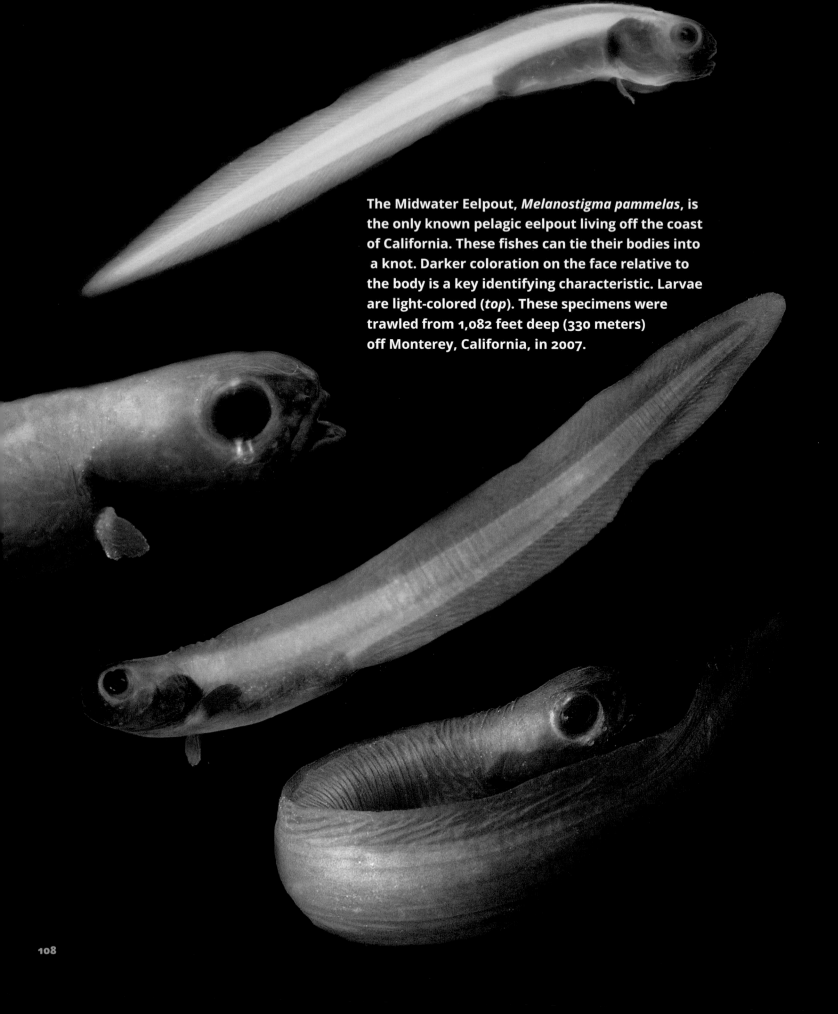

The Midwater Eelpout, *Melanostigma pammelas*, is the only known pelagic eelpout living off the coast of California. These fishes can tie their bodies into a knot. Darker coloration on the face relative to the body is a key identifying characteristic. Larvae are light-colored (*top*). These specimens were trawled from 1,082 feet deep (330 meters) off Monterey, California, in 2007.

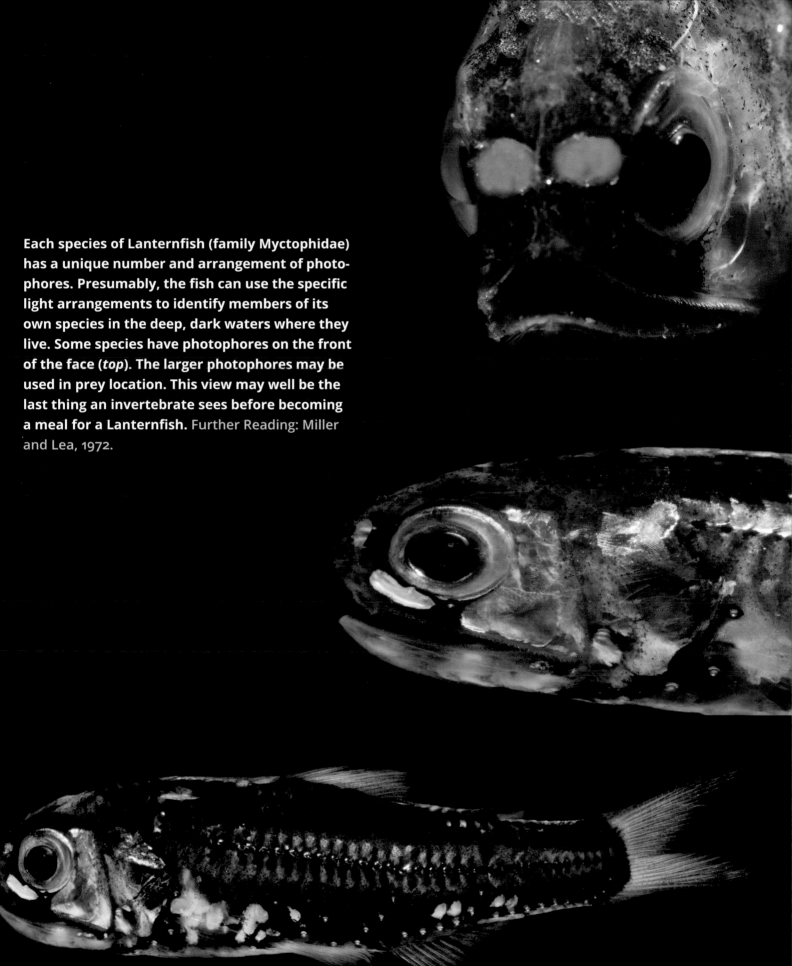

Each species of Lanternfish (family Myctophidae) has a unique number and arrangement of photophores. Presumably, the fish can use the specific light arrangements to identify members of its own species in the deep, dark waters where they live. Some species have photophores on the front of the face (*top*). The larger photophores may be used in prey location. This view may well be the last thing an invertebrate sees before becoming a meal for a Lanternfish. Further Reading: Miller and Lea, 1972.

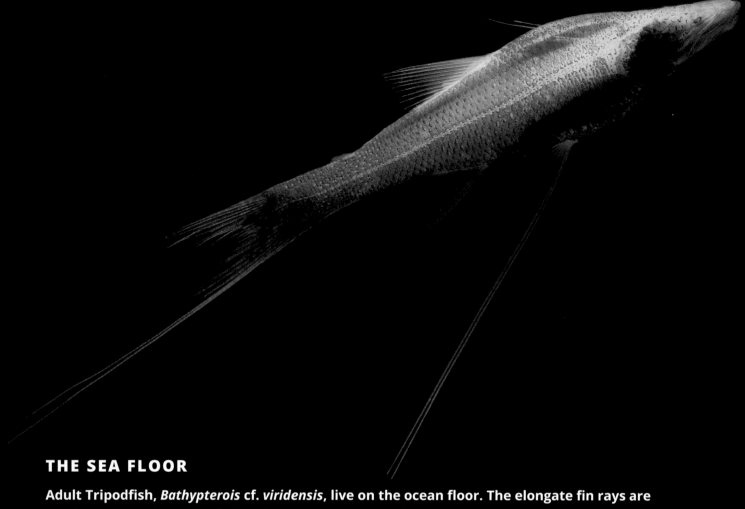

THE SEA FLOOR

Adult Tripodfish, *Bathypterois* cf. *viridensis*, live on the ocean floor. The elongate fin rays are used as stilts to keep the fish slightly elevated. A number of specimens have been captured in trawl nets, but little is known of their biology and ecology. Some biologists have speculated that Tripodfishes hop, others that they crawl like a Frogfish, and others that they swim up off the bottom to snatch prey and then sink back down to rest in the sediments on their stilts. ROV footage is slowly being captured and these questions will be answered. This individual was collected between 2,952 feet (900 meters) and the surface in the Gulf of Mexico in 2011.

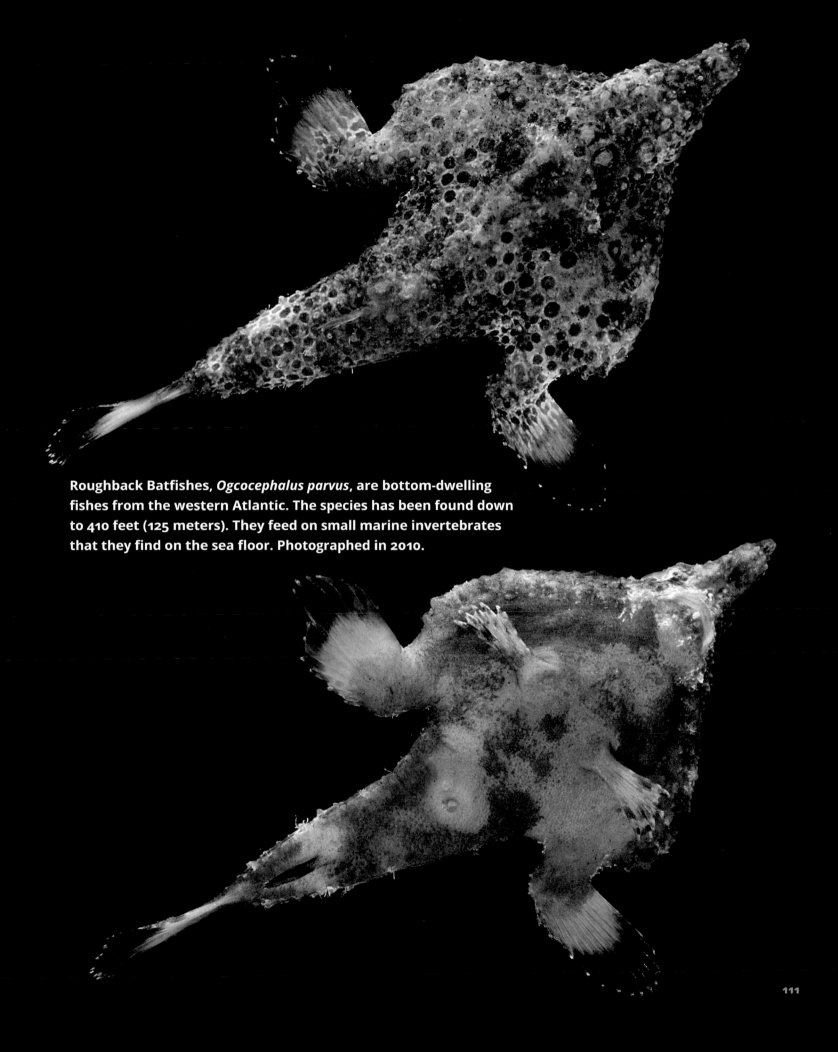

Roughback Batfishes, *Ogcocephalus parvus*, are bottom-dwelling fishes from the western Atlantic. The species has been found down to 410 feet (125 meters). They feed on small marine invertebrates that they find on the sea floor. Photographed in 2010.

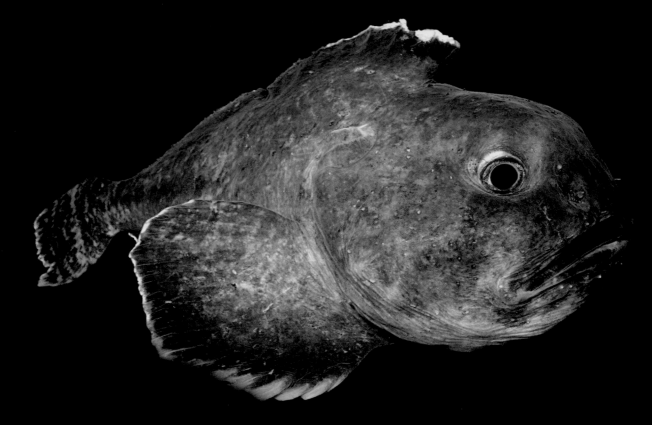

The Whitetail Sculpin, *Malacocottus gibber* (*top*), lives at depths that can exceed 3,280 feet (1,000 meters). This individual, from the Sea of Japan, was photographed in 2007. Courtesy of the Uozo Aquarium. Minipizza Batfishes, *Halieutaea stellata* (*bottom*), are found at depths down to 1,312 feet (400 meters). Batfishes have a modified dorsal fin ray called an illicium protruding from the head, at the end of which is a fleshy lure called an esca. A special space on the face, called the illicial cavity, accommodates the lure. If these terms sound familiar from the description of anglerfishes, that is because batfishes and anglerfishes are related. This individual, from the Sea of Japan, was photographed in 2007. Courtesy of the Uozo Aquarium.

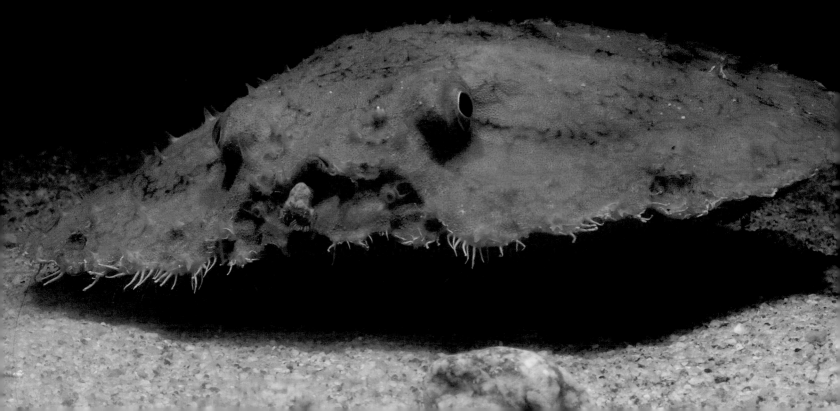

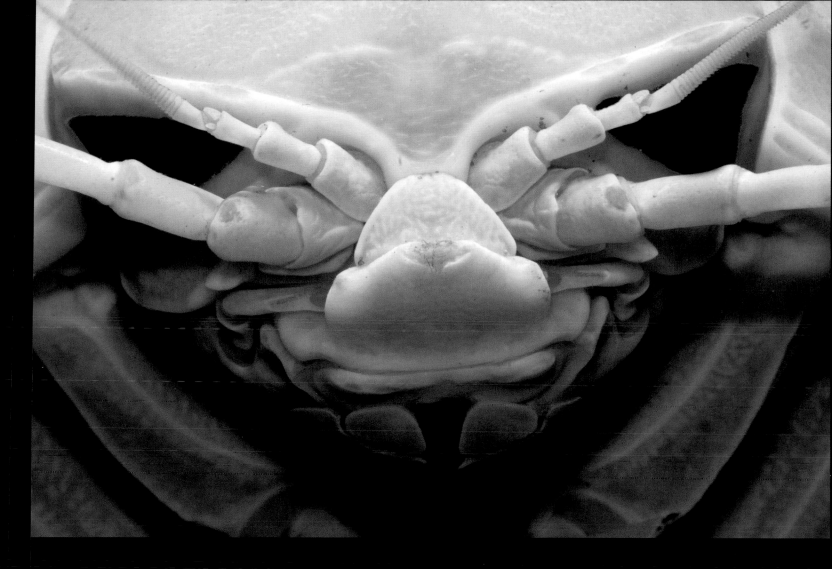

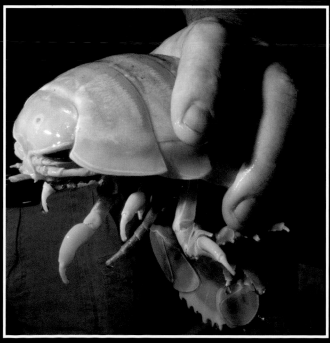

A Giant Marine Isopod, *Bathynomus giganteus*, can attain lengths of roughly 30 inches (76 centimeters). It is the largest-known isopod in the world. Isopods are crustaceans, related to shrimp, crabs, lobsters, prawns, and amphipods (side-swimmers, or "scuds"). They are also related to the pill bugs ("roly polys") found in temperate basements and gardens. Most isopods are small. In fact, it is uncommon to see one longer than an inch or two, in both terrestrial and aquatic species. There are about nine species of the genus *Bathynomus* inhabiting the sea floors of the Atlantic and Pacific Oceans. *Bathynomus giganteus* lives on the deep-ocean sea floors of the Gulf of Mexico and the Caribbean, at depths ranging from 590 feet (180 meters) down to more than 7,644 feet (2,330 meters). This specimen was photographed at the Shedd Aquarium in Chicago, Illinois, USA.

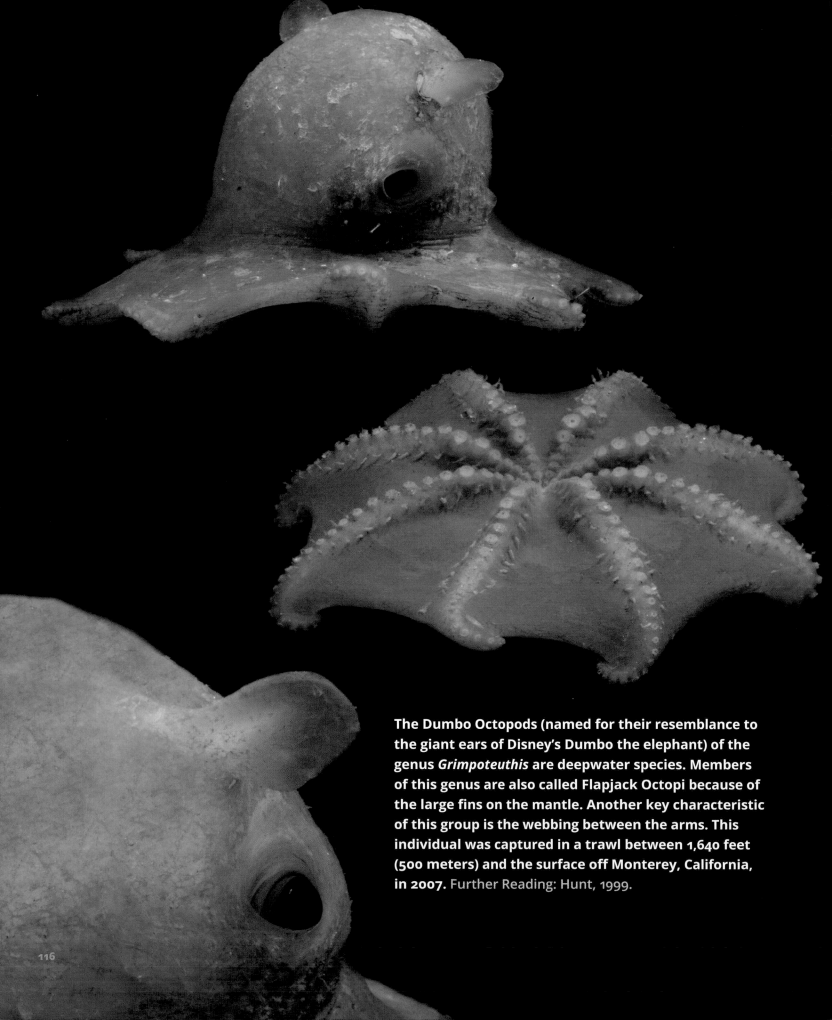

The Dumbo Octopods (named for their resemblance to the giant ears of Disney's Dumbo the elephant) of the genus *Grimpoteuthis* are deepwater species. Members of this genus are also called Flapjack Octopi because of the large fins on the mantle. Another key characteristic of this group is the webbing between the arms. This individual was captured in a trawl between 1,640 feet (500 meters) and the surface off Monterey, California, in 2007. Further Reading: Hunt, 1999.

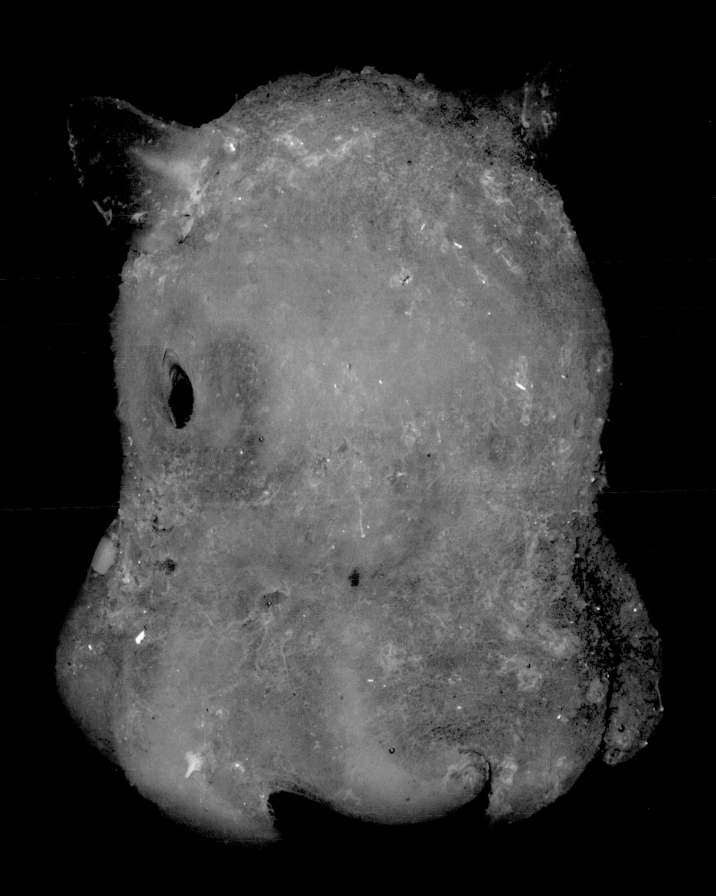

NEAR-SHORE DEEPWATER WILDLIFE

The shallow and well-lit surface waters of the world's oceans, the ocean waters with which most of us are familiar, are only a minor habitat when we're considering oceanic environments and light. Light and light intensity drop off at a predictable rate with increasing depth, such that at around 656 feet (200 meters), there isn't enough ambient light for humans to see. There are factors other than the water itself that can affect light penetration, such as the water being murky with suspended particulates of one form or another (dirt, sand, etc.). The particulate matter filters light out much more rapidly. Even in clear water, the initial filtration of light by the water column is rapid. For example, less than half of the light that hits the ocean's surface makes it down to 3.2 feet (1 meter), less than 25 percent makes it down to 32.8 feet (10 meters), and by 656 feet (200 meters), less than 1 percent of the surface light remains. The true depth at which there is no surface light is something closer to 3,280 feet (1,000 meters); however, most of the light is gone at a far shallower depth. The point is that, in an aquatic environment, you don't need to go very deep, even in clear water, before most of the surface light has been filtered out.

The depths between 656 feet (200 meters) and the surface accommodate some extraordinary species. Many of the creatures never leave the lower portions of these depths. Often, they are found in submarine "drop-offs" located near shore. Because there is still some light in these habitats, striking patterns or colors can still be used to convey messages to members of the same species or even to different species. Vision and visual cues are still in play for these species, whose often-large eyes are designed to collect any available light.

Also, recall that what might be a striking coloration in well-lit surface waters does not look at all the same in the depths. For instance, "hot colors" like red, yellow, and orange are filtered out by water more rapidly than "cool colors" like blue and green. Red is effectively filtered out of the water column by 50 feet (15.2 meters), yellow by roughly

100 feet (30.4 meters), and orange by 164 feet (about 50 meters). What appears as a bright, hot color in surface waters can literally vanish in the depths because this part of the spectrum doesn't penetrate the water column. One thing to look for in species inhabiting the depths is striking differences between colors and stark patterns. The little light that does penetrate to the depths can be used to illuminate patterns, not just colors. The business of sending a message from one individual to another can still be accomplished by vision, but pattern rather than color might become more important.

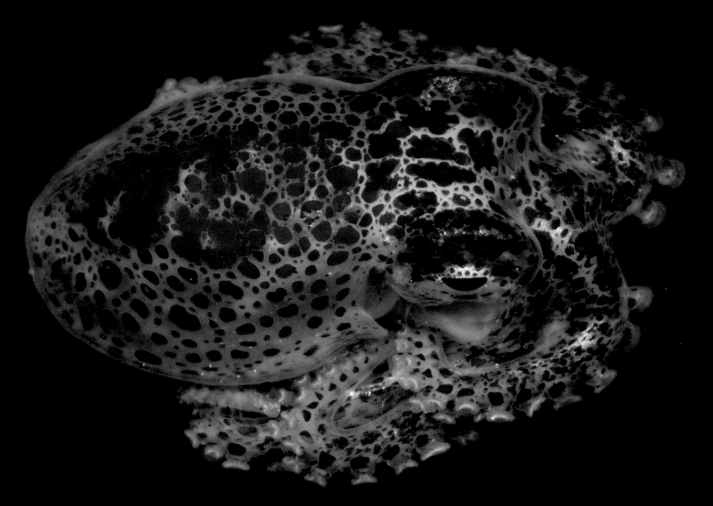

This larval Pacific Giant Octopus, *Enteroctopus dofleini*, will mature into the world's largest species of octopus. In adults, an individual arm can exceed 6 feet (1.8 meters) in length, and the arm span (from one arm tip to another) in large adults can exceed 14 feet (4.2 meters). This individual was trawled from between 1,640 feet (500 meters) and the surface off Monterey, California, in 2007.

The Chambered Nautilus, *Nautilus pompilius*, (*facing page*) a cephalopod related to squid, octopi, and cuttlefishes, ranges through the tropical Pacific and Indian Oceans. Individuals live in deep water by day, down to 2,001 feet (610 meters), and swim up to shallow water to feed at night. *Nautilus* uses jet propulsion to move, pumping water out of a structure called the siphon. It can adjust the direction in which it travels by changing the orientation of the siphon. Adult *N. pompilius* can grow to about 7.8 inches (20 centimeters) in length. The shell is filled with gases and liquids; the body is accommodated only within the outermost chamber. To regulate its buoyancy, the nautilus can move liquids into and out of the chambers through tubelike connections called siphuncles. These cephalopods have poor eyesight and rely on touch and smell to detect prey. To capture prey, they use their tentacles, which, in contrast to those of other cephalopods, lack suction cups. Some *Nautilus* species have up to 90 tentacles. *Nautilus pompilius* has changed very little over the past 150 million years and has extinct relatives that date back as far as 450 million years, but it is now threatened by overharvesting for the shell trade. Photographed in 2009.

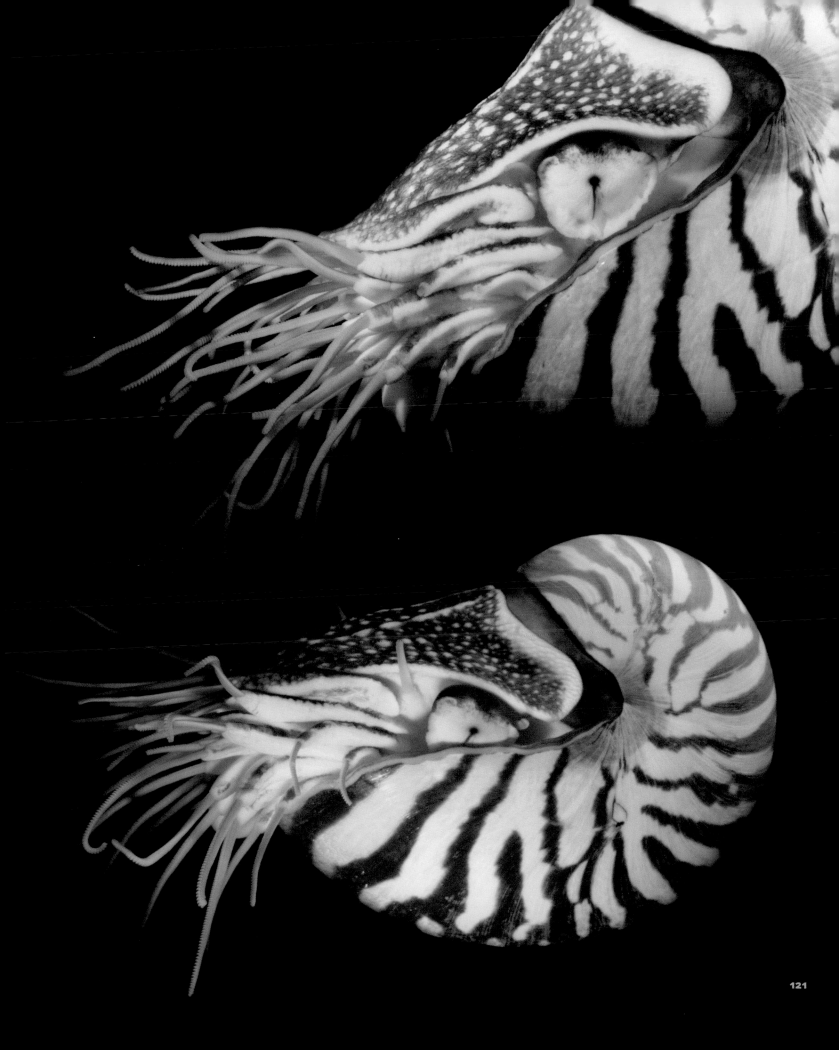

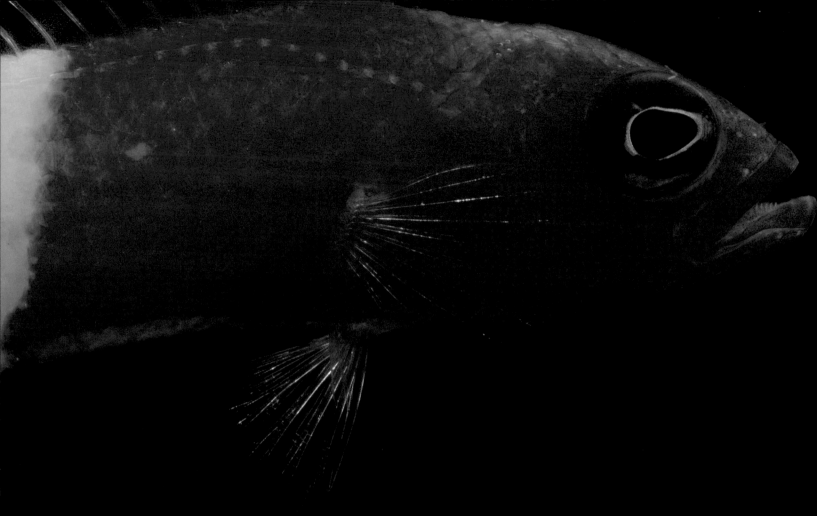

A host of fishes live at depths where the light begins to dim and drop off. Many have bright colors and distinct patterns intended to convey messages to other fishes. The Bicolor Dottyback, *Pictichromis diadema* (*facing page, top*), inhabits coral reefs in the Indo-Pacific Ocean at depths down to 90 feet (30 meters). The Blue-Eye Royal Dottyback, *Pictichromis dinar* (*this page and facing page, second from top*), is a reef inhabitant from the tropical Atlantic and Caribbean that lives down to depths of 82 feet (25 meters), along drop-offs and beneath overhangs. Found in the Red Sea are the Orchid Dottyback, *Pseudochromis fridmani* (*facing page, middle*), commonly seen on vertical rock faces or in the shadows of overhangs down to roughly 197 feet (60 meters), and the Blue-Striped Dottyback, *Pseudochromis springeri* (*facing page, second from bottom*), at depths down to 121 feet (37 meters); *P. springeri* has been bred in captivity. The Royal Gramma, *Gramma loreto* (*facing page, bottom*), inhabits marine caves and dark spaces under overhangs in the tropical waters of the Indo-Pacific Ocean at depths down to 180 feet (55 meters). Individuals of this species are often observed upside down under ledges or along the roof of sea caves. Photographed in 2010.

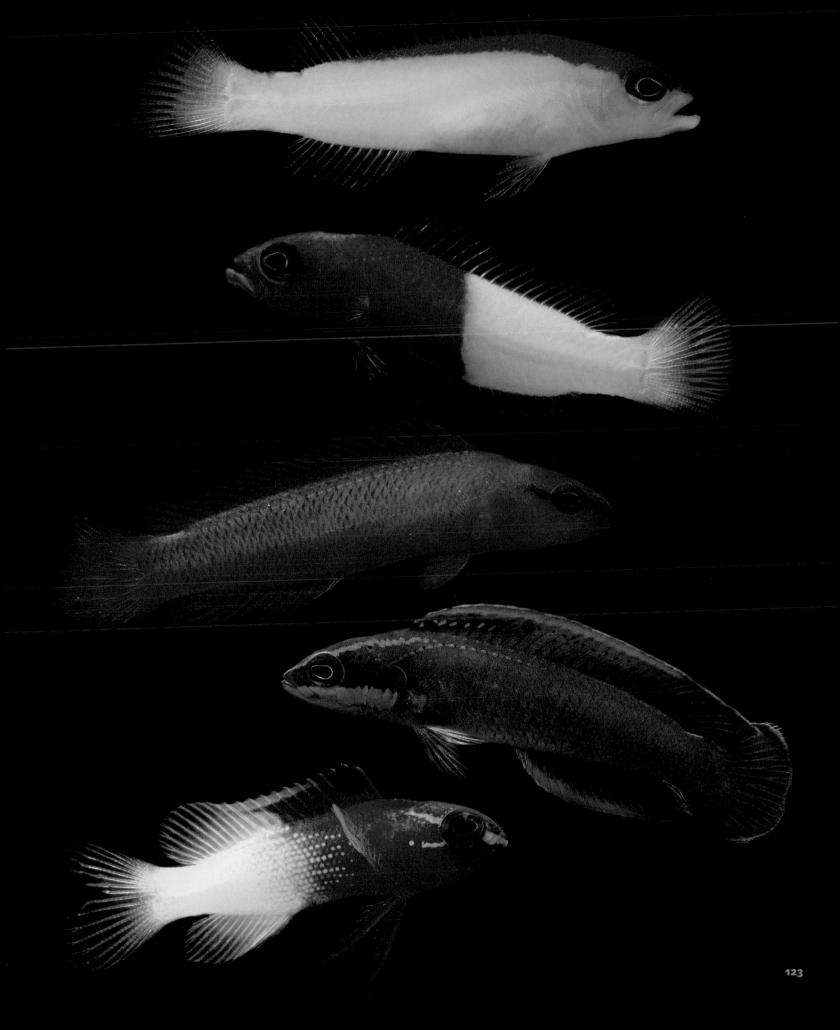

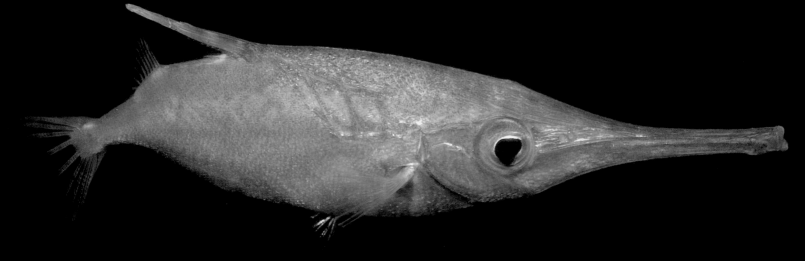

The Longspine Snipefish, *Macroramphosus scolopax* (*top*), feeds on copepods and other mesopelagic invertebrates in its juvenile state. Adults feed on benthic invertebrates. The species is encountered at depths between roughly 82 and 1,968 feet (25 to 600 meters). This individual was photographed in the Sea of Japan in 2007. Courtesy of the Uozo Aquarium. Short Bigeyes, *Pristigenys alta* (*bottom*), typically live along deep reefs at depths to about 656 feet (200 meters). The species is tropical and subtropical, ranging through the Caribbean and north along the Atlantic coast of North America. Photographed in 2009. Further Reading on Snipefish: Miller and Lea, 1972.

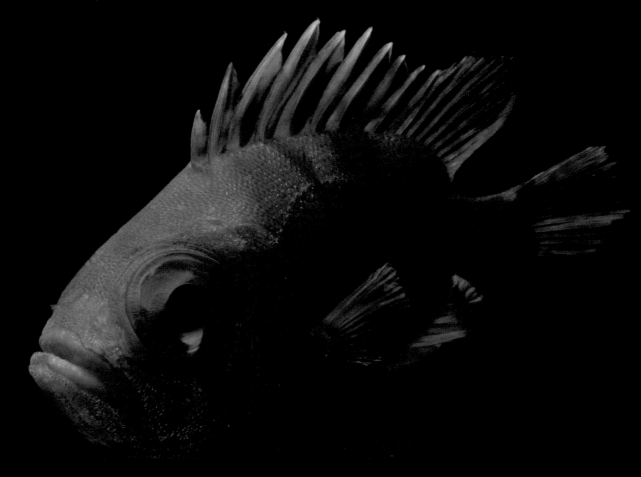

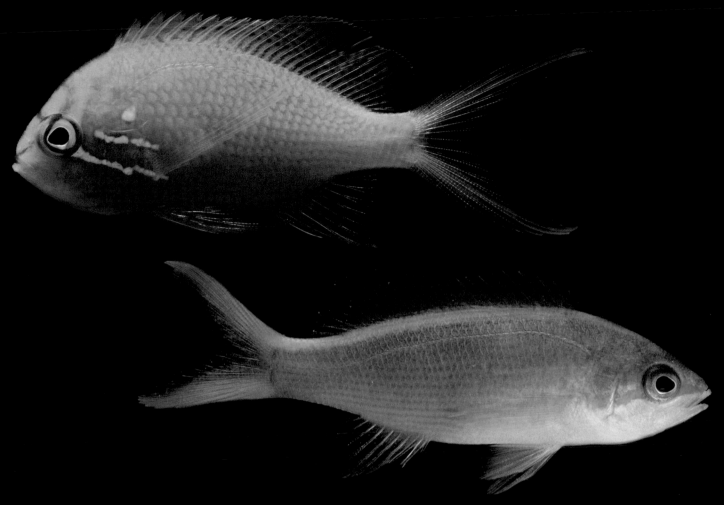

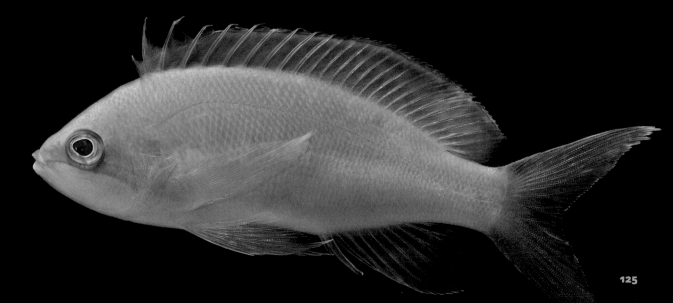

Several Anthine species are shown here. The Fathead Sunburst Anthias, *Serranocirrhitus latus* (*top*), is an inhabitant of deep reefs and submarine caves, where small groups are often observed. In marine caves, they have been observed swimming upside down. They live at depths down to roughly 230 feet (70 meters). Photographed in 2010. The Purple Queen Anthias, *Pseudanthias pascalus* (*middle*), inhabits the Indo-Pacific Ocean. Individuals are often found in large schools near drop offs down to about 196 feet (60 meters). Photographed in 2010. Thompson's Fairy Bass, *Pseudanthias thompsoni* (*bottom*), inhabits the Hawaiian Islands and the Ogasawara Islands. They can be found down to 623 feet (190 meters). This individual was photographed in 2012.

Purple Firefishes, *Nemateleotris decora* (family Ptereleotridae) (*this page*), are found in the tropical western Pacific Ocean at depths down to roughly 230 feet (70 meters). They inhabit open bottoms and dart into holes when threatened. The Helfrichi's Firefish, *Nemateleotris helfrichi* (*facing page, top*), is found in the tropical West Pacific Ocean down to 295 feet (90 meters). *Nemateleotris magnifica* (*facing page, bottom*) is a Firefish found in the tropical Pacific, in the Red Sea, and off the coast of East Africa. It lives in burrows on the outer reef slope, sometimes sharing them with several other individuals, at depths down to roughly 230 feet (70 meters). Photographed in 2010.

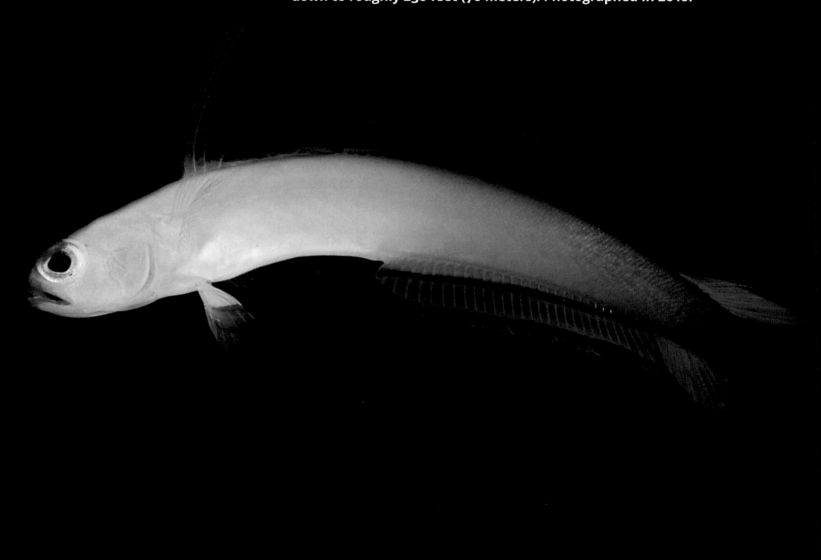

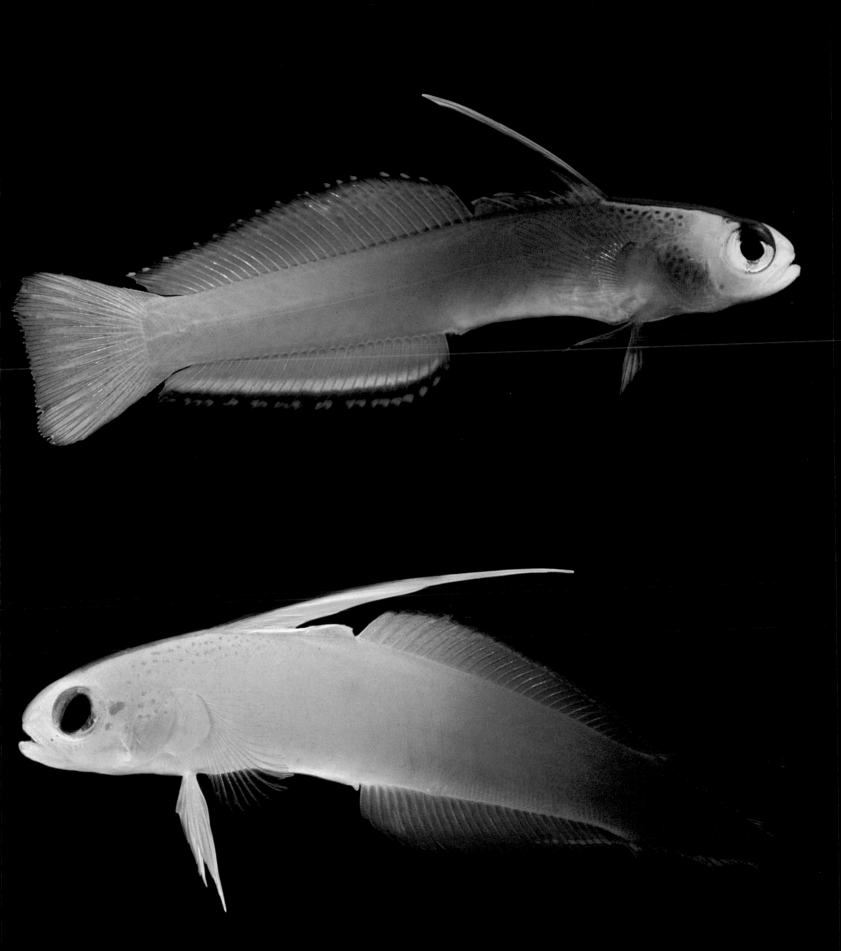

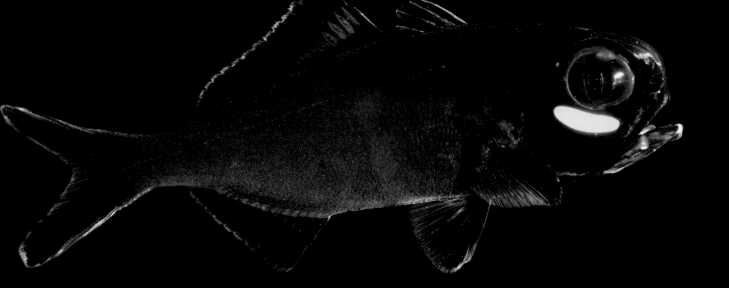

Flashlightfishes belong to the family Anomalopidae. The Splitfin or Giant Flashlightfish, *Anomalops katoptron*, the largest of the Flashlightfishes, is native to the Indo-Pacific Ocean. Flashlightfishes are famous for the bioluminescent organ (photophores) below each eye. The organ accommodates bioluminescent bacteria that produce a bright white, greenish, or slightly blue light. Bacteria and fish are engaged in a symbiotic relationship. The fish needs the light to find food and communicate with other Flashlightfishes; the bacteria are so far only known to set up residence inside of photophores. The lights are used in a variety of ways, ranging from communication between members of the species to prey location. The Flashlightfishes can turn their lights on and off, but the mechanism differs among genera. In the genus *Photoblepharon*, the fish moves a flap of skin over the organ to block it and turn the light off. In *Anomalops*, the organ can be rotated outward or inward to turn the light on and off. Species of the genus *Kryptophanaron* use both mechanisms. By day, most species live in deeper waters. *Anomalops katoptron* typically spends its time at depths ranging from 656 to 1,312 feet (200 to 400 meters), usually around drop-offs and sea caves. Particularly on moonless nights, Flashlightfishes often come close to the surface to feed on plankton. Stories of massive schools of these glowing fishes near the surface at night are common among seafarers. There are also reports of ship captains following schools of Flashlightfishes to navigate safely through reef passages at night, because the schools stick to deeper channels. Photographed in 2012. Further Reading: Morin et al., 1975; McCosker, 1977; Watson et al., 1978; McCosker and Rosenblatt, 1987; Haygood, 1990; Wolfe and Haygood, 1991.

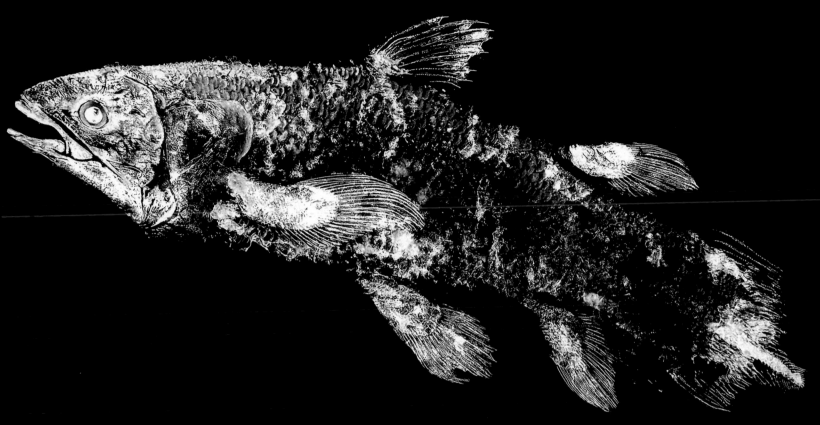

The discovery of a coelacanth off the east coast of South Africa in 1938 rocked the scientific community because these fishes were known only from fossils millions of years old. The coelacanth, *Latimeria chalumnae*, as it turned out, had survived into the modern era out of sight in the ocean depths. The discovery captured the interest of scientists and the public, and books were written about the first specimen and the subsequent searches for more. Then, in 1997, another shocking discovery took place: a second species, the Sulawesi Coelacanth, *L. menadoensis*, was found in the waters off Indonesia. Much remains unknown about the biology and ecology of this ancient group, which inhabits the dim twilight zone at depths between 490 and 2,300 feet (150 to 700 meters). Coelacanths can grow to 5.9 feet (1.8 meters) in length, so they are not small animals that evaded detection by Western science owing to size. It's exciting to think of the other creatures that await discovery in the ocean's depths. This *gyotaku*, or direct fish print, was made by artist Heather Fortner. Courtesy of the California Academy of Sciences. Further Reading: Smith, 1956; Thomson, 1991; Pouyaud et al., 1999; Weinberg, 2000.

*f*or freshwater habitats, it's not just depth that can provide the darkness. Turbidity, for example, can create conditions that are nearly dark just a few feet below the surface. Particles in the water, such as sediment, reflect light and keep it from penetrating the water below. Even shallow rivers can have a dark bottom owing to turbidity—with a community of creatures living there.

Some rivers and lakes have dark habitats because of depth. The world's deepest river is the Congo River in Africa, with depths exceeding 720 feet (220 meters). For comparison, the Amazon River in South America averages 164 feet (50 meters), but in spots reaches depths exceeding about 300 feet (92 meters); the Mississippi River in North America is about 200 feet (60 meters) at its deepest point; and Canada's Deep River is just over 400 feet (123 meters) deep. Lake Baikal in Russia is the deepest lake in the world, at 5,369 feet (1,637 meters). Other deep lakes include Lake Tanganyika in Africa (4,823 feet, or 1,025 meters), Lake Vostok in Antarctica (approximately 3,300 feet, or 1,000 meters), O'Higgins–San Martín Lake straddling the border between Argentina and Chile (2,742 feet, or 836 meters), and Crater Lake in the United States (1,949 feet, or 594 meters). All of these aquatic systems are dark in their depths, yet life exists there.

The Giant Freshwater Prawn, *Macrobrachium rosenbergii*, is a denizen of the bottoms of stygian rivers and lakes in Southeast Asia. These prawns can reach lengths up to 13 inches (33 cm). The rostrum is long and has between 11 and 14 "rostral teeth." Adults breed in fresh water, but the larvae require brackish water to survive. Subadults migrate back into freshwater habitats.

Many kinds of organisms inhabit the dark depths of rivers and lakes, despite the lack of light and the cold temperatures. But conditions can get challenging. Lake Vostok in Antarctica isn't just cold and deep, it's also covered by a layer of ice more than 2 miles (3,700 meters) thick. It is possible that hydrothermal activity in the lake's depths produces environments similar to those of deep-sea hydrothermal vents and could be home to a similarly bizarre assortment of species. The last time Lake Vostok was exposed to the surface environment was more than 35 million years ago, a time when it was surrounded by forest. The deep layer of ice puts significant pressure on the lake's depths, and there are few nutrients that can make it to the lake from the surface. Nevertheless, Shtarkman et al. (2013) found the genetic signatures—that

One of the goliath catfishes of the Amazon River is *Brachyplatystoma filamentosum*, in Peru called Saltón, in Brazil called Piraíba, and in Colombia called Lechero. The catfishes can reach lengths approaching 12 feet (3.7 meters) and prey on smaller fishes and invertebrates. An unusually large catfish was photographed in the Belén Market, Iquitos, Peru, in 2010.

is, the unique DNA structures—of more than 3,500 life forms in samples collected from the lake. Most are bacteria and fungi, especially extremophile species (species that thrive in extreme conditions), including psychrophiles, species that can survive and reproduce at temperatures ranging from 10° C to –15° C (50° F to 5° F). A small percentage of the genetic signatures came from more complex life forms. We'll learn more as exploration continues, but in the meantime, it is exciting to speculate about what may be living in these extreme conditions.

As is true for deep oceanic habitats, the species found in deep freshwater habitats are adapted to the conditions in the depths. Lake Baikal

in Siberia and Lakes Tanganyika and Malawi in Africa are home to deepwater fishes. In fishes that inhabit Lake Baikal's depths at 1,312 feet (about 400 meters), a "blue shift" in their visual pigments has evolved, which enhances their visual abilities in the light spectrum available in this environment (Hunt et al., 1995). A similar blue shift has been documented in deepwater fishes of the African lakes (Sugawara et al., 2005). Deepwater fish species living in the water column—that is, those with a pelagic lifestyle—must find a way to stay "afloat" at specific depths. The fishes of Lake Baikal and the Great Lakes of North America have converged, evolutionarily speaking, on the same two basic solutions to stay afloat in the water column: (1) some fishes achieve neutral buoyancy by being able to change their specific gravity and having fatter body types; (2) others are able to remain in the water column because they have leaner builds and larger fins (Eshenroder et al., 1999).

Another large specimen was photographed by Richard Scully in Puerto López on the Meta River in Colombia, circa 1978. This species inhabits the dark depths of the Amazon and Orinoco Rivers, as well as many of the drainage systems of the Guianas. Reports of attacks on swimming humans exist. The catfish is considered a delicacy, and the species supplies an important fishery for communities in these areas. Lechero—and many other Amazonian species—are overfished, and the future of the fisheries is in doubt. Overfishing is of critical concern to communities along the Amazon River.

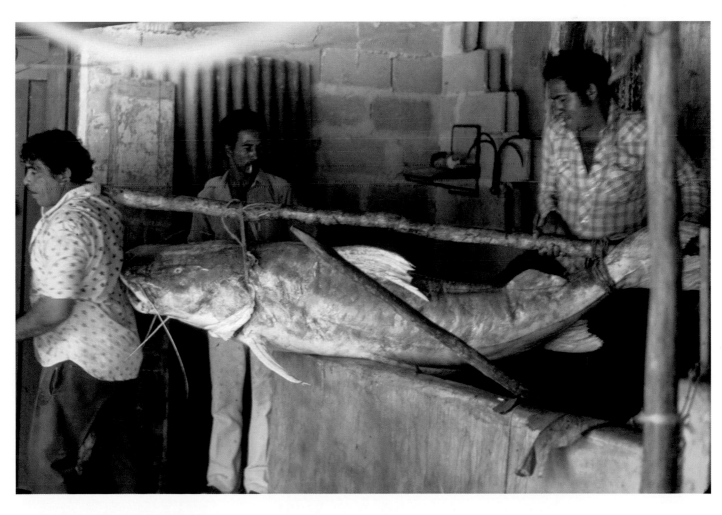

The electric knifefishes of South America occupy a wide variety of habitats. The Pink Knifefish, *Orthosternarchus tamandua* (*facing page, top and middle*), of the family Apteronotidae, is found in moderately deep waters of the Amazon. The small mouth opening limits the size of its prey species. The eyes are degenerated and do not function beyond deciphering light from dark. Photographed in 2007. Courtesy of River Wonders Inc. Lurking in the depths of the Amazon, the Duck-Billed Knifefish, *Compsaraia samueli* (*below and facing page, bottom*), of the family Apteronotidae, was not formally described until 2009, and little is known about this fish. Some individuals of this species have a bent upper jaw, creating a salmon-like appearance. The Duck-Billed Knifefish can be found in deeper waters of the Amazon by day and in shallower water at night. Photographed in 2008. Courtesy of River Wonders Inc. South American knifefishes and the African mormyrids are capable of generating weak electrical fields around their bodies. They use these fields to do things like hunt prey, navigate in dark or murky waters (electrolocation), and communicate with one another (electrocommunication). Differences in the electrical discharges of species allow for differentiation. Further differences between the sexes and even between individuals exist and can be used for identification. The descriptive word for these fishes that produce an electric field around them is electrogenic and being able to detect electric fields is known as being electroreceptive—our two groups of fish here can do both. Structures called electroreceptors are used to detect electrical fields. Further Reading: Hilton et al., 2007; Albert and Crampton, 2009; Ho et al., 2010.

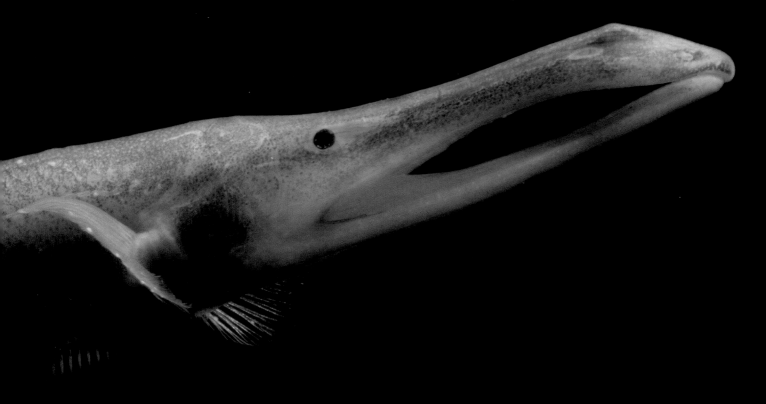

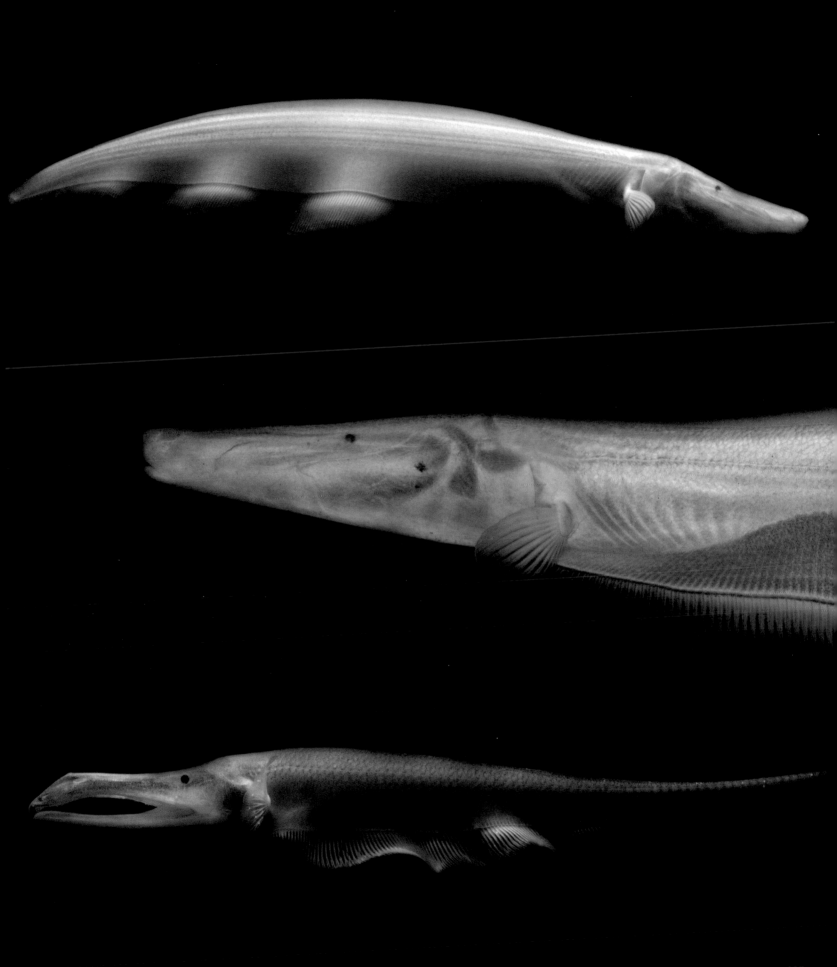

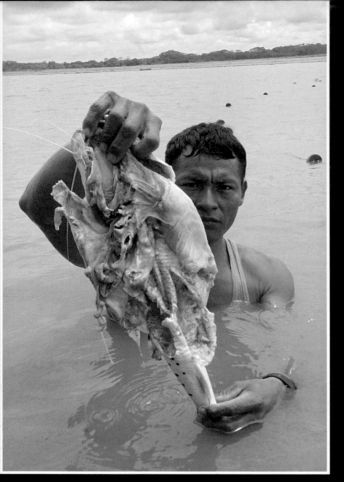

Catfishes of the genus *Cetopsis* are known as whale catfishes. Sleek and streamlined, they live in waterways of South America and can be found at considerable depths. Some species allegedly enter the bodies of larger fishes by chewing their way in through the fish's sides or entering through the mouth or anus. They seek larger fishes that have been caught on hook and line (*top*) and feed on the innards. Photographed in 2006. Courtesy of Ornamental Fish Inc. The Blue Whale Catfish, *Cetopsis coecutiens* (*bottom*), can be found in large schools in deep water, and the Speckled Whale Catfish, *C. sandrae* (*middle*), is another species from the upper Amazon River. Photographed in 2010 on the Amazon River in Peru.

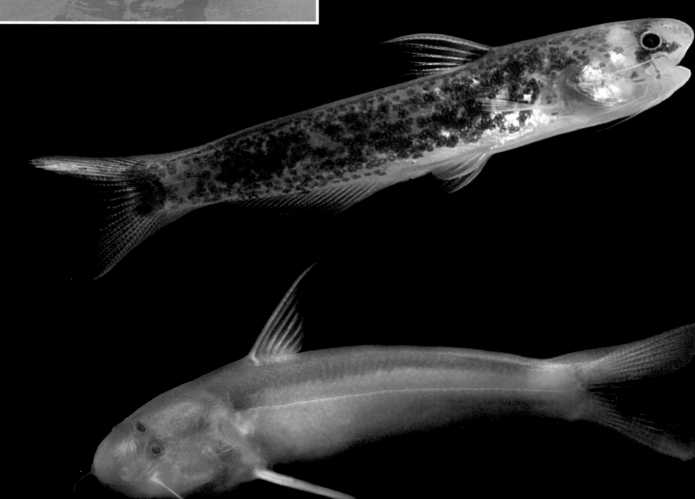

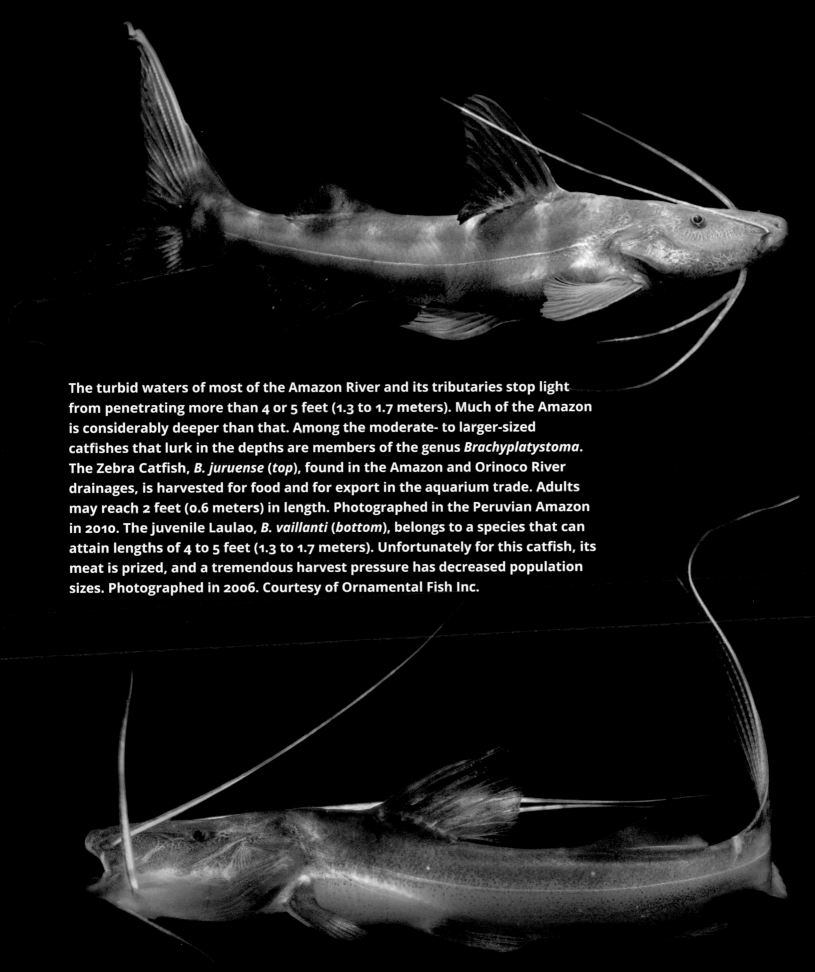

The turbid waters of most of the Amazon River and its tributaries stop light from penetrating more than 4 or 5 feet (1.3 to 1.7 meters). Much of the Amazon is considerably deeper than that. Among the moderate- to larger-sized catfishes that lurk in the depths are members of the genus *Brachyplatystoma*. The Zebra Catfish, *B. juruense* (*top*), found in the Amazon and Orinoco River drainages, is harvested for food and for export in the aquarium trade. Adults may reach 2 feet (0.6 meters) in length. Photographed in the Peruvian Amazon in 2010. The juvenile Laulao, *B. vaillanti* (*bottom*), belongs to a species that can attain lengths of 4 to 5 feet (1.3 to 1.7 meters). Unfortunately for this catfish, its meat is prized, and a tremendous harvest pressure has decreased population sizes. Photographed in 2006. Courtesy of Ornamental Fish Inc.

137

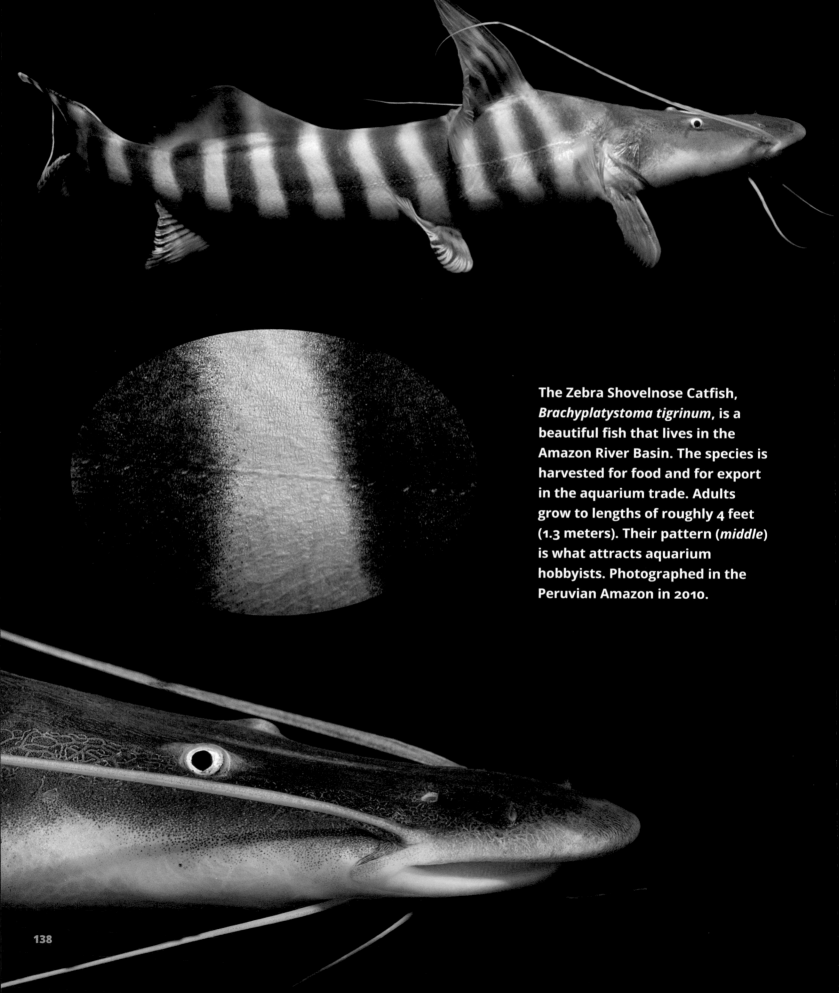

The Zebra Shovelnose Catfish, *Brachyplatystoma tigrinum*, is a beautiful fish that lives in the Amazon River Basin. The species is harvested for food and for export in the aquarium trade. Adults grow to lengths of roughly 4 feet (1.3 meters). Their pattern (*middle*) is what attracts aquarium hobbyists. Photographed in the Peruvian Amazon in 2010.

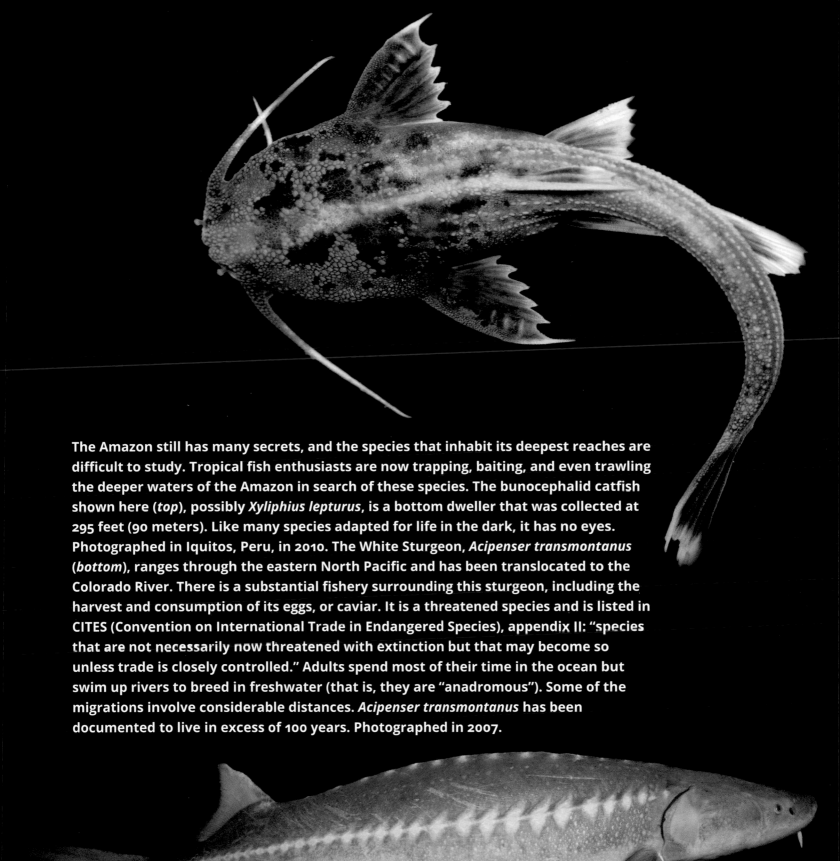

The Amazon still has many secrets, and the species that inhabit its deepest reaches are difficult to study. Tropical fish enthusiasts are now trapping, baiting, and even trawling the deeper waters of the Amazon in search of these species. The bunocephalid catfish shown here (*top*), possibly *Xyliphius lepturus*, is a bottom dweller that was collected at 295 feet (90 meters). Like many species adapted for life in the dark, it has no eyes. Photographed in Iquitos, Peru, in 2010. The White Sturgeon, *Acipenser transmontanus* (*bottom*), ranges through the eastern North Pacific and has been translocated to the Colorado River. There is a substantial fishery surrounding this sturgeon, including the harvest and consumption of its eggs, or caviar. It is a threatened species and is listed in CITES (Convention on International Trade in Endangered Species), appendix II: "species that are not necessarily now threatened with extinction but that may become so unless trade is closely controlled." Adults spend most of their time in the ocean but swim up rivers to breed in freshwater (that is, they are "anadromous"). Some of the migrations involve considerable distances. *Acipenser transmontanus* has been documented to live in excess of 100 years. Photographed in 2007.

Blind Spiny Eels, *Mastacembelus brichardi* (top), have eyes, but they are covered by a layer of connective tissue (Kish et al., 2011). These eels inhabit rapids in the Lower Congo River, Africa. The water in the Congo River is turbid, and light fails to penetrate farther than a few feet; at 6 feet (2 meters), the water is dark. The species averages 5.5 inches (14 centimeters) in total length but can reach 6.7 inches (17 centimeters).The Congo River is also the deepest river in the world, exceeding 720 feet (220 meters) in spots. Congo River Blind Cichlids, *Lamprologus lethops* (bottom), live in the inky black depths, down so deep that bringing them to the surface usually kills them. Note the similarities between *L. lethops* and the cavefishes shown in chapter 5. It would appear that the deepwater habitats of lakes and rivers can promote characteristics similar to those of fish species found only in subterranean habitats. This circumstance may teach us something about the developmental process in vertebrates. For example, although blind cavefishes and blind cave salamanders have no eyes as adults, they do have eyes early in development; one hypothesis argues that rudimentary eyes may help maintain circadian rhythms. Perhaps development of the eye might still be present in animals that will be blind as adults because early eye development plays an important role in development of the skull (Kish et al., 2011). Photograph of the cichlid by Oliver Lucanus. Further Reading: Kish et al., 2011.

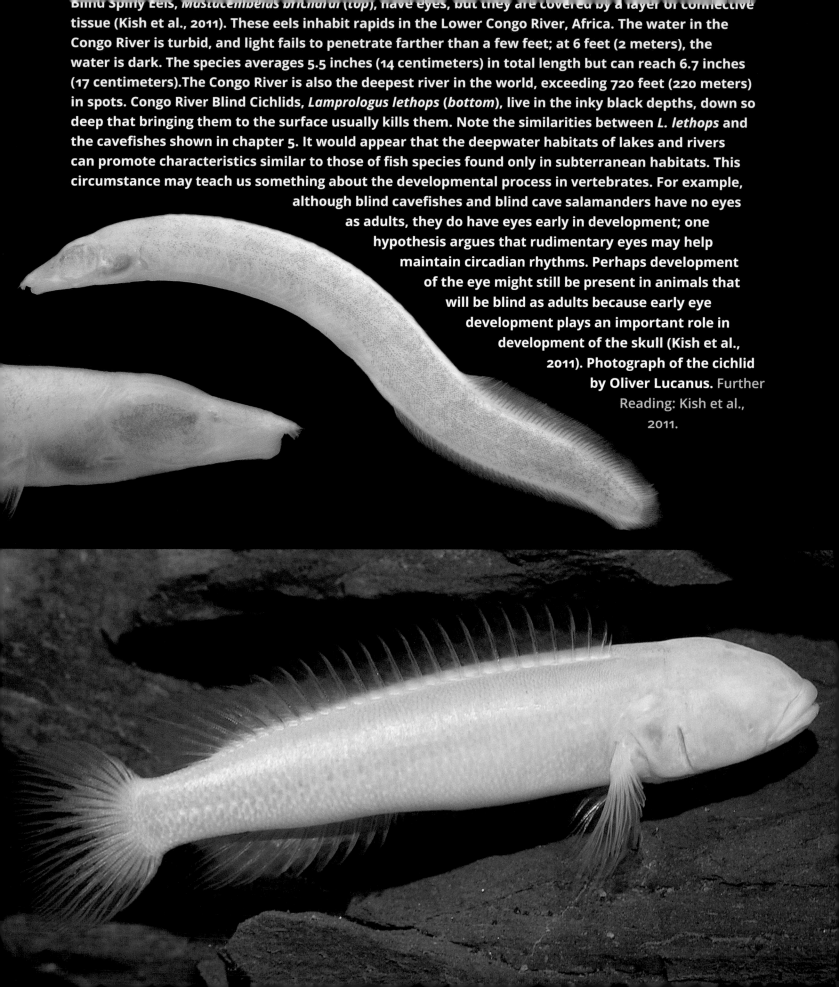

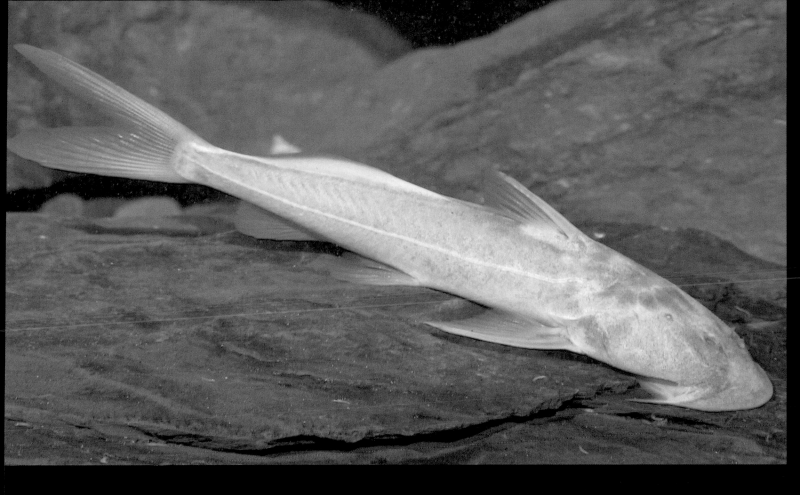

The bottom of the Congo River is full of surprises. This blind catfish, *Chiloglanis* sp., has not yet been described scientifically and given a formal scientific name. It was hauled up from the dark bottom of the river. The specialized mouthparts are undoubtedly used to rasp food from surfaces (*lower right*). Photographs by Oliver Lucanus.

*f*ossorial animals are those that burrow and live below the ground. The cast of characters with this lifestyle is bigger than one might imagine, and the range of "fossoriality" is considerable. Pocket Gophers and moles, for example, rarely leave the safety of their subterranean haunts, while Meerkats and some tortoise species dig burrows but live part-time on the surface and are, in a sense, only semi-fossorial. Insects, arachnids, reptiles, amphibians, mammals, and even some birds are also among those animals that can be at least partially fossorial. I find the species that spend nearly all of their lives below ground more interesting. There is an entire ecosystem down there that humans rarely encounter.

Although they live belowground and are generally out of sight, caecilians—the third living group of amphibians (the others being the frogs and toads and the salamanders and newts) and the least understood—have captured the attention of naturalists through the ages. The first amphibian recorded by visitors to the island of Sri Lanka (then Ceylon) was a caecilian, even though the island has quite a few species of frogs, some of which are much more evident than the caecilians (Kirtisinghe, 1957). All caecilians live below ground or in freshwater streams. What little we know about their predators comes from analyzing the stomach contents of animals such as snakes. It should come as no surprise that some of the primary predators of caecilians are also fossorial—namely, fossorial snakes. In particular, several species of coralsnakes of the American tropics feed on caecilians; likewise, a burrowing asp has been documented as feeding on a caecilian in East Africa (Gower et al., 2004). A coralsnake mimic from South America, *Anilius scytale*, also eats caecilians (Maschio et al., 2010).

A forest floor presents wildlife with many places to hide. Rotting logs, deep leaf litter, and soft soils all are attractive to burrowers. Desert sands are likewise an ideal medium through which to burrow, and there are numerous fossorial animals inhabiting deserts.

Sometimes the decomposing materials within and below leaf litter twinkle with light. There is an entire assemblage of wildlife that burrows into this habitat. Beetles of the family Phengodidae are referred to collectively as "railroad worms." The name comes from several South and Central American species that have greenish lights on their sides and orange or red lights at their ends—like a train. The "lights" are photophores, or light-producing organs. Female phengodids never metamorphose, instead remaining in a "larviform" state. This means that they reach sexual maturity while still in a larval body form. Males do metamorphose into something that looks like a winged beetle with a moth's antennae. Larvae, larviform females, and males all have photophores. Larvae and larviform females have numerous photophores spanning the length of their bodies. North American species do not produce orange or red light. These phengodids were photographed in 2010 in the Great Smoky Mountains National Park, Tennessee, USA.
Further Reading: Bechara et al., 1999.

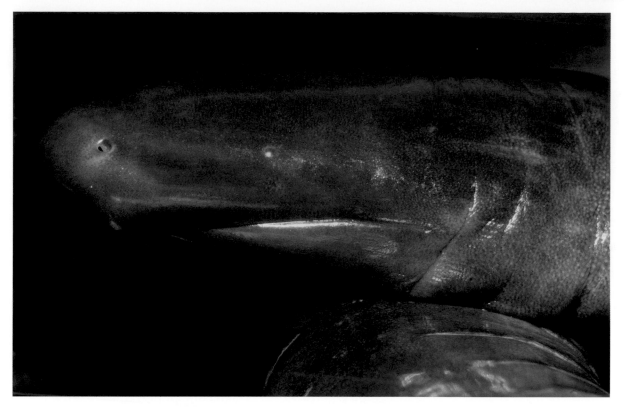

Like many amphibians, caecilians come in bright colors. Their skin toxins are not well studied, but there is little doubt that many caecilians have potent chemical defenses in their skin, as do many other amphibians.

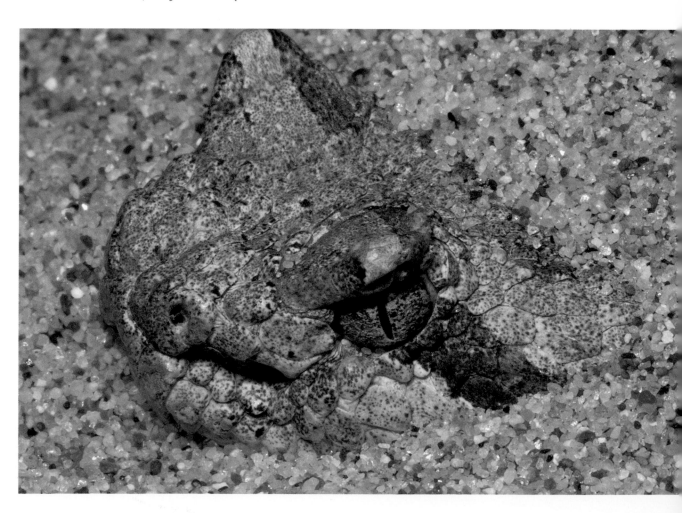

Nor is fossoriality restricted to terrestrial environments. For example, the tadpole of the Pe-reť Toad, *Otophryne pyburni*, burrows into the sand at the bottom of clear tropical streams. The tadpole has an elongate feeding tube that it extends above the substrate (Wassersug and Pyburn, 1987). Similarly, tadpoles of the Southeast Asian frog *Leptobrachella mjobergi* live within the gravel beds of small streams (Haas et al., 2006). Various ghost shrimp species around the world dig extensive burrows in the intertidal zone. Often they share these burrows with goby fishes. Many of the shrimp are blind, and the gobies sit at the mouth of the burrows and watch for potential predators; the shrimp does the burrow housekeeping. A study of a stream in the Amazon found a community of fishes that have adapted to life under the sand, and in the five fish species that burrow below the sand, a similar group of characteristics has evolved, including (1) feeding on aquatic, immature insects; (2) cryptic coloration matching the color and pattern of sand *or* a translucent body; (3) small body size; (4) fewer vertebrae than is typical of other fish species; (5) dorsally placed, larger eyes; and (6) burying behavior (Zuanon et al., 2006). Another sand-inhabiting catfish from South America, *Pygidianops amphioxus*, was described as literally "diving" into the sand after being forced out of the sand by biologists digging for the fish. This species spends all of its time buried below the sand; it is described as having an "eel-like" body form (de Pinna and Kirovsky, 2011).

(*Facing page*)
The Sidewinder, *Crotalus cerastes*, is a venomous pitviper of the southwestern United States and adjacent Mexico. The common name comes from the snake's peculiar sideways locomotion, which allows it to move over sand quickly and easily. Adults often bury themselves in the sand with only their eyes exposed. The maximum size for the species is just short of 3 feet (almost 1 meter). Photographed in Las Vegas, Nevada, in 2012.

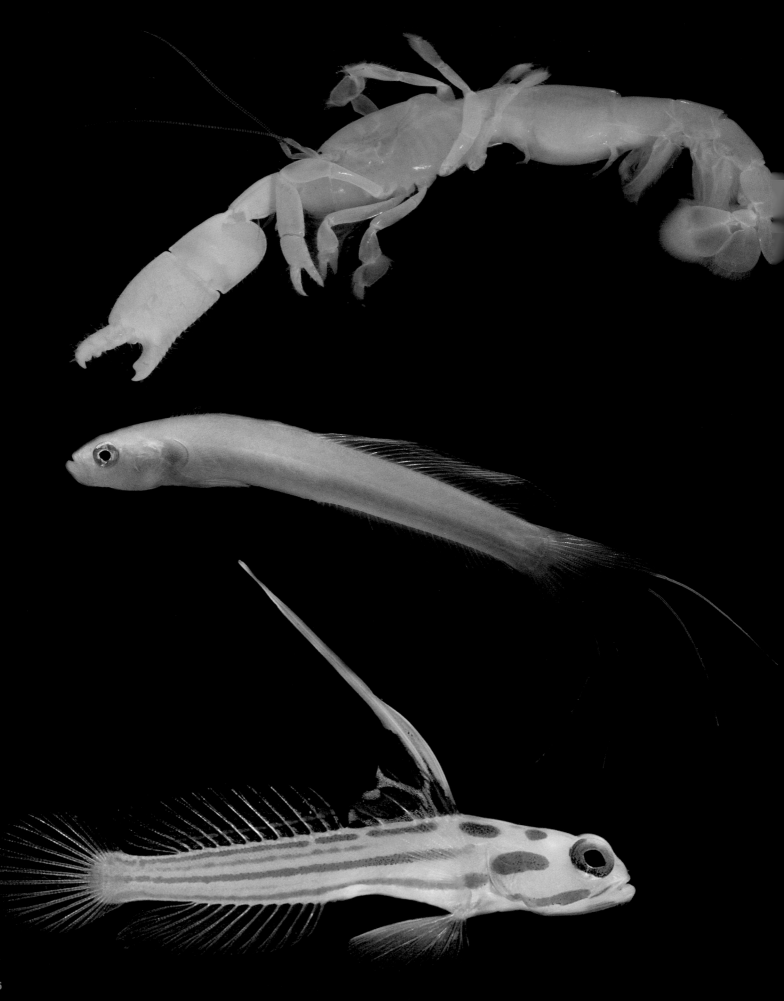

(*Facing page*)

Shrimp and gobies frequently live in symbiotic relationships. The shrimp build burrows and allow gobies to live with them. In turn, the gobies may feed the shrimp or watch at the mouth of the burrow for danger. The Tidepool Ghost Shrimp, *Callianassa affinis* (*top*), digs a burrow below rocks and in thick rubble along the California coast, south to Baja California. Like its relative the Bay Ghost Shrimp, *Callianassa californiensis*, the Tidepool Ghost Shrimp sometimes has a house guest in the dark depths of its burrow: the California Blind Goby, *Typhlogobius californiensis*, which is completely blind and lacks much in the way of pigment—similar to a blind cavefish. The relationship between the shrimp and this goby is not completely understood. The Blue Hana Goby, *Ptereleotris hanae* (*middle*), inhabits the Indo-Pacific Ocean at depths down to 164 feet (50 meters), where it lives over sand or rubble bottoms in proximity to reefs. The species will inhabit burrows made by alpheid shrimp, but it does not interact with the shrimp as other gobies do. The Shrimp-Rayed Goby, *Stonogobiops yasha* (*bottom*), of the tropical western Pacific can be found at depths down to 131 feet (40 meters). It lives symbiotically in a burrow made by the burrowing shrimp *Alpheus randalli*. The shrimp maintains the burrow, and the fish contributes food and watches for predators. Further Reading: Hoffman, 1982.

Reticulated Flatwoods Salamanders, *Ambystoma bishopi*, live below ground for 99 percent of their lives, emerging on the surface in winter rains to breed in temporary pools. The aquatic larvae develop over a period of two to four months, metamorphose into their terrestrial phase, and move below ground. Habitat loss has significantly affected this species, and a conservation breeding program is underway. This is a federally endangered species in the United States. Photographed in the Atlanta Botanical Garden's amphibian facilities. Further Reading: Fenolio et al., 2014a.

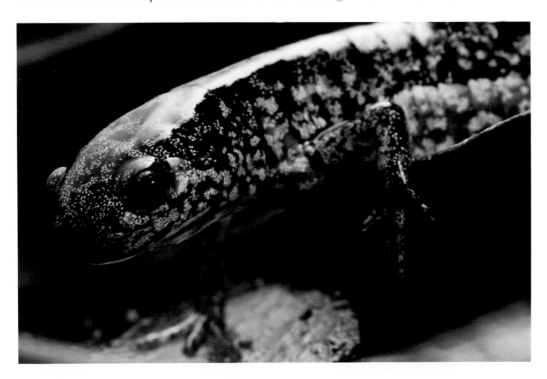

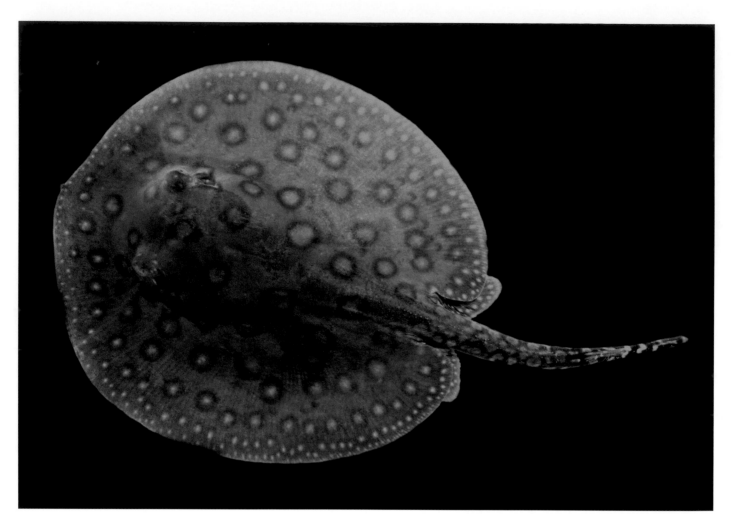

Animals that live in the sand are referred to as psammophilic, or "sand-loving." The Freshwater Stingrays, *Potamotrygon* spp., are psammophilic fishes. The specimen shown here is *P. motoro.* This species is often exported from South America for the aquarium trade. Freshwater Stingrays are frequently found in shallow water with a sand or silt bottom, where they bury themselves with only their eyes protruding. They wait for small invertebrates to come close and pounce on them. To locate food in the murky darkness, rays, sharks, and skates use special organs on their ventral surface and face called ampullary organs. These organs detect temperature gradients and electrical fields, including the electrical fields that potential prey produce. Freshwater rays, as well as a shark, the Bull Shark, *Carcharhinus leucas*, use ampullary organs in freshwater habitats to help locate prey. Freshwater Stingrays have a barb on their tail that they can use in defense. Dangerous bacteria may live on the barb and can cause serious infections in humans who accidentally step on a ray and are pierced by the barb. A potent venom makes the sting of these fishes dangerous. Photographed in the Peruvian Amazon in 2012. Further Reading: Szamier and Bennett, 1980; Whitehead, 2002.

Termite Mound Wildlife

Termite mounds, or termitaria, are a distinctive component of many xeric (that is, arid) landscapes. They provide refuge as well as higher humidity and cooler temperatures than the surrounding environment (Pomeroy and Service, 1986). The termitaria also add to the heterogeneity and complexity of the environment, thus also contributing to the region's biodiversity and carrying capacity (a measure used by biologists to describe the number and variety of species an environment can support), even for reptiles and amphibians (Flemming and Loveridge, 2003). Certain reptiles and amphibians live in the mounds, breed within them, and feed on the termites and other invertebrates that inhabit them (Magnusson et al., 1985; Murray and Schramm, 1987; Ehmann et al., 1991; Wikramanayake and Dryden, 1993; Griffiths and Cristian, 1996; Gandolfi and Rocha, 1998; Peña, 2000; Fleming and Loveridge, 2003; Moreira et al., 2009).

I have been participating in studies of the fauna living in termite mounds of the Brazilian Cerrado since 1998, with my good friend and fellow biologist Dr. Nelson Jorge da Silva Jr. The Cerrado is a seasonally xeric tropical savannah peppered with termite mounds. In fact, this habitat accommodates 23 percent of all known neotropical termite species (that is, of the tropics of the western hemisphere), many of which are mound builders (Brown, 1996; Domingos and Gontijo, 1996; Raw, 1998; Peña, 2000; Cavalcanti and Joly, 2002). Termite mounds in the Cerrado house complicated assemblages of invertebrates, with as many as 14 termite species in a single mound (Domingos and Gontijo, 1996), as well as ant colonies, scorpions, spiders, beetles and their larvae, opilionids (harvestmen or "daddy longlegs"), mites, and often dense populations of roaches (Lourenço, 1975, 1978; Mill, 1981; Bechara et al., 1999; Moreira et al., 2009).

The invertebrates living inside a termite mound undoubtedly increase the mound's attractiveness to reptiles and amphibians, particularly to ant- and termite-feeding specialists. The protective environment inside

the mound is probably another attractive feature because the Cerrado can experience temperature swings exceeding 35°C within a 24-hour period (Moreira et al., 2009).

On one memorable evening hike on the Cerrado at the beginning of the rainy season, I was amazed to see swarms of termites emerging from the hundreds of termite mounds that dotted the landscape. Winged termites clustered all over the surfaces of the mounds, making them look alive. Even more spectacular were the predatory click beetle larvae, *Pyrearinus termitilluminans*, which emerged from the mounds to feast on the preoccupied termites. The beetle larvae are bioluminescent and produce a bright light that is easy to see from a distance. Many dozens of the glowing larvae covered the surface of each mound, lighting up the landscape all the way to the horizon.

(*Facing page*)
Termite mounds have many pockets and corners that offer cooler temperatures and higher humidity than the external environment, and the mounds become refugia for numerous smaller animals. As many as 14 species of termites can inhabit the same mound, along with ants, roaches, beetles, scorpions, spiders, opilionids, and mites. Further Reading: Domingos and Gontijo, 1996; Baptista, 1998; Moreira et al., 2009.

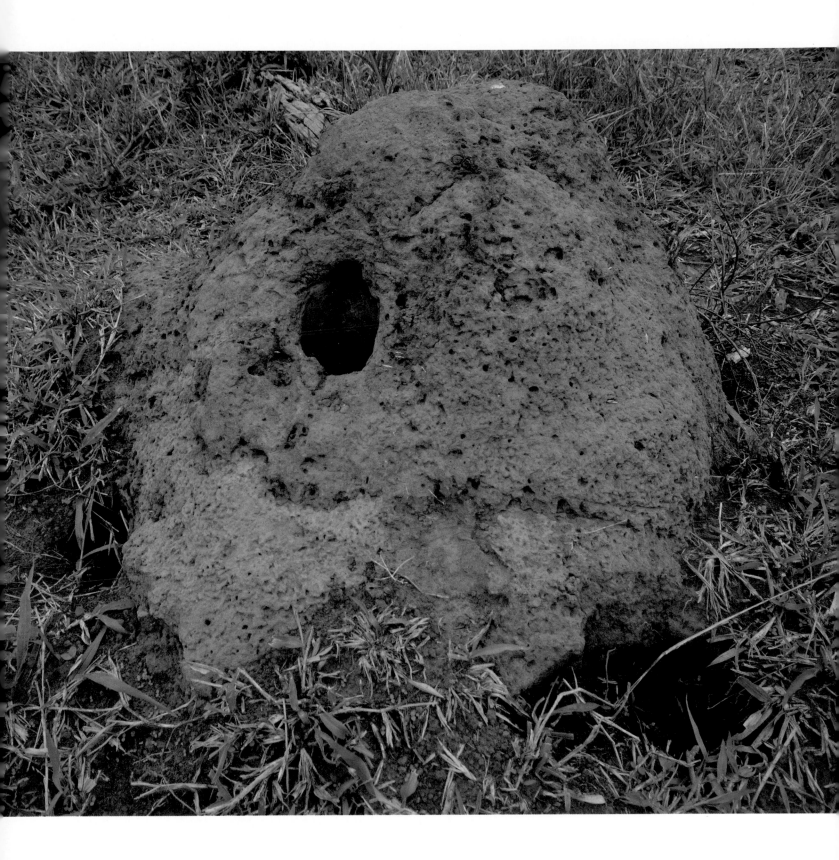

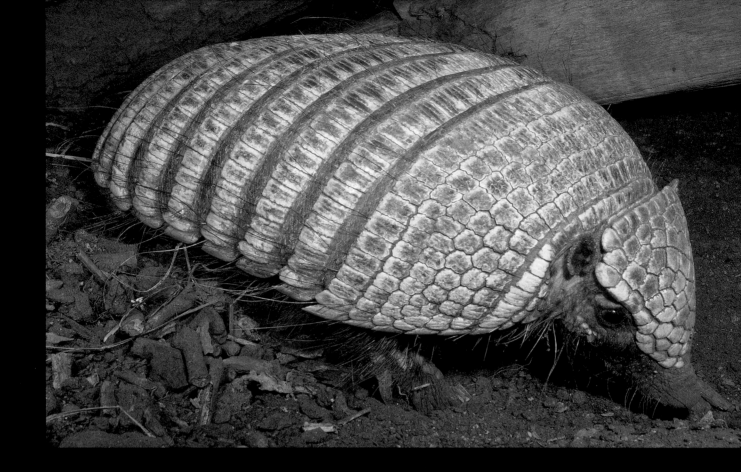

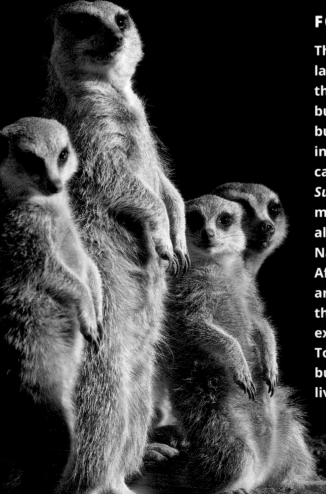

FOSSORIAL BIODIVERSITY

The *Pichi*, or Dwarf Armadillo, *Zaedyus pichiy* (*top*), inhabits grass-lands and pampas from central and southern Argentina, west through Chile, and south to the Strait of Magellan. The *Pichi* digs burrows and forages by day and night. The dark refuge of its burrow provides a safe hideout. These animals will eat any small invertebrate or vertebrate they can catch, as well as eating carrion. Some Amerindian groups hunt them for food. Meerkats, *Suricata suricatta* (*left*), are small mammals related to the mongoose and are in the same family, Herpestidae. They live in all parts of the Kalahari Desert in Botswana, in much of the Namib Desert in Namibia and southwestern Angola, and in South Africa. They eat small vertebrates and invertebrates. Meerkats are immune to the venom of several species of scorpions found in the same habitats. These mammals live in social groups that excavate and inhabit extensive burrow networks. As with Gopher Tortoises and other North American burrowing tortoises, the burrows of Meerkats are home to countless other animals that live belowground.

Caecilians are amphibians that have no arms or legs and superficially resemble an earthworm. They are vertebrates, however, with a backbone and jaws filled with teeth. This bright blue caecilian (*below*), of the genus *Caecilia*, was encountered in the Peruvian Amazon Basin. It was 2.8 feet (about 1 meter) long and had enormous teeth. The strange appearance and reclusive lifestyle of the caecilians have produced some odd beliefs among indigenous groups. For example, Amerindians of Tenejapa in the Mexican state of Chiapas believe that a local species of caecilian, *Dermophis mexicanus*, enters the anus of people while they are relieving themselves and then consumes the unfortunate victim from within. Their common name for caecilians is *tapaculo*, Spanish for "anus-plugger." Photographed in 2011. Further Reading: Hunn, 1977.

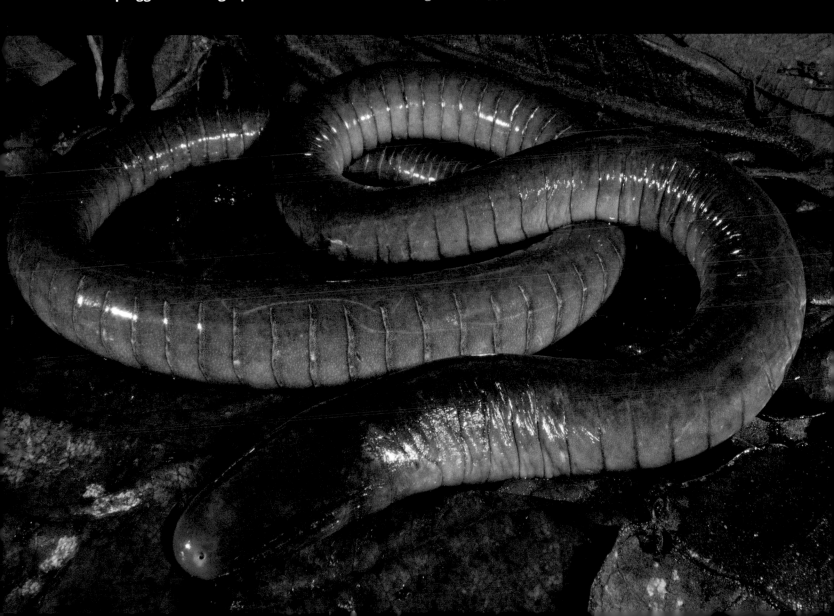

The caecilian *Ichthyophis kohtaoensis* (*top*) has several common names, including Koh Tao Island caecilian, Koa Tao caecilian, common caecilian, yellow stripe caecilian, and Koh Tao snake frog. The species was first described in 1960 and named for Koh Tao Island in the Gulf of Siam (now Gulf of Thailand), off the eastern shore of Thailand, by one of the most prominent caecilian biologists of all time, E. H. Taylor. The females lay their eggs in damp soil near a water source and remain with them until they hatch (a practice called egg brooding, in which an adult guards the eggs, and sometimes the hatchlings, for a period of time). When the eggs hatch, the young make their way to the water, where they pass through an aquatic larval stage before metamorphosing into a terrestrial adult. The adults have many sharp teeth for capturing their food, which includes earthworms. They are fossorial, living beneath the ground in soil and decomposing vegetation. The bright yellow stripe down the side may be an aposematic (warning) coloration, indicating to potential predators that the animal has toxic skin compounds. This female was collected in Thailand and photographed in 2005. The Congo Caecilian, *Herpele squalostoma* (*middle*), is found in West Africa. Every aspect of its body is adapted for burrowing. Its eyes are covered by bone, its muscles can generate tremendous force to push its body through the soil, and it has many sharp teeth for capturing food, which includes earthworms. This female was collected in Cameroon and photographed in 2005. Gaboon Caecilians, *Geotrypetes seraphini* (*bottom*), of West Africa give live birth to small, translucent young that look like earthworms. The female guards them for several weeks after birth. During that time, the offspring eat skin that the mother sloughs off. This "skin feeding" was described as a novel form of parental care in amphibians. The female shown here was collected in Cameroon and photographed in 2005.

Recent studies suggest that the presence of bright skin color in caecilians indicates occasional movement aboveground, where the animals are exposed to an entirely different set of potential predators, and their skin color may be aposematic. Alternatively, the bright coloration might exist simply because there are no selective pressures against it underground—that is, over the course of evolution, there has been no survival advantage or disadvantage to any particular coloration.

Further Reading: O'Reilly et al., 1996, 1997, 2000; Kupfer et al., 2005; Wollenberg and Measey, 2009.

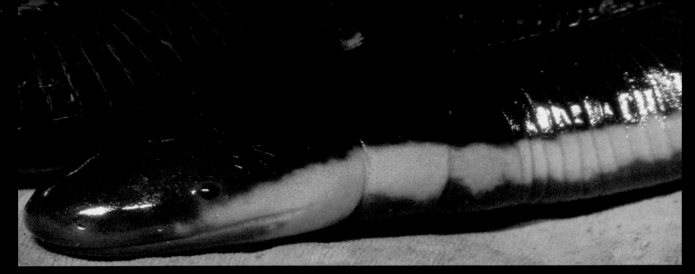

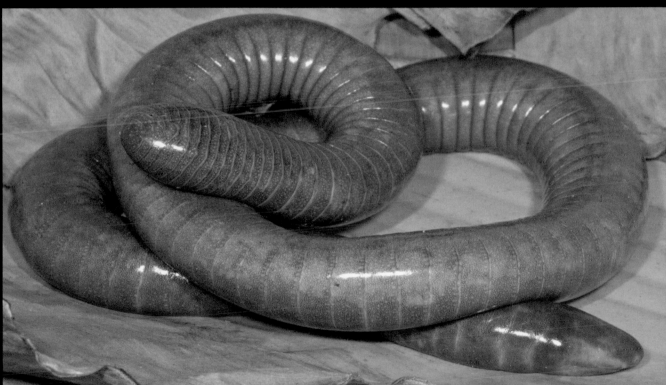

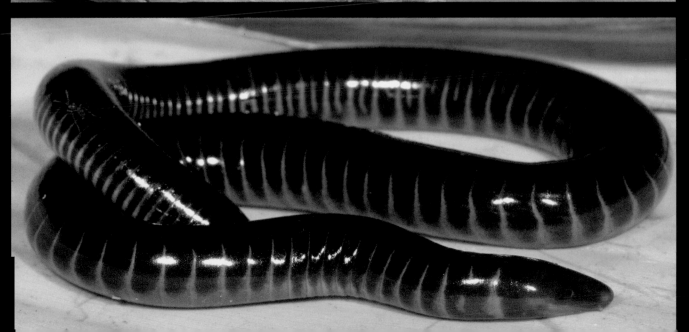

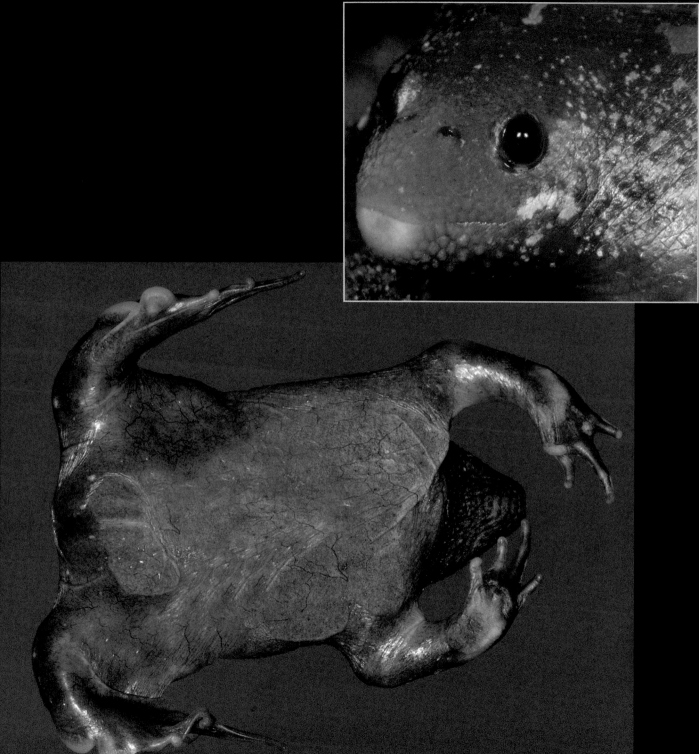

Mexican Burrowing Toads, *Rhinophrynus dorsalis*, spend much of their life belowground. The species' range extends from extreme southern Texas, USA, south to Costa Rica. They are found in dry habitats with strong rainy seasons that form temporary ponds in which the animals breed. The frogs have large "spades" on their hind feet for digging, called metatarsal tubercles. The Spanish name for this frog in Costa Rica is *sapo borracho*, or "drunken toad." The name comes from the observation that the frogs can walk backward as easily as forward. **Photographed in 2007.** Further Reading: Duellman, 1971.

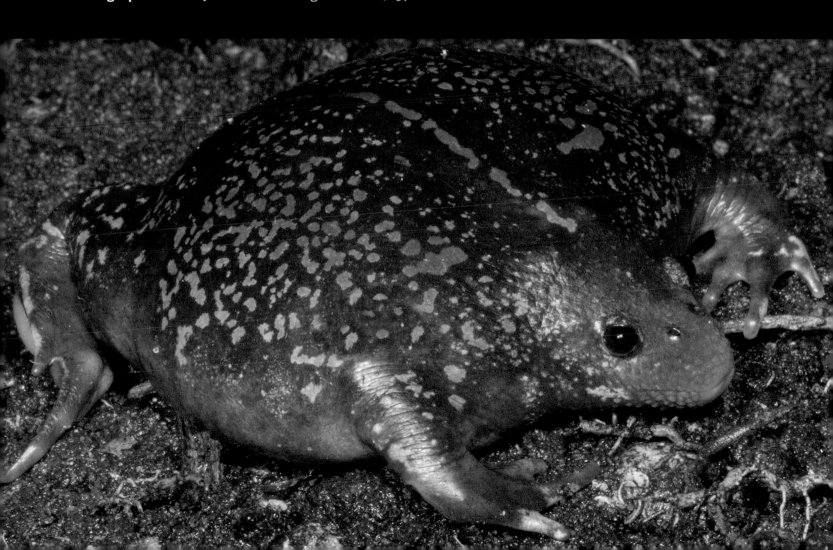

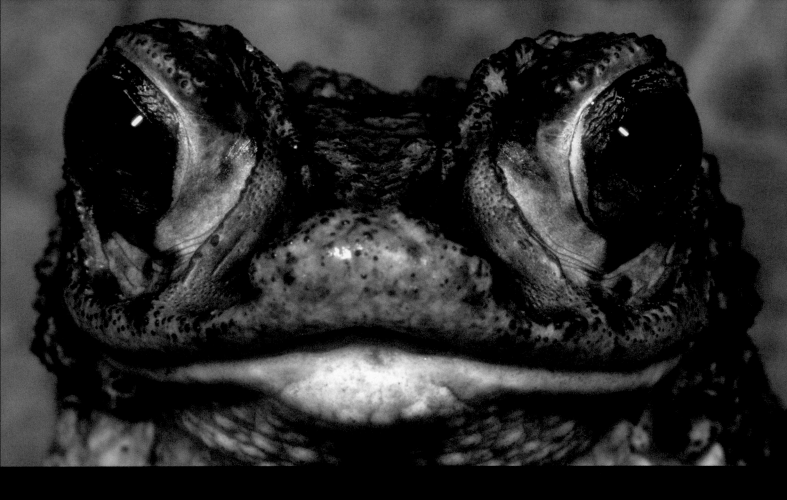

Endemic to the Caribbean island of Puerto Rico, the Puerto Rican Crested Toad, *Peltophryne lemur* (*top*), spends much of its life belowground. Human-driven environmental change has eliminated much of the appropriate habitat for this amphibian. The International Union for Conservation of Nature (IUCN) lists this species as critically endangered. Zoos and aquariums have developed a captive breeding program, and captive-produced Crested Toads have been reintroduced into the wild.

The Red Hills Salamander, *Phaeognathus hubrichti* (*bottom*), is endemic to several counties in Alabama, USA. The species was not described until 1960; because it lives belowground in burrows, it had eluded biologists. It is a large salamander, reaching a length of roughly 10 inches (25 centimeters). The Red Hills Salamander is listed as an endangered species by the U.S. Fish and Wildlife Service and the IUCN. Sixty percent or so of the remaining habitat of the salamander is owned or leased by paper companies. Photographed in 2010. Further Reading: Stuart et al., 2004; Mendelson et al., 2006; Gascon et al., 2007; Collins and Crump, 2009.

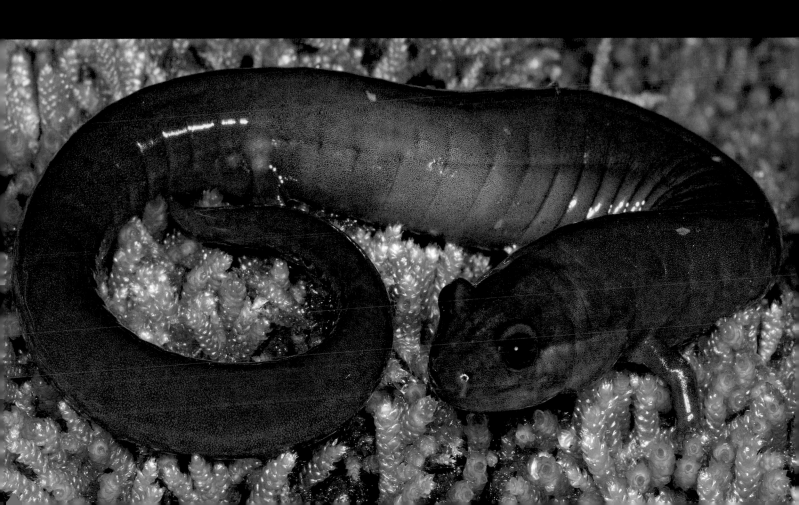

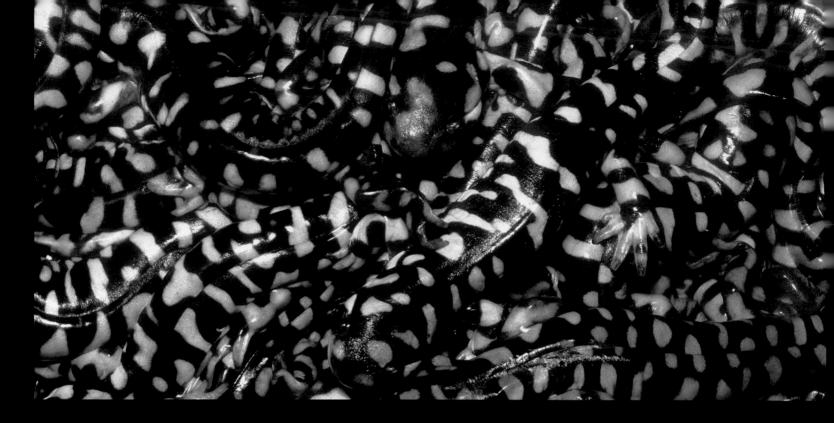

Some species of salamander move in huge numbers. Usually, such mass migrations take place near breeding seasons. This writhing mass of Tiger Salamanders, *Ambystoma tigrinum* (*top*), was many individuals deep. The California Tiger Salamander, *A. californiense* (*bottom*), is a secretive amphibian that spends much of its life belowground, often in burrows created by other animals or below the root systems of large trees. With the first rains of the fall season, the animals migrate to temporary ponds and deposit their eggs. The larvae metamorphose in several months, but an "overwintering" phase of larvae can take up to 13 months to go through metamorphosis. Individuals may live as long as 15 years. The California Tiger Salamander is listed by the IUCN as vulnerable, and the U.S. Fish and Wildlife Service lists specific populations as endangered. Habitat loss has added to their decline. Further Reading: Stebbins, 1972; Fisher and Shaffer, 1996.

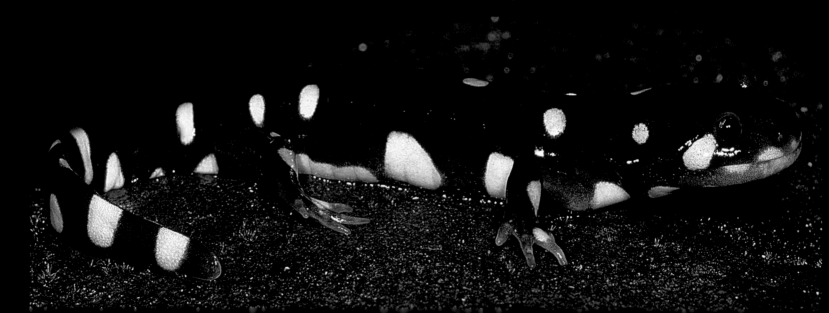

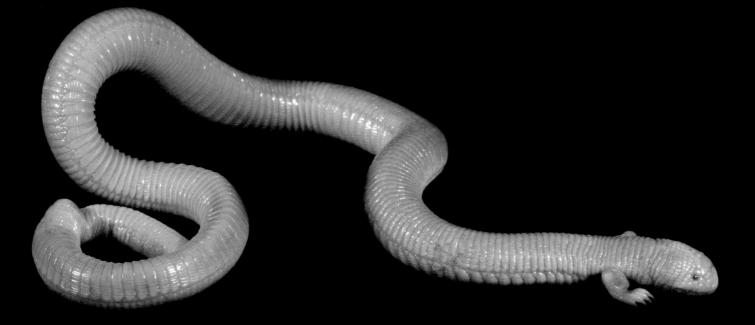

The Mexican Mole Lizard, *Bipes biporus* (*top*), of the family Bipedidae, is a 10-inch (25.4-centimeter) creature known as an amphisbaenian. They are a scale-covered reptile, related to lizards and snakes, and they use their limbs to help burrow in sandy soils. Although it is not related to the caecilian *Dermophis mexicanus*, a similar mythology surrounds this species. Allegedly, the Mexican Mole Lizard, or *ajolote*, will crawl up the anus of sleeping or defecating people and kill the victim through gastrointestinal trauma (Wright and Mason, 1981; Franklin, 2011). Or the lizard can enter a woman's vagina and impregnate her (Franklin, 2011). The mythology has accompanied Mexican immigrants to the United States; there is an old story of a *Bipes* attack on a Mexican man in south-central California, where scientists have not found any *Bipes* species (Wright and Mason, 1981). Karl Franklin graciously allowed photography of this specimen. The Giant Blindsnake, *Amerotyphlops reticulatus* (*bottom*), spends its life belowground. These fossorial reptiles are modified for burrowing; the eyes are covered by tissue, and the snout is covered by a shield that aids in the burrowing process. The overlapping scales form a glassy shield that protects the snake from the stings of ants as it feeds on their eggs and larvae. The species is found across tropical South America, east of the Andes. This individual was photographed in Amazonian Peru in 2013.

Further Reading: Wright and Mason, 1981; Franklin, 2011.

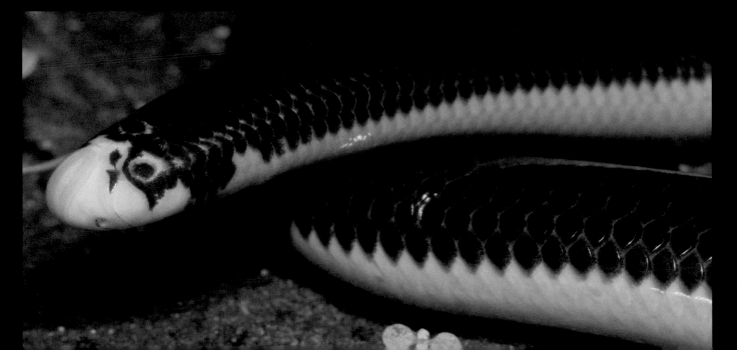

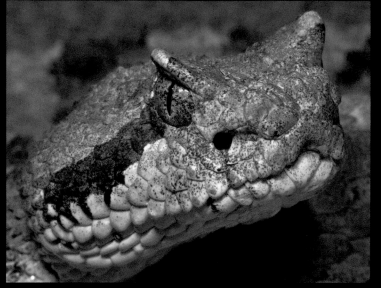

Sidewinders, *Crotalus cerastes* (*top*), are rattlesnakes of the American Southwest that are adapted to life in soft soils and sand. They burrow and can be completely hidden except for their eyes, protruding out from the sand (*upper right*). Along with the Beaded Lizard, *Heloderma horridum*, the Gila Monster, *Heloderma suspectum* (*bottom*), is a venomous lizard of the American Southwest and Mexico. These lizards spend much of their time in burrows but are otherwise outside after dark—depending on temperature, they can be very active at dusk and dawn. They look for bird nests (they love eggs), small insects, birds, and mammals. Further Reading: Campbell and Lamar, 2004; Campbell and Vannini, 1988; Brown and Carmony, 1991; Beck, 2005; Reiserer et al., 2013.

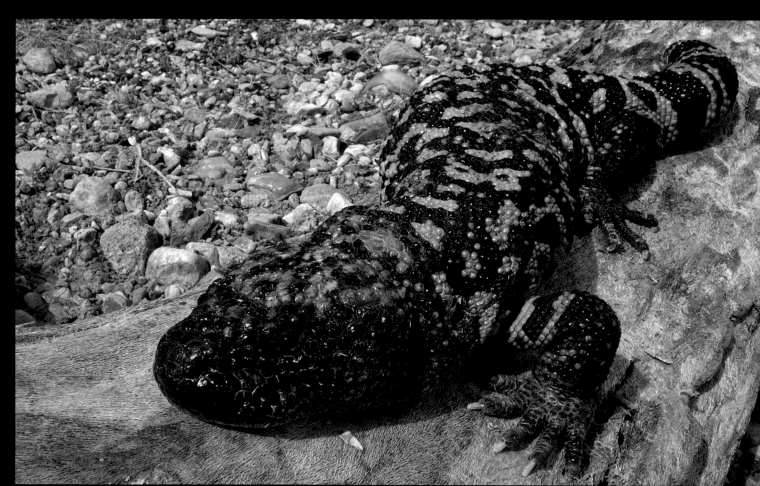

TERMITE MOUND WILDLIFE

The South American worm lizards are squamate (scaled) reptiles that are related to snakes and lizards. With the exception of the genus *Bipes*, they have no arms and legs. Members of the genus *Leposternon* are exceptional burrowers and are physically strong and difficult to handle. They are commonly encountered inside termite mounds. This individual was photographed in Brazil's Cerrado in 2000. Further Reading: Moreira et al., 2009.

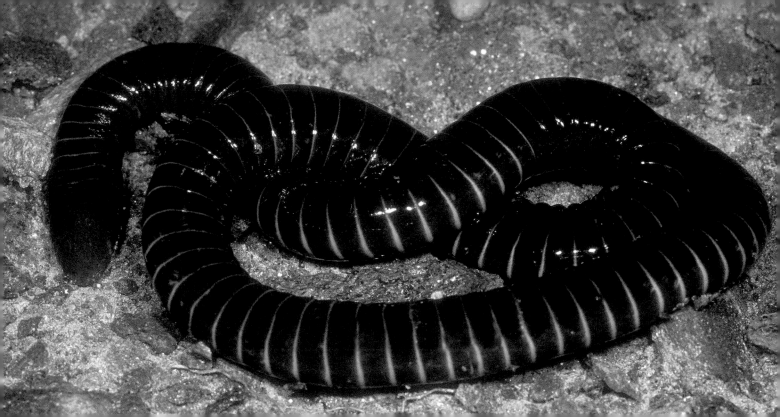

Soil at the base of and beneath termite mounds offers a combination of moist substrate, cooler temperatures, and potential food items. Caecilians, highly evolved for burrowing, are not uncommon in such spots. *Siphonops paulensis* (*facing page*) was often encountered in a study examining termite mounds of the Brazilian Cerrado. Also found inside the mounds are lanceheads, which include the most dangerous pitvipers in Latin America. Some, such as *Bothrops moojeni* (*this page*), are responsible for hundreds of venomous snake-bites each year in Brazil. The nocturnal habits of lanceheads coupled with a scarcity of flashlights result in many such cases in rural areas. Further Reading: Campbell and Lamar, 2004; O'Reilly et al., 1996, 1997, 2000; Moreira et al., 2009.

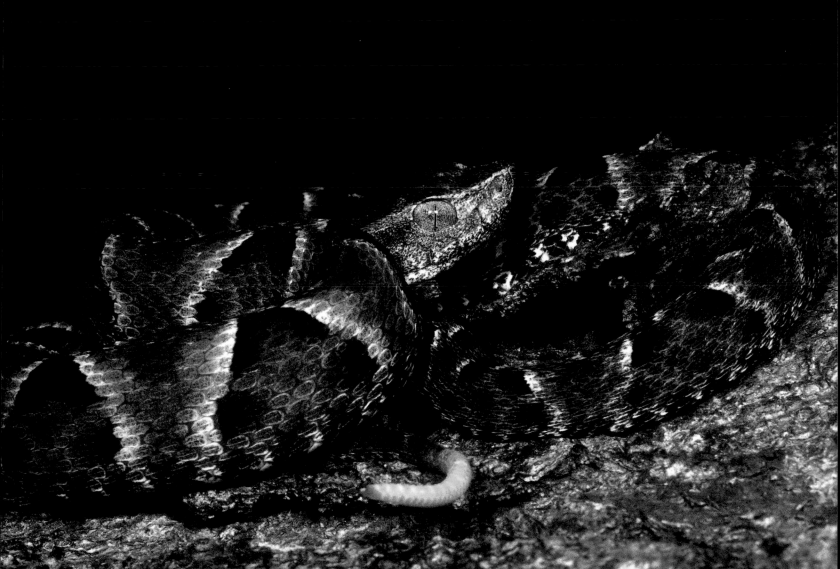

The White Spotted Humming Frog, *Chasmocleis albopunctata* (*this page*), ranges through Bolivia, Paraguay, and Brazil in drier habitats. It spends much of its time buried beneath the ground. In Brazil's Cerrado, the frogs are common inside termite mounds, where they may have a longer activity period than populations in more exposed habitats. When it rains on the Cerrado, the frogs leave the termite mounds and forage. They can occasionally be heard calling from within the mounds. This individual was observed in the Cerrado of Brazil in 2002. Further Reading: Caramaschi and Da Cruz, 1997.

Another common inhabitant of termite mounds in the xeric Cerrado of central Brazil is the Brazilian Black-and-White Tarantula, *Nhandu coloratovillosus* (*facing page*). Living inside chambers that are not active parts of termite colonies, this species benefits from the lower daytime temperatures and higher humidity inside the mound. This individual was photographed in Goiás, Brazil, in 1998.

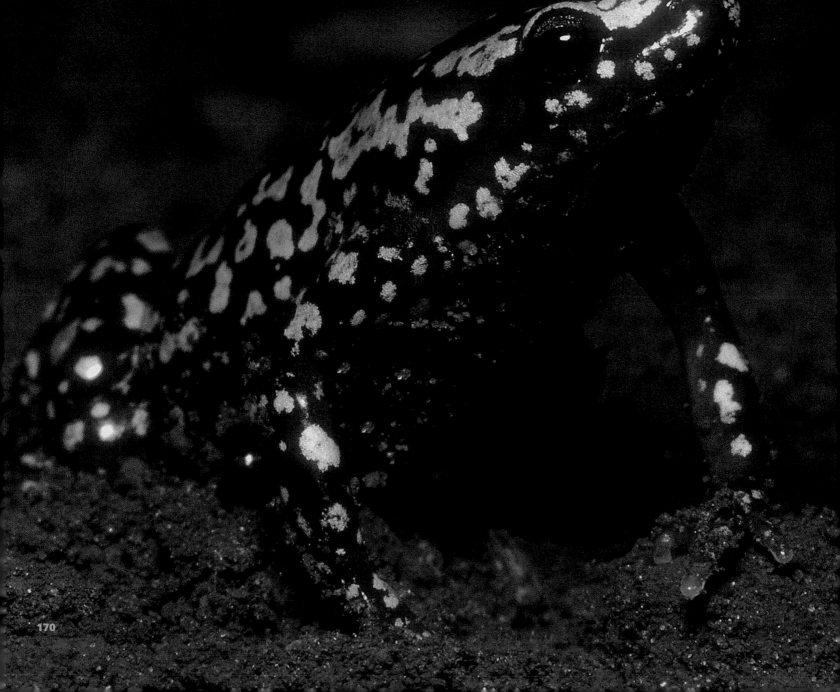

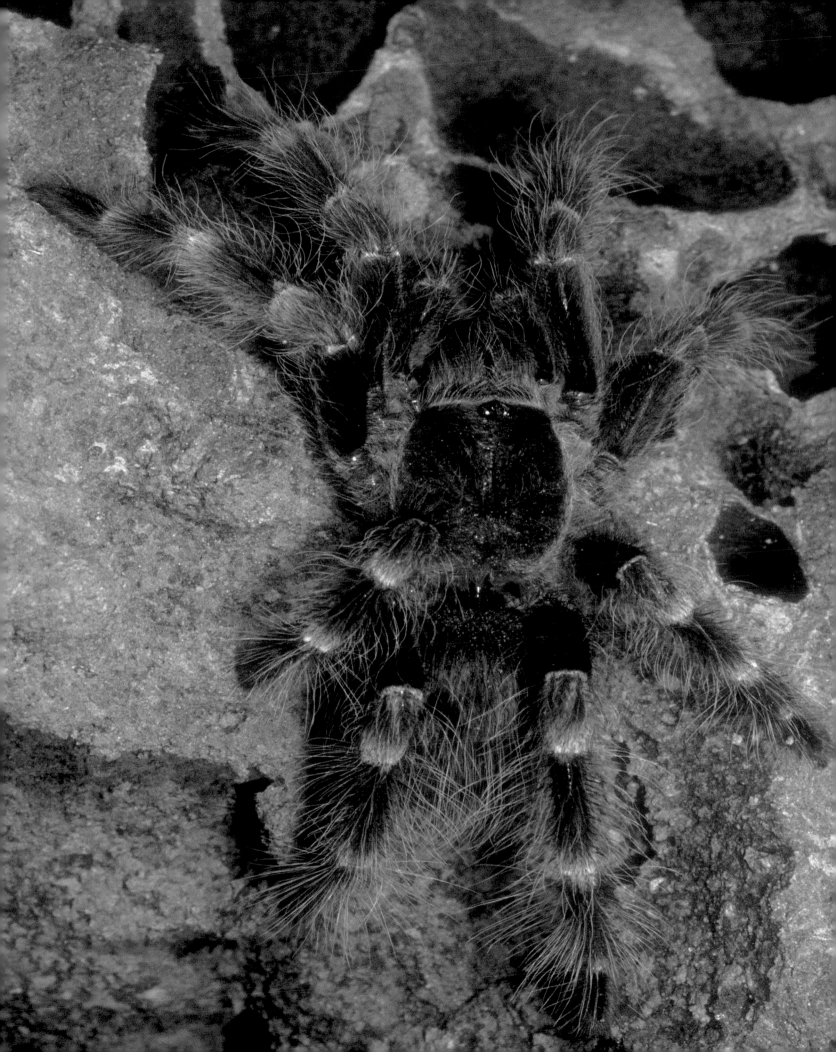

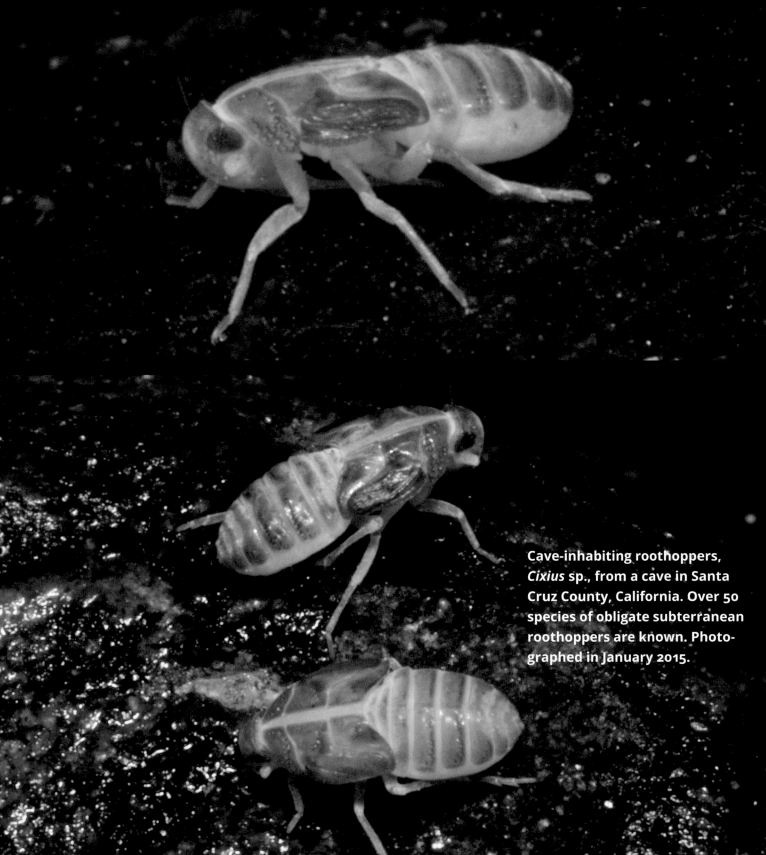

Cave-inhabiting roothoppers, *Cixius* sp., from a cave in Santa Cruz County, California. Over 50 species of obligate subterranean roothoppers are known. Photographed in January 2015.

*d*ark habitats impose unique challenges on their inhabitants. Animals specialized for life in caves are called troglobionts if they live on the land, stygobionts if they live in cave waters or groundwater. Obvious challenges include finding food and mates in the darkness of hypogean (belowground) systems. Subterranean animals meet these challenges in several ways. First, troglobionts and stygobionts typically have slower metabolic rates than their surface-dwelling relatives, which means that they require less food, less often. This is a good thing, because food is generally scarcer in subterranean habitats, portions may be small, and both predators and prey may have to go a long time between meals (Culver, 1982; Culver et al., 1995; Graening et al., 2012). Nutrient-poor habitats are referred to as oligotrophic. There are exceptions to this generalization, but it holds true for the life forms of many caves. Second, subterranean fauna often improve their chances of finding a meal or a mate by utilizing enhanced senses other than vision; for example, the ability to detect slight movements in the water or to detect and follow the slightest chemical trails.

Troglobionts and stygobionts face limited supplies of energy or nutrients in their dark habitats. No light means no plants and no photosynthesis. Energy usually comes from external sources; that is, with several exceptions, the energy that reaches these underground habitats originates outside, in the surface world. Scientists call this externally

Cave crayfishes are good examples of the body modifications associated with living belowground. The Oklahoma Cave Crayfish, *Cambarus tartarus*, has lost its visual structures and much of its pigment, has legs that are elongated and thin, and has claws that are longer, spindly, and weak, compared with surface crayfishes.

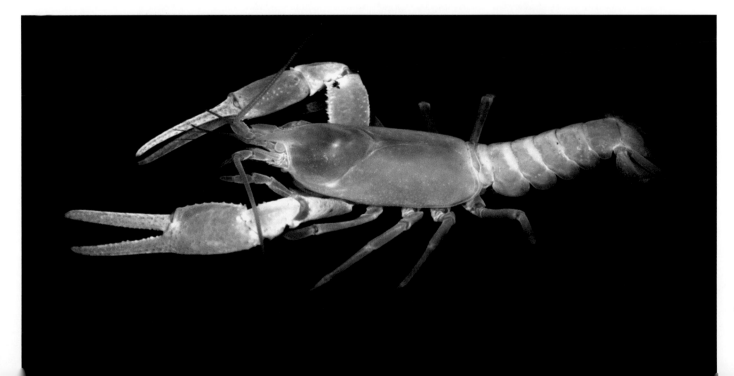

Subterranean habitats come in a variety of forms, and most, but not all, develop in karst landscapes. Karst landscapes are regions characterized by dissolution of rock by rainwater; the rock is of a type that can be dissolved by weakly acidic rainwater. Rainwater picks up its weak acids from carbon dioxide in the air and from the soil. As the rainwater passes through the rock units, pathways are dissolved and, through time, become larger and larger. Some become large enough for humans to pass through—what we call "caves"—though many are too small for humans to enter. The roof of a cave can collapse and form an opening to the surface, or water can simply erode an opening from the surface and into a subterranean space through its ceiling; these openings are known as sinkholes or sinks. They come in all varieties of sizes from very small to massive pits that are dozens or even hundreds of feet across. Epikarst is the soil and rock matrix above a subterranean passageway. The spaces in this matrix are passageways through which rainwater flows; epikarst networks are small—too small for humans to pass through but large enough for small animals to inhabit. In fact, some species spend their entire lives in, and are specialists of, the epikarst. Water that passes through the epikarst makes its way to subterranean passageways, flowing into subterranean pools, streams, and rivers—this is what the term "groundwater" refers to: water under the surface of the earth. As water drips through the roof of caves, it can pool below into "drip pools." Drip pools are good places for biologists to look for epikarst fauna—individual animals that accidently fell from their epikarst habitat above and wound up trapped in these pools. Water can also be captured from surface streams and delivered to subterranean waterways through a process known as stream capture or stream piracy. The circumstances where this phenomenon exists include water dissolution that has opened a hole large enough in the bed of a surface stream to capture the stream and deliver it to subterranean systems. Subterranean waterways can meander and have virtually no current, or they can rush through caves, creating rapids and waterfalls. Both the water that makes its way into a subsurface matrix of soluble bedrock, sand, and/or gravel, as well as the actual soluble bedrock, constitute an aquifer; these kinds of rock are known as water-bearing rock. Water can remain in an aquifer for short to very long periods of time. The outflow of a cave stream or an aquifer is known as a spring, which feeds a surface stream. Springs are places where biologists can sometimes find stygobionts. There are also species that are specialized for life in springheads. Illustration by Dr. G.O. Graening.

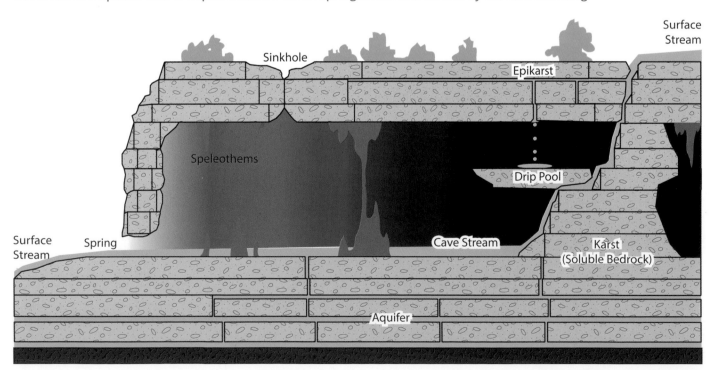

originating energy "allochthonous" energy. In caves, allochthonous energy sources include bat guano and cricket droppings, or frass (bats and cave crickets deposit their feces inside caves but feed outside caves), organic materials that wash down through surface openings, and animals that fall or wander into caves and die. This means that the food webs of many subterranean systems start with the decomposition of organic material in one form or another. Decomposing organics don't produce nearly as much energy as the photosynthesis of surface systems, so subterranean ecosystems tend to have fewer species and fewer individuals of each species than surface ecosystems.

Simply put, subsurface ecosystems simply do not have the energy to accommodate as many species and individuals as surface systems. Relative to surface habitats, there are fewer life forms at the base of

In an energy-limited environment, cave fauna tend to be concentrated around resources. Raccoon scat is an important resource for cave invertebrates in North America. This scat is being decomposed by several species of fungus and beetle larvae. A millipede has been attracted to the resource, probably to graze on fungus, and a fly has landed, possibly to lay eggs. Bat guano similarly attracts a host of species; animals living primarily on guano piles are known as guanobites.

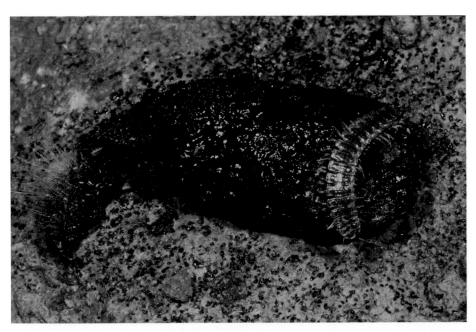

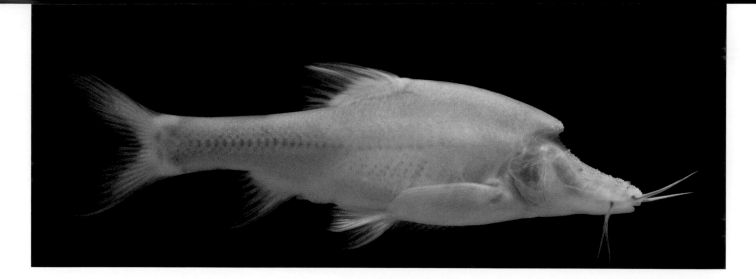

The Double-Horned Golden-Lined Barbel, *Sinocyclocheilus bicornutus*, is usually a top predator in the subterranean streams where it is found, in Xingren County, Guizhou, China. Populations of this fish tend to be smaller than those of related surface fishes because not as many prey species are available, and those that are available are present in smaller numbers than related prey species aboveground. The conical spines on the face indicate that this is a mature adult in breeding condition.

the food pyramid. There are even fewer individual predators hunting them.

Given this situation, it makes sense that subterranean predators have a well-developed ability to capture prey when opportunities arise. For example, many cave salamanders have more teeth than their surface relatives and have a broadened, flattened head that allows a larger mouth opening (Brandon, 1971); both are characters that may translate to an improved ability to capture prey. Another factor that demonstrates just how limited food can be in underground systems is subterranean predators' willingness to accept nonstandard food items. In my own research, my colleagues and I discovered that larval salamanders in Ozark cave waterways weren't just eating the few small bugs that they encountered. They also ate fresh bat guano—a nonliving but, as it turns out, nutritious food.

Larval Grotto Salamanders, *Eurycea spelaea*, are known to eat fresh bat guano. Because these ecosystems don't offer the volume of food items that a surface ecosystem offers, most predators in subterranean systems will eat whatever they can get.

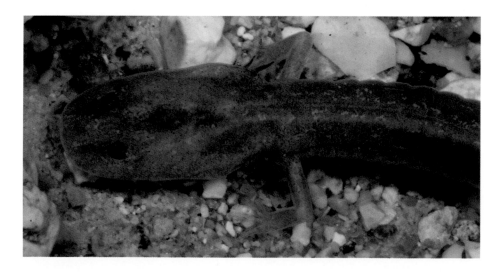

To maintain the physics of flight, a short digestive tract has evolved in some bats that is inefficient at digesting insects. The physics of flight mandates that if the bats eat too much and their weight goes up, they won't be able to fly. These bats use a shotgun approach to dietary intake: eat as much as you can, extract whatever nutrients you can get from it in a short period, and excrete whatever materials might take longer to digest. This translates to guano with considerable amounts of undigested nutrients still present; guano provides an important seasonal resource for the larval salamanders (for more information on this topic, see Fenolio et al., 2006).

Cave Biology as a Frontier Science

Another aspect of subterranean biology that makes it so exciting is the constant discovery of new caves. Humans have been wandering the landscape for a long time, but they have missed most cave systems because most subterranean systems do not have surface openings. For example, in the Ozark Plateaus Ecoregion, which overlaps parts of Missouri, Arkansas, Kansas, and Oklahoma (USA), it has been estimated that a paltry 10 percent of subterranean systems have surface openings (Curl, 1958). Geologic shifts and hydrologic erosion can alter the landscape and open a previously hidden system to explorers. And then there are regions with so many accessible caves that biologists haven't yet had time to examine them all.

South China's vast karst region is one of the largest contiguous limestone units in the world, at roughly 240,000 square miles (620,000 square kilometers) (Huang et al., 2008), and has countless numbers of caves. (Karst is a landscape with any type of rock that can be dissolved by acidic rainwater and results in caves, sinkholes, springs, towers, and pits in the landscape.) The subterranean waters of the world unquestionably hold hundreds of undescribed species. I can remember driving endless miles through Guangxi Province (China) with acclaimed cavefish biologist Dr. Yahui Zhao. We passed cave after cave with water

streaming from its mouth. I would ask whether anyone had checked the cave yet for cavefishes. Almost without exception, the answer was "not yet."

The Discovery of Subterranean Organisms in North America

Europeans first began reporting pink, eyeless, eel-like creatures that had been flushed from caves, often after heavy rains, in the 1600s. So alien were these life forms that they were immediately labeled "larval dragons" (Aljančič et al., 1993; Lajovic, 1993; Hodalic, 1997). Some call these animals—Europe's only groundwater salamander—the "human fish." Ultimately, the amphibian was described as *Proteus anguinus*, the Olm. The Olm is a salamander, and an odd one at that.

Over two hundred years later, subterranean creatures were being discovered in Texas, USA, at a feverish pace. The aquifer system below the Edwards Plateau has produced some spectacular wildlife, including subterranean catfishes known as Texas Blindcats (Hubbs and Bailey, 1947). In the late 1920s and early 1930s, artesian wells roughly 1,000 to 1,300 feet (330 to 430 meters) deep were being used to irrigate fields near San Antonio, Texas. After one of these wells had been used to water a field, the farmer found 20 or so blind and pigmentless catfishes sluggishly flopping around in the irrigation ditches. A scientist who interviewed the farmer learned that more blind catfishes had been expelled from other wells. One of the specimens he collected turned out to be a new species of blind groundwater catfish. Unlike the one species previously known from the aquifer, *Trogloglanis pattersoni*, this new species had teeth. It was named *Satan eurystomus*, which translates to "wide-mouthed prince of darkness." Who said biologists don't have a sense of humor?

The relationship between the two species of blind catfish living in this deep aquifer is not clear, but one hypothesis suggests the toothless species is a specialist, perhaps feeding on biofilm (microbial mats). In

turn, the toothed catfish probably includes the toothless catfish in its diet (Sneegas and Hendrickson, 2009).

Serendipitous discoveries such as this have produced specimens from habitats completely inaccessible to humans and blanketed in absolute darkness.

The discovery and study of groundwater fauna in Texas and elsewhere in North America goes even further back than the 1920s. In 1896, a salamander was described among specimens that had been expelled from a well 188 feet (57 meters) deep in the Edwards Aquifer. The blind, silvery salamanders had a shovel-shaped head and were among the strangest salamanders known to science. These specimens were named the Texas Blind Salamander, *Eurycea* (*Typhlomolge*) *rathbuni*. (Note that the name in parentheses indicates the older name of the genus.)

Adaptation in subterranean vertebrates was a hot scientific topic in the late 1800s and early 1900s. North America's first-discovered troglobitic salamander, the Grotto Salamander, *Eurycea* (*Typhlotriton*) *spelaea* (Stejneger, 1892), had recently been described. The Ozark Cavefish, *Troglichthys* (*Amblyopsis*) *rosae* (Eigenmann, 1898), an amazingly modified, eyeless fish, was described in 1898 from specimens found in the Ozarks. Stygobitic vertebrates were also being discovered across North America at an impressive rate.

The Blanco Blind Salamander, *Eurycea robusta*, of Texas was discovered and then lost again (for more information on these discoveries, see Longley, 1977; Potter and Sweet, 1981). In 1951, a drought had dried up the Blanco River in central Texas. A local gravel-washing crew in the San Marcos area sought water for their work and began to excavate a fissure in the dried bed of the Blanco River from which a small spring flowed. The excavation efforts struck water 20 feet (6 meters) below the surface. The crew found several white salamanders in the exposed groundwater and were thoughtful enough to set aside four specimens in a bucket. To the great dismay of scientists who later learned of the

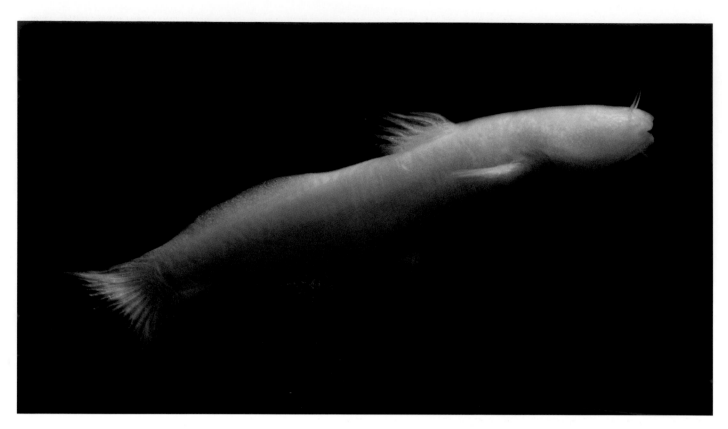

Blind catfishes, also known as "blindcats," are found in aquifers in Texas and Mexico, as well as in other parts of the world such as China and Brazil. These creatures are highly evolved for subterranean life. The Mexican Blindcat, *Prietella phreatophila*, is shown here. Further Reading: Eigenmann, 1919; Hubbs and Bailey, 1947; Langecker and Longley, 1993; Hendrickson et al., 2001.

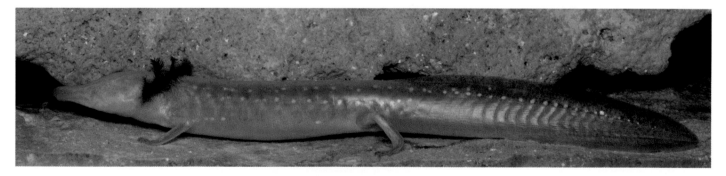

With its shovel-shaped head, odd coloration, and lack of eyes, the Texas Blind Salamander, *Eurycea rathbuni*, was quite a novelty when it was first described in 1896.

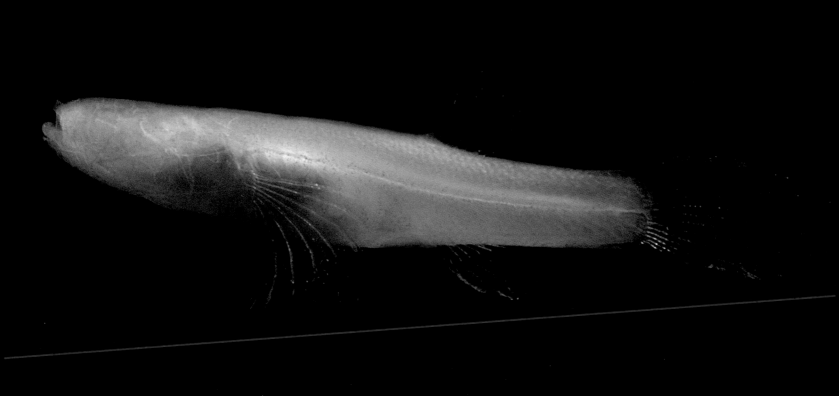

The Ozark Cavefish, *Troglichthys* (*Amblyopsis*) *rosae* (*top*), and the Grotto Salamander, *Eurycea spelaea* (*bottom*), were both described in the late 1800s, a period of active cave biology research in North America. Researchers continue to find and describe new species from caves, including blind cavefishes. Further Reading: Willis and Brown, 1985; Fenolio and Trauth, 2005; Fenolio et al., 2006; Fenolio and Bonett, 2009; Graening et al., 2010.

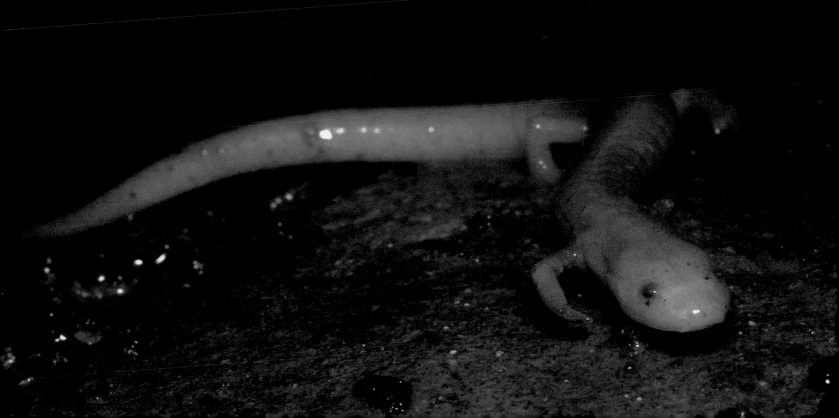

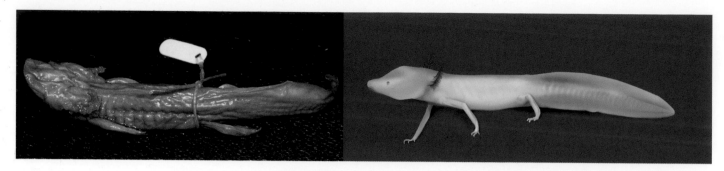

The Blanco Blind Salamander, *Eurycea robusta*, is one of North America's most enigmatic species. The single specimen (*left*) is all that remains as proof of the species. Perhaps one day we will get to see what an adult looks like. The drawing (*right*) is artist Mark Mandica's rendition of what *E. robusta* might look like in life.

find, a heron consumed two of the four individuals right out of the bucket! When the rains finally returned to central Texas, the waters of the Blanco River filled in the excavation site where the salamanders had been collected, and its exact location has been a contentious issue ever since.

The two salamanders that survived the heron were ultimately given to C. S. Smith of Southwest Texas State College. One of the two specimens subsequently disappeared. The remaining specimen was deposited in the Texas Memorial Museum, where F. E. Potter later examined it. Potter recognized that the stout, shovel-headed specimen was new to science. He described it in an unpublished thesis but never got around to a formal description in a scientific journal. Longley renamed the salamander *Typhlomolge* (*Eurycea*) *robusta*, the Blanco Blind Salamander (Potter and Sweet, 1981). This amphibian had no pigment, no eyes, and a shovel-shaped head, just like the Texas Blind Salamander. The difference was that this salamander was larger and had a robust build. The single specimen is all that remains to document the existence of what may well be one of the most bizarre-looking amphibians to haunt the subterranean waterways of the world. No other specimens have been collected.

CAVEFISHES

Banded Sculpins, *Cottus carolinae*, inhabit freshwater habitats, including caves, west of the Appalachians and into the Ozarks. This species can be an important predator of subterranean fauna in cave streams. It has no problem finding food in the dark and gets large enough to consume any species of stygobitic salamander, crayfish, amphipod, isopod, or cavefish species known in North America.

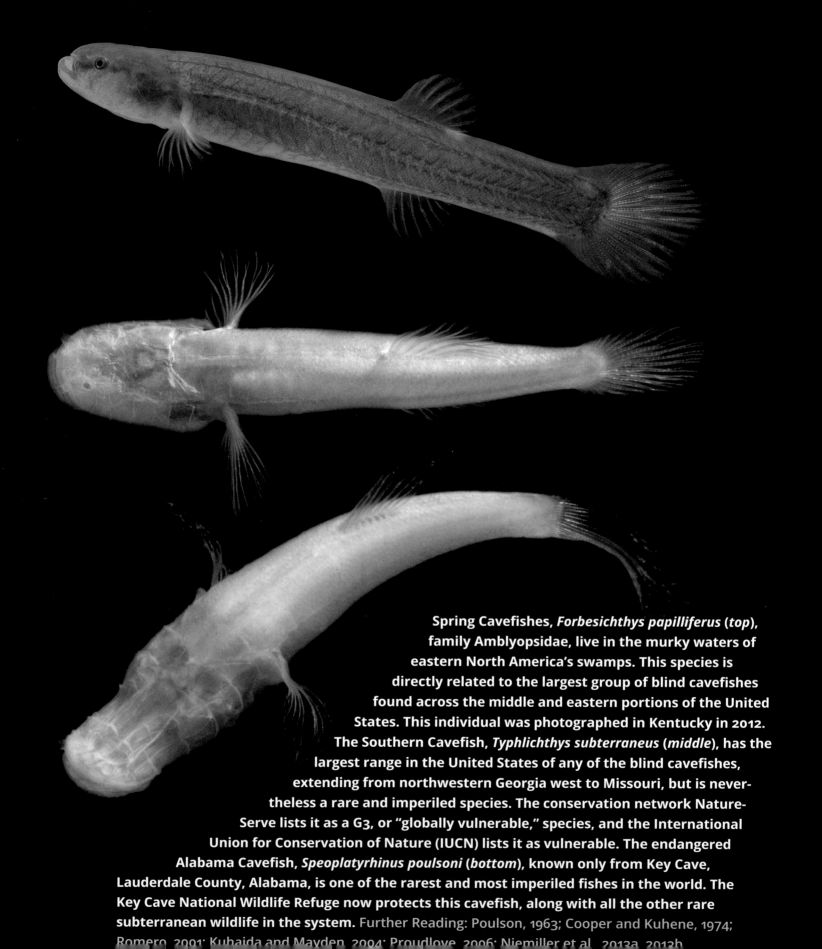

Spring Cavefishes, *Forbesichthys papilliferus* (*top*), family Amblyopsidae, live in the murky waters of eastern North America's swamps. This species is directly related to the largest group of blind cavefishes found across the middle and eastern portions of the United States. This individual was photographed in Kentucky in 2012. The Southern Cavefish, *Typhlichthys subterraneus* (*middle*), has the largest range in the United States of any of the blind cavefishes, extending from northwestern Georgia west to Missouri, but is nevertheless a rare and imperiled species. The conservation network Nature-Serve lists it as a G3, or "globally vulnerable," species, and the International Union for Conservation of Nature (IUCN) lists it as vulnerable. The endangered Alabama Cavefish, *Speoplatyrhinus poulsoni* (*bottom*), known only from Key Cave, Lauderdale County, Alabama, is one of the rarest and most imperiled fishes in the world. The Key Cave National Wildlife Refuge now protects this cavefish, along with all the other rare subterranean wildlife in the system. Further Reading: Poulson, 1963; Cooper and Kuhene, 1974; Romero, 2001; Kuhaida and Mayden, 2004; Proudlove, 2006; Niemiller et al., 2013a, 2013b.

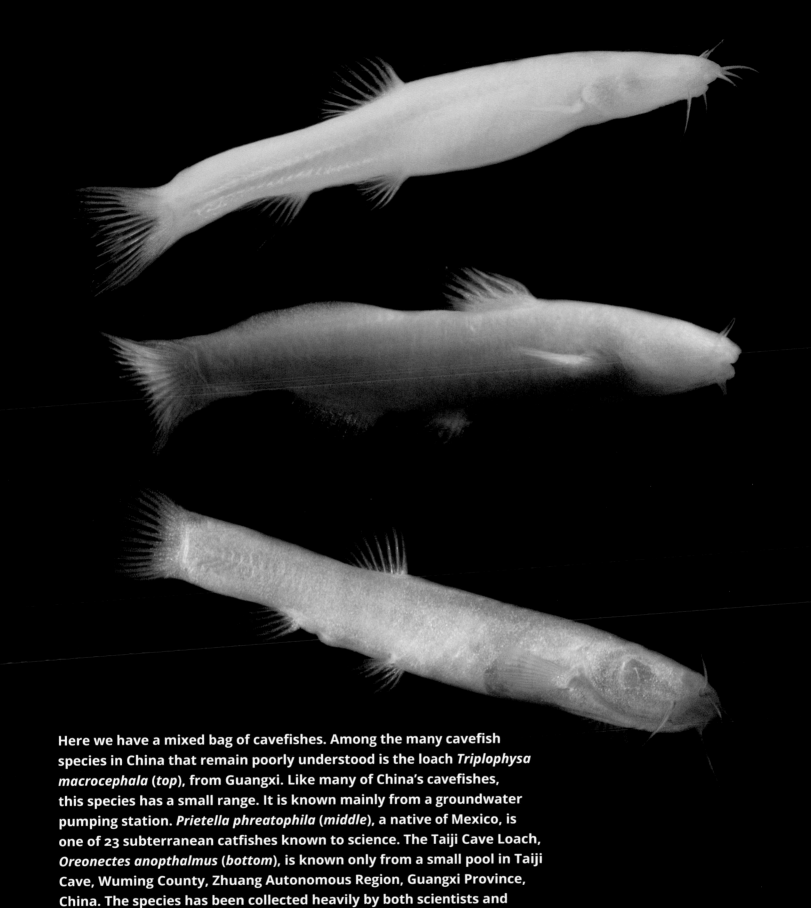

Here we have a mixed bag of cavefishes. Among the many cavefish species in China that remain poorly understood is the loach *Triplophysa macrocephala* (*top*), from Guangxi. Like many of China's cavefishes, this species has a small range. It is known mainly from a groundwater pumping station. *Prietella phreatophila* (*middle*), a native of Mexico, is one of 23 subterranean catfishes known to science. The Taiji Cave Loach, *Oreonectes anopthalmus* (*bottom*), is known only from a small pool in Taiji Cave, Wuming County, Zhuang Autonomous Region, Guangxi Province, China. The species has been collected heavily by both scientists and aquarium enthusiasts, and a population decline is evident. Further Reading: Romero et al., 2009.

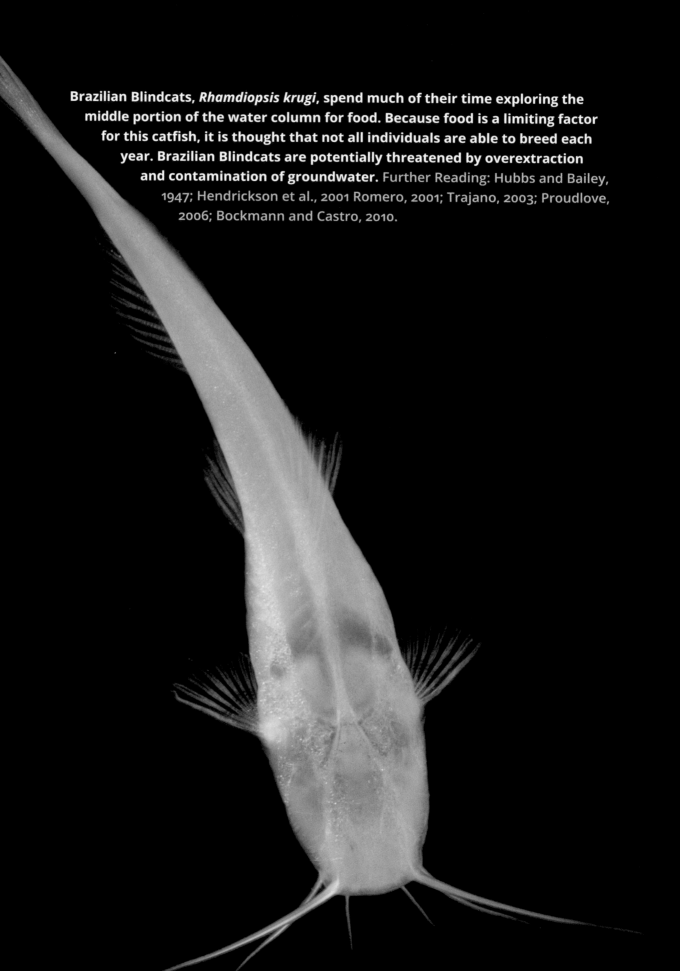

Brazilian Blindcats, *Rhamdiopsis krugi*, spend much of their time exploring the middle portion of the water column for food. Because food is a limiting factor for this catfish, it is thought that not all individuals are able to breed each year. Brazilian Blindcats are potentially threatened by overextraction and contamination of groundwater. Further Reading: Hubbs and Bailey, 1947; Hendrickson et al., 2001 Romero, 2001; Trajano, 2003; Proudlove, 2006; Bockmann and Castro, 2010.

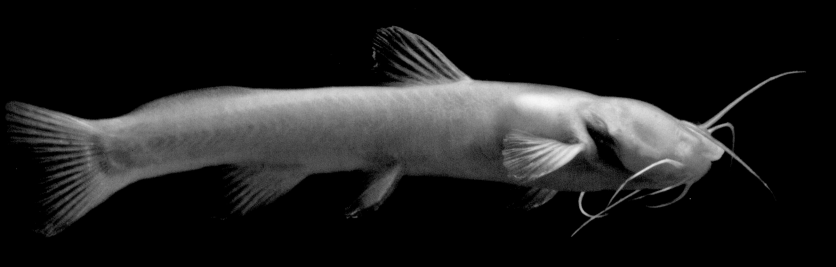

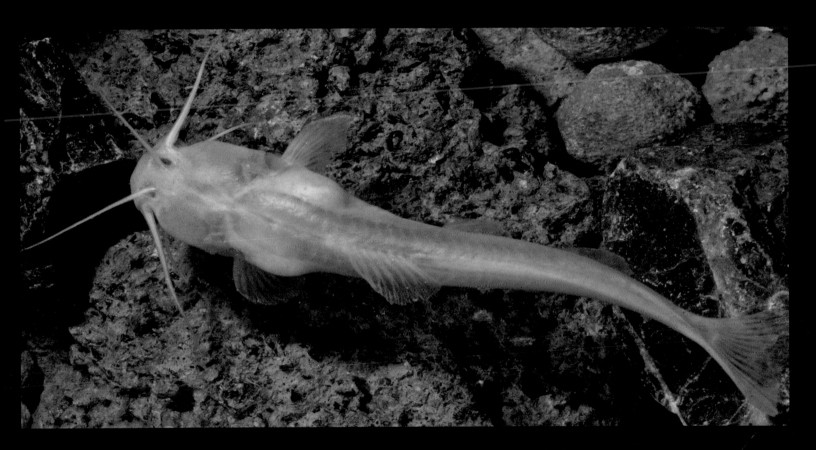

The Chinese Blindcat, *Xiurenbagrus dorsalis*, is an inhabitant of an aquifer in Guangxi, China. These are the first images of a live individual. Further Reading: Xiu et al., 2014.

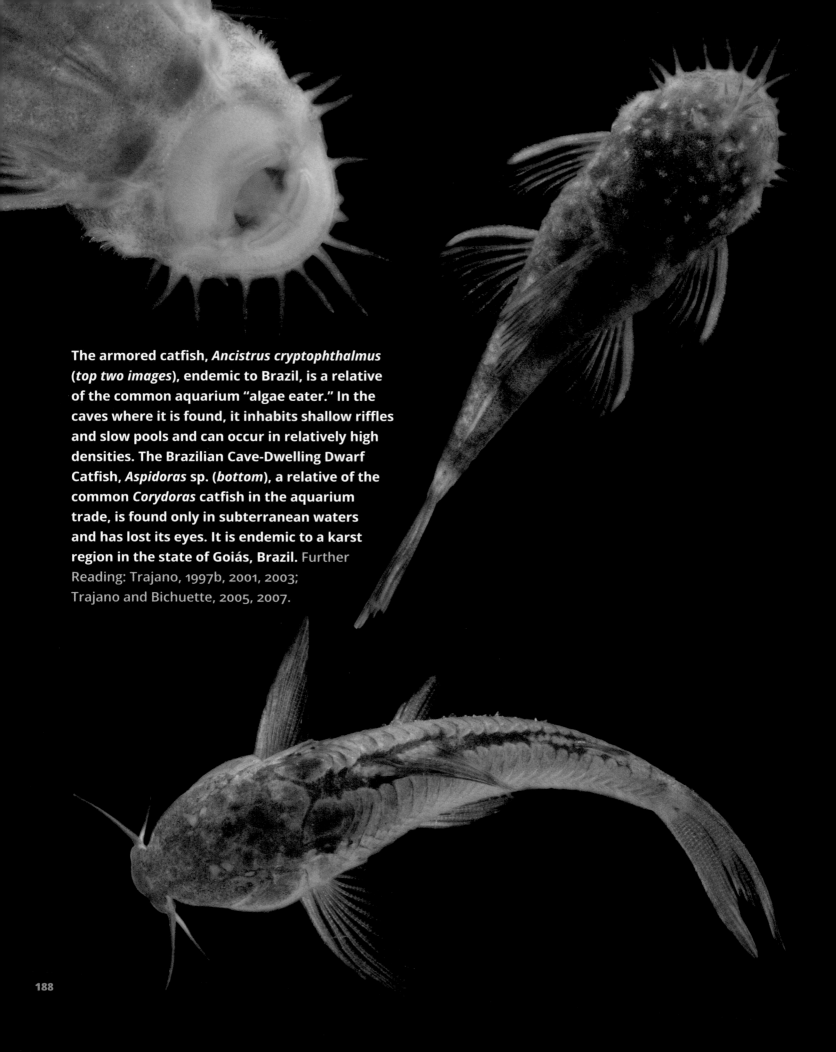

The armored catfish, *Ancistrus cryptophthalmus* (*top two images*), endemic to Brazil, is a relative of the common aquarium "algae eater." In the caves where it is found, it inhabits shallow riffles and slow pools and can occur in relatively high densities. The Brazilian Cave-Dwelling Dwarf Catfish, *Aspidoras* sp. (*bottom*), a relative of the common *Corydoras* catfish in the aquarium trade, is found only in subterranean waters and has lost its eyes. It is endemic to a karst region in the state of Goiás, Brazil. Further Reading: Trajano, 1997b, 2001, 2003; Trajano and Bichuette, 2005, 2007.

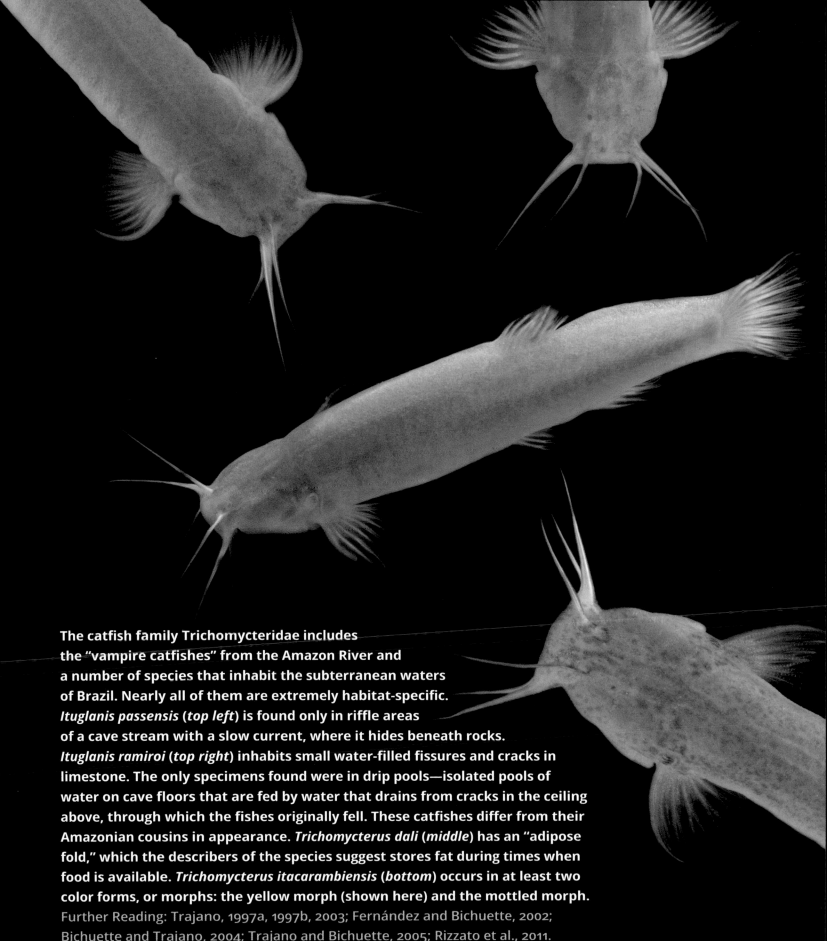

The catfish family Trichomycteridae includes
the "vampire catfishes" from the Amazon River and
a number of species that inhabit the subterranean waters
of Brazil. Nearly all of them are extremely habitat-specific.
Ituglanis passensis (*top left*) is found only in riffle areas
of a cave stream with a slow current, where it hides beneath rocks.
Ituglanis ramiroi (*top right*) inhabits small water-filled fissures and cracks in
limestone. The only specimens found were in drip pools—isolated pools of
water on cave floors that are fed by water that drains from cracks in the ceiling
above, through which the fishes originally fell. These catfishes differ from their
Amazonian cousins in appearance. *Trichomycterus dali* (*middle*) has an "adipose
fold," which the describers of the species suggest stores fat during times when
food is available. *Trichomycterus itacarambiensis* (*bottom*) occurs in at least two
color forms, or morphs: the yellow morph (shown here) and the mottled morph.

Further Reading: Trajano, 1997a, 1997b, 2003; Fernández and Bichuette, 2002;
Bichuette and Trajano, 2004; Trajano and Bichuette, 2005; Rizzato et al., 2011.

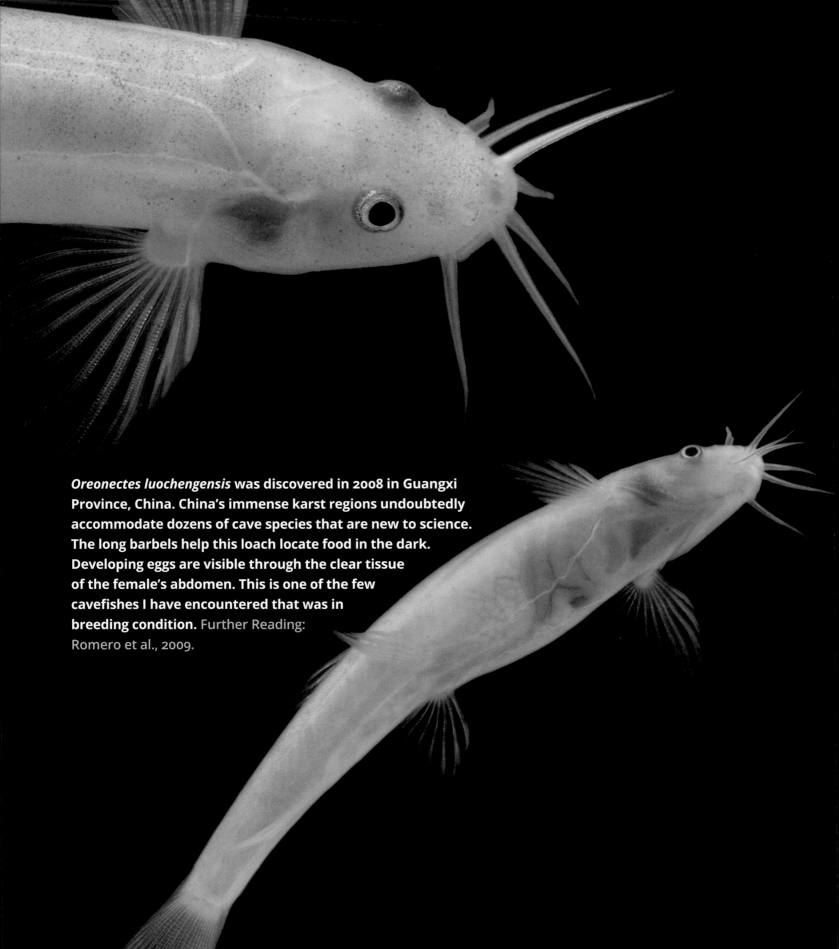

Oreonectes luochengensis was discovered in 2008 in Guangxi Province, China. China's immense karst regions undoubtedly accommodate dozens of cave species that are new to science. The long barbels help this loach locate food in the dark. Developing eggs are visible through the clear tissue of the female's abdomen. This is one of the few cavefishes I have encountered that was in breeding condition. Further Reading: Romero et al., 2009.

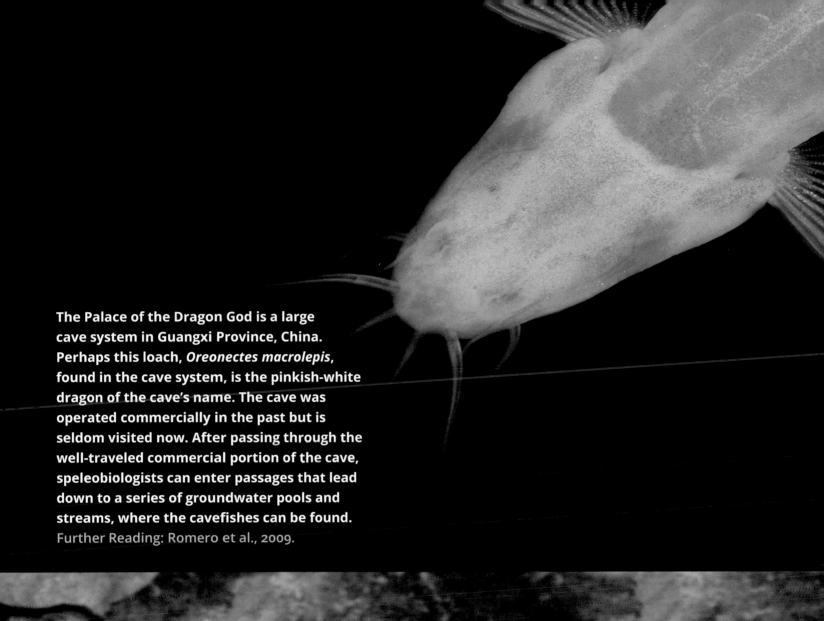

The Palace of the Dragon God is a large cave system in Guangxi Province, China. Perhaps this loach, *Oreonectes macrolepis*, found in the cave system, is the pinkish-white dragon of the cave's name. The cave was operated commercially in the past but is seldom visited now. After passing through the well-traveled commercial portion of the cave, speleobiologists can enter passages that lead down to a series of groundwater pools and streams, where the cavefishes can be found.

Further Reading: Romero et al., 2009.

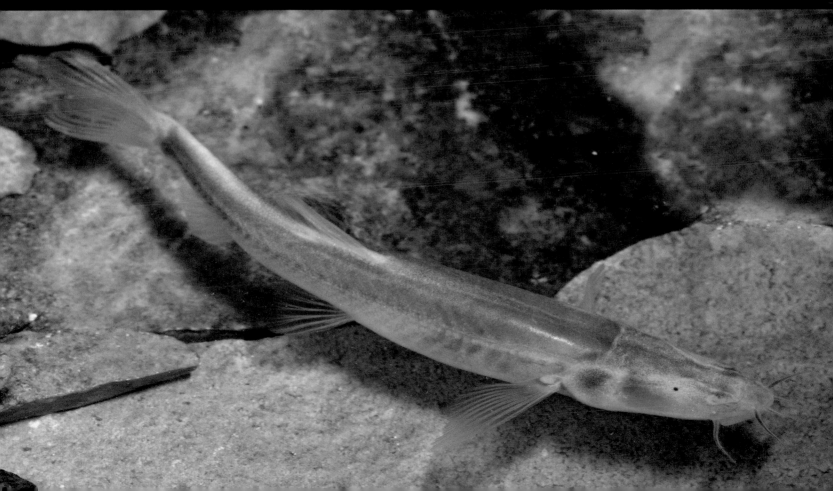

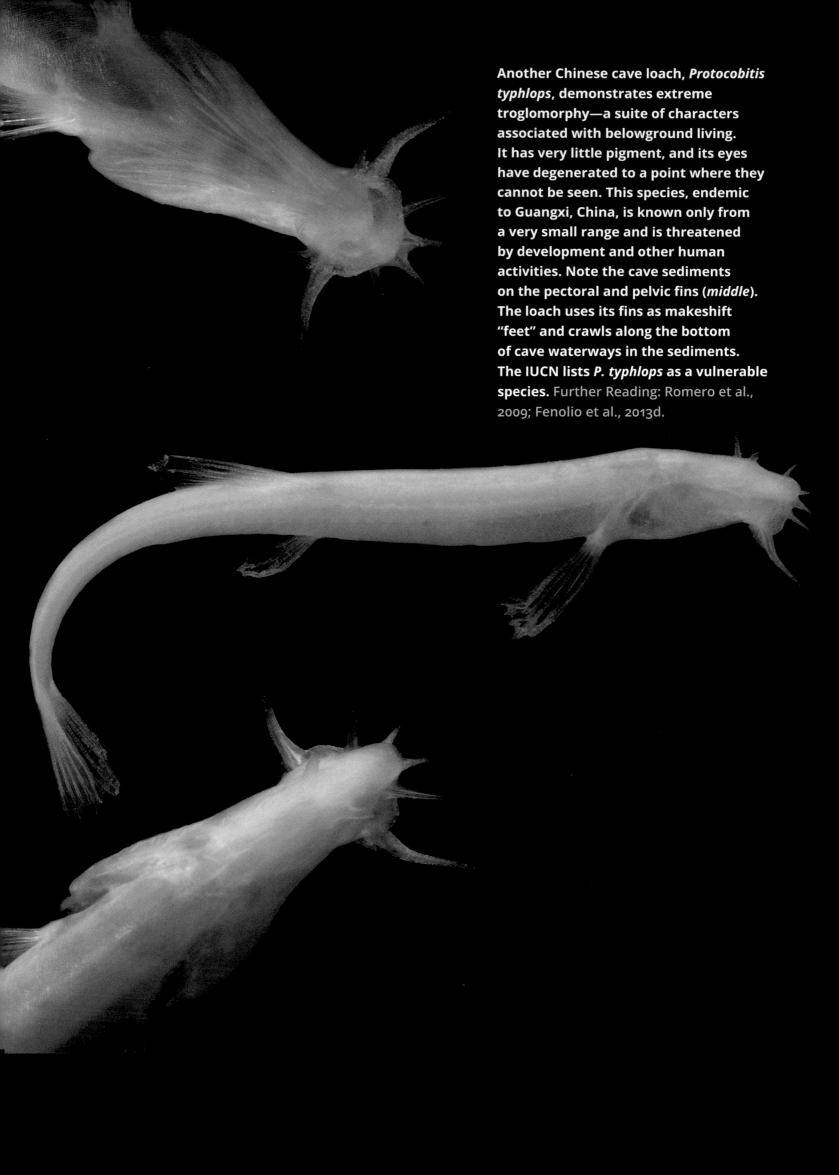

Another Chinese cave loach, *Protocobitis typhlops*, demonstrates extreme troglomorphy—a suite of characters associated with belowground living. It has very little pigment, and its eyes have degenerated to a point where they cannot be seen. This species, endemic to Guangxi, China, is known only from a very small range and is threatened by development and other human activities. Note the cave sediments on the pectoral and pelvic fins (*middle*). The loach uses its fins as makeshift "feet" and crawls along the bottom of cave waterways in the sediments. The IUCN lists *P. typhlops* as a vulnerable species. Further Reading: Romero et al., 2009; Fenolio et al., 2013d.

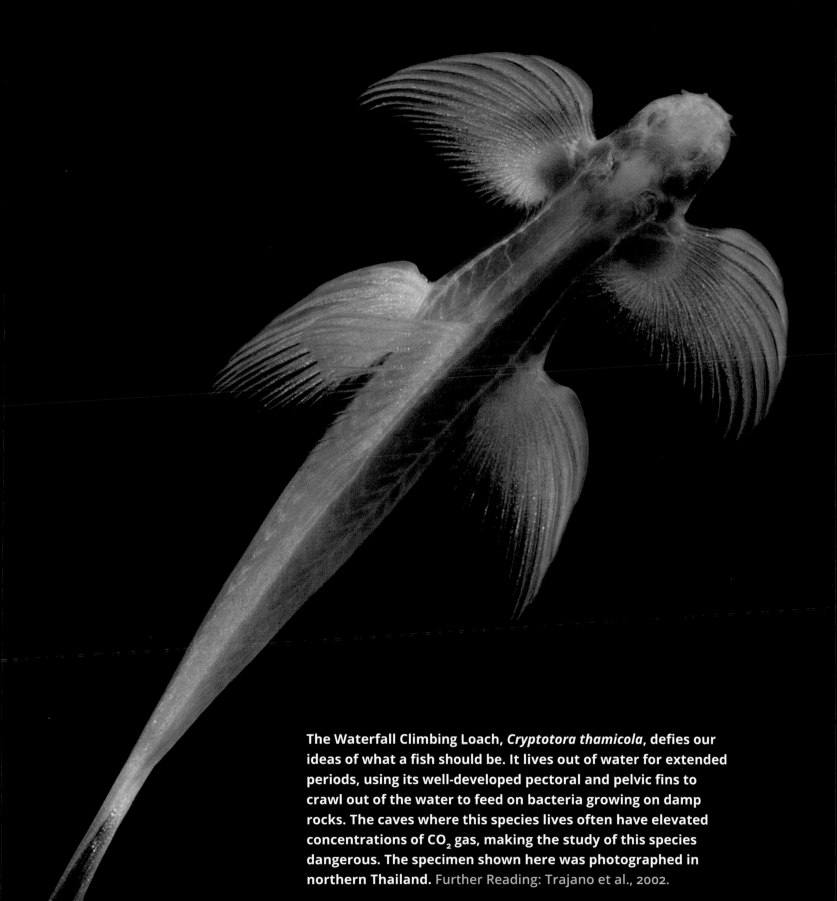

The Waterfall Climbing Loach, *Cryptotora thamicola*, defies our ideas of what a fish should be. It lives out of water for extended periods, using its well-developed pectoral and pelvic fins to crawl out of the water to feed on bacteria growing on damp rocks. The caves where this species lives often have elevated concentrations of CO_2 gas, making the study of this species dangerous. The specimen shown here was photographed in northern Thailand. Further Reading: Trajano et al., 2002.

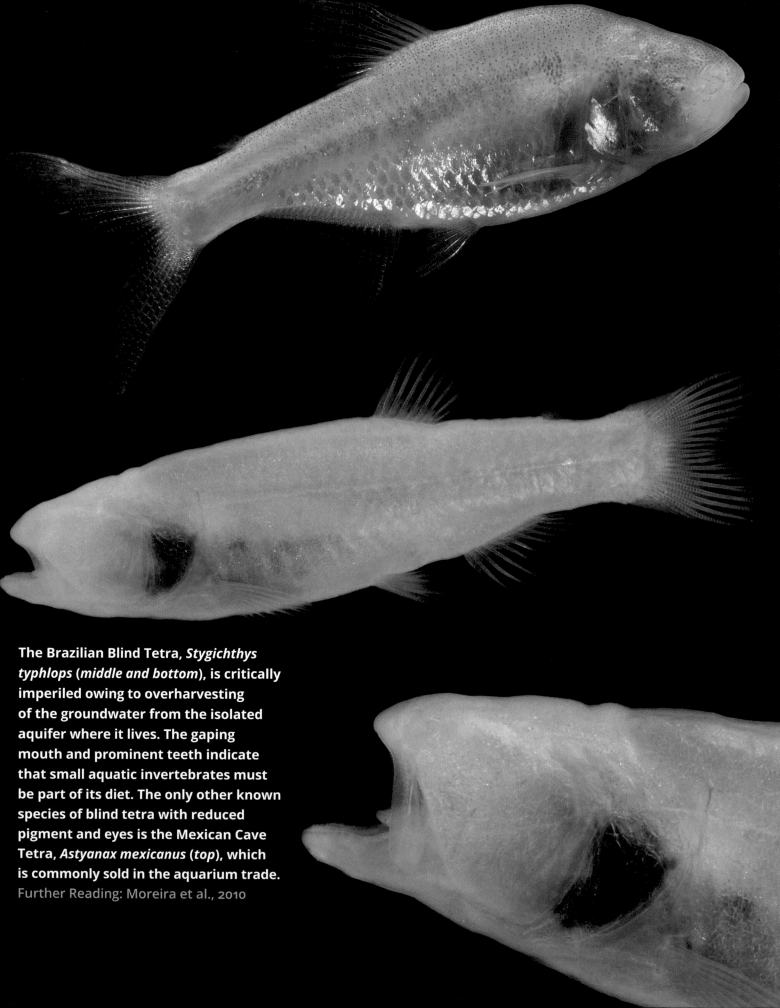

The Brazilian Blind Tetra, *Stygichthys typhlops* (*middle and bottom*), is critically imperiled owing to overharvesting of the groundwater from the isolated aquifer where it lives. The gaping mouth and prominent teeth indicate that small aquatic invertebrates must be part of its diet. The only other known species of blind tetra with reduced pigment and eyes is the Mexican Cave Tetra, *Astyanax mexicanus* (*top*), which is commonly sold in the aquarium trade.

Further Reading: Moreira et al., 2010

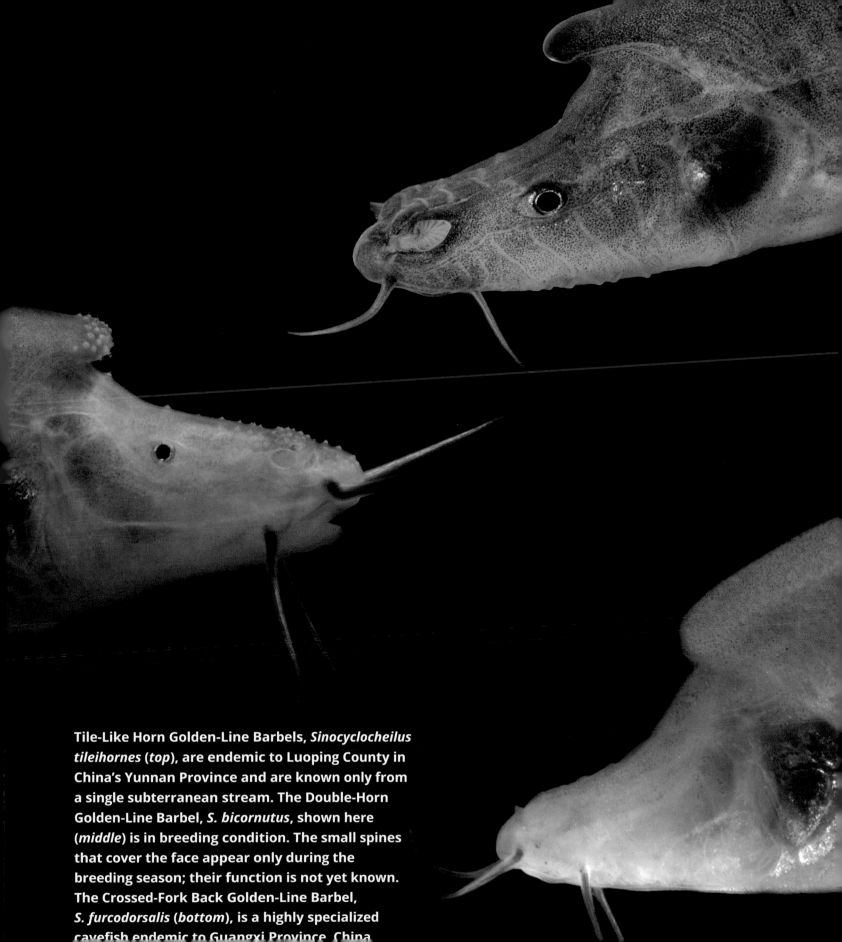

Tile-Like Horn Golden-Line Barbels, *Sinocyclocheilus tileihornes* (*top*), are endemic to Luoping County in China's Yunnan Province and are known only from a single subterranean stream. The Double-Horn Golden-Line Barbel, *S. bicornutus*, shown here (*middle*) is in breeding condition. The small spines that cover the face appear only during the breeding season; their function is not yet known. The Crossed-Fork Back Golden-Line Barbel, *S. furcodorsalis* (*bottom*), is a highly specialized cavefish endemic to Guangxi Province, China.

All species of the genus *Sinocyclocheilus* are endemic to China. Science has not yet explained why some members of this genus have "horns" protruding from their forehead. Many cave-dwelling species have a flattened, duckbill-shaped mouth. All members of the genus have barbels that hold taste buds and help the fishes find food in murky or dark waters. Further Reading: Romero et al., 2009; Zhao and Chunguang, 2009.

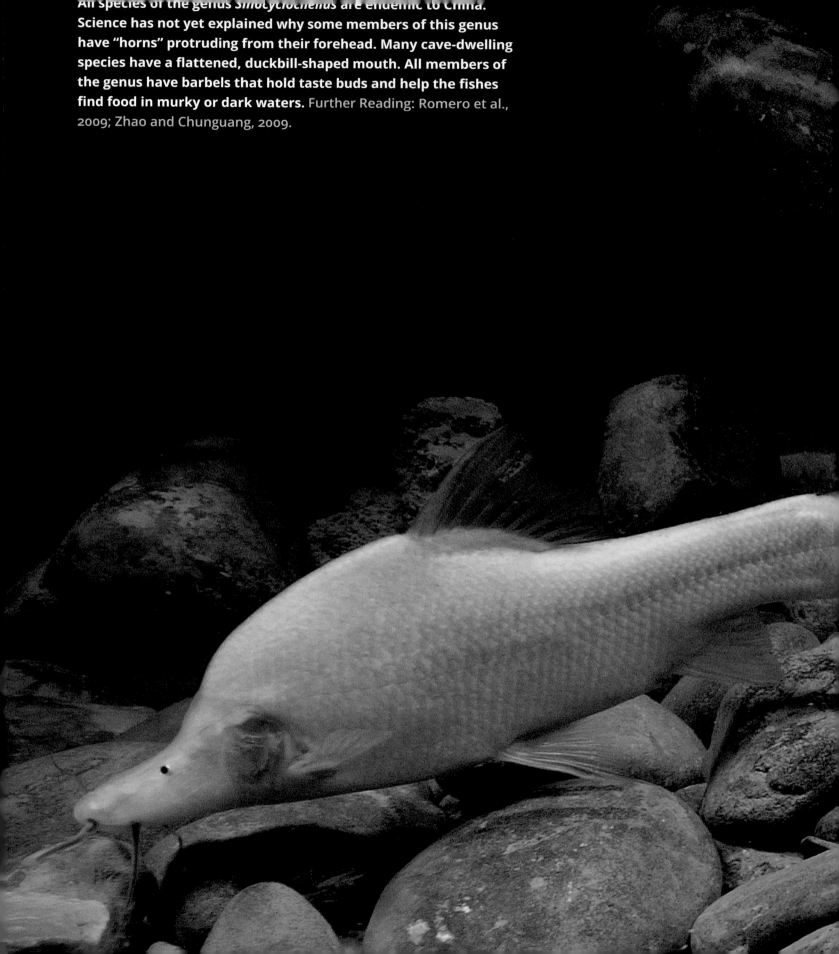

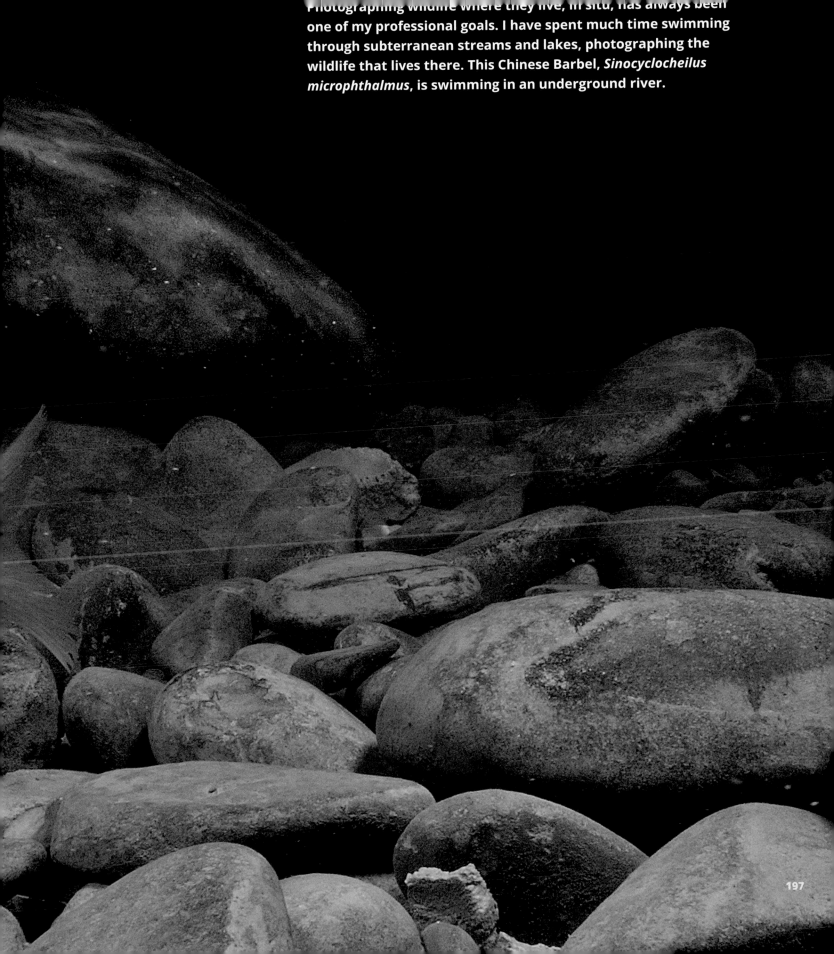

Photographing wildlife where they live, in situ, has always been one of my professional goals. I have spent much time swimming through subterranean streams and lakes, photographing the wildlife that lives there. This Chinese Barbel, *Sinocyclocheilus microphthalmus*, is swimming in an underground river.

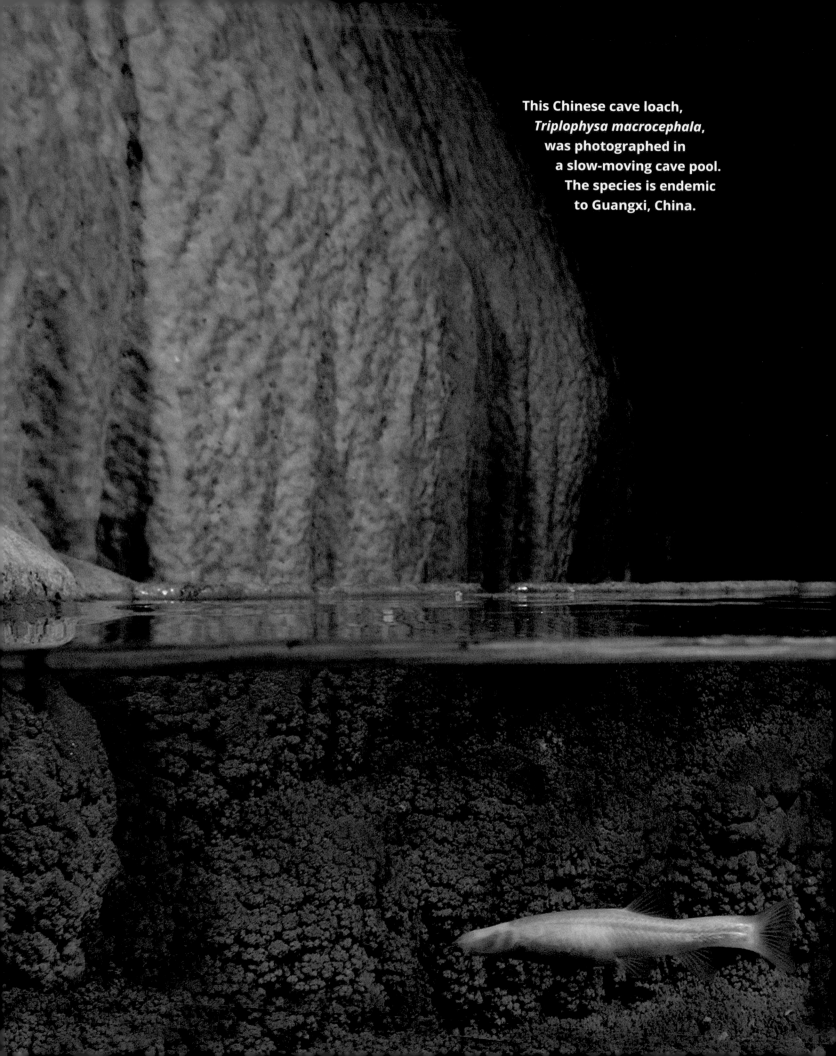

This Chinese cave loach,
Triplophysa macrocephala,
was photographed in
a slow-moving cave pool.
The species is endemic
to Guangxi, China.

OTHER VERTEBRATES

Asiatic Watersnakes, *Sinonatrix aequifasciata* (*this page*), are found throughout southern China, Laos, and Vietnam and have been encountered in caves of that region. This individual was photographed in a cave in Guangxi, China, in 2011.

Amphibians

The West Virginia Spring Salamander, *Gyrinophilus subterraneus*, is known only from General Davis Cave in West Virginia, USA, making it one of the rarest salamanders in the world. Larval individuals have external gills (next page, *top*), which they begin to lose just before metamorphosis (next page, *middle*). Biologists aren't sure why, but most individuals do not pass through metamorphosis, and adults (next page, *bottom*) are rarely found. Photographed in 2007. Further Reading: Niemiller et al., 2010; Niemiller and Graham, 2013.

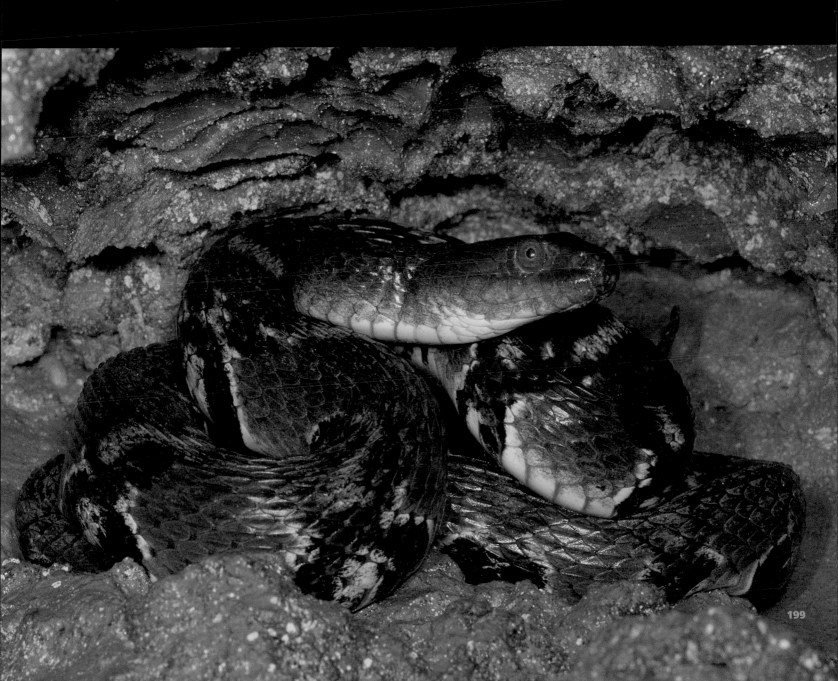

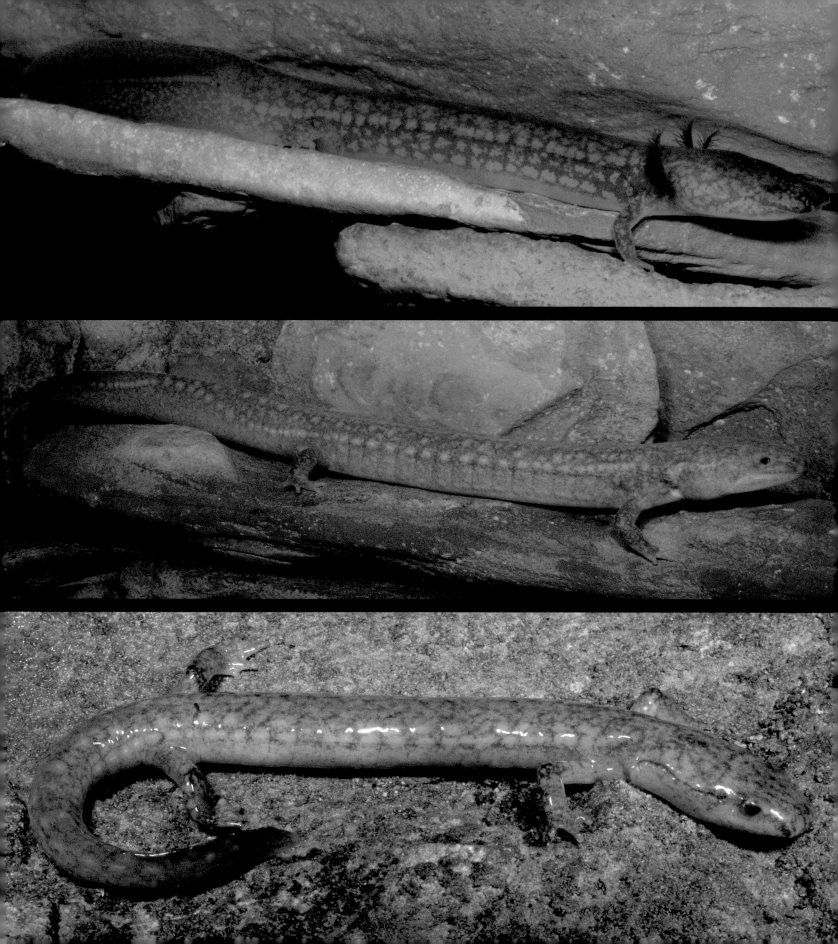

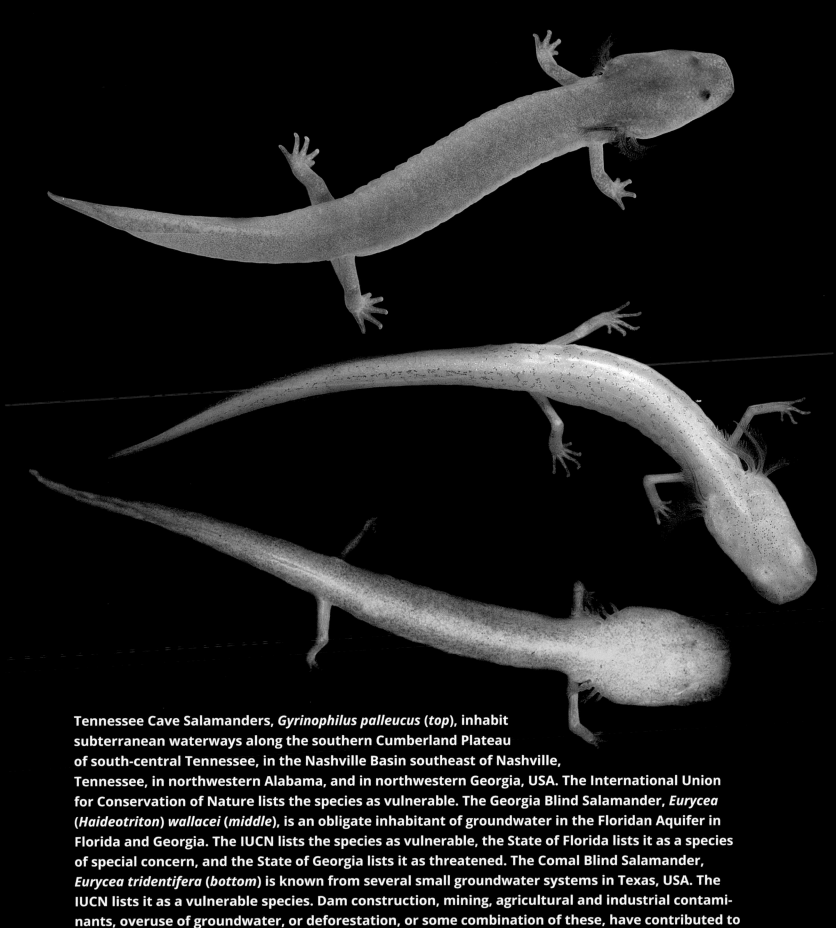

Tennessee Cave Salamanders, *Gyrinophilus palleucus* (*top*), inhabit
subterranean waterways along the southern Cumberland Plateau
of south-central Tennessee, in the Nashville Basin southeast of Nashville,
Tennessee, in northwestern Alabama, and in northwestern Georgia, USA. The International Union
for Conservation of Nature lists the species as vulnerable. The Georgia Blind Salamander, *Eurycea*
(*Haideotriton*) *wallacei* (*middle*), is an obligate inhabitant of groundwater in the Floridan Aquifer in
Florida and Georgia. The IUCN lists the species as vulnerable, the State of Florida lists it as a species
of special concern, and the State of Georgia lists it as threatened. The Comal Blind Salamander,
Eurycea tridentifera (*bottom*) is known from several small groundwater systems in Texas, USA. The
IUCN lists it as a vulnerable species. Dam construction, mining, agricultural and industrial contami-
nants, overuse of groundwater, or deforestation, or some combination of these, have contributed to
general population declines in all three species. Further Reading: Fenolio et al. 2012a, 2013a.

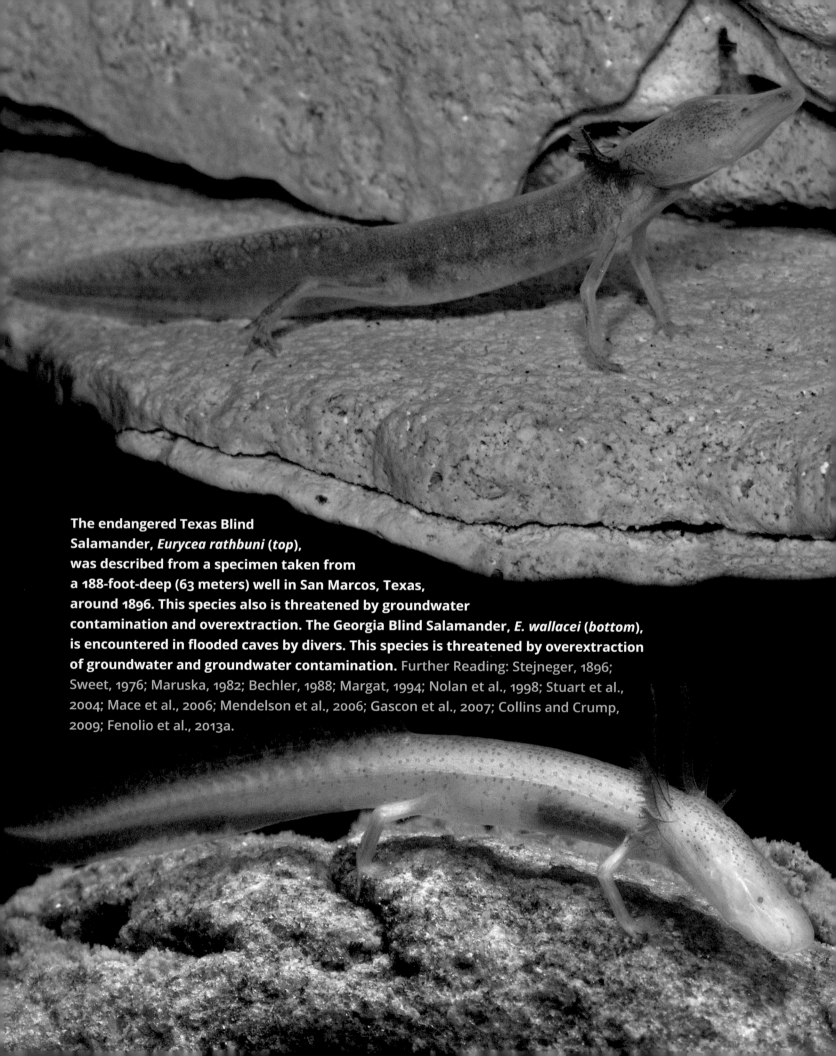

The endangered Texas Blind
Salamander, *Eurycea rathbuni* (*top*),
was described from a specimen taken from
a 188-foot-deep (63 meters) well in San Marcos, Texas,
around 1896. This species also is threatened by groundwater
contamination and overextraction. The Georgia Blind Salamander, *E. wallacei* (*bottom*),
is encountered in flooded caves by divers. This species is threatened by overextraction
of groundwater and groundwater contamination. Further Reading: Stejneger, 1896;
Sweet, 1976; Maruska, 1982; Bechler, 1988; Margat, 1994; Nolan et al., 1998; Stuart et al.,
2004; Mace et al., 2006; Mendelson et al., 2006; Gascon et al., 2007; Collins and Crump,
2009; Fenolio et al., 2013a.

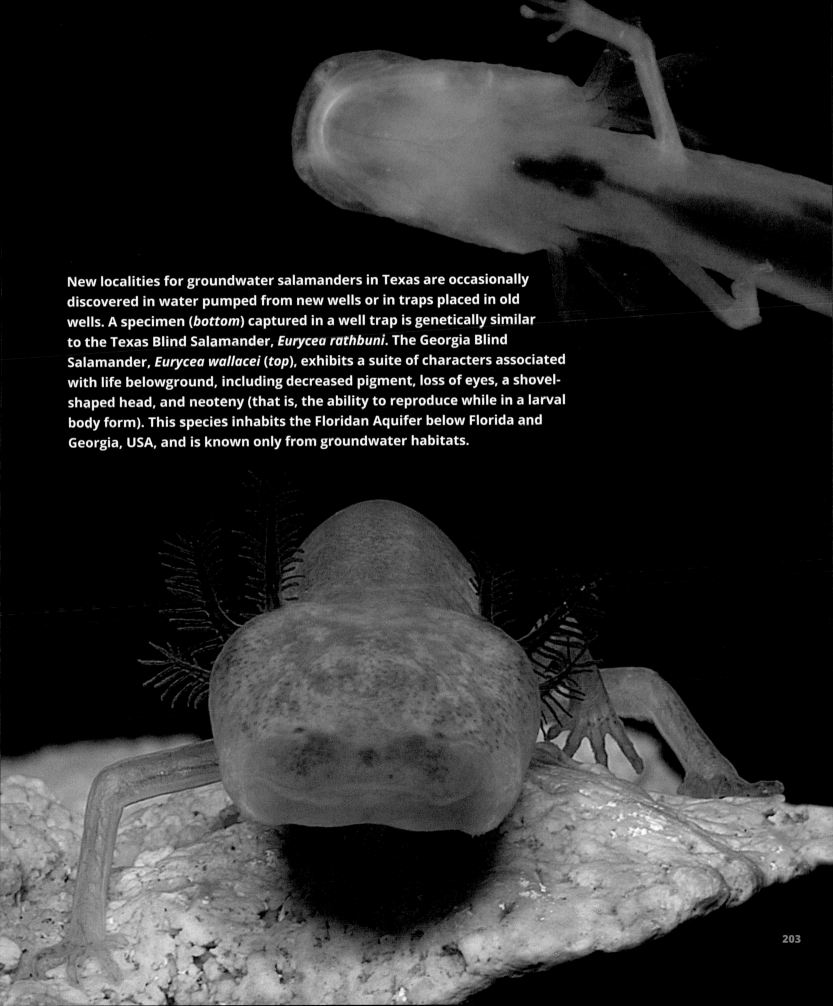

New localities for groundwater salamanders in Texas are occasionally discovered in water pumped from new wells or in traps placed in old wells. A specimen (*bottom*) captured in a well trap is genetically similar to the Texas Blind Salamander, *Eurycea rathbuni*. The Georgia Blind Salamander, *Eurycea wallacei* (*top*), exhibits a suite of characters associated with life belowground, including decreased pigment, loss of eyes, a shovel-shaped head, and neoteny (that is, the ability to reproduce while in a larval body form). This species inhabits the Floridan Aquifer below Florida and Georgia, USA, and is known only from groundwater habitats.

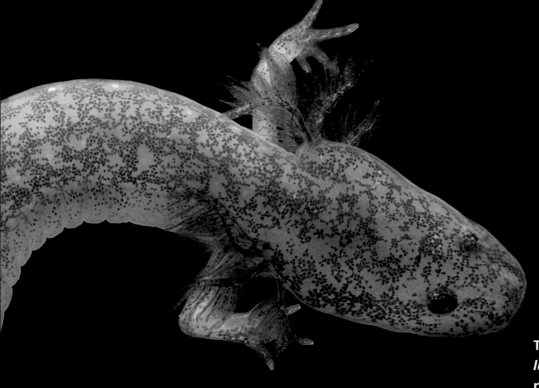

This Cascade Caverns Salamander, *Eurycea latitans* (*top*), is from the type locality—that is, the locality where the species was first found and named—in Cascade Caverns, Texas. This species has variability in appearance both between and within populations. Members of the population at the type locality have functional eyes and some pigmentation remaining. Members of some other cave-dwelling populations have reduced, nonfunctional eyes and little or no pigment. Red Salamanders, *Pseudotriton ruber* (*bottom*), are sometimes found in caves, and certain populations are known to deposit their eggs in caves. Further Reading: Miller et al., 2008.

The Cave Salamander, *Eurycea lucifuga*, (*facing page*) has a large range across the midwestern and eastern United States. This aberrantly patterned individual was photographed in the Ozark Mountains of Missouri in 2004. The species sometimes hybridizes with the Dark-Sided Salamander, *E. longicauda melanopleura*. Further Reading: Hutchison, 1956, 1958; Graening et al., 2012.

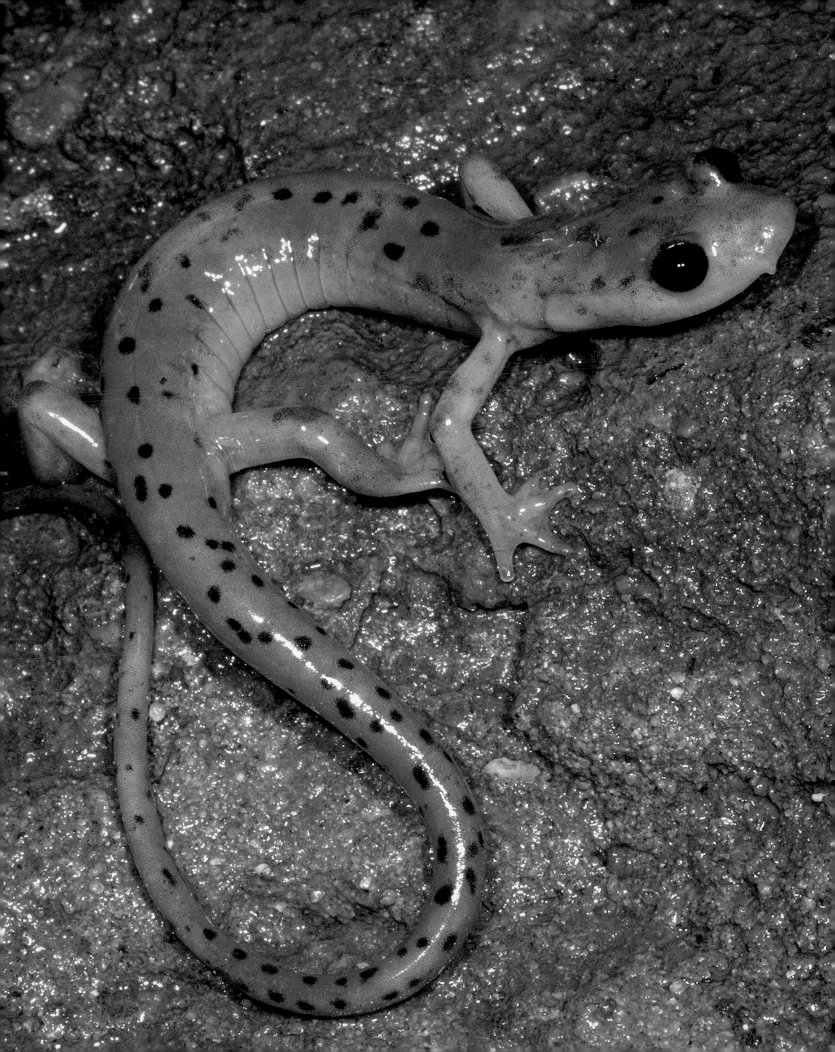

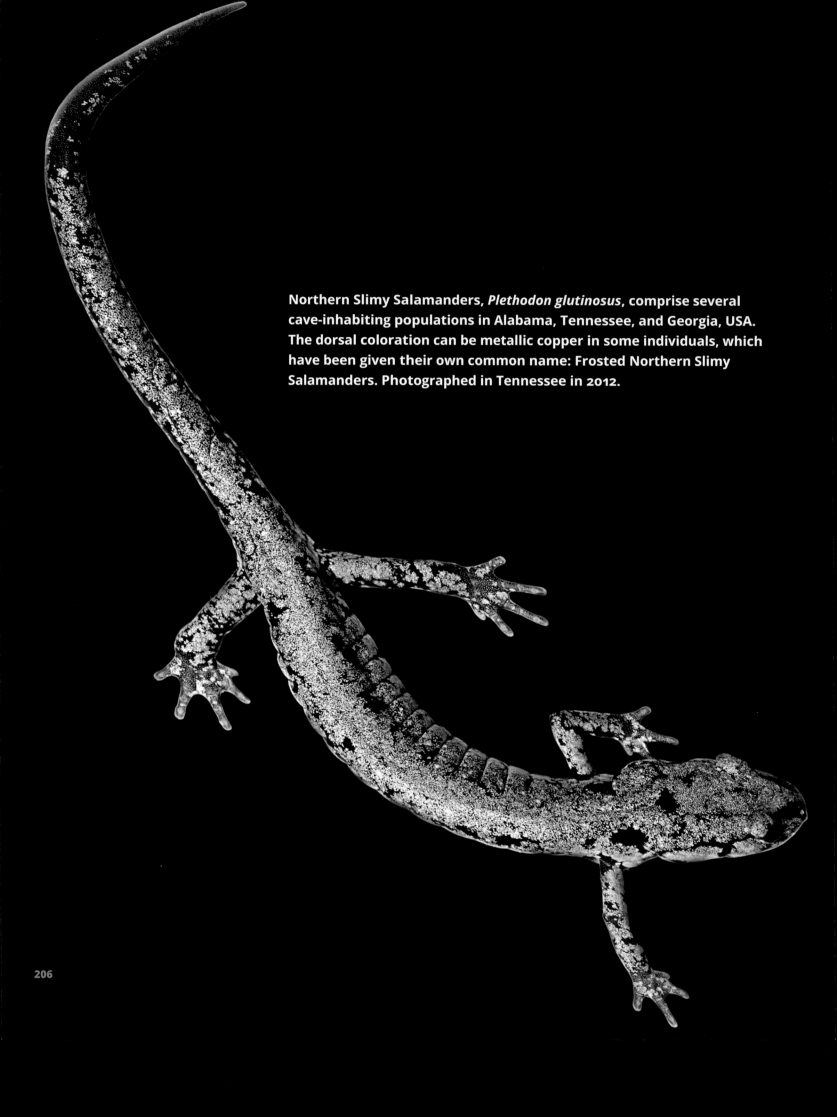

Northern Slimy Salamanders, *Plethodon glutinosus*, comprise several cave-inhabiting populations in Alabama, Tennessee, and Georgia, USA. The dorsal coloration can be metallic copper in some individuals, which have been given their own common name: Frosted Northern Slimy Salamanders. Photographed in Tennessee in 2012.

Western Slimy Salamanders, *Plethodon albagula*, are commonly encountered in caves of the Ozark Mountains, USA. In the fall, females can be observed guarding egg masses. The mother typically remains with the hatchlings for a week or more. Photographed in 2013 (*top*) and 2004 (*bottom*) in the Ozarks of Oklahoma. Further Reading: Trauth et al., 2004; Milanovich et al., 2007.

Long-tailed Salamanders, *Eurycea longicauda* (*top*), inhabit limestone areas and forests across the eastern portion of the United States and west into the Ozarks. They can be common in the twilight zones of caves (near the entrance and where there is still some light), with fewer numbers observed deeper into the cave systems. Populations vary considerably in color and pattern; some sport bright orange dorsal coloration, some are yellow, and others are muddy yellow to brown. This individual was photographed in West Virginia in 2006. The Pigeon Mountain Salamander, *Plethodon petraeus* (*bottom*), is limited to the Cumberland Plateau, a small region in northwestern Georgia, USA. It is listed by the IUCN as a vulnerable species.

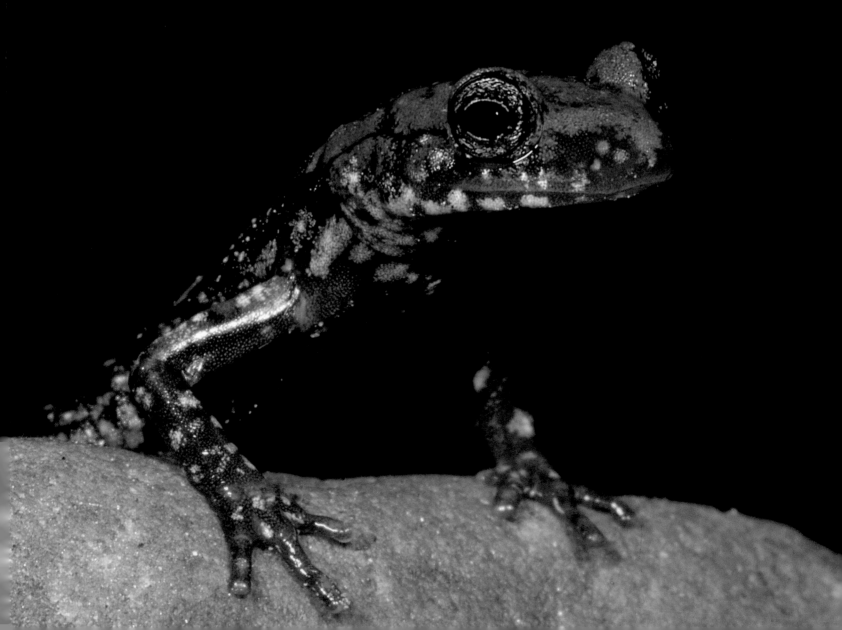

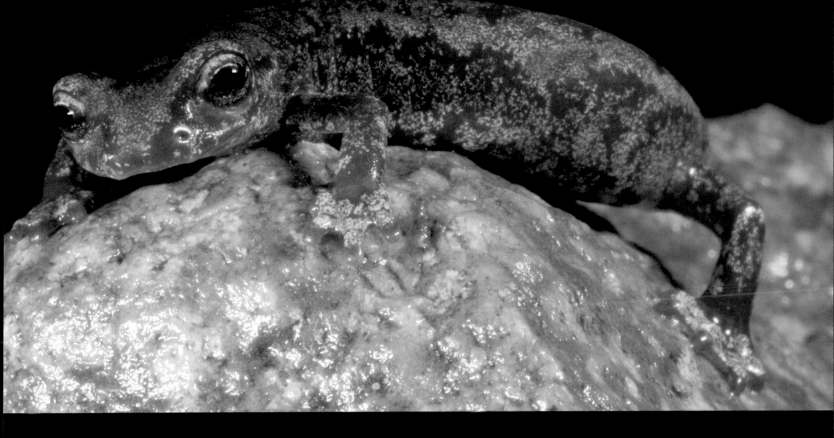

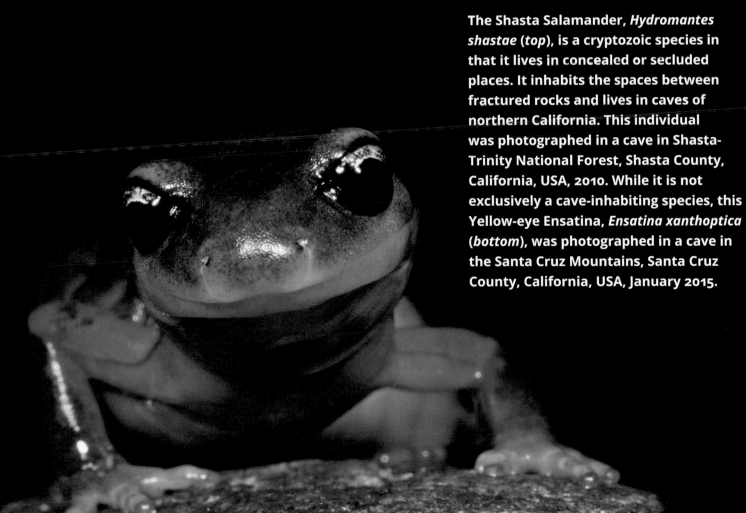

The Shasta Salamander, *Hydromantes shastae* (*top*), is a cryptozoic species in that it lives in concealed or secluded places. It inhabits the spaces between fractured rocks and lives in caves of northern California. This individual was photographed in a cave in Shasta-Trinity National Forest, Shasta County, California, USA, 2010. While it is not exclusively a cave-inhabiting species, this Yellow-eye Ensatina, *Ensatina xanthoptica* (*bottom*), was photographed in a cave in the Santa Cruz Mountains, Santa Cruz County, California, USA, January 2015.

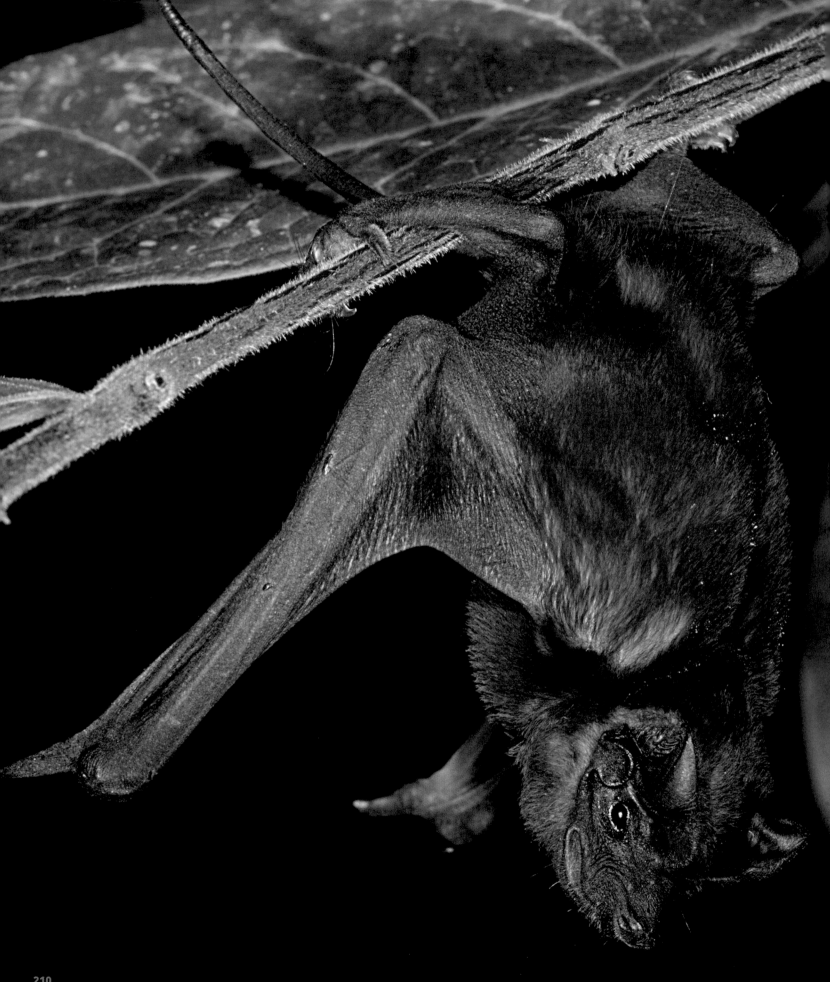

Bats

Brazilian Free-tailed Bats, *Tadarida brasiliensis*, live in colonies that can number in the millions. This individual (*facing page*) was photographed in Amazonian Peru in 2011. The bats feed on insects and so provide millions of dollars worth of free agricultural pest control in the regions they inhabit. The colony exiting the cave (*this page*) was photographed in western Oklahoma in 2004. Further Reading: Cleveland et al., 2006.

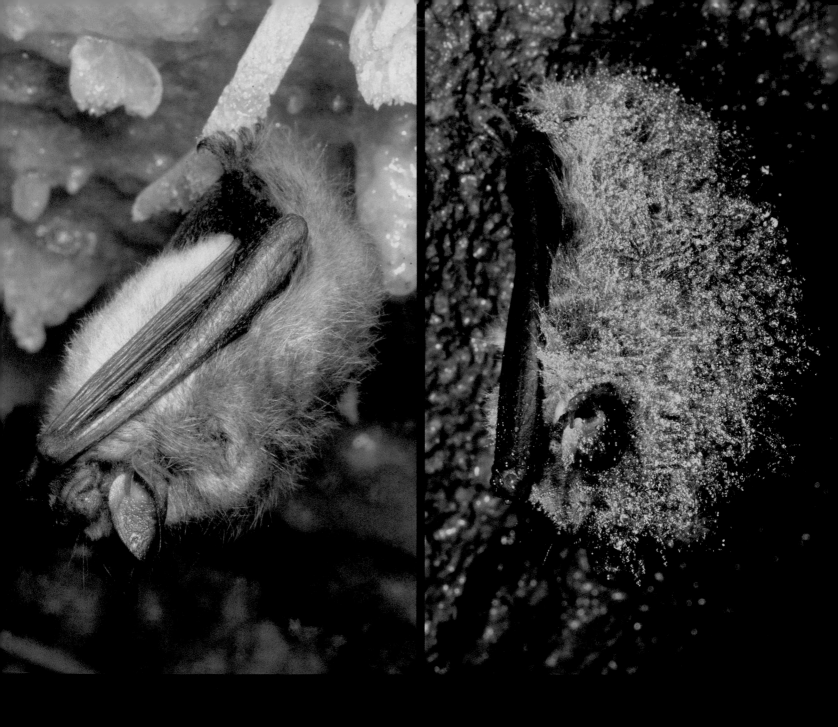

The Eastern Pipistrelle, *Perimyotis subflavus*, is common in caves in the Ozark Mountains. When these bats go into torpor, their body temperature drops and water droplets condense at the tip of each hair, giving a bat the appearance of being silver or white (*right*). This creates local stories of white or albino bats.

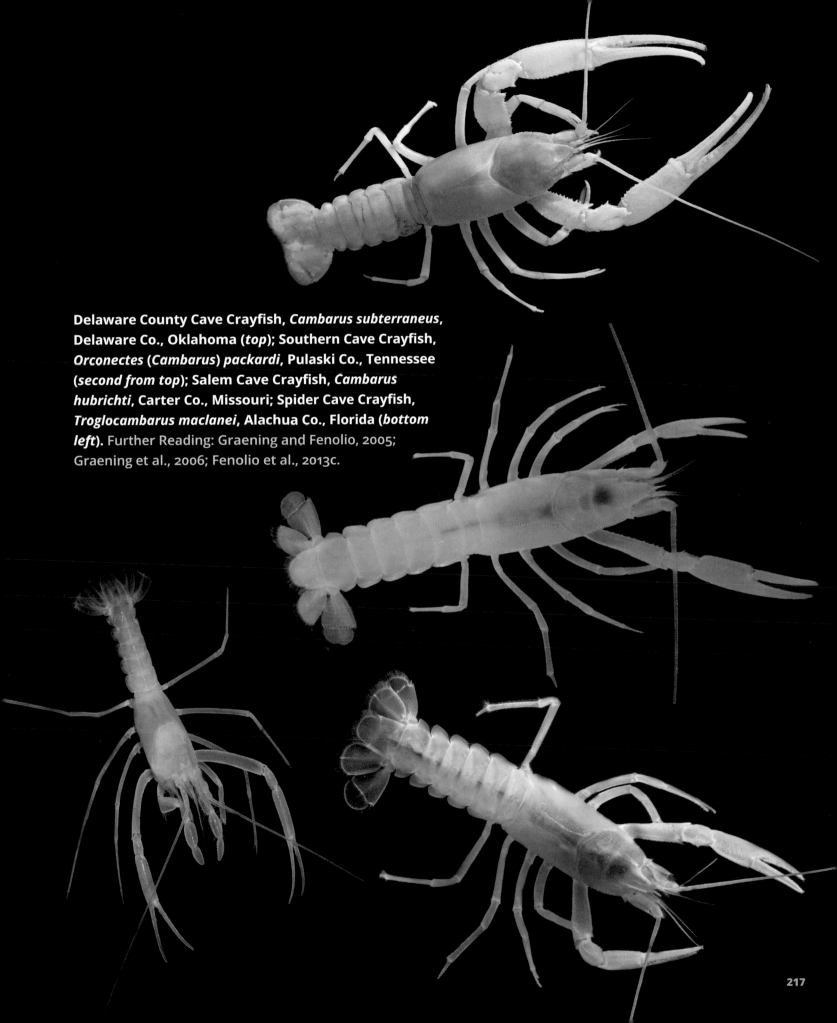

Delaware County Cave Crayfish, *Cambarus subterraneus*, Delaware Co., Oklahoma (*top*); Southern Cave Crayfish, *Orconectes* (*Cambarus*) *packardi*, Pulaski Co., Tennessee (*second from top*); Salem Cave Crayfish, *Cambarus hubrichti*, Carter Co., Missouri; Spider Cave Crayfish, *Troglocambarus maclanei*, Alachua Co., Florida (*bottom left*). Further Reading: Graening and Fenolio, 2005; Graening et al., 2006; Fenolio et al., 2013c.

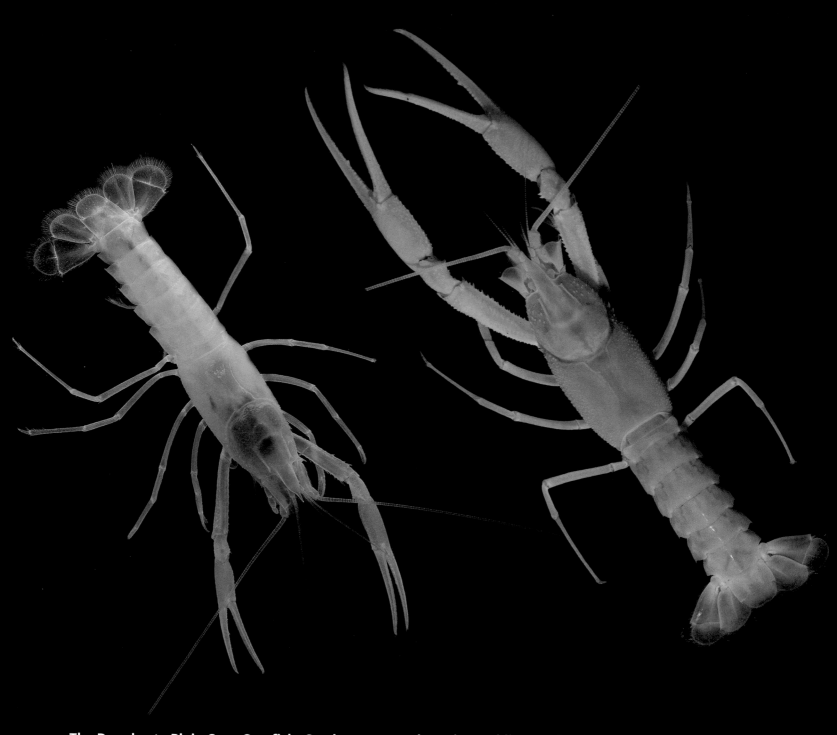

The Dougherty Plain Cave Crayfish, *Cambarus cryptodytes*, is an obligate inhabitant of groundwater. It lives only in the Floridan Aquifer in sites in Florida and Georgia, USA. Groundwater contamination and intensive agriculture above the aquifer currently threaten this species. *This page:* As individuals mature, their bodies get thicker and more robust. A young male (*bottom*) is contrasted with an older male (*top*). *Facing page:* The female attaches her eggs to the bottom of her tail (*top and middle*), where they develop. The hatchlings remain beneath her tail for a week or two before dropping off and living alone (*bottom*). Unlike surface crayfishes, cave crayfishes probably cannot breed each year; when they do, they have far fewer offspring than surface species. There is simply not enough food in most subterranean waters to support large populations of cave crayfishes. Further Reading: Fenolio et al., 2014c

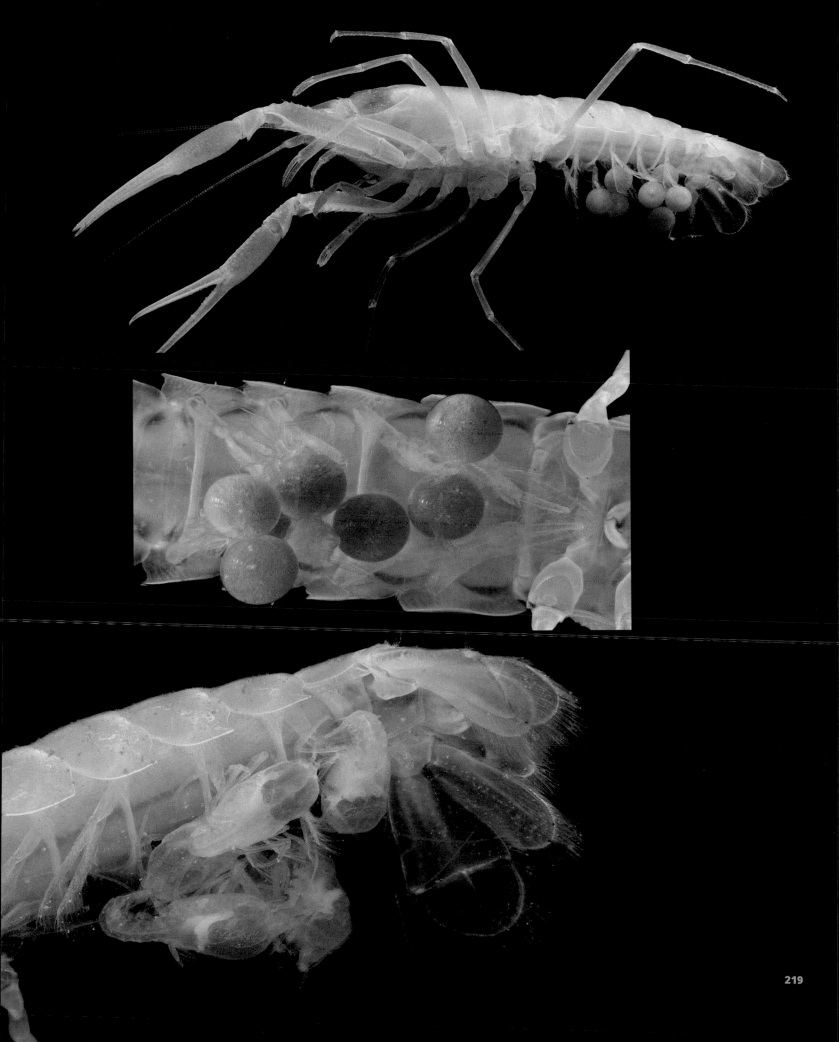

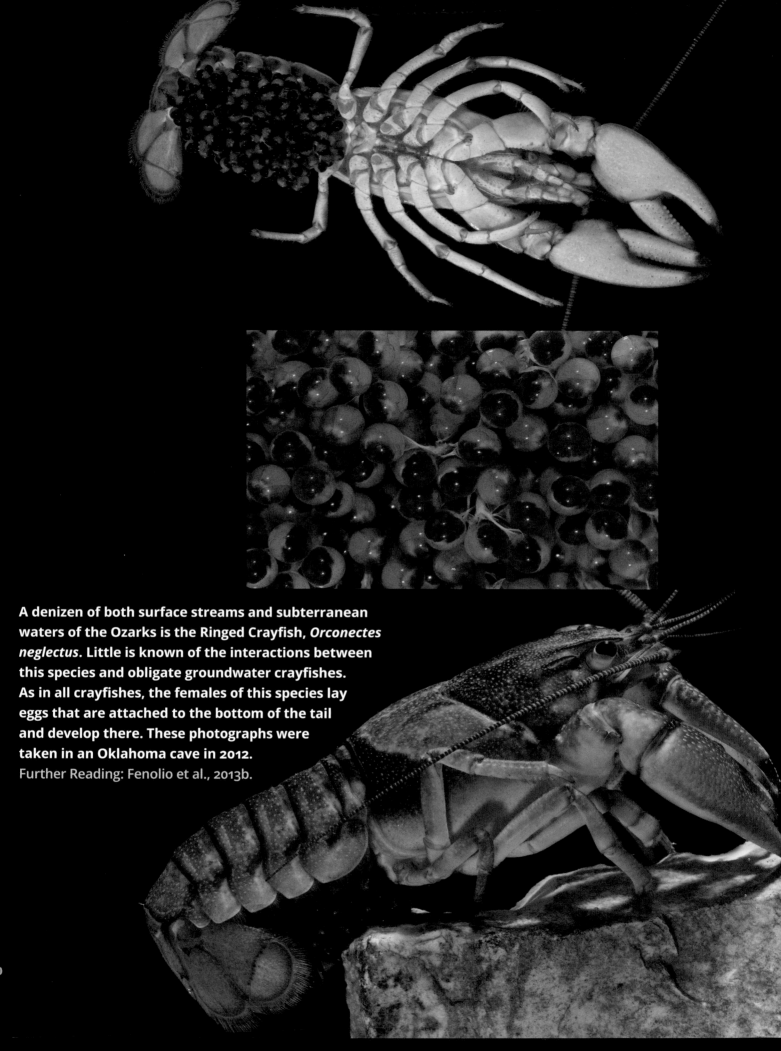

A denizen of both surface streams and subterranean waters of the Ozarks is the Ringed Crayfish, *Orconectes neglectus*. Little is known of the interactions between this species and obligate groundwater crayfishes. As in all crayfishes, the females of this species lay eggs that are attached to the bottom of the tail and develop there. These photographs were taken in an Oklahoma cave in 2012.
Further Reading: Fenolio et al., 2013b.

The Appalachian Cave Crayfish, *Orconectes* (*Cambarus*) *packardi*, is known only from subterranean waters in Kentucky, USA, where this specimen was photographed in 2012. Photographing this species in situ is a challenge, achieved here by caving on a day when the water clarity was excellent and by following the crayfish around the boulder-strewn cave stream.

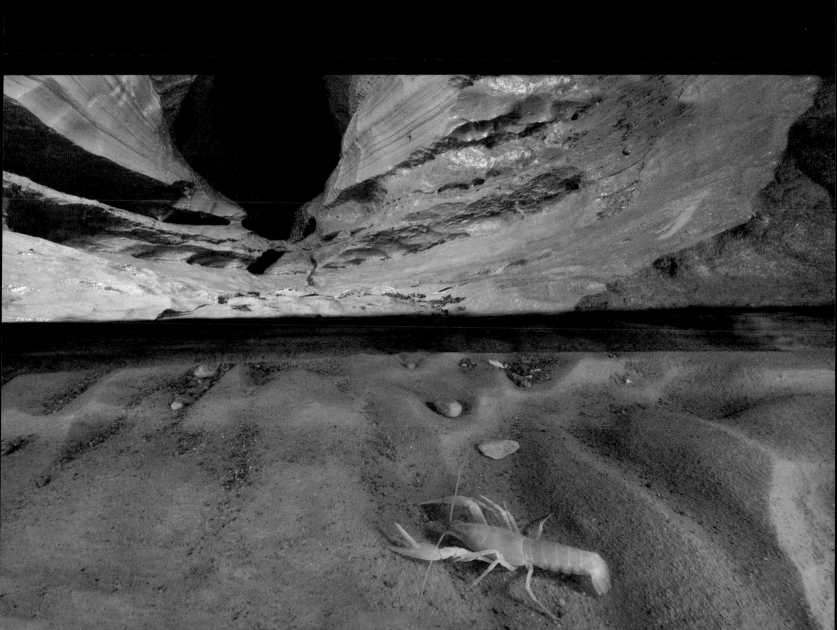

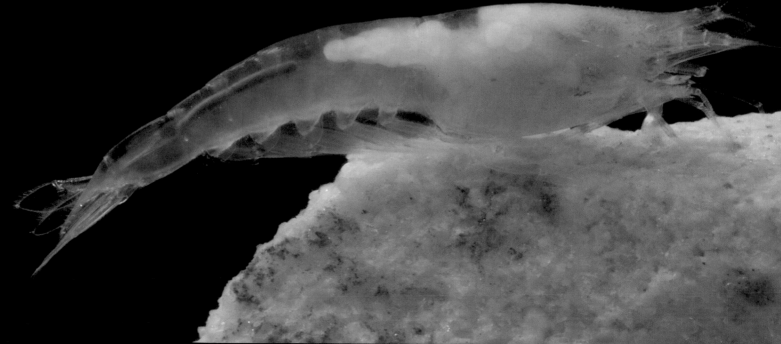

The inch-long Alabama Cave Shrimp, *Palaemonias alabamae* (*top*), is listed as endangered by both the U.S. Fish and Wildlife Service and the IUCN. Groundwater extraction and contamination threaten this species. Like many other obligate subterranean animals, this shrimp is blind and lacks pigment. Developing eggs are visible inside the carapace of this female, photographed in Alabama, USA, in 2010. Freshwater shrimp do well in subterranean waters. In fact, around the world, there have been at least nine independent colonizing events in which surface shrimp moved into subterranean waters. Over time and generations, these "invasions" have produced cave-adapted species that are now found only in groundwater. The Taiji Blind Cave Shrimp, *Typhlocaridina lanceifrons* (*bottom*), was photographed in Taiji Cave, Guangxi, China, in 2011. Further Reading: Margat, 1994; Nolan et al., 1998; Mace et al., 2006; von Rintelen et al., 2012.

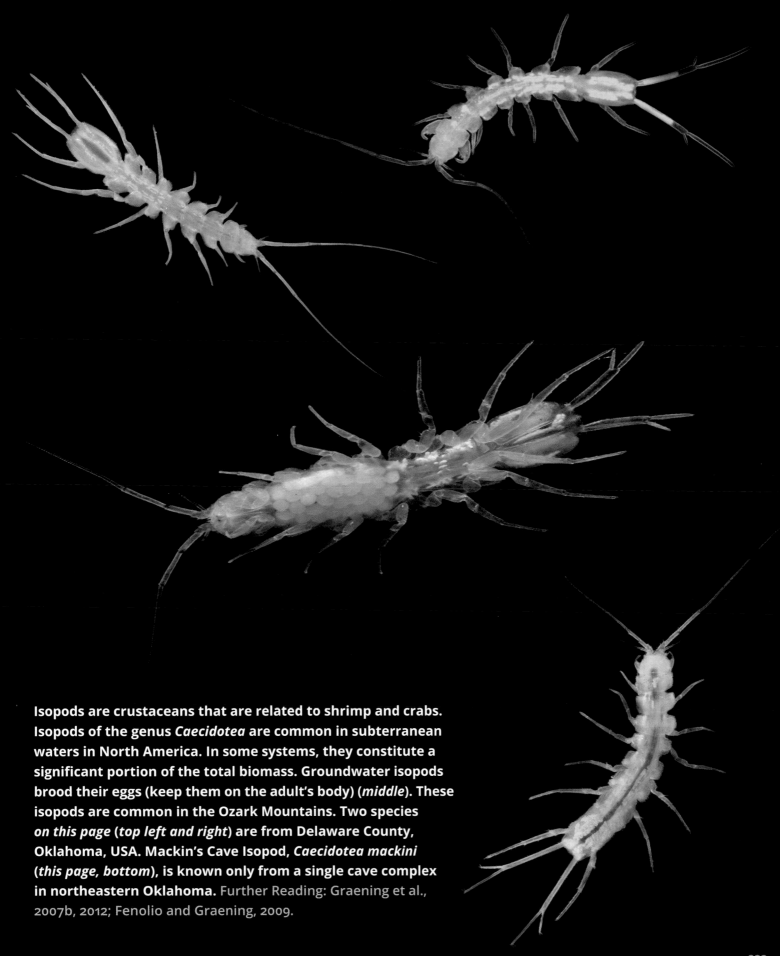

Isopods are crustaceans that are related to shrimp and crabs. Isopods of the genus *Caecidotea* are common in subterranean waters in North America. In some systems, they constitute a significant portion of the total biomass. Groundwater isopods brood their eggs (keep them on the adult's body) (*middle*). These isopods are common in the Ozark Mountains. Two species *on this page* (*top left and right*) are from Delaware County, Oklahoma, USA. Mackin's Cave Isopod, *Caecidotea mackini* (*this page, bottom*), is known only from a single cave complex in northeastern Oklahoma. Further Reading: Graening et al., 2007b, 2012; Fenolio and Graening, 2009.

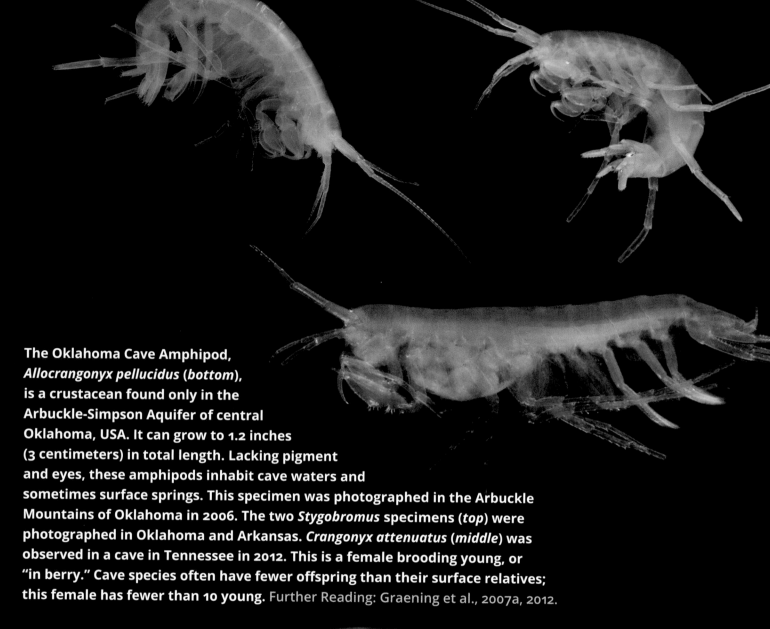

The Oklahoma Cave Amphipod,
Allocrangonyx pellucidus (*bottom*),
is a crustacean found only in the
Arbuckle-Simpson Aquifer of central
Oklahoma, USA. It can grow to 1.2 inches
(3 centimeters) in total length. Lacking pigment
and eyes, these amphipods inhabit cave waters and
sometimes surface springs. This specimen was photographed in the Arbuckle
Mountains of Oklahoma in 2006. The two *Stygobromus* specimens (*top*) were
photographed in Oklahoma and Arkansas. *Crangonyx attenuatus* (*middle*) was
observed in a cave in Tennessee in 2012. This is a female brooding young, or
"in berry." Cave species often have fewer offspring than their surface relatives;
this female has fewer than 10 young. Further Reading: Graening et al., 2007a, 2012.

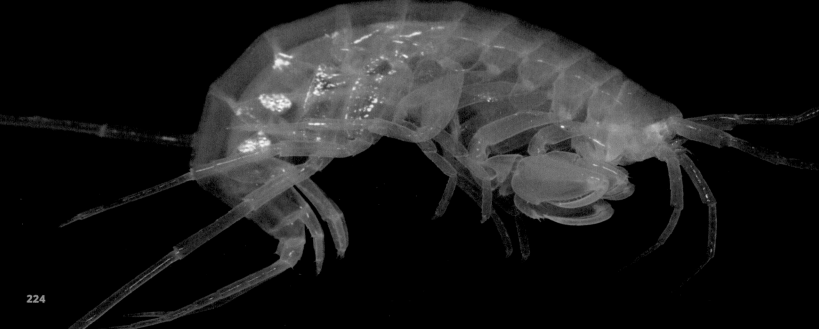

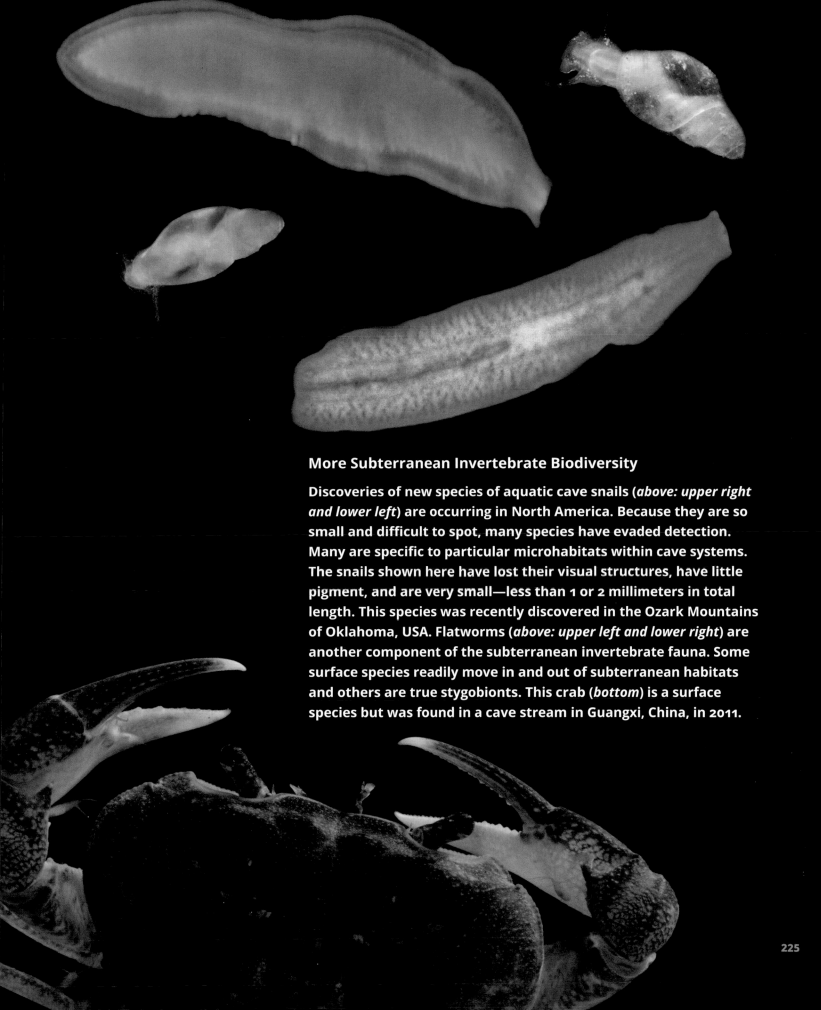

More Subterranean Invertebrate Biodiversity

Discoveries of new species of aquatic cave snails (*above: upper right and lower left*) are occurring in North America. Because they are so small and difficult to spot, many species have evaded detection. Many are specific to particular microhabitats within cave systems. The snails shown here have lost their visual structures, have little pigment, and are very small—less than 1 or 2 millimeters in total length. This species was recently discovered in the Ozark Mountains of Oklahoma, USA. Flatworms (*above: upper left and lower right*) are another component of the subterranean invertebrate fauna. Some surface species readily move in and out of subterranean habitats and others are true stygobionts. This crab (*bottom*) is a surface species but was found in a cave stream in Guangxi, China, in 2011.

Terrestrial Invertebrates

Spiders seem like a natural fit for cave life, and many species inhabit subterranean haunts. In spider species found only in caves, eyes are often reduced or missing entirely, as in the individual depicted here (*top*), observed in Delaware County, Oklahoma, USA. *Nesticus barri* (*bottom*) is a common spider around cave mouths. This individual was photographed in King Spring Cave, Marion County, Tennessee, USA, in 2013.

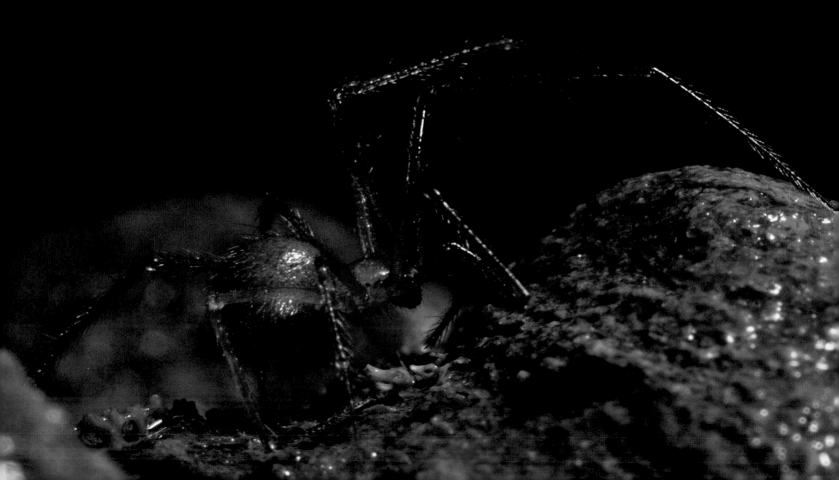

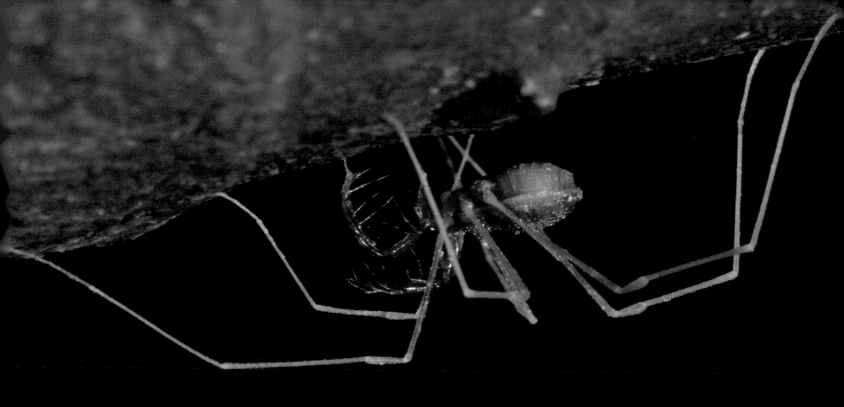

Harvestmen, or "daddy longlegs," known to scientists as opilionids, are arachnids related to spiders and scorpions. Opilionids are small predators that feed on tiny invertebrates. Obligate cave species can be white (often as juveniles or newly molted individuals, less commonly as adults), red, or orange. Many species frequent caves opportunistically, and many others are obligate cave dwellers. Shown here are *Bishopella* cf. *laciniosa* (*top*), photographed in Tennessee, USA, in 2013, and *Tolus appalachius* (*bottom*), photographed in Grundy County, Tennessee, in 2008. Further Reading: Graening et al., 2012.

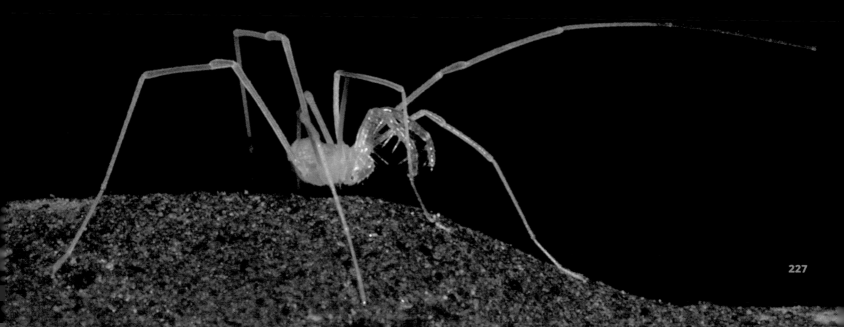

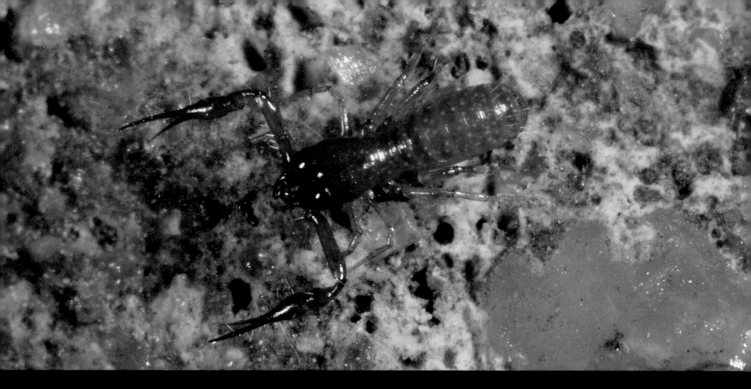

Pseudoscorpions are arachnids (related to scorpions, mites, and spiders); they have no tail. These tiny predators are common in leaf litter, and some species are attracted to caves. The pseudoscorpion of the genus *Apochthonius* (*above*) was observed climbing a limestone wall near a bat roost in a cave in the Ozark Mountains, Oklahoma, USA, in 2012. The individual of the genus *Globocreagris* (*below*) was found in a cave in the "Mother Lode" gold region of central California, USA, in 2011.

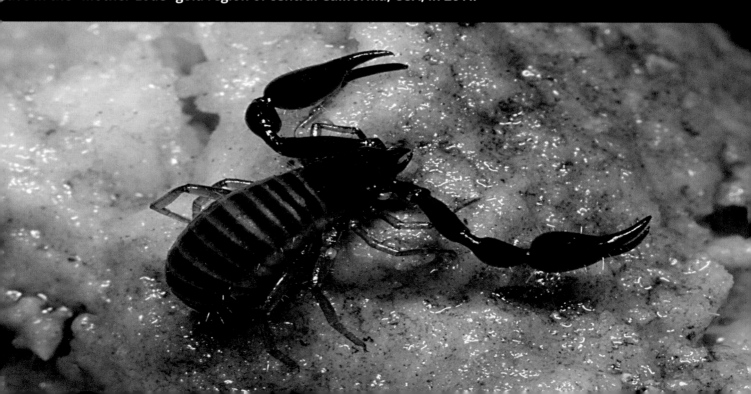

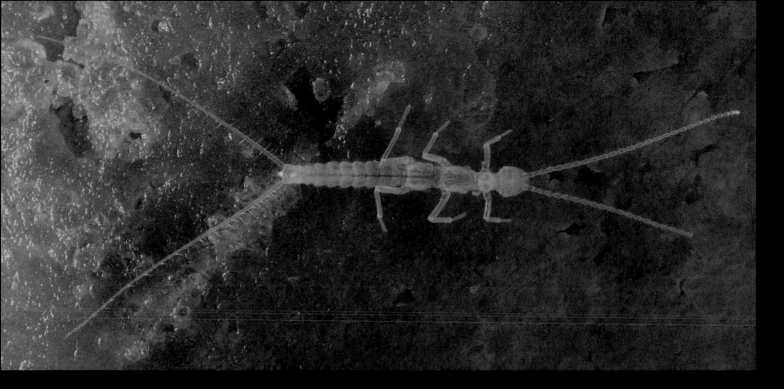

Diplurans are flightless, blind invertebrates with beadlike antennae; they are six-legged relatives of insects that evolutionarily diverged from the insects before flight evolved. Many species of diplurans specialize in caves. Litocampid diplurans (*top*) are often found along mud flats in caves, particularly in damp spots with fungal growth. This specimen was photographed in Delaware County, Oklahoma, USA. Japygid diplurans (*bottom*) can be confused with earwigs because they have similar pinching structures at their posterior end. Further Reading: Graening et al., 2012.

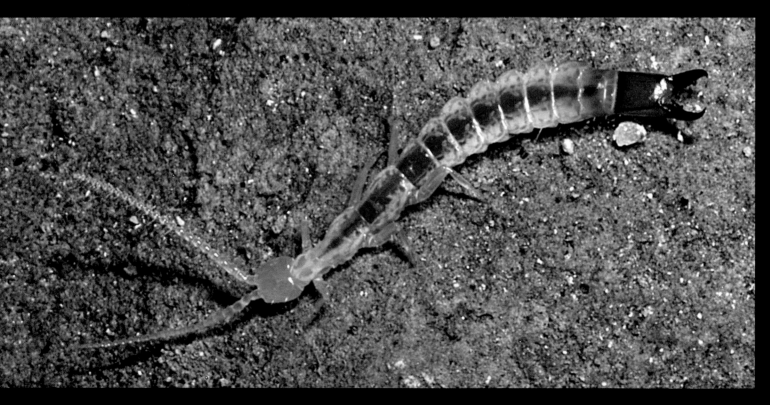

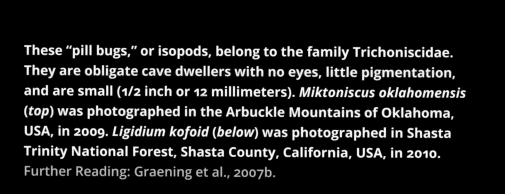

These "pill bugs," or isopods, belong to the family Trichoniscidae. They are obligate cave dwellers with no eyes, little pigmentation, and are small (1/2 inch or 12 millimeters). *Miktoniscus oklahomensis* (*top*) was photographed in the Arbuckle Mountains of Oklahoma, USA, in 2009. *Ligidium kofoid* (*below*) was photographed in Shasta Trinity National Forest, Shasta County, California, USA, in 2010.

Further Reading: Graening et al., 2007b.

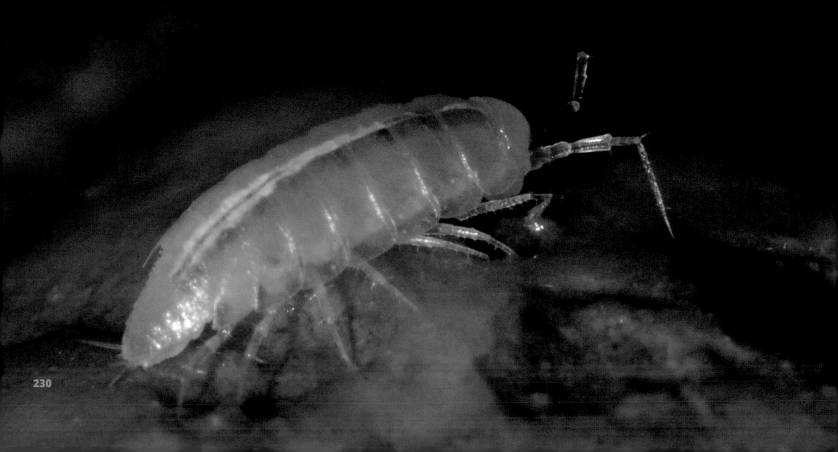

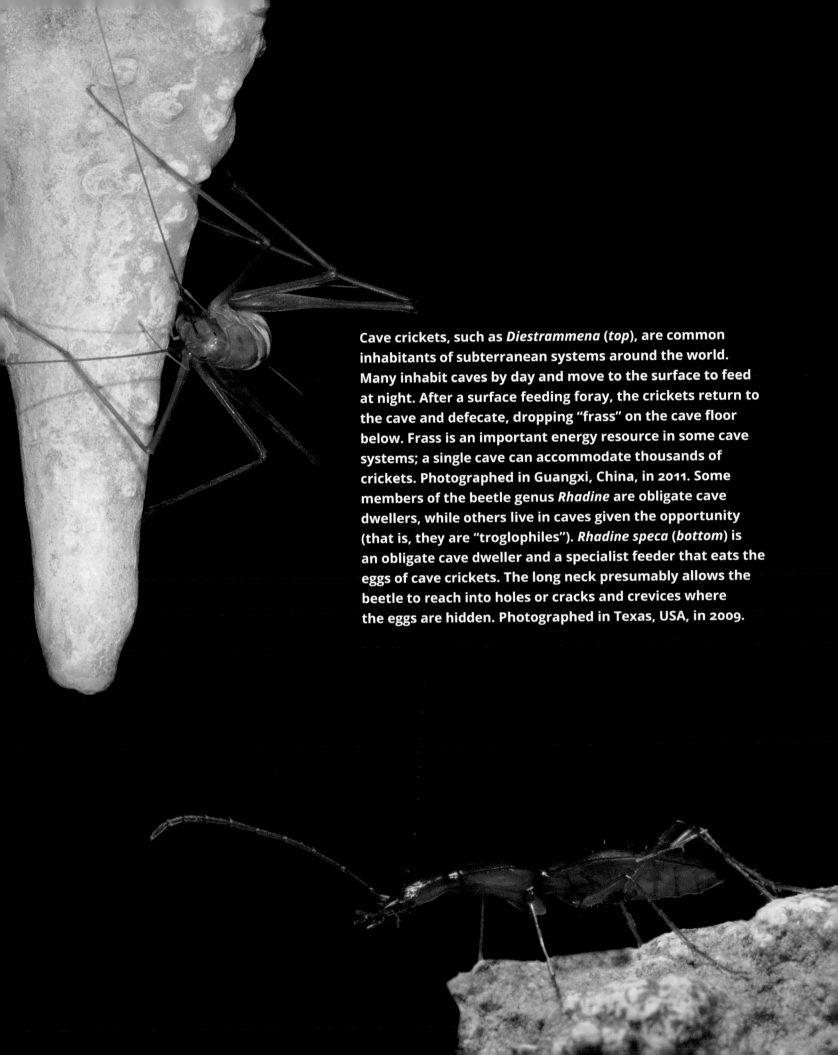

Cave crickets, such as *Diestrammena* (*top*), are common inhabitants of subterranean systems around the world. Many inhabit caves by day and move to the surface to feed at night. After a surface feeding foray, the crickets return to the cave and defecate, dropping "frass" on the cave floor below. Frass is an important energy resource in some cave systems; a single cave can accommodate thousands of crickets. Photographed in Guangxi, China, in 2011. Some members of the beetle genus *Rhadine* are obligate cave dwellers, while others live in caves given the opportunity (that is, they are "troglophiles"). *Rhadine speca* (*bottom*) is an obligate cave dweller and a specialist feeder that eats the eggs of cave crickets. The long neck presumably allows the beetle to reach into holes or cracks and crevices where the eggs are hidden. Photographed in Texas, USA, in 2009.

Cave silverfishes are reclusive, rarely seen invertebrates. The Ozark Cave Silverfish, *Speleonycta ozarkensis* (top) was photographed during a bioinventory in Delaware County, Oklahoma, USA, in 2012. Springtails, such as *Pseudosinella hirsuta* (bottom), are common edaphic (that is, soil-dwelling) invertebrates in caves. This individual was photographed in a Tennessee cave in 2009. Many species of springtail will readily move into caves, given the opportunity, which makes obligate cave inhabitants difficult to distinguish. Further Reading: Espinasa et al., 2014.

The larval stage of the fungus gnat, *Macrocera nobilis* (*above*), is a predatory, wormlike invertebrate that spins a web, similar to a spider's web, to snare its prey. Prey can include any small flying invertebrates, including other fungus gnats. Web worms are common in Ozark caves and are also found elsewhere. The individual that has captured a mosquito in its web (*below*) was photographed at the mouth of a cave in Guangxi, China, in 2014.

Small invertebrates comprise the bulk of subterranean fauna, including many species of millipedes. Cave-obligate millipedes frequently feed on decomposing organic materials or fungi. The Samwell Cave Millipede, *Amplaria shastae* (*this page*), is known only from caves in the vicinity of Mt. Shasta, Shasta County, California, USA. The Crystal Cave Millipede, *Amplaria muiri* (*facing page, top*), was photographed in Sequoia National Park, Tulare County, California, in 2010. There are still cave-inhabiting millipedes of which scientists know virtually nothing, such as two species from China's Guangxi Province (*facing page, middle and lower*), photographed in 2014 and 2011. Further Reading: Graening et al., 2012.

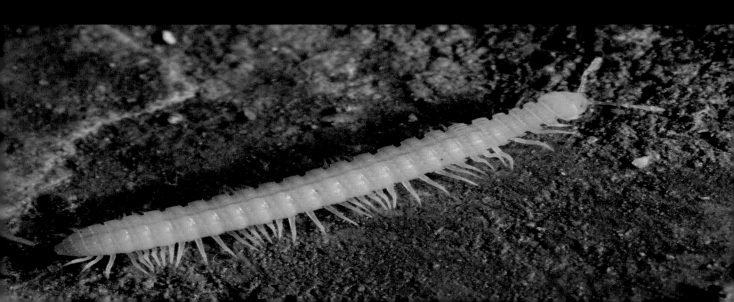

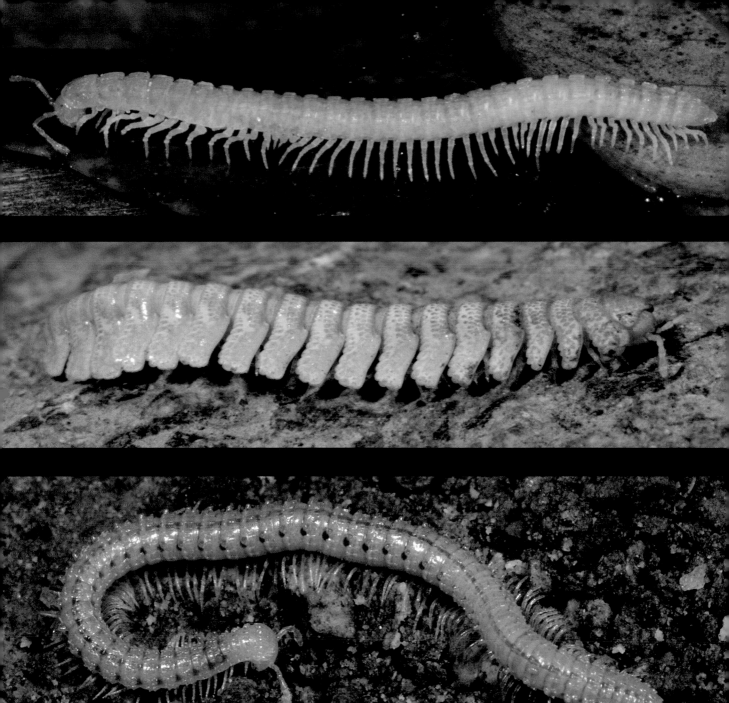

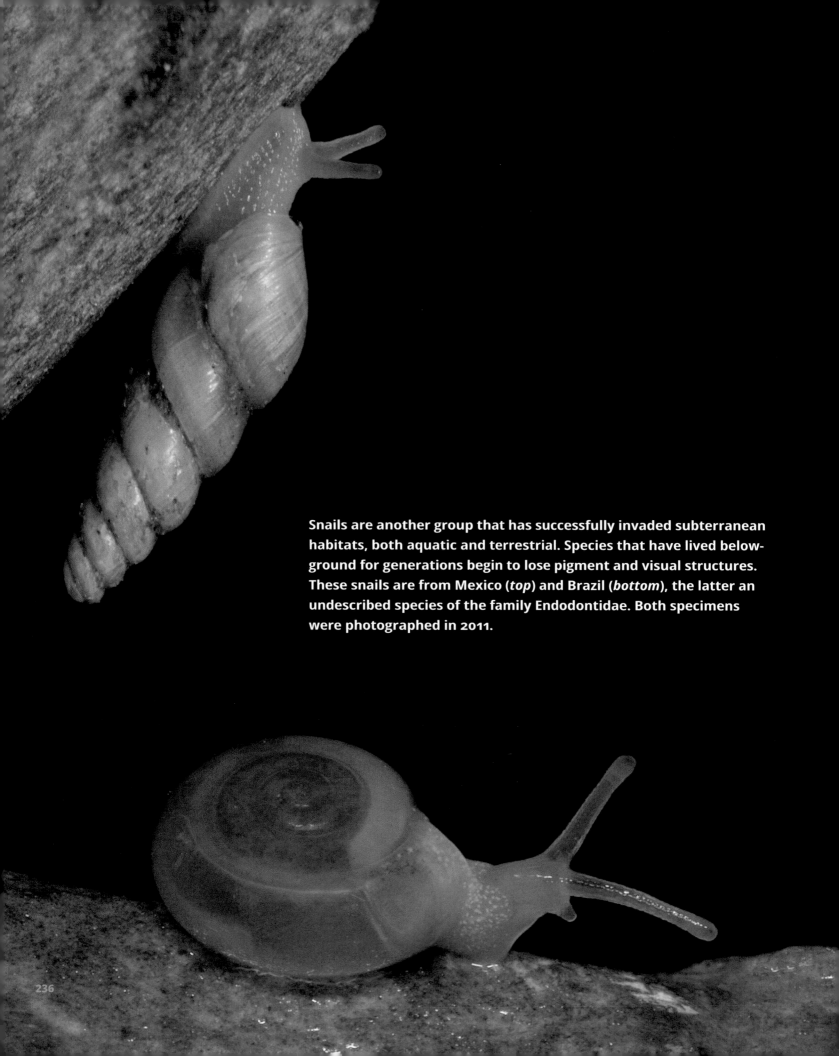

Snails are another group that has successfully invaded subterranean habitats, both aquatic and terrestrial. Species that have lived below-ground for generations begin to lose pigment and visual structures. These snails are from Mexico (*top*) and Brazil (*bottom*), the latter an undescribed species of the family Endodontidae. Both specimens were photographed in 2011.

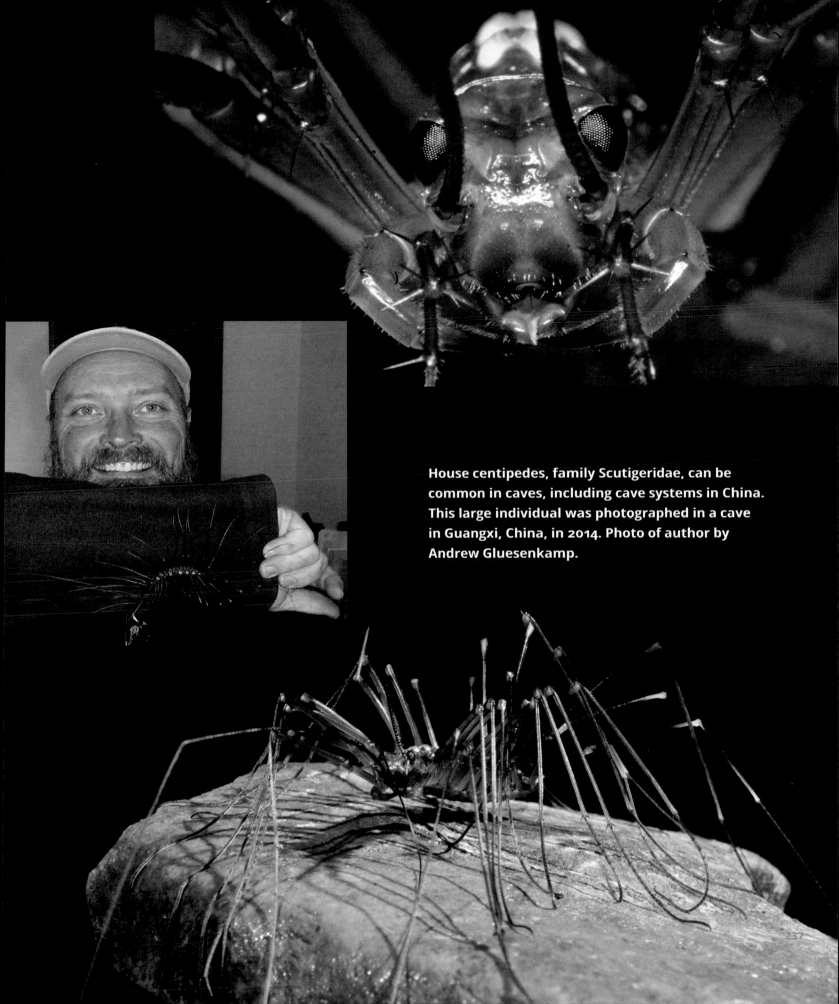

House centipedes, family Scutigeridae, can be common in caves, including cave systems in China. This large individual was photographed in a cave in Guangxi, China, in 2014. Photo of author by Andrew Gluesenkamp.

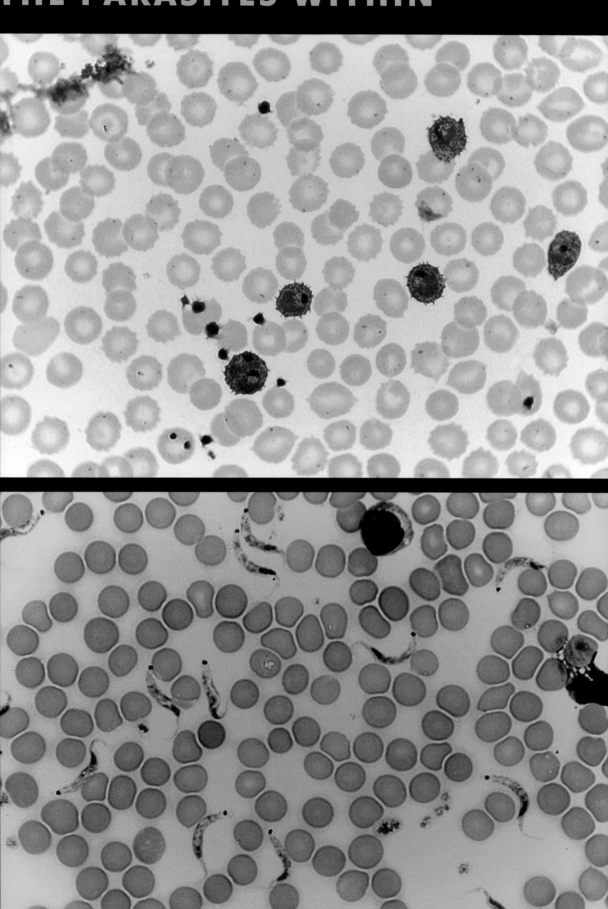

*W*e seldom think of parasites when considering creatures that live in the dark. However, many parasites do live in darkness, inside other organisms. Volumes have been written on parasites, of course. I hope to capture your interest with just a few examples here. First, some definitions can help with what is otherwise a complicated field of biology.

Parasites are organisms that derive nutrients from other organisms, called host species. The host does not benefit from the relationship, but the parasite does not kill its host. Parasitoids also derive nutrients from a host, but unlike parasites, they ultimately kill the host. From here, let's delve into some examples of these relationships.

Some parasitic relationships are obvious to observers; others are not. A group of South American catfishes called *candirú*, for example, parasitize other fish species by inhabiting their gill chambers and feeding on blood from the gill tissue—acting as true vampires. *Candirú*

Facing page: Malaria is caused by a protozoan parasite that lives within the organisms it infects. Malaria kills tens of thousands of humans each year. *Plasmodium vivax* (*top*, stained deep purple) is one species of this parasite that can infect humans. One vector for this disease is the female *Anopheles* mosquito. *Trypanosoma lewisi* (*bottom*, stained blue) is a bloodborne parasite of rats, spending its lifespan within the dark interior of either the rat or the vector between rats—a flea. Another member of this genus, *T. cruzi*, causes Chagas disease in humans. The vector with Chagas disease is a reduviid insect. Both images courtesy of Christina Hanson.

Predatory fungi are also known as "entomopathogenic fungi." Many species live in the Upper Amazon Basin, including fungi of the genus *Cordyceps*. The fungus kills its invertebrate host, such as this spider, and then one or more fungal fruiting bodies sprout from the host's exoskeleton, forming structures called stromatic clavae. The spores produced by the fruiting bodies are swept away on air currents to infect new hosts. (Some biologists argue that these fungi are parasitoids rather than predators.) Further Reading: Samson et al., 1988.

Are you sure vampires don't exist? There are certainly blood-feeding (or "hematophagous") organisms in nature. Most animals with this lifestyle are invertebrate parasites, such as female mosquitoes and leeches. But there is a guild of parasitic catfishes that feed on blood that they extract from larger fishes by entering their gill cavities and ingesting blood from the thin, vulnerable gill tissue. These blood-feeding catfishes, of the family Trichomycteridae, are prominent in Brazilian Amazon lore as the famed *candirú*. While biologists have not yet established exactly how it's done, *candirú* seem to have the ability to locate animals that are urinating while swimming, then enter the urethra and lodge themselves inside. There is only one medically documented case of this happening to a human (in Brazil). The trichomycterid catfish *Vandellia sanguinea* shown here was observed on the Napo River in Loreto, Peru, in 2010.

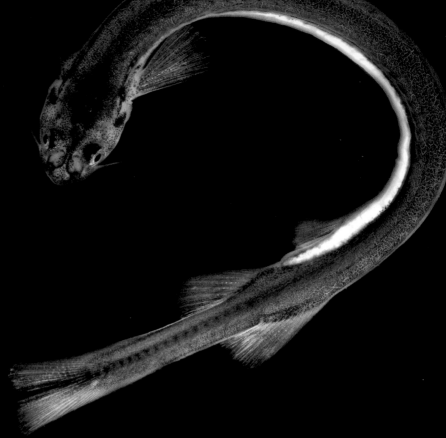

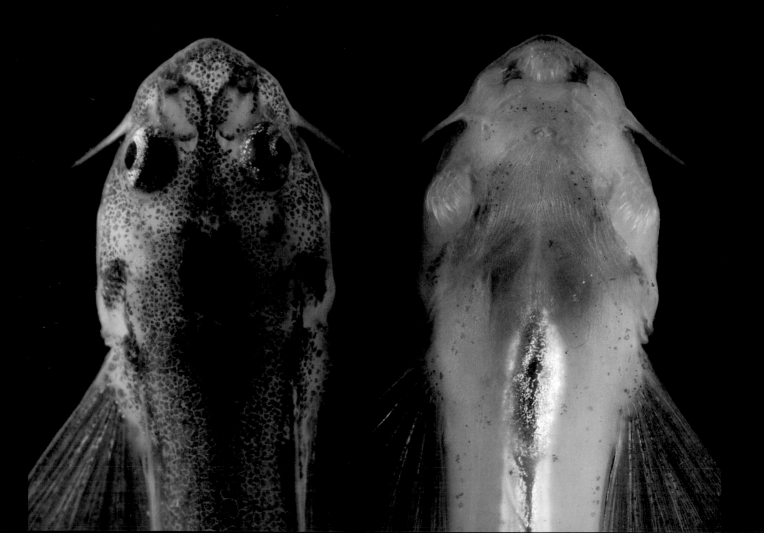

are better known, however, for allegedly entering species that are not their target hosts, including humans. Careful reviews of these accounts reveal that the stories are myth rather than reality. There are a few credible though medically undocumented cases of *candirú* entering the urethra or anus, often while the person urinates; however, most accounts are secondhand. One medically documented case occurred in Brazil (Gudger 1930a, 1930b; Breault, 1991; Spotte, 2002). Much remains unknown about these catfishes, including exactly how they locate their host species and the cues they use to target the appropriate portions of a host species.

Humans have their own parasites, of course. Roundworms are parasitic nematode worms that cause a variety of illnesses. Depending on the nematode species, the adults inhabit different parts of the human body, including the circulatory, lymphatic, pulmonary, or cardiovascular

Tarantula Hawks are wasps of the family Pompilidae that immobilize spiders by stinging them. This female parasitoid wasp carries the paralyzed spider to an excavation site and buries it, along with an egg that she deposits on the living but immobile spider. The egg hatches, and the larval wasp consumes the spider alive. This wasp is in the process of carrying off a theraphosid (a tarantula) to bury it. Photographed in Chile in 2012.

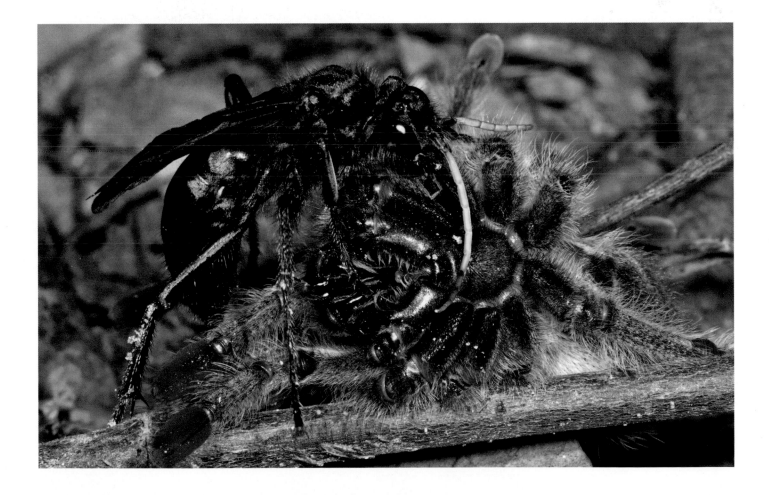

Mosquitoes sometimes act as vectors for other parasites. The female Human Botfly, *Dermatobia hominis*, captures another parasitic fly, such as a biting fly or mosquito, glues her eggs (up to 25) to this "carrier" insect, and then releases it unharmed. When the carrier insect feeds on a host—sometimes a human (*below*)—the host's body heat induces the eggs to hatch (a larva is shown *on the right*). The larvae then drop off onto the host. Botfly larvae often use the puncture wound made by the carrier species to penetrate the host's body, but they can and do burrow effectively on their own into host tissues. Once inside, the botfly larvae begin to develop in the tissues. A boil-like lesion develops just under the skin where a larva is growing. Botfly larvae have a pair of special snorkels (called spiracles) that remain at the opening of the wound and supply oxygen to the developing larva. Barbs covering the larva's exterior prevent easy removal. In humans, the developing larva and the inflamed area begin to become intensely painful at roughly four weeks after infection. The larval stage of the botfly lasts between 50 and 100 days. One of the many names for this fly and its larvae in Latin America is *ver macaque* ("macaque worm"), used in French Guiana.

Further Reading: Strong, 1943; Mackie et al., 1945; Shattuck, 1951.

systems. The larvae of the worms are referred to as microfilaria. Diseases associated with these infections include blinding filarial disease, elephantiasis, and African eye worm disease (loiasis).

Roundworms don't move from one host to another on their own: another parasite, called a vector, transmits the disease between hosts. The vectors include blood-feeding biting flies such as mango flies, midges, black flies, and tabanid flies, as well as mosquitoes. The vector takes up the microfilaria in the process of blood-feeding. Once in the stomach of the vector, the microfilaria bore through the stomach wall and into the insect's body. The microfilaria usually pass through developmental stages while inside the vector, ultimately ending up in the region of the mouthparts or in the salivary glands. When the vector next feeds, the microfilaria infect a new host.

Microfilaria typically rest in deep body tissues within the host for at least half the day; the rest of the time, they circulate through the host's bloodstream. Because microfilaria rely on vectors for transmission, it is in their best interest to be actively circulating in the host's blood at the times of day when vectors are biting. It is in the timing of the microfilaria's circulating in the bloodstream that an interesting relationship can be found.

If the microfilaria rely on day-active vectors (such as biting midges, mango flies, and black flies), they are most numerous in the host bloodstream during the day, when they might be taken up during a vector's blood-feeding. Similarly, where there are night-active vectors (such as mosquitoes), the greatest concentrations of microfilaria are present in the host bloodstream at night (Strong, 1943). When the vector is active at two or more specific times of the day, the microfilaria reach their greatest concentration in the host bloodstream at those times (Mattingly, 1962). The parasitic nematode *Wuchereria bancrofti* (responsible for the disease Bancroftian filariasis), for instance, is found in larger numbers in the bloodstream at night in geographic regions where the vector is a nocturnal mosquito (*Culex quinquefasciatus*).

Where the vector is a day-flying mosquito (*Aedes scutellaris*), the microfilaria spike in number during the day (Shattuck, 1951).

Parasitic roundworms infect all types of wildlife. An interesting parasitoid can be found in cave streams and within some of the cave-inhabiting insects of the Ozarks. Horsehair worms, "Gordian worms" of the phylum Nematomorpha, are parasitoids of various arthropods, including cave crickets. Wingless cave crickets, or camel crickets, *Ceuthophilus* sp., are common in caves throughout North America. They typically emerge from caves at night to feed on the surface and then rest in subterranean systems by day. The excrement, or frass, that they deposit in some cave systems is an important energy source for the subterranean community. Horsehair worms develop inside the body of the insect and grow larger and larger. When the cricket goes to water to drink, the worms break out of its body and enter the water. The host then dies. (And you thought the movie *Alien* was just a fantasy . . .) Apparently, adult horsehair worms breed in the aquatic environment where their host delivered them and then lay their eggs in the water. It is not yet clear exactly how new hosts are infected, but it may be by drinking water that contains the larval worms or eating something contaminated with the eggs. The majority of horsehair worms observed in cave streams probably come from cave crickets.

Horsehair worms (*right*) and cave crickets (*left*) are an example of a parasitoid-host relationship. The worms grow inside cave crickets until they become so large that the cricket breaks open. Horsehair worms are often found in cave streams after breaking out of their hosts.

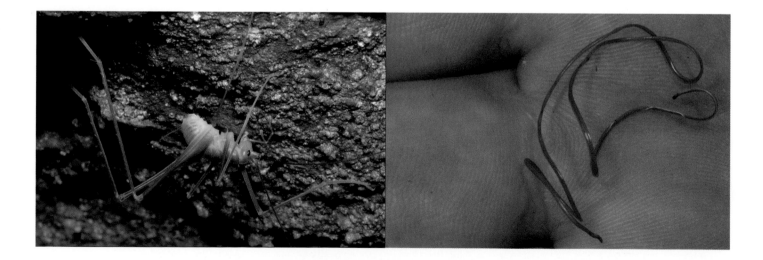

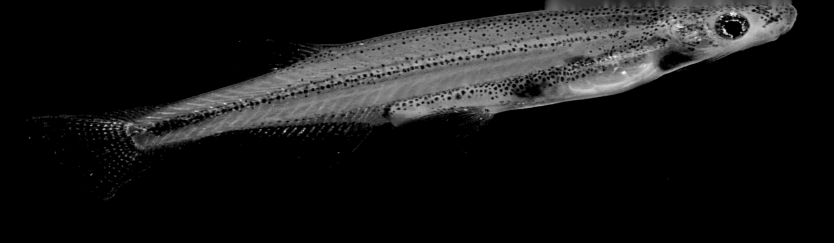

A *candirú, Tridensimilis brevis* (*top*), from the Napo River, Loreto, Peru, and a member of the same species trying to enter the gill chamber of a larger species of catfish, *Rhamdia sebae* (*bottom*). Of all the fish species in South America, only piranhas evoke the same reaction of horror as the *candirú*. Local legend holds that these small catfishes, of the family Trichomycteridae, routinely swim up the urethra of unsuspecting bathers. In fact, there is only a single medically documented case of this happening to a human (in Brazil). In any event, it would simply be a case of mistaken identity on the *candirú*'s part. It seems likely that the presumed chemical signals that the fish uses to locate its host are momentarily confused . . . and mistakes happen. Many *Candirú* are blood-feeders—they prefer the confines of a large fish's gill chambers, where they gnaw on the gills and drink the blood. I highly recommend Stephen Spotte's *Candiru: Life and Legend of the Bloodsucking Catfishes* (2002) for more about these much-maligned fishes.

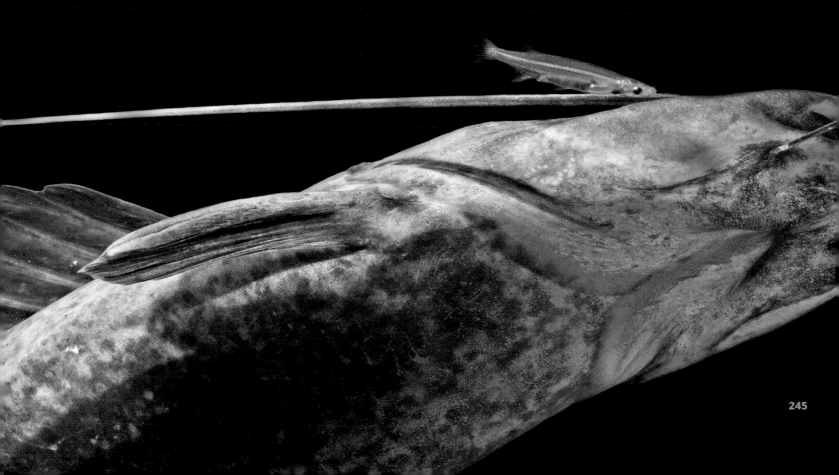

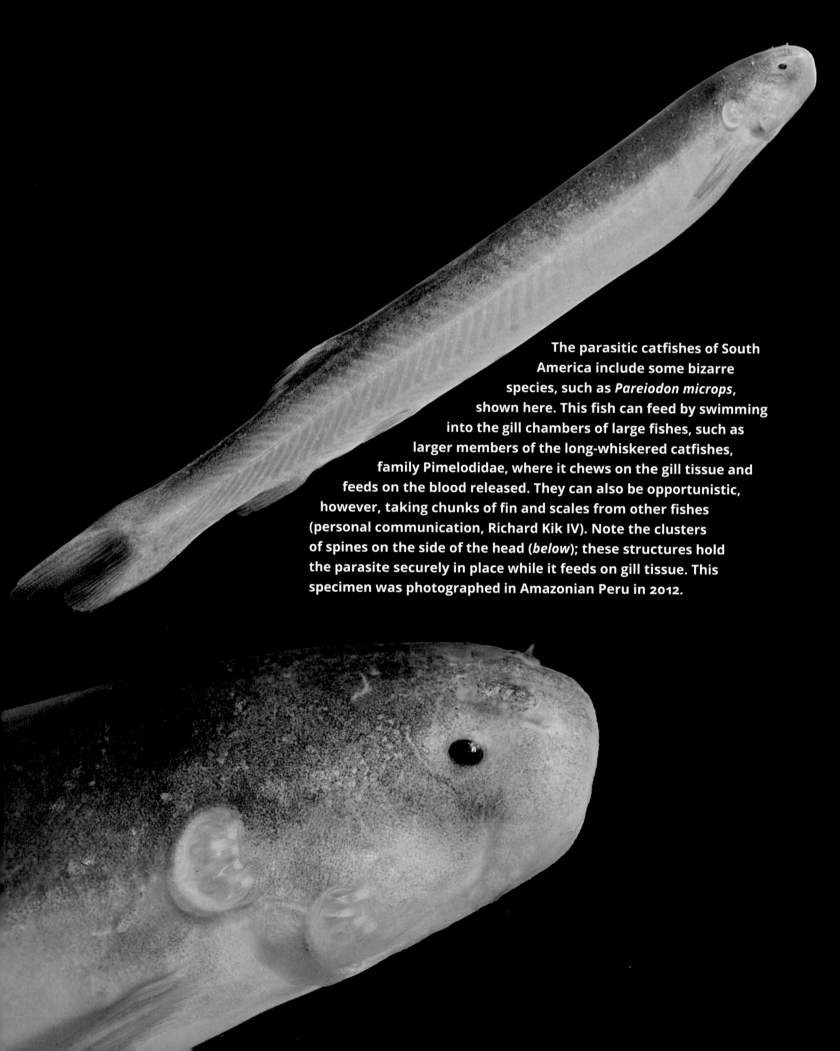

The parasitic catfishes of South
America include some bizarre
species, such as *Pareiodon microps*,
shown here. This fish can feed by swimming
into the gill chambers of large fishes, such as
larger members of the long-whiskered catfishes,
family Pimelodidae, where it chews on the gill tissue and
feeds on the blood released. They can also be opportunistic,
however, taking chunks of fin and scales from other fishes
(personal communication, Richard Kik IV). Note the clusters
of spines on the side of the head (*below*); these structures hold
the parasite securely in place while it feeds on gill tissue. This
specimen was photographed in Amazonian Peru in 2012.

The Chestnut Lamprey, *Ichthyomyzon castaneus*, ranges through central- and eastern North America and reaches a maximum length of about 1 foot (32 centimeters). Larval Chestnut Lampreys are filter-feeders, but adults are parasitic and feed on other fishes. Adults mate just once in their life and then die. Although this species does not parasitize hosts from within, it does inhabit the darker depths of rivers and embodies the notion of life in the dark. This individual was photographed in the White River of Arkansas, USA, in 2001.

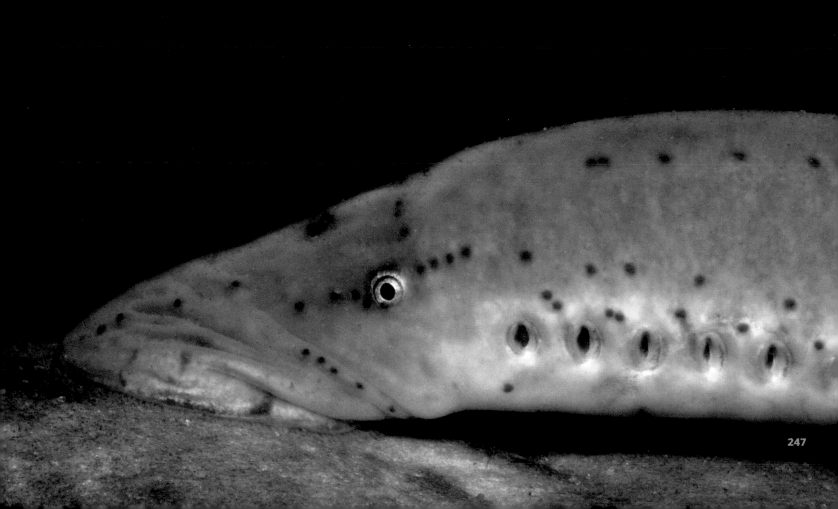

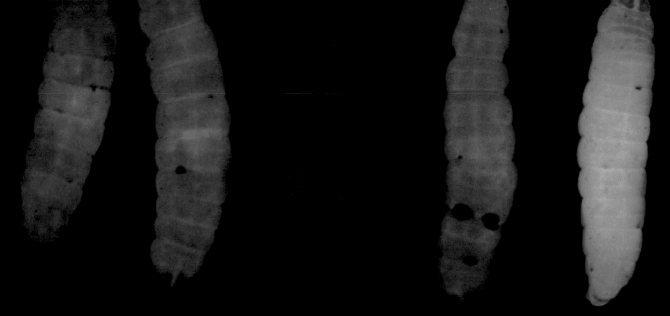

An intricate series of interactions led to these glowing dead moth grubs (*top*). It all began when a predatory nematode, *Heterorhabditis bacteriophora*, bored into the body cavity of the live grub. The nematode carries symbiotic bacteria (in this case, a bioluminescent *Photorhabdus* cf. *luminescens*) in its gut, and it expels some of these bacteria inside the grub. The bacteria proliferate, killing and digesting the grub, glowing all the while. The nematode feeds on both the decomposing grub and the bacteria, ultimately depositing eggs in the grub. The hatchling nematodes inoculate their guts with the bacteria, then move out of the corpse and hunt on their own. The bacteria appear to be obligate symbionts with the nematode—they have been found only in nematode guts and in glowing grub corpses. Photographed in 2007. Some leeches are parasites, and that is how we generally think of them. The leech shown here (*bottom*) was observed in Lost Maples State Natural Area, Bandera County, Texas, USA, while feeding on the tail of a tadpole. Many leeches spend their time hiding below objects, out of sight until a host presents itself. Further Reading: Poinar, 1975.

Among the most unusual experiences my colleagues and I had during the Subterranean Biodiversity Project came while visiting a cave in the Ozark Mountains of eastern Arkansas. After entering the cave, we noticed that the walls were covered by dozens of silver-white rings, ranging from 3 to 10 inches (7.62 to 25.4 centimeters) in diameter (*bottom*). On closer inspection, we found that each ring had a dead fly at its center. The rings were made of fungal hyphae. It is not clear whether this fungus is a species of predatory fungus of the genus *Cordyceps* or something else entirely. A subsequent caving trip in Alabama produced a similar find with a dead cave cricket, *Ceuthophilus* sp. (*top*), apparently killed and consumed by a predatory fungus.

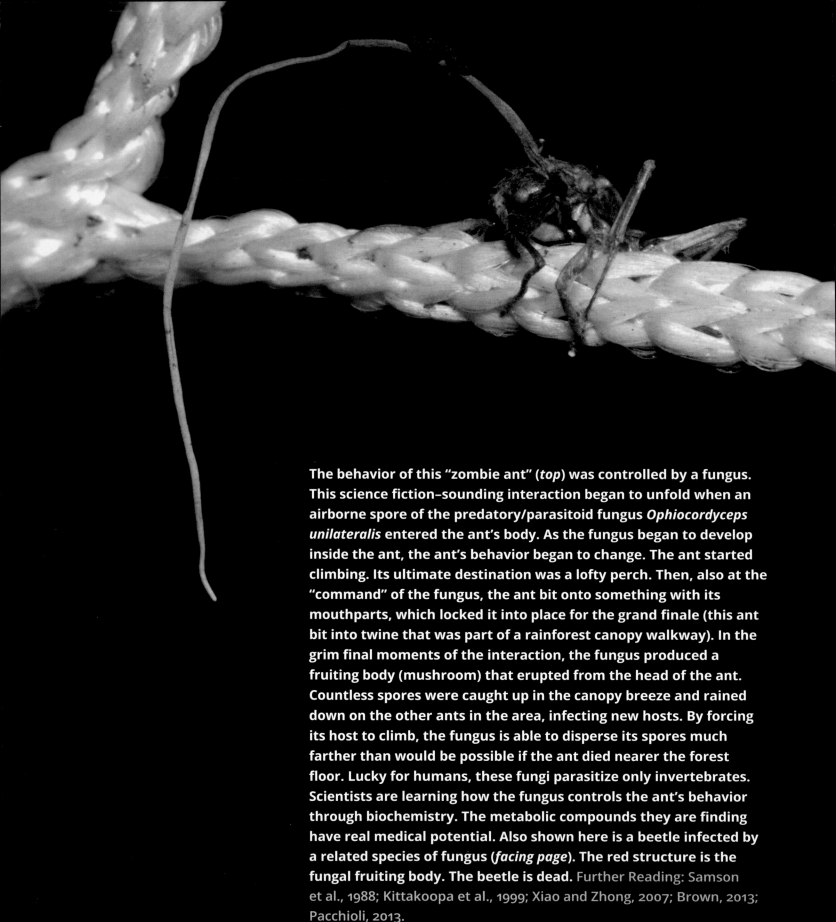

The behavior of this "zombie ant" (*top*) was controlled by a fungus. This science fiction–sounding interaction began to unfold when an airborne spore of the predatory/parasitoid fungus *Ophiocordyceps unilateralis* entered the ant's body. As the fungus began to develop inside the ant, the ant's behavior began to change. The ant started climbing. Its ultimate destination was a lofty perch. Then, also at the "command" of the fungus, the ant bit onto something with its mouthparts, which locked it into place for the grand finale (this ant bit into twine that was part of a rainforest canopy walkway). In the grim final moments of the interaction, the fungus produced a fruiting body (mushroom) that erupted from the head of the ant. Countless spores were caught up in the canopy breeze and rained down on the other ants in the area, infecting new hosts. By forcing its host to climb, the fungus is able to disperse its spores much farther than would be possible if the ant died nearer the forest floor. Lucky for humans, these fungi parasitize only invertebrates. Scientists are learning how the fungus controls the ant's behavior through biochemistry. The metabolic compounds they are finding have real medical potential. Also shown here is a beetle infected by a related species of fungus (*facing page*). The red structure is the fungal fruiting body. The beetle is dead. Further Reading: Samson et al., 1988; Kittakoopa et al., 1999; Xiao and Zhong, 2007; Brown, 2013; Pacchioli, 2013.

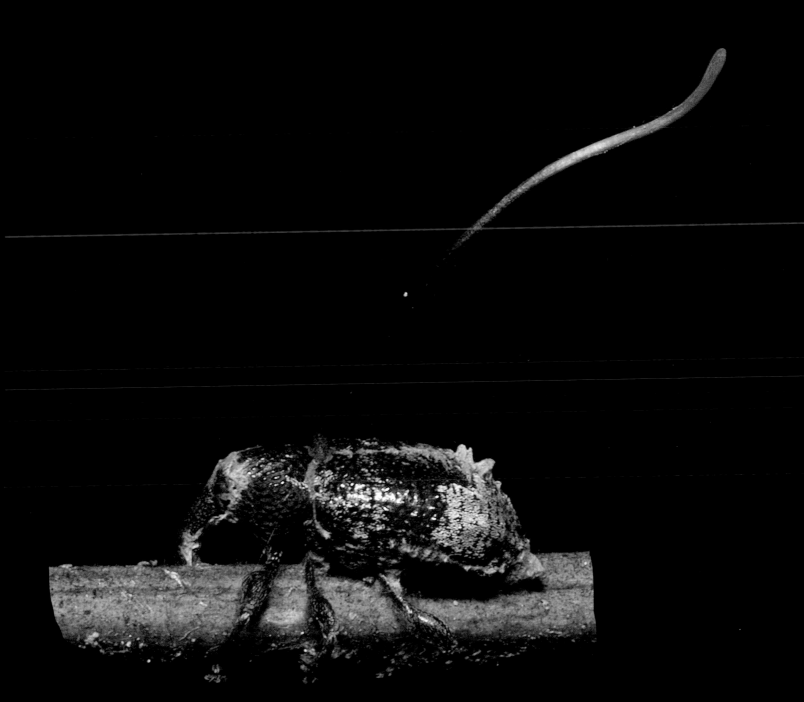

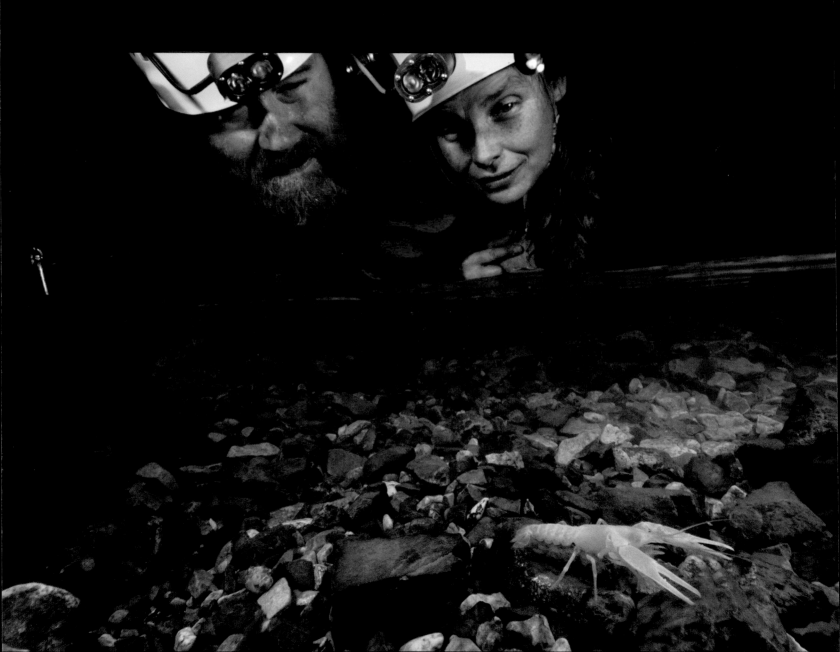

I have struggled mightily to understand why so many humans cannot see the irreparable damage we are doing to the environment. I find myself asking why these people do not consider the consequences of our unrelenting collective destructive behaviors on future generations. These questions have led me to read about some widely divergent hypotheses in disciplines including human behavior and psychology— all in a search to understand why we are the way we are. I wish I had an answer for you, but I do not. I have connected with some arguments more than others, but, in my mind, none has entirely explained our self-destructive tendencies. However, I did come across an interesting argument that managed to bring into the fold evolution, psychology, and the human brain.

Almost 50 years ago, Arthur Koestler described the evolution of the human brain as a hasty process that expanded around primitive brain structures—an increase of brain size in hominids occurring in a relatively short span of evolutionary time. Koestler felt that the major problem with the process was that it never got rid of the relict components, the parts we inherited from primeval lineages. He argued that the process had left a dysfunctional relationship between old and new portions of the brain. He aptly termed this "the ghost in the machine." His hypothesis stated that the primitive parts of the human brain can override the more contemporary portion that promotes reason, logic, and compassion. When this happens, it allows the terrible things we see humans do today that defy everything the more recently evolved components of the brain would have promoted (Koestler, 1967).

Koestler's "ghost in the machine" may or may not exist; but there sure do seem to be a lot of people working overtime to support his argument, or an argument along similar lines.

Precisely because there are those that do not appreciate life on our planet, we must celebrate this life. The images in this book have been assembled to both celebrate biodiversity and stir people to action. Our natural environment is disappearing day by day. Biodiversity is being

Keeping track of populations of endangered wildlife is a big job. Biologists struggle to monitor critically endangered species in their habitats. Here, cave biologists are performing a head count of cave crayfish in the Ozarks of Oklahoma, USA. The Oklahoma Cave Crayfish, *Cambarus tartarus*, is known from only three cave systems and nowhere else on Earth. Its limited habitat is threatened by surface development and contamination of the groundwater where it lives.

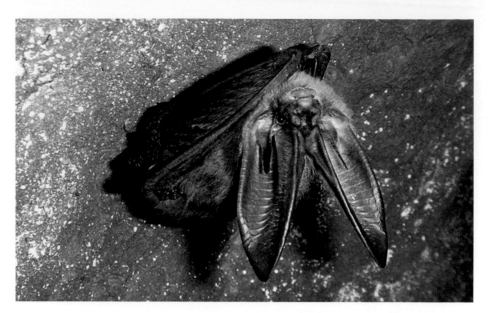

The Ozark Big-eared Bat, *Corynorhinus townsendii ingens*, is an endangered species that has suffered serious population declines. This is certainly one of the strangest-looking faces one could encounter in a cave. Further Reading: Graening et al., 2011.

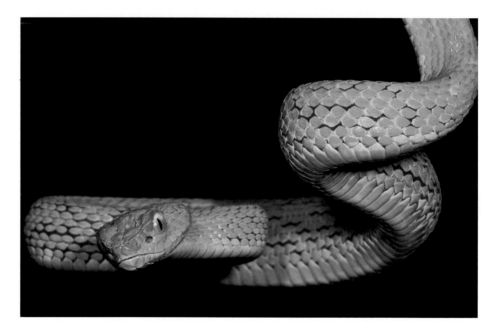

Animal species all over the world are in danger of extinction. Venomous snakes are no exception. The Mexican Palm-Pitviper, *Bothriechis rowleyi*, inhabits elevated forests, approximately 4,900 to 6,000 feet (1,500 to 1,830 meters) above sea level, but its habitat is vanishing rapidly. The International Union for Conservation of Nature lists the species as vulnerable. It is hard enough to raise money to save something furry and cuddly like a panda; consider the difficulties in raising money to protect a venomous snake such as this one. Photographed courtesy of the San Antonio Zoo, April 2013. Further Reading: Campbell and Lamar, 2004.

lost irreparably. Humanity is driving a global mass extinction event that will dwarf the one that eliminated the dinosaurs. But it's not too late to do something. Some of these unique organisms are doomed, their habitats too far gone to retrieve, but others can still be saved. Funding is a major hurdle to environmental efforts. Donate to any environmental cause with which you connect. Encourage your family and friends to do so as well. Check backgrounds and choose wisely.

It should come as no surprise—and I have made it explicit in places—that many of the species depicted in this book are encountering serious problems. Deep-sea species face contamination from things like oil spills, a never-ending rain of human trash, and damage from destructive fishing practices. Subterranean communities that live in groundwater face overharvesting of the water (drying out their habitats) and contamination of the water that remains. The dry, savannah-like habitats where many termite mounds abound are frequently labeled as "waste lands," and active efforts to develop these habitats or convert them to agriculture result in removal of the termite mounds and the biological diversity they support. All of these problems put biodiversity at risk—even in dark places.

Why is biodiversity important? I could say that biodiversity should be saved for its own sake, for its beauty alone—which is my personal belief. I could discuss the intricate connections between food webs around the world and explain how removing key elements of these webs will bring on devastating collapses and ripple effects—which will affect all life on our planet. But there are more pragmatic and short-term reasons for wanting to save biodiversity. I'll use amphibians as an example to explain why saving biodiversity is in the best interests of everyone. To do this, I first need to explain a little bit about amphibians.

The earliest amphibians made the transition from the water to the land, able to do so partly because they could breathe through their skin. That ability allowed them to leave the water and exploit resources on the land. They no longer required gills and an aquatic environment

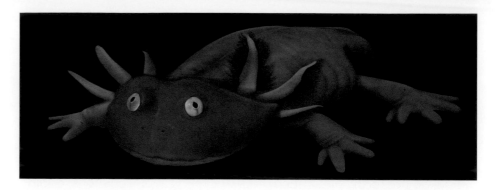

Amphibians were the group of vertebrates that made the transition from the water to the land. This extinct Triassic amphibian, *Gerrothorax*, was redrawn by Mark Mandica from an illustration by Stanton F. Fink.

to survive. All living amphibians have a permeable skin, which simply means that gases and water can freely pass through it, and the process requires virtually no expenditure of energy. To maintain this permeability, amphibians need to be moist. But moist skin can create problems. It is a great place for bacteria and fungi to grow. One hypothesis holds that at some relatively early evolutionary stage, amphibians responded to the problem with the appearance of granular glands. Granular glands are microscopic structures embedded in the skin that secrete toxins onto the animal's body surface, keeping microbes at bay. All living amphibians have granular glands, and many species produce unique blends of antimicrobial toxins. And therein lies a pragmatic reason for humans to do everything possible to keep amphibians (and biodiversity in general) around.

Medical biochemists and other research scientists are just beginning to open the storehouse of biochemically active compounds in amphibian skin secretions. Quite literally, amphibians constitute a pharmaceutical treasure chest. Many amphibian skin secretions hold the promise of treating human diseases; some chemicals are already in the testing or trial phase. To understand why these substances could be so useful, it helps to understand the history behind the antibiotic-resistance problem.

Hospitals and convalescent facilities are plagued with antibiotic-resistant strains of bacteria. We are down to a single antibiotic that is usually effective against resistant strains of *Staphylococcus*, the bacteria that cause "staph infections." Resistant bacterial strains can be deadly. My father's best friend entered a southern California hospital with a

bad case of poison oak and died days later with an antibiotic-resistant staph infection that he contracted in the hospital. How did bacteria become resistant to antibiotics that once killed them efficiently?

In essence, we have created "super bugs." More often than you'd think, people do not follow prescribed antibiotic medication regimens, ending them early while some bacteria—the strongest and most resistant—remain in their body. Mutations in the surviving bacteria give them some level of resistance to the antibiotic. As a result, new regimens of the antibiotic are not quite as effective. The cycle continues. At some

The Giant Monkey Frog, *Phyllomedusa bicolor*, is a canopy-dwelling frog of the Amazon Basin. The Matses Amerindians of the region along the Peru-Brazil border use this frog for "hunting magic." The toxins from the frog are introduced into an open wound (from a burn). The initial reaction is violent, and the user becomes very sick and vomits. After the sickness passes, the user allegedly has enhanced senses, including improved hearing, sight, smell, and stamina. Many Westerners would dismiss all of this as nonsense, but a landmark paper published in the *Proceedings of the National Academy of Sciences* in 1992 details how the bioactive peptides in the frog's skin secretion could potentially enhance the senses through manipulation of biochemical pathways, producing a result just like the one the Amerindians claim. Further Reading: Daly et al., 1992; Gorman, 1993; Slack, 1993; Milton, 1994; Lyttle, 1995.

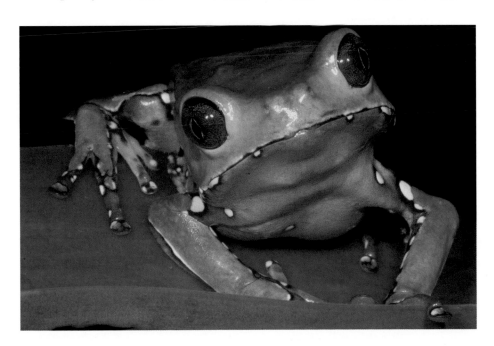

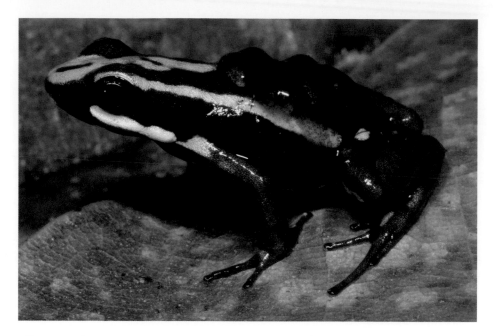

All poison frogs produce skin toxins, and most have gaudy colors and patterns, such as *Epipedobates tricolor*, shown here; this "aposematic" coloration warns potential predators of the animal's toxicity. Some poison frogs have dangerous compounds in their skin called batrachotoxins; others have less toxic compounds. Each species produces a unique blend of toxic compounds, and more than 200 toxins have been identified from the frog family Dendrobatidae alone. The toxins tend to have specific effects when they enter the vertebrate system; for example, a toxin from one species blocks pain. Not surprisingly, scientists have taken an interest in the toxins for use as potential human medicines. *Epipedobates tricolor* produces a compound called epibatidine, which, in tests on mice, was found to be 200 times more effective than morphine in blocking pain. While the compound may or may not lead to a specific human medication, it has produced dozens of studies and advances in our understanding of these toxins. Further Reading: Pennisi, 1992; Bradley, 1993.

point, bacterial forms evolve that do not respond to the medication that once would have eliminated them. As bacterial strains develop greater resistance, and these strains become more widespread, the problems will get worse for humans. In short, we are running out of antibiotics to fight the bacterial infections of our time. But all is not lost; amphibians (and biodiversity) may yet save the day.

The skin secretions of dozens of amphibians have been shown to destroy antibiotic-resistant bacterial strains, and before long, they

may provide the blueprints for new killers of deadly bacteria. Likewise, amphibian skin secretions may be used to prevent or treat cancers, chronic pain, and other ailments. There is even an amphibian skin secretion that functionally inhibits the human immunodeficiency virus, HIV, so that it cannot be transmitted across the body's mucous membranes.

We don't know anything about the skin secretions in the majority of the world's 7,000-plus amphibian species, but it is certain that countless unique compounds await discovery. Are you willing to bet that any one particular species "not worth saving" isn't the one with a skin secretion that could ultimately cure a human disease, treat a family member, or save your own life? The problem is that time is running out.

At least one-third of the world's amphibian species are in decline or have disappeared, and it's more likely that the number is closer to 50 percent. One-third of all amphibians are "data deficient," meaning that scientists don't know enough about them to know how they are doing; chances are that many of these species are in trouble as well. Habitat loss, environmental contamination, emergent infectious diseases, invasive species, overcollection of specimens, and other factors have

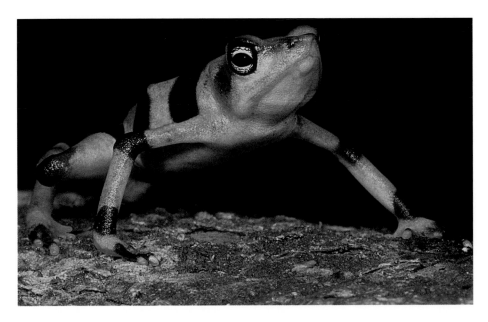

It was once commonplace to find a Golden Harlequin Toad, *Atleopus zeteki*, asleep on a leaf in the low foliage alongside a Central American creek, but the species has now vanished from the wild. Small captive populations survive, but wild individuals have not been seen since an amphibian chytrid fungus, *Batrachochytrium dendrobatidis*, proliferated in the species' range in Central America. Countless species of amphibians are being lost to this rapidly spreading infectious disease.

driven the declines around the globe (Longcore et al., 1999; Daszak et al., 1999, 2000, 2003; Stuart et al., 2004; Mendelson et al., 2006; Gascon et al., 2007; Collins and Crump, 2009). Nearly all of the species in decline suffer from anthropogenic—human-generated—activities. For example, humans' transport of frogs around the globe may be one way that diseases have been introduced to native amphibian populations— those never before exposed to that disease. That is to say, humans have probably transmitted some amphibian diseases around the globe through the sale of frogs for the pet trade, for use by the research/ biomedical community, and for consumption or cultivation. For many years, frogs were also transported worldwide to be used in pregnancy testing. Several of the frog species that have been globally transshipped harbor deadly fungal, viral, or bacterial infections. These infections have wrought havoc with native amphibian communities around the world.

As a quick exercise, make a written inventory of the medicines in your bathroom cabinet, then go online to check the origins of each. Most will have come directly from nature. Think about the example I just provided and then substitute any group of organisms. So much of the world's biodiversity is in trouble that the wildlife group you substituted will probably have a similar story.

There is no telling where the next cure for a human disease will come from. Even the most unlikely life forms may provide amazing chemicals. For example, bacteria from soil have recently produced a novel antibiotic called teixobactin that kills disease-causing bacteria in a way that may not allow the pathogenic bacteria to develop resistance (Ling et al., 2015). This discovery provides hope in the race to develop new antibiotics before humanity suffers from uncontrollable bacterial infections. Perhaps the greatest diversity of chemical defenses is to be found in coral reefs, not to mention elsewhere in the oceans. Which life form will provide a substance that conquers a cancer? Which animal will produce a chemical that treats heart disease? Is there an organism out there that produces a chemical that would eliminate some addictions?

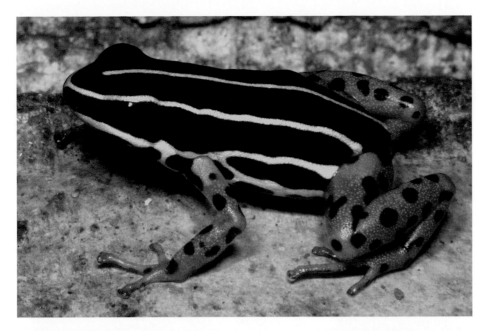

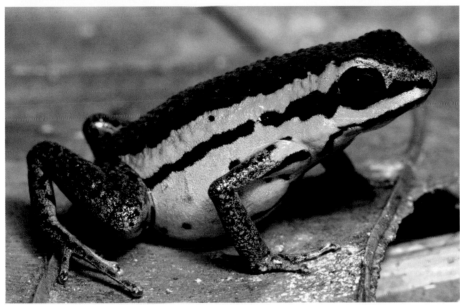

Poison frogs of the family Dendrobatidae produce a diverse array of skin toxins. The origin of the skin toxins in this group of amphibians has been something of a mystery; however, when a bird from Indo-Australia proved to produce the same lethal toxins as poison frogs from Colombia, researchers had a lead with which to work. The bird may get its toxins from eating Melyrid beetles, something the frogs may do as well. Researchers are currently developing techniques to replicate the compounds and make them available for use in human medications. In the meantime, these frogs—and biodiversity in general—are a pharmaceutical treasure chest well worth keeping around. Further Reading: Daly et al., 1978, 1987; Myers et al., 1978; Neuwirth et al., 1979; Dumbacher et al., 1992, 2004; Jønsson et al., 2008.

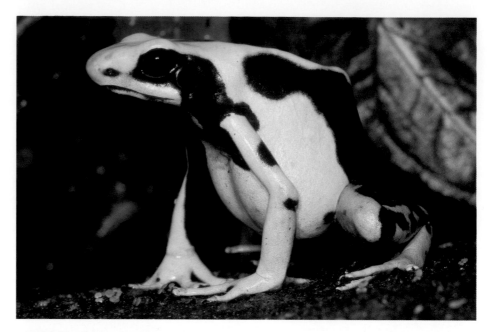

"Tapirage" is the process by which Amerindian groups such as the Achagua, Carib, Mojo, and Tupinamba are said to have changed the color of parrots' feathers. The process allegedly involved plucking the green feathers from a live parrot and rubbing the plucked area with the skin secretions or blood of this frog, *Dendrobates tinctorius*. The new feathers that grew in to replace the plucked ones were yellow or red rather than green. The process is well illustrated in the older literature, but modern scientists have not yet replicated the process or seen it demonstrated. Further Reading: Eder, 1791; Gilmore, 1946; Métraux, 1946a, 1946b.

While I'd much prefer not to express the value of biodiversity in terms of human gain, it is the only argument some people will accept. Humanity simply cannot afford to turn its back on biodiversity. Our very future depends on it. But don't take my word for it; look through this book's appendix, which lists some literature on amphibian skin secretions and biomedical research (and only scratches the surface of this topic), and decide for yourself.

As you might predict, of course, the transition from a natural extract to a medicine is a lengthy and expensive process. A particular chemical compound that is showing promise may be mixed in with dozens or even hundreds of other compounds. Isolating the important

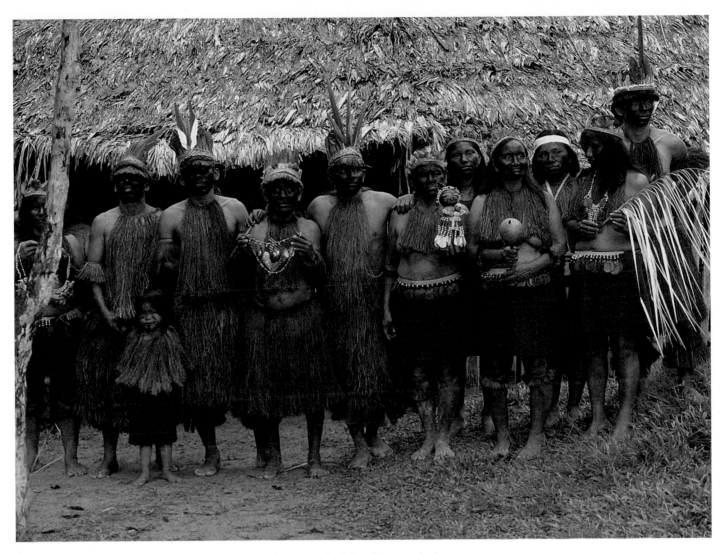

"Westernization" of indigenous cultures and removal of the forests their people inhabit have put these cultures in jeopardy. By destroying the forests, we aren't just losing the myriad forms of wildlife; we are losing unique human cultures and their understanding of the environment.

compound is difficult, and replicating it in an economically feasible way may as yet be impossible (Conniff, 2012). However, much more efficient technology is always being developed, and if we don't conserve our biodiversity today, this technology will have no natural reservoirs from which to draw.

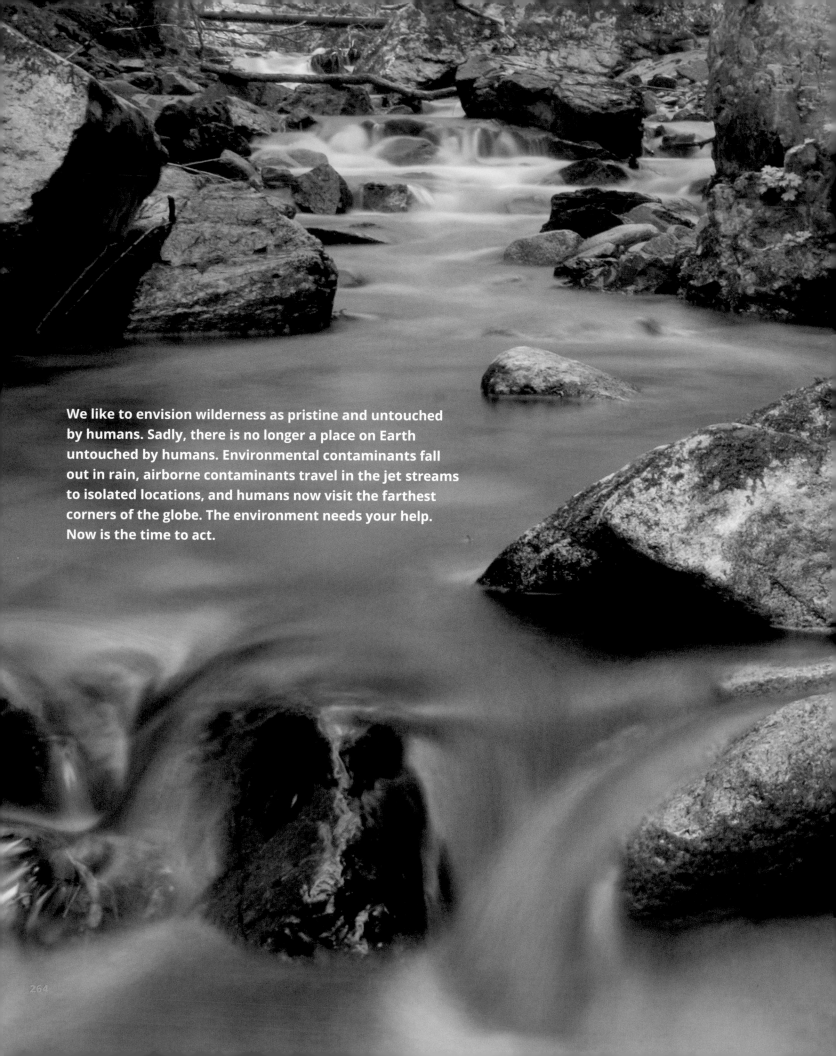

We like to envision wilderness as pristine and untouched by humans. Sadly, there is no longer a place on Earth untouched by humans. Environmental contaminants fall out in rain, airborne contaminants travel in the jet streams to isolated locations, and humans now visit the farthest corners of the globe. The environment needs your help. Now is the time to act.

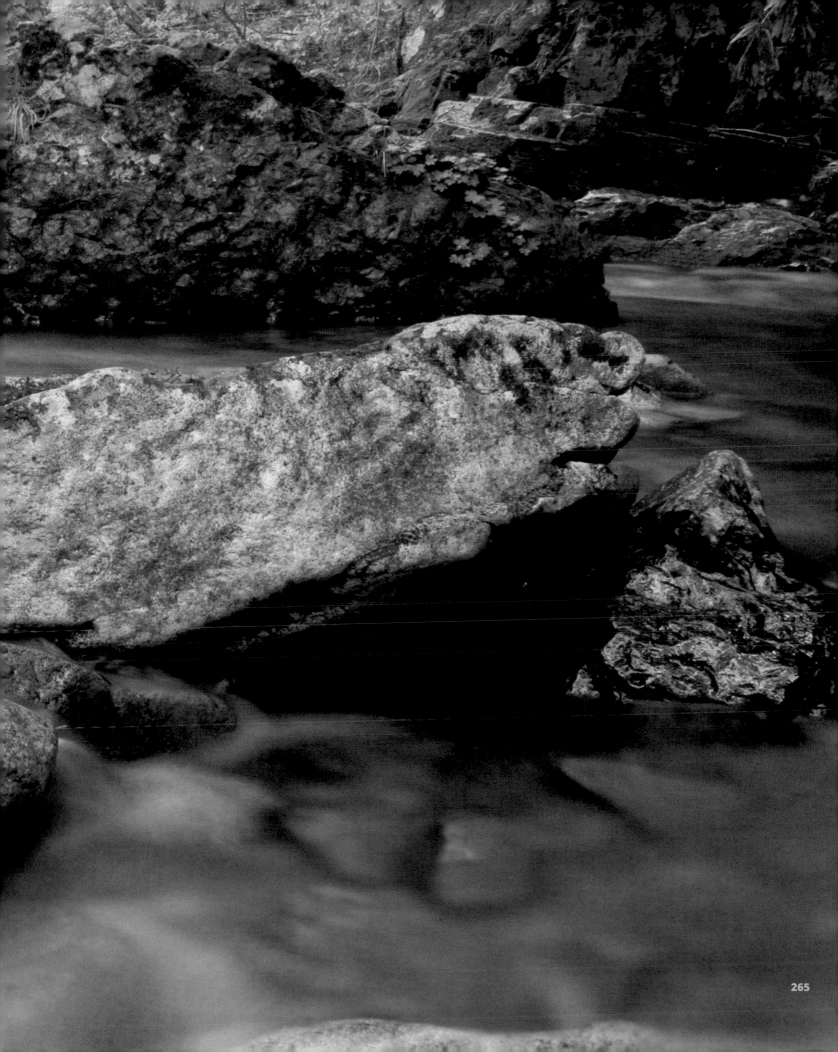

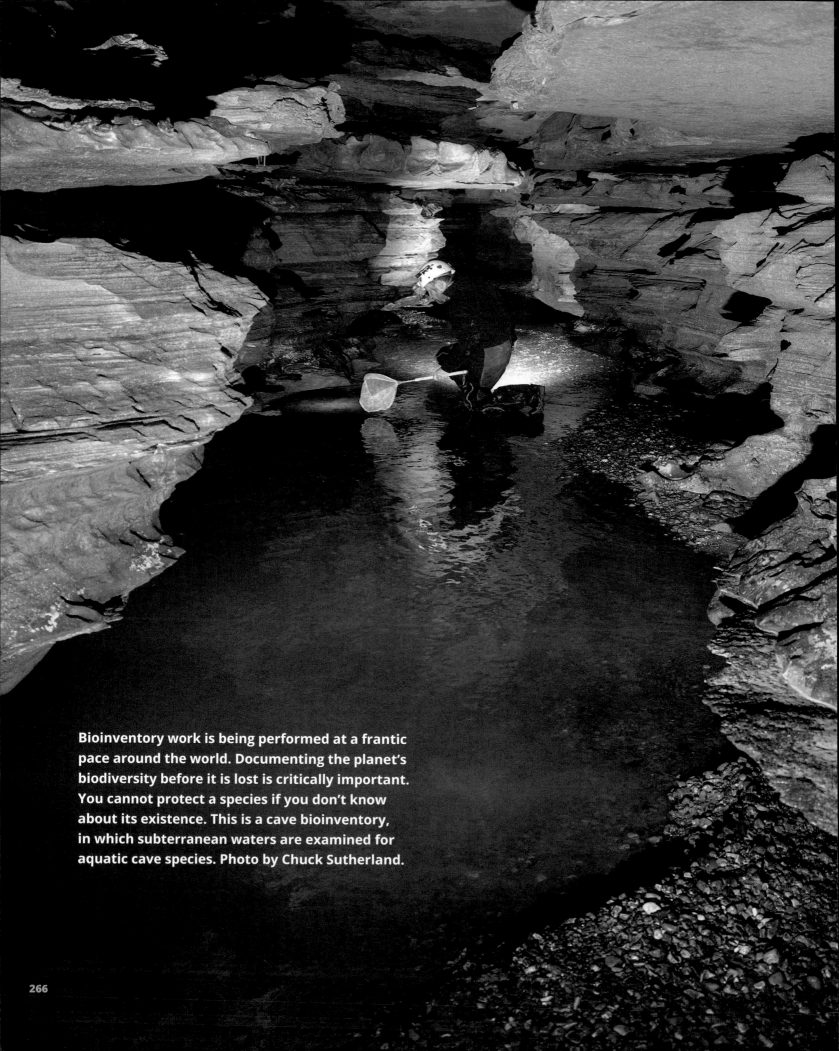

Bioinventory work is being performed at a frantic pace around the world. Documenting the planet's biodiversity before it is lost is critically important. You cannot protect a species if you don't know about its existence. This is a cave bioinventory, in which subterranean waters are examined for aquatic cave species. Photo by Chuck Sutherland.

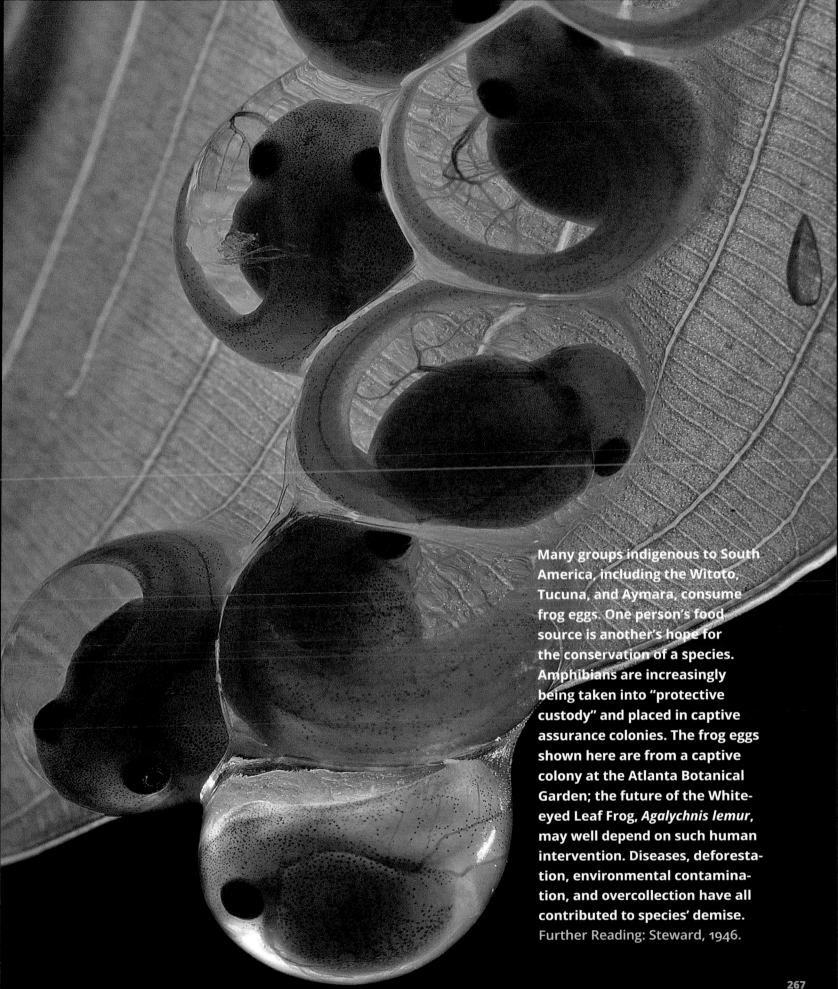

Many groups indigenous to South America, including the Witoto, Tucuna, and Aymara, consume frog eggs. One person's food source is another's hope for the conservation of a species. Amphibians are increasingly being taken into "protective custody" and placed in captive assurance colonies. The frog eggs shown here are from a captive colony at the Atlanta Botanical Garden; the future of the White-eyed Leaf Frog, *Agalychnis lemur*, may well depend on such human intervention. Diseases, deforestation, environmental contamination, and overcollection have all contributed to species' demise. Further Reading: Steward, 1946.

Traditional medicine has taken a tremendous toll on the world's wildlife. In particular, belief systems in which esteemed animals are consumed for their supposed qualities or characteristics have focused on King Cobras, tigers, rhinos, pangolins, and many other species. While there is absolutely no evidence to support consumption of specific body parts to either cure disease or enhance physical qualities, the belief systems remain strong today. The illegal harvest of wildlife to support these customs will undoubtedly lead to countless extinctions of the Earth's fauna. This old apothecary vessel (*bottom*), photographed in Guangxi, China, is filled with snake heads—among them, King Cobras—preserved in alcohol. By drinking the "snake wine," the consumer is believed to attain the strength and vitality of the snake. Development of a conservation ethic at a young age is critical if the Earth's biodiversity is to be preserved (*top, right*).

An aged traditional medicine street vendor in Southeast Asia explained to me that the Tokay Gekko, *Gekko gecko*, is believed to be of use in treating Human Immuno-deficiency Virus (HIV) in humans. The lizards are dried and then ground up and added to a tea. No evidence has emerged to support any benefit from this treatment for HIV. The medicinal beliefs surrounding the lizard are now beginning to include other ailments with long-established histories in humans, such as diabetes. The lizards are becoming more difficult to find because the demand skyrocketed as soon as the belief system targeted the species. The street vendor explained that the lizard had not been sought after for the traditional medicine market just 10 or 20 years ago. In other words, the demand for the lizard, with regard to traditional medicine, is recent. If traditional medicine continually includes species that were otherwise not harvested what I call "species drift"), moving from the unavailable to the available, then we can expect heavy collecting pressures to shift as availability shifts. In as much, species drift is a mechanism through which traditional medicine belief systems will continue to serve as a major cause of wildlife declines by targeting previously unexploited species.

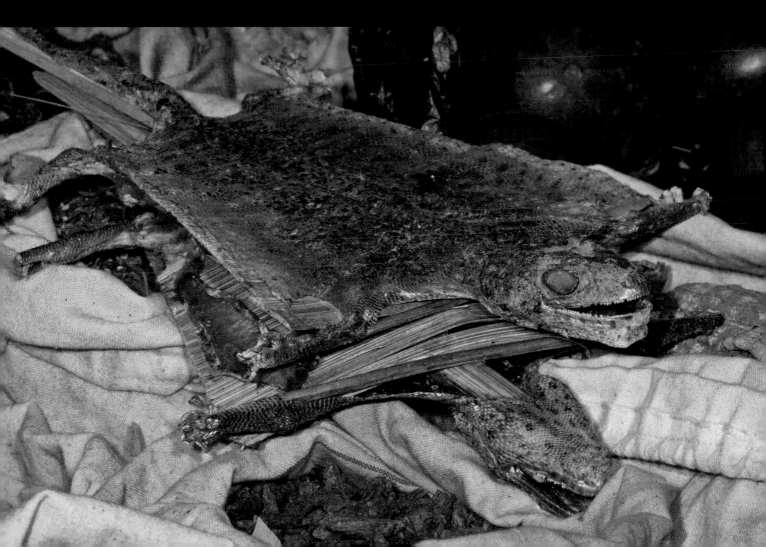

John Edmonstone, a former slave from Guyana, taught taxidermy to Charles Darwin in Edinburgh and regaled him with tales of the sunny tropical rainforests of South America. Later, Darwin jumped at the chance to join Captain Robert FitzRoy on HMS *Beagle* as the expedition's naturalist. Instead of sunshine, however, he found himself in the incessant rains and gray mists enveloping the gloomy forests of Tierra del Fuego and southern Chile's coastline. A bit farther north, on November 26, 1834, the rains ceased, and the ship's company glimpsed glacier-capped Volcán Osorno billowing smoke over the Andes. They set out through pounding storms to explore the coast of Chiloe Island by yawl and whale boat. That evening, they anchored in a lovely cove north of Isla Caucahue, next to the lush ferns and mosses of what Darwin described as "one impervious blackish-green forest." Later, while exploring the forests of nearby Valparaiso, he discovered a strange and beautiful creature and described it in his journal: "Nose finely pointed. Jumps like a frog. Inhabits gloomy forest." He was referring to what is now called Darwin's Frog, *Rhinoderma darwinii* (*lower left*). These frogs often live in forests dominated by Southern Beech Trees, *Nothofagus* spp. (*right*). These magnificent trees, which can live for hundreds of years, are vanishing along with the temperate rainforests of southern Chile, and all of the wildlife found only within these forests. Further Reading: Darwin 1989 [1839].

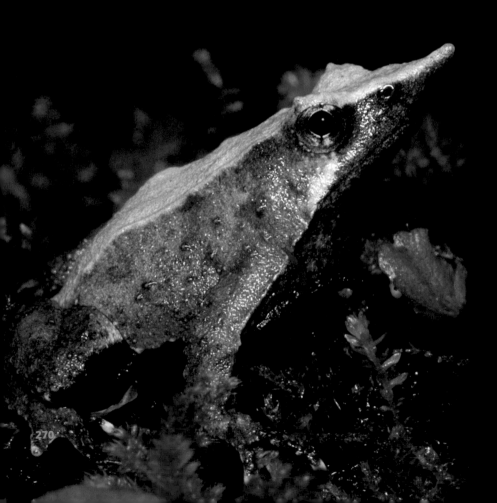

270

The Common Snapping Turtle, *Chelydra serpentina*, ranges
across North America east of the Rocky Mountains with
some populations as far north as Canada. In the southwest,
they range into Texas and inhabit spring-fed drainage
systems in otherwise dry habitat. Captive animals have
exceeded 80 pounds and had a shell length approaching
2 feet (0.6 meters). This individual was captured during
a turtle survey at Comal Springs, Bexar County, Texas, in
2013. Turtles are in trouble around the globe, and surveys
such as these aim to document current abundance
patterns for future comparisons.

Environmental insults come in a variety of forms, and for many habitat types "death by a thousand cuts" has been the name of the game. But that is not always the case. For those who may wonder how threatened subterranean biological communities really are, consider this . . . the cave formations depicted here were for sale in Asia by a vendor who had formations from many different caves. There were at least a dozen vendors like him in this small town, and there are hundreds of small towns in this region. It adds up. This is the equivalent of the wholesale removal of an entire habitat, cave by cave. And this is just the formations. With all of the limestone mining in the region, entire mountains are disappearing. The limestone goes to make cement, floor tiles, and counter tops. The formations are sold to decorate homes and offices.

This book is intended to get you thinking, not only about the biodiversity of darkness, but about the environment that supports all of us. Seeing the amazing life forms in person has stirred my emotions, and I hope the images I shared have stirred yours too. While photographing the book's subjects I have met an army of amazing conservation workers striving to save them and what remains of our beautiful planet. And I know they all need help. I feel certain there is a conservation project out there that matches your strongest interest. Perhaps the project that does was mentioned in this book? Perhaps not, for there are many. My closing message is a request, a plea really, that we not only marvel at life's wonder, but also do our part to preserve it. Your contribution to conservation, whatever it may be, will pay dividends for generations to come.

Amphibian Skin Secretions and Potential Use by Humans: A Short Bibliography

Bepler, G., D. N. Carney, A. F. Gazdar, and J. D. Minna. 1987. In vitro growth inhibition of human small cell lung cancer by physalaemin. *Cancer Research* 47(9): 2371–2375.

Brinkworth, C. S., J. H. Bowie, M. J. Tyler, and J. C. Wallace. 2002. A comparison of the antimicrobial skin peptides of the New Guinea Tree Frog (*Litoria genimaculata*) and the Fringed Tree Frog (*Litoria eucnemis*). *Australian Journal of Chemistry* 55(9): 605–610.

Conlon, J. M. 2004. The therapeutic potential of antimicrobial peptides from frog skin. *Reviews in Medical Microbiology* 15: 17–25.

Conlon, J. M., J. Kolodziejek, and N. Nowotny. 2004. Antimicrobial peptides from ranid frogs: taxonomic and phylogenetic markers and a potential source of new therapeutic agents. *Biochimica et Biophysica Acta* 1696: 1–14.

Conlon, J. M., A. Sonnevend, A. Davidson, A. Demandt, and T. Jouenne. 2005. Host-defense peptides isolated from the skin secretions of the Northern red-legged frog *Rana aurora aurora*. *Developmental and Comparative Immunology* 29: 83–90.

Conlon, J. M., A. Sonnevend, M. Patel, V. Camasamudram, N. Nowotny, E. Zilahi, S. Iwamuro, P. F. Nielsen, and T. Pál. 2003. A melittin-related peptide from the skin of the Japanese frog, *Rana tagoi*, with antimicrobial and cytolytic properties. *Biochemical and Biophysical Research Communications* 306: 496–500.

Daly, J. W., J. Caceres, R. W. Moni, F. Gusovsky, M. Moos Jr., K. B. Seamon, K. Milton, and C. W. Myers. 1992. Frog secretions and hunting magic in the Upper Amazon: identification of a peptide that interacts with an adenosine receptor. *Proceedings of the National Academy of Sciences* 89: 10,960–10,963.

Dennison, S. R., F. Harris, and D. A. Phoenix. 2007. The interactions of aurein 1.2 with cancer cell membranes. *Biophysical Chemistry* 127(1–2): 78–83.

Doyle, J., C. S. Brinkworth, K. L. Wegener, J. A. Carver, L. E. Llewellyn, I. N. Olver, J. H. Bowie, P. A. Wabnitz, and M. J. Tyler. 2003. nNOS inhibition, antimicrobial and anticancer activity of the amphibian skin peptide, citropin 1.1 and synthetic modifications. *European. Journal of Biochemistry* 270(6): 1141–1153.

Doyle, J., L. E. Llewellyn, C. S. Brinkworth, J. H. Bowie, K. L. Wegener, T. Rozek, P. A. Wabnitz, J. C. Wallace, and M. J. Tyler. 2002. Amphibian peptides that inhibit neuronal nitric oxide synthase. *European. Journal of Biochemistry* 269(1): 100–109.

Erspamer, V., P. Melchiorri, E. G. Falconieri, P. C. Montecucchi, and R. de Castiglione. 1985. *Phyllomedusa* skin: a huge factory and store-house of a variety of active peptides. *Peptides* 6(Suppl. 3): 7–12.

Giacometti, A., O. Cirioni, W. Kamysz, C. Silvestri, M. S. Del Prete, A. Licci, G. D'Amato, J. Tukasiak, and G. Saclise. 2005. In vitro activity and killing effect of Citropin 1.1 against gram-positive pathogens causing skin and soft tissue infections. *Antimicrobial Agents and Chemotherapy* 49(6): 2507–2509.

Giacometti, A., O. Cirioni, W. Kamysz, C. Silvestri, A. Licci, G. D'Amato, P. Nadolski, A. Riva, J. Lukasiak, and G. Scalise. 2005. In vitro activity and killing effect of Uperin 3.6 against gram-positive cocci isolated from immunocompromised patients. *Antimicrobial Agents and Chemotherapy* 49(9): 3933–3936.

Lazarus, L. H., S. D. Bryant, A. Martti, and S. Severo. 1994. Frog skin opioid peptides: a case for environmental mimicry. *Environmental Health Perspectives* 102(8): 648–654.

Libério, M. S., G. A. Joanitti, R. B. Azevedo, E. M. Cilli, L. C. Zanotta, A. C. Nascimento, M. V. Sousa, O. R. Pires Jr., W. Fontes, and M. S. Castro. 2009. Anti-proliferative and cytotoxic activity of pentadactylin isolated from *Leptodactylus labyrinthicus* on melanoma cells. *Amino Acids* 40(1): 51–59.

Lu, Y., J. Li, H. Yu, X. Xu, J. Liang, Y. Tian, D. Ma, G. Lin, G. Huang, and R. Lai. 2006. Two families of antimicrobial peptides with multiple functions from skin of rufous-spotted torrent frog, *Amolops loloensis*. *Peptides* 27(12): 3085–3091.

Maclean, M. J., C. S. Brinkworth, D. Bilusich, J. H. Bowie, J. R. Doyle, L. E. Llewellyn, and M. J. Tyler. 2006. New caerin antibiotic peptides from the skin secretion of the Dainty Green Tree Frog *Litoria gracilenta*: identification using positive and negative ion electrospray mass spectrometry. *Toxicon* 47(6): 664–675.

Mangoni, M. L., G. Maisetta, M. D. Luca, L. M. H. Gaddi, S. Esin, W. Florio, F. L. Brancatisano, D. Barra, M. Campa, and G. Batoni. 2008. Comparative analysis of the bactericidal activities of amphibian peptide analogues against multi-drug-resistant nosocomial bacterial strains. *Antimicrobial Agents and Chemotherapy* 52(1): 85–91.

Papo, N., and Y. Shai. 2005. Host defense peptides as new weapons in cancer treatment. *Cellular and Molecular Life Sciences* 62(7–8): 784–790.

Prates, M. V., M. L. Sforça, W. C. B. Regis, J. R. S. A. Leite, L. P. Silva, T. A. Pertinhez, A. L. T. Araújo, R. B. Azevedo, A. Spisni, and C. Bloch Jr. 2003. The NMR-derived solution structure of a new cationic antimicrobial peptide from the skin secretion of the anuran *Hyla punctata*. *Journal of Biological Chemistry* 279(13): 13,018–13,026.

Rozek, T., J. H. Bowie, J. C. Wallace, and M. J. Tyler. 2000. The antibiotic and anticancer active aurein peptides from the Australian Bell Frogs *Litoria aurea* and *Litoria raniformis*. Part 2. Sequence determination using electrospray mass spectrometry. *Rapid Communications in Mass Spectrometry* 14(21): 2002–2011.

VanCompernolle, S. E., R. J. Taylor, K. Oswald-Richter, J. Jiang, B. E. Youree, J. H. Bowie, M. J. Tyler, et al. 2005. Antimicrobial peptides from amphibian skin potently inhibit human immunodeficiency virus infection and transfer of virus from dendritic cells to T cells. *Journal of Virology* 79(18): 11,598–11,606.

Wong, H., J. H. Bowie, and J. A. Carver. 1997. The solution structure and activity of caerin 1.1, an antimicrobial peptide from the Australian green tree frog, *Litoria splendida*. *European Journal of Biochemistry* 247(2): 545–557.

Zhou J., S. McClean, A. Thompson, Y. Zhang, C. Shaw, P. Rao, and A. J. Bjourson. 2006. Purification and characterization of novel antimicrobial peptides from the skin secretion of *Hylarana guentheri*. *Peptides* 27(12): 3077–3084.

The **abyssopelagic zone** of the ocean extends from the bottom of the bathypelagic zone, 13,123 feet (4,000 meters) below the surface, down to 19,685 feet (6,000 meters). Sunlight does not penetrate into this zone.

Allochthonous refers to something that is found in a place where it did not originate. For example, nutrient (and thus energy) inputs to subterranean habitats and their food webs are often allochthonous in that they did not originate in the cave; examples include bat guano, cricket frass, and nutrients washed down from surface habitats.

Amerindians are peoples that are native or indigenous to the Americas, generally referring to any group in the Americas prior to European colonization.

Amphisbaenians are squamate (scaled) reptiles related to lizards and snakes. They are burrowers and thus live a fossorial lifestyle.

A **barbel** is the pole-like structure extending from the upper or lower jaws of fish (dragonfishes, some female anglerfishes, catfishes, etc.). A bioluminescent bulb is attached to the end of the barbel in some species. It is believed to attract prey. The barbels are of various lengths, depending on the species and gender. **Barbel** is also the common name for a group of Chinese cavefishes of the genus *Sinocyclocheilus*.

The **bathypelagic zone** of the ocean extends from the bottom of the mesopelagic zone, 3,280 feet (1,000 meters) below the surface, down to 13,123 feet (4,000 meters). Virtually no sunlight penetrates into this zone.

Bioluminescence is the biological production of light. It is sometimes known as "cold light" owing to its efficiency and its formation of very little heat.

The **biosphere** is the thin layer around the globe where life is found.

A **bulb** is the bioluminescent lure attached to the end of the barbel of a dragonfish (both sexes) and some female anglerfishes. The bulb can be a compact, discrete structure or can have any number of filamentous appendages hanging from it (these differences are species specific characteristics).

Cephalopods are a group of mollusk invertebrates that includes squid, octopus, nautilus, and cuttlefish species.

Cerrado is a seasonally dry (xeric) tropical savannah in Brazil, often peppered with termite mounds.

A **chemoautotrophic system** is a system that acquires energy from sulfur-reducing bacteria at the base of the food web. The bacteria derive their energy from chemicals (by chemosynthesis) rather than through photosynthesis.

Chemosynthesis is a process by which life forms (such as bacteria) produce carbohydrates through the oxidation of inorganic molecules, including methane and hydrogen sulfide.

Counterillumination is a defense mechanism used by organisms inhabiting the water column where some light from the surface still penetrates. Hungry predators often look upward to spot potential prey silhouetted against the dim surface light. Many midwater species have light-producing organs called photophores lining their undersides. These species produce a dim blue light in the photophores that matches the color and intensity of the faint surface glow above them. This makes the silhouette of the animal blend in with the background light—allowing the animal to "hide in plain sight" (when a predator is looking up from below).

Crustaceans are a subphylum of invertebrates that includes crabs, shrimp, lobsters, prawns, isopods, barnacles, ostracods, copepods, and amphipods.

Cryptozoic describes species inhabiting hidden, out-of-sight places.

In **deep-sea gigantism** (also known as "abyssal gigantism"), life forms that are relatively small in shallow waters have deep-sea relatives that are far larger, sometimes orders of magnitude larger.

Dinoflagellates are small, single-celled organisms. Some move through the water using a structure called a dimorphic flagellum. Some dinoflagellates contain chloroplasts and can convert sunlight to chemical energy by photosynthesis. Because of the abundance of these organisms in the ocean, and because they carry out photosynthesis, they form part of the base of many oceanic food webs and produce a significant portion of the oxygen in our atmosphere. Some species are bioluminescent.

Dissolution is the dissolving process; in this book, it refers to the slow and gradual dissolving of rock units by the weak acids in rainwater.

Diurnal refers to being day-active.

A **drip pool** is collected water that has fallen from the roof of a cave into a depression. These pools are good places for biologists to look for epikarst fauna, consisting of individual animals that accidently fell from their epikarst habitat above and wound up trapped in these pools.

Electrocommunication is the use of an electrical field to communicate in otherwise dark or murky circumstances.

Electrogenic is a term used to describe fishes that generate an electric field.

Electrolocation is the use of an electrical field to navigate in dark or murky circumstances.

Electroreceptive is the ability to detect electrical fields.

Electroreceptors are structures used to detect electrical fields.

Entomopathogenic fungi are parasitoids of invertebrates. Most are host-specific and infect only one invertebrate species or several closely related species.

Epikarst is the soil and rock matrix above a subterranean passageway. Spaces in the matrix are passageways through which rainwater flows. Epikarst networks are small—too small for humans to pass through but large enough for entire communities of small animals to inhabit. Some species spend their entire lives in, and are specialists of, the epikarst. Water that passes through the epikarst makes its way to subterranean passageways.

The **epipelagic zone** of the ocean extends from the surface down to 656 feet (200 meters). This zone receives light and contains an immense concentration of phytoplankton and zooplankton.

An **esca** is the lure at the end of an illicium used by female anglerfish to attract prey. In deep--sea species, the esca is bioluminescent. The bioluminescence comes from symbiotic bacteria and is not a product of the fish's biochemistry.

A **food web** is a depiction of the organisms living in a habitat in relation to predator and prey relationships, including the consumers that feed on primary resources such as plants or bacteria. Food webs depict all of the food chains that interact for a given ecological community.

Fossorial is a word used to describe animals that live belowground, often burrowing species.

Frass is the excrement of insects. It can be an important nutrient input for some communities and food webs, such as subterranean ecosystems.

Groundwater is water under the surface of the Earth. It can be found as water in an aquifer, flowing in streams and rivers, or pooled in subterranean lakes.

Guano is the scat from bats. It can be an important nutrient resource for subterranean ecosystems and food webs.

A **guanobite** is a species associated with guano piles, and usually found only in guano piles.

The **hadopelagic zone** of the ocean includes all depths that extend below 19,685 feet (6,000 meters). These depths include the waters of deep-sea trenches and craters.

A **heteropod** is a marine snail, a type of mollusk, related to octopods and squid.

A **hydrothermal vent** is an opening in the sea floor where magma-heated, mineral-rich water spouts into the ocean. The water is rapidly cooled by the cold deep-sea water, and the minerals deposit in successive layers, forming spires of mineral deposits. As long as the super-heated water continues to flow through the spires, the spires continue to grow. Many hydrothermal vents are found along a mid-ocean ridge.

Hypogean refers to something below the Earth's surface.

An **illicium** is the fishing pole<N>like structure that extends from the head of female anglerfishes. It is a highly derived first dorsal fin ray. At the end of the illicium is the esca, or lure, used to attract prey.

The **IUCN** is the International Union for Conservation of Nature. Its work "focuses on valuing and conserving nature, ensuring effective and equitable governance of its use, and deploying nature-based solutions to global challenges in climate, food and development" (www.iucn.org). It is the oldest and largest global environmental organization in the world. The IUCN provides status rankings for much of the world's wildlife, and these ranks are used to focus conservation initiatives.

Karst is best defined in a landscape setting as regions dominated by the dissolution of rock by rainwater. The rock associated with karst is of a type that can be dissolved by weakly acidic rainwater, including limestone, gypsum, and marble. Rainwater picks up its weak acids from carbon dioxide in the air and from the soil. As the weakly acidic rainwater passes through the rock units, pathways are dissolved and increase in size over time. Some become large enough for humans to pass through—what we call "caves." Many are too small for humans to pass through.

A **leptocephalus** is a larval eel. This larval stage, living in the ocean, can last up to several years. The transforming eel then swims back into freshwater habitats to grow into a reproductively mature adult. Adults swim back out to sea to breed. The Sargasso Sea is the breeding ground for both American and European eels. Leptocephalus literally means narrow-headed.

The **mesopelagic zone** of the ocean extends from the bottom of the epipelagic zone, 656 feet (200 meters) below the surface, down to 3,280 feet (1,000 meters). The bottom portion of this zone is where surface light drops off.

An organism's **niche** describes how that species fits into its ecological environment with regard to resources, competitors, predators, prey, and so on, and into its abiotic environment with regard to temperature, light, water chemistry, and so forth.

Nocturnal refers to being active after dark.

Nyctophilia is a love of the dark.

Oligotrophic is a term used to describe habitats that are low in nutrients and have a greater amount of dissolved oxygen, including cave streams, aquifers, and high-elevation lakes.

A **parasite** is an organism that feeds off another organism, called the host, but does not kill the host.

A **parasitoid** is an organism that feeds off another organism, called the host, and ultimately kills the host.

Pelagic refers to something that lives within the water column (above the bottom and beneath the surface).

Photophores are the structures on some fish and invertebrate species that produce light through bioluminescence. Photophores often have complex structures used to reflect and direct the light.

Photosynthesis is the conversion of sunlight to chemical energy (in the form of carbohydrates), using carbon dioxide and a source of water, such as occurs in plants, dinoflagellates, and some bacteria. Oxygen is a byproduct.

A **phreatic passageway** is one that formed underwater. It was carved from the rock through dissolution.

A **phreatobite** is an organism that inhabits groundwater.

Phytoplankton is the plant portion of the assemblage of freely floating life forms that comprise plankton. Phytoplankton consists of single-celled organisms typically associated with life in the upper portions of a water column, where they are exposed to sunlight. Phytoplankton species carry out photosynthesis and form the base of many, but not all, aquatic food webs.

Poisonous refers to something that is toxic when ingested. This term is often misused in describing venomous snakes.

Refugia (singular: **refugium**) are habitats or areas where a species continues to survive after environmental conditions outside the refugia have changed and populations in those habitats have either become extinct or moved into refugia.

Siphuncles are tubelike connections used by the nautilus to move liquids between the chambers of its shell to regulate buoyancy.

A **stygobiont** (also called a "stygobite") is an organism that is limited to living in groundwater and usually has a suite of characters commonly associated with animals living belowground, such as reduced or missing eyes and/or little pigmentation. The root of the word is derived from the River Styx—in Greek Mythology, the river that had to be crossed to enter the underworld.

Stygobitic is a descriptive term applied to life forms that live in groundwater. The root of the word is derived from the River Styx—in Greek mythology, the river that had to be crossed to enter the underworld.

Taxonomic groupings are related assemblages of organisms. Relatedness can be determined by physical characters, by genetics, or by both.

A **tentacle** is (1) the retractable appendage of a cephalopod (for example, squid have two tentacles and eight arms, while octopods have no tentacles and eight arms) or (2) a sensory structure of a caecilian amphibian that can be extended from its face through a pore in the skull.

Termitaria are termite mounds. The presence of termite mounds in any habitat can increase the regional biodiversity because of the multitude of species that are associated with the mounds.

Terrestrial refers to living on the ground.

Trichomycteridae is a family of catfishes commonly referred to as *candirú* or Pencil Catfishes. Many species in this family are parasitic on other, larger fishes, feeding on blood by swimming into the gill chambers and chewing on gill

tissue. Other species are not parasitic, and some species inhabit subterranean waterways.

A **troglobiont** (also called a "troglobite") is an organism that inhabits only subterranean environments.

Troglobitic is a descriptive term used to describe organisms that live only belowground in caves. It is more strongly associated with animals that live in terrestrial rather than aquatic habitats.

The term **troglomorphic** is used to describe a suite of characteristics often associated with wildlife found only belowground. These characteristics include the loss or reduction of the eyes, the loss or reduction of pigment, and, when compared with surface relatives, a smaller size, elongation and attenuation of the limbs, an increased number of teeth, an ability to go longer periods of time between meals, a reduced metabolic rate, an increased longevity, a general delay in reproduction, and decreased reproductive output.

A **troglophile** is a species that can complete its life cycle in a subterranean habitat and is often found there, but it can also complete its life cycle in surface habitats.

A **trogloxene** is a species that likes to live in subterranean habitats for periods of time but cannot complete its life cycle within cave habitats.

A **vadose passageway** is a subterranean space that was carved out through dissolution by weakly acidic rainwater flowing through the rock.

Venomous refers to the ability of an organism to inject venom into another organism by means of structures such as fangs or a stinger.

The **water column** is the area in an aquatic environment below the surface and above the bottom. Species that "live in the water column" are species that do not live at the bottom of the aquatic habitat.

Zooplankton is the animal portion of the assemblage of freely floating life forms that comprise plankton. Zooplankton species are typically multicellular organisms. Oceanic zooplankton mostly consists of small crustaceans (copepods, ostracods, euphausiids), gelatinous organisms, pelagic worms, small molluscs, larval fishes, larval crustaceans, and other immature stages of invertebrates.

Ahyong S. T., and D. E. Brown. 2002. New species and new records of Polychelidae from Australia (Crustacea: Decapoda). *Raffles Bulletin of Zoology* 50(1): 53–79.

Albert, J. S., and W. G. R. Crampton. 2009. A new species of electric knife fish, genus *Compsaraia* (Gymnoformes: Apteronotidae) from the Amazon River, with extreme sexual dimorphism in snout and jaw length. *Systematics and Biodiversity* 7(1): 81–92.

Aljančič, M., B. Bulog, A. Kranjc, D. Josipovič, B. Sket, and P. Skoberne. 1993. *Proteus: The Mysterious Ruler of Karst Darkness*. Vitrum Publishers, Ljubljana, Slovenia.

Baptista, G. M. G. 1998. Caracterizaçáo climatológica do Distrito Federal. In: *Inventário Hidrogeológico e dos Recursos Hídricos e Superficiillas do Distrito Federal*, pp. 187–208. IEMA/SEMATEC/UnB, Brasília, Brazil.

Bechara, E. J. H., P. Colepicolo-Neto, V. R. Viviani, M. P. Barros, and C. Costa. 1999. Colors and biological functions of beetle bioluminescence. *Anais da Academia Brasiliera de Ciências* 71(2): 169–174.

Bechler, D. L. 1988. Courtship behavior and spermatophore deposition by the subterranean salamander, *Typhlomulge rathbuni* (Caudata, Plethodontidae). *Southwestern Naturalist* 33: 124–126.

Beck, D. D. 2005. *Biology of Gila Monsters und Deaded Lizards*. University of California Press, Berkeley, CA, USA.

Bernard, J. L., and C. L. Ingram. 1986. The supergiant amphipod *Alicella gigantea* Chevreux from the north Pacific gire. *Journal of Crustacean Biology* 6(4): 825–839.

Bichuette, M. E., and E. Trajano. 2004. Three new subterranean species of *Ituglanis* from central Brazil (Siluriformes: Trichomycteridae). *Ichthyological Exploration of Freshwaters* 15(3): 243–256.

Bockmann, F. A., and R. M. C. Castro. 2010. The blind catfish from the caves of Chapada Diamantina, Bahia, Brazil (Siluriformes: Heptapteridae): description, anatomy, phylogenetic relationships, natural history, and biogeography. *Neotropical Ichthyology* 8(4): 673–706.

Bolstad, K. S., and S. O'Shea. 2010. Gut contents of a giant squid *Architeuthis dux* (Cephalopoda: Oegopsida) from New Zealand waters. *New Zealand Journal of Zoology* 31(1): 15–21.

Borgoine, G., A. García-Moyano, D. Litthauer, W. Bert, A. Bester, E. van Heerden, C. Möller, M. Erasmus, and T. C. Onstott. 2011. Nematoda from the deep subsurface of South Africa. *Nature Letter* 474: 79–82.

Bradley, D. 1993. Frog venom cocktail yields a one-handed painkiller. *Science* 261: 1117.

Brandon, R. A. 1971. North American troglobitic salamanders: some aspects of modification in cave habitats, with special reference to *Gyrinophilus palleucus*. *National Speleological Society Bulletin* 33(1): 1–21.

Breault, J. L. 1991. Candirú: Amazonian parasitic catfish. *Journal of Wilderness Medicine* 2: 304–312.

Brown, D. E., and N. B. Carmony. 1991. *Gila Monster: Facts and Folklore of America's Aztec Lizard*. High-Lonesome Books, Silver City, NM, USA.

Brown, K. S. Jr. 1996. Diversity of Brazilian Lepidoptera: history of study, methods for measurement, and use and indicators for genetic, specific, and system richness. In: C.A. Bicudo and N. A. Menezes (eds.). *Biodiversity in Brazil: A First Approach*. CNPq / Instituto de Botânica, São Paulo, Brazil.

Brown, P. 2013. Zombie ants and a cultural obsession. *Scientific American*, July 8. http://blogs.scientificamerican.com/guest-blog/2013/07/08/zombie-ants-and -a-cultural-obsession.

Bruun, A. F., S. V. Greve, H. Mielche, and R. Spärck. 1956. *The Galathea Deep Sea Expedition*. Macmillan, New York, NY, USA.

Burghart, S. E., T. L. Hopkins, and J. J. Torres. 2007. The bathypelagic Decapoda, Lophogastrida, and Mysida of the eastern Gulf of Mexico. *Marine Biology* 152(2): 315–327.

Busse, K. 1970. Care of the young by male *Rhinoderma darwinii*. *Copeia* 1970(2): 395.

Busse, K. 1989: Zum Brutpflegeverhalten des Nasenfrosches *Rhinoderma darwinii* (Anura: Rhinodermatidae). *Tier u. Museum* 1(3): 59–63.

Busse, K. 1991. Bemerkungen zum fortpflanzungsverhalten und zur Zucht von *Rhinoderma darwinii*. *Herpetofauna* 13(71): 11–21.

Busse, K. 2003: Fortpflanzungsbiologie von *Rhinoderma darwinii* (Anura: Rhinodermatidae) und die stammesgeschichtliche und funktionelle Verkettung der einzelnen Verhaltensabläufe. Bonn. *Zoologische Beltrage* 51(1): 3–34.

Busse, K., and H. Werning. 2002. Another extinct amphibian species? The fate of the Darwin Frogs. *ZGAP Mitteilungen* 18(2): 16–18.

Campbell, J. A., and J. P. Vannini. 1988. A new subspecies of Beaded Lizard, *Heloderma horridum*, from the Motagua Valley of Guatemala. *Journal of Herpetology* 22(4): 457–468.

Caramaschi, U., and C. A. G. Da Cruz. 1997. Redescription of *Chiasmocleis albopunctata* (Boettger) and description of a new species of *Chiasmocleis* (Anura: Microhylidae). *Herpetologica* 53(2): 259–268.

Cavalcanti, R. B., and C. A. Joly. 2002. Biodiversity and conservation priorities in the Cerrado region. In: P. S. Oliveira and R. J. Marquis (eds.). *The Cerrados of Brazil*, pp. 351–367. Columbia University Press, New York, NY, USA.

Cei, J. M. 1962. *Batracios de Chile*. Ediciones Universidad de Chile, Santiago, Chile.

Cei, J. M. 1980. Amphibians of Argentina. *Italian Journal of Zoology*, Monograph 2: 1–609.

Cherel, Y., and K. A. Hobson. 2005. Stable isotopes, beaks and predators: a new tool to study the trophic ecology of cephalopods, including giant and colossal squids. *Proceedings of the Royal Society B* 272(1572): 1601–1607.

Cleveland C. J., M. Betke, P. Federico, J. D. Frank, T. G. Hallam, J. Horn, J. D. López Jr, et al. 2006. Economic value of the pest control service provided by Brazilian free-tailed bats in south-central Texas. *Frontiers in Ecology and the Environment* 4(5): 238–243.

Collins, J. P., and M. L. Crump. 2009. *Extinction in Our Times: Global Amphibian Decline.* Oxford University Press, New York, NY, USA.

Conniff, R. 2012. A bitter pill. *Conservation* 13(1): 18–23.

Cooper, J. E., and R. A. Kuhene. 1974. *Speoplatyrhynus poulsoni*, a new genus and species of subterranean fish from Alabama. *Copeia* 1974: 486–493.

Crump, M. L. 2002. Natural history of Darwin's frog *Rhinoderma darwinii*. *Herpetological Natural History* 9: 21–31.

Crump, M. 2003. Vocal sac-brooding frogs. In: M. Hutchins (ed.). *Grzimek's Animal Life Encyclopedia*, 2nd ed. Gale Group, Farmington Hills, MI, USA.

Crump, M. L., and A. Veloso. 2005. El aporte de observaciones de terreno y del análisis genético para la conservación de (*Rhinoderma darwinii*) en Chile. In: C. Smith-Ramirez, J. J. Armesto, and C. Valdovinos (eds.). *Historia, Biodiversidad y*

Ecología de los Bosques Costeros de Chile, pp. 452–455. Editorial Universitaria, Santiago, Chile.

Culver, D. C. 1982. *Cave Life: Evolution and Ecology*. Harvard University Press, Cambridge, MA, USA.

Culver, D. C., T. C. Kane, and D. W. Fong. 1995. *Adaptation and Natural Selection in Caves*. Harvard University Press, Cambridge, MA, USA.

Curl, R. L. 1958. A statistical theory of cave entrance evolution. *Bulletin of the National Speleological Society* 20: 9–22.

Daly, J. W., B. Brown, M. Mensah-Dwumah, and C. W. Myers. 1978. Classification of skin alkaloids from neotropical poison-dart frogs (Dendrobatidae). *Toxicon* 16: 163–188.

Daly, J. W., J. Caceres, R. W. Moni, F. Gusovsky, M. Moos Jr., K. B. Seamon, K. Milton, and C. W. Myers. 1992. Frog secretions and hunting magic in the upper Amazon: identification of a peptide that interacts with adenosine receptor. *Proceedings of the National Academy of Sciences USA* 89: 10,960–10,963.

Daly, J. W., C. W. Myers, and N. Whittaker. 1987. Further classification of skin alkaloids from neotropical poison frogs (Dendrobatidae), with a general survey of toxic/noxious substances in the amphibian. *Toxicon* 25(10): 1023–1095.

Darwin, C. W. 1989 [1839]. *Voyage of the Beagle*. Edited and abridged by J. Browne and M. Neve. Penguin Books, London, UK.

Daszak, P., L. Berger, A. A. Cunningham, A. D. Hyatt, D. E. Green, and R. Speare. 1999. Emerging infectious diseases and amphibian population declines. *Emerging Infectious Diseases* 5: 735–748.

Daszak, P., A. A. Cunningham, and A. D. Hyatt. 2000. Emerging infectious diseases of wildlife—threats to biodiversity and human health. *Science* 287: 443–449.

Daszak, P., A. A. Cunningham, and A. D. Hyatt. 2003. Infectious disease and amphibian population declines. *Diversity and Distributions* 9(2): 141–150.

Deagle, B. E., S. N. Jarman, D. Pemberton, and N. J. Gales. 2005. Genetic screening for prey in the gut contents from a giant squid (*Architeuthis* sp.). *Journal of Heredity* 96(4): 417–423.

DeNiro, M. J., and S. Epstein. 1981. Influence of diet on the distribution of nitrogen isotopes in animals. *Geochimica et Cosmochimica Acta* 45: 341–351.

Denton, E. J., J. B. Gilpen-Brown, and P. G. Wright. 1970. On the "filters" in the photophores of mesopelagic fish and on a fish emitting red light and especially sensitive to red light. *Journal of Physiology* 208(2): 72–73.

de Pinna, M. C. C., and A. L. Kirovsky. 2011. A new species of sand-dwelling catfish, with a phylogenetic diagnosis of *Pygidianops* Myers (Silurifirmes: Trichomycteridae: Glanapteryginae). *Neotropical Ichthyology* 9(3): 113–128.

Domingos, D. J., and T. A. Gontijo. 1996. Multi-occupation of termite mounds in cerrado vegetation in south-eastern Brazil. *Revista Brasiliera de Biologia* 56(4): 717–723.

Douglas, R. H., C. W. Mullineaux, and J. C. Partridge. 2000. Long-wave sensitivity in deep-sea stomiid dragonfish with far-red bioluminescence: evidence for a dietary origin of the chlorophyll-derived retinal photosensitizer of *Malacosteus niger*. *Philosophical Transactions of the Royal Society B* 355(1401): 1269–1272.

Drazen, J. C., S. K. Goffredi, B. Schlining, and D. S. Stakes. 2003. Aggregations of egg-brooding deep-sea fish and cephalopods on the Gorda Escarpment: a reproductive hotspot. *Biological Bulletin* 205: 1–7.

Duellman, W. E. 1971. The burrowing toad, *Rhinophrynus dorsalis*, on the Caribbean lowlands of Central America. *Herpetologica* 27: 55–56.

Dumbacher, J. P., B. M. Beehler, T. F. Spande, H. M. Garraffo, and J. W. Daly. 1992. Homobatrachotoxin in the genus *Pitohui*: chemical defense in birds? *Science* 258: 799–801.

Dumbacher, J. P., A. Wako, S. R. Derrickson, A. Samuelson, T. F. Spande, and J. W. Daly. 2004. Melyrid beetles (Choresine): a putative source for the batrachotoxin alkaloids found in poison-dart frogs and toxic passerine birds. *Proceedings of the National Academy of Sciences USA* 101: 15,857–15,860.

Eder, F. X. 1791. *Descriptio provinciae Moxitarum in regno Peruano*. Typis universitatis, Budapest, Hungary.

Ehmann, H., G. Swan, G. Swan, and B. Smith. 1991. Nesting, egg incubation, and hatching by the heath monitor, *Varanus rosenbergi*, in a termite mound. *Herpetofauna* 21(1): 17–24.

Eigenmann, C. 1898. A new blind fish (*Typhlichthys rosae*). *Proceedings from the Indiana Academy of Science* 1897: 231.

Eigenmann, C. H. 1919. *Trogloglanis pattersoni* a new blind fish from San Antonio, Texas. *Proceedings of the American Philosophical Society* 58: 397–400.

Ellis, R. 1996. *Deep Atlantic*. Knopf, New York, NY, USA.

Erdmann, M. V. 1999. An account of the first living coelacanth known to scientists from Indonesian waters. *Environmental Biology of Fishes* 54: 439–443.

Eshenroder, R. L., V. G. Sideleva, and T. N. Todd. 1999. Functional convergence among pelagic sculpins of Lake Baikal and deepwater ciscoes of the Great Lakes. *Journal of Great Lakes Research* 25(4): 847–855.

Espinasa, L., M. Espinasa, D. Fenolio, M. Slay, and M. Niemiller. 2014. Distribution and conservation status of *Speleonycta ozarkensis* (Insecta, Zygentoma, Nicoletiidae) from caves of the Ozark Highlands of Arkansas and Oklahoma, US. *Subterranean Biology* 14: 51–62.

Faust, L. F. 2010. Natural history and flash repertoire of the synchronous firefly *Photinus carolinus* (Coleoptera: Lampyridae) in the Great Smoky National Park. *Florida Entomologist* 93(2): 208–217.

Fenolio, D. 2012. Conserving South Chile's amphibian fauna. *FrogLog* 100: 30–31.

Fenolio, D., and R. Bonett. 2009. Recent findings about the biology, ecology, and systematics of the grotto salamander, *Eurycea spelaea*. *Proceedings of the 15th International Congress of Speleology* 1: 234–237.

Fenolio, D., and G. O. Graening. 2009. Report of a mass aggregation of isopods in an Ozark cave of Oklahoma with considerations of population sizes of stygobionts. *Speobiology Notes* 1: 9–11.

Fenolio, D., and S. Trauth. 2005. Species account for *Eurycea* (*Typhlotriton*) *spelaeus*. In: M. Lannoo (ed.). *Amphibian Declines in North America*, pp. 863–866. University of California Press, Berkeley, CA, USA.

Fenolio, D. B., G. O. Graening, B. A. Collier, and J. F. Stout. 2006. Coprophagy in a cave-adapted salamander: the importance of bat guano examined through stable isotope and nutritional analyses. *Proceedings of the Royal Society B* 273(1585): 439–443.

Fenolio, D., R. Bonett, and M. Niemiller. 2012a. Developing a captive breeding protocol for Georgia's Blind Salamander (*Haideotriton wallacei*) at the Atlanta Botanical Garden. *Leaf Litter* 1(2): 40–45.

Fenolio, D., M. Fabry, A. Charrier, M. Tirado, M. Crump, and B. Lamar. 2012b. The Darwin's Frog Conservation Initiative. *Leaf Litter* 1(2): 11–19.

Fenolio, D. B., M. L. Niemiller, M. Levy, and B. Martinez. 2013a. Conservation status of the Georgia Blind Salamander (*Eurycea wallacei*) from the Floridan Aquifer of Florida and Georgia. *Reptiles and Amphibians: Conservation and Natural History* 20(3): 97–111.

Fenolio, D. B., M. L. Niemiller, D. Soares, M. E. Slay, A. Harris, and N. Harris. 2013b. Subterranean reproduction of the Ringed Crayfish, *Orconectes neglectus* Faxon 1885 (Astacoidea: Cambaridae) within an Ozark Highlands cave in Oklahoma, USA. *Speleobiology Notes* 5: 43–46.

Fenolio, D. B., M. L. Niemiller, D. Soares, M. E. Slay, R. C. Stark, and S. L. Hensley. 2013c. A maximum size and abundance record for *Cambarus subterraneus* (Astacoidea: Cambaridae). *Speleobiology Notes* 5: 9–13.

Fenolio, D. B., Y. Zhao, M. L. Niemiller, and J. F. Stout. 2013d. In-situ observations of seven enigmatic cave loaches and one cave barbell from Guangxi, China, with notes on conservation status. *Speleobiology Notes* 5: 19–33.

Fenolio, D. B., T. A. Gorman, K. C. Jones, M. Mandica, L. Phillips, L. Melde, H. Mitchell, and C. A. Haas. 2014a. Rearing the federally endangered Reticulated Flatwoods Salamander, *Ambystoma bishopi*, from eggs through metamorphosis. *Herpetological Review* 45(1): 62–65.

Fenolio, D., W. W. Lamar, M. Fabry, M. Tirado, and M. Crump. 2014b. Chile's endangered amphibians. *Anima Mundi* 15(4): 76–95.

Fenolio, D. B., M. L. Niemiller, and B. Martinez. 2014c. Observations of reproduction in captivity by the Dougherty Plain Cave Crayfish, *Cambarus cryptodytes* (Decapoda: Astacoidea: Cambaridae). *Speleobiology Notes* 6: 14–26.

Fernández, L., and M. E. Bichuette. 2002. A new cave dwelling species of *Ituglanis* from the São Domingos karst, central Brasil (Siluriformes: Trichomycteridae). *Ichthyological Exploration of Freshwaters* 13(3): 273–278.

Fisher, C. R., I. R. MacDonald, R. Sassen, C. M. Young, S. A. Macko, S. Hourdez, R. S. Carney, S. Joye, and E. McMullen. 2000. Methane Ice Worms: *Hesiocaecamethanicola* colonizing fossil fuel reserves. *Naturwissenschaften* 87(4): 184–187.

Fisher, R. N., and H. B. Shaffer. 1996. The decline of amphibians in California's Great Central Valley. *Conservation Biology* 10: 1387–1397.

Fitch, J. E., and R. J. Lavenberg. 1968. *Deep Water Fishes of California*. University of California Press, Berkeley, CA, USA.

Flemming, P. A., and J. P. Loveridge. 2003. Mombo woodland termite mounds: resource islands for small vertebrates? *Journal of the Zoological Society of London* 259: 161–168.

Francisco, R., G. Angel, S. Michel, and G. Angel. 2002. Behavioural observations of the cephalopod *Vulcanoctopus hydrothermalis*. *CBM—Cahiers de Biologie Marine* 43(3–4): 299–302.

Franklin, C. J. 2011. Some notes on the natural history and captive maintenance of the Mexican Mole Lizard (*Bipes biporus*). *Cross Timbers Herpetologist* 14(6): 3–18.

Frazer, J. 2015. Deepest fish features angel wings, tentacles and amazing ability to perform under pressure. *Scientific American*, January 8. http://blogs.scientific american.com/artful-amoeba/2015/01/08/deepest-fish-features-angel-wings -tentacles-and-amazing-ability-to-perform-under-pressure.

Galil, B. S. 2000. Crustacea Decapoda: review of the genera and species of the family Polychelidae Wood-Mason, 1874. *Mémoires du Muséum National d'Histoire Naturelle* 184: 285–387.

Gandolfi, S. M., and C. F. D. Rocha. 1998. Orientation of thermoregulating *Tropidurus torquatus* (Sauria: Tropiduridae) on termite mounds in an open area of south-eastern Brazil. *Amphibia-Reptilia* 19(3): 319–323.

Gascon, C., J. P. Collins, R. D. Moore, D. R. Church, J. E. McKay, and J. R. Mendelson III (eds.). 2007. *Amphibian Conservation Action Plan*. IUCN/SSC Amphibian Specialist Group. Gland, Cambridge, UK.

Gilly, W. F., U. Markaida, C. H. Baxter, B. A. Block, A. Boustany, L. Zeidberg, K. Reisenbichler, B. Robison, G. Bazzino, and C. Salinas. 2006. Vertical and horizontal migrations by the jumbo squid *Dosidicus gigas* revealed by electronic tagging. *Marine Ecology Progress Series* 324: 1–17.

Gilmore, R. M. 1946. Fauna and ethnozoology of South America. In: J. H. Steward (ed.). *Handbook of South American Indians*, vol. 6, pp. 345–464. Smithsonian Institution Bureau of American Ethnology, prepared in cooperation with the United States Department of State as a project of the Interdepartmental Committee on Cultural and Scientific Cooperation. U.S. Government Printing Office, Washington, DC, USA.

Gorman, P. 1993. Making magic. *Omni*, July, pp. 63–66, 86–88, 92–93.

Gower, D. J., J. B. Rasmussen, S. P. Loader, and M. Wilkinson. 2004. The caecilian amphibian *Scolecomorphus kirkii* Boulenger as prey of the burrowing asp *Atractaspis aterrima* Günther: trophic relationships of fossorial vertebrates. *African Journal of Ecology* 42: 83–87.

Graening, G. O., and D. B. Fenolio. 2005. Status update of the Delaware County Cave Crayfish, *Cambarus subterraneus* (Decapoda: Cambaridae). *Proceedings of the Oklahoma Academy of Sciences* 85: 85–89.

Graening, G. O., D. B. Fenolio, H. H. Hobbs, S. Jones, M. E. Slay, S. R. McGinnis, and J. F. Stout. 2006. Range extension and status update for the Oklahoma Cave Crayfish, *Cambarus tartarus* (Decapoda: Cambaridae). *Southwestern Naturalist* 51(1): 94–99.

Graening, G. O., J. R. Holsinger, D. B. Fenolio, E. A. Bergey, and C. C. Vaughn. 2007a. Annotated checklist of the amphipod crustaceans of Oklahoma, with emphasis on groundwater habitats. *Proceedings of the Oklahoma Academy of Sciences* 86: 65–74.

Graening, G. O., M. E. Slay, D. B. Fenolio, and H. W. Robison. 2007b. Annotated checklist of the isopoda (Subphylum Crustacea; Class Malacostraca) of Arkansas and Oklahoma, with an emphasis upon subterranean habitats. *Proceedings of the Oklahoma Academy of Sciences* 87: 1–14.

Graening, G. O., D. B. Fenolio, M. L. Niemiller, A. V. Brown, and J. V. Beard. 2010. The 30-year recovery effort for the Ozark Cavefish (*Amblyopsis rosae*): analysis of current distribution, population trends, and conservation status of this threatened species. *Environmental Biology of Fishes* 87: 55–88.

Graening, G. O., M. J. Harvey, W. L. Puckette, R. C. Stark, D. B. Sasse, S. L. Hensley, and R. K. Redman. 2011. Conservation status of the endangered Ozark Big-ear bat (*Corynorhinus townsendii ingens*)—a 34-year assessment. *Publications of the Oklahoma Biological Survey* 11: 1–16.

Graening, G. O., D. B. Fenolio, and M. E. Slay. 2012. *Cave Life of Oklahoma and Arkansas*. University of Oklahoma Press, Norman, OK, USA.

Griffiths, A. D., and K. A. Cristian. 1996. The effects of fire on the Frillneck lizard (*Chlamydosaurus kingii*) in northern Australia. *Australian Journal of Ecology* 21(4): 386–398.

Gudger, E. W. 1930a. On the alleged penetration of the human urethra by an Amazonian catfish called Candiru: With a review of the allied habits of other members of the family Pygidiidae. part 1. *American Journal of Surgery* 8(1): 170–188.

Gudger, E. W. 1930b. On the alleged penetration of the human urethra by an Amazonian catfish called Candiru: With a review of the allied habits of other members of the family Pygidiidae. part II. *American Journal of Surgery* 8(1): 443–457.

Guerra, A., A. B. Rodríguez-Navarro, A. F. González, C. S. Romanek, P. Álvarez-Lloret, and G. J. Pierce. 2010. Life-history traits of the giant squid *Architeuthis dux* revealed from stable isotope signatures recorded in beaks. *ICES Journal of Marine Science* 67(7): 1425–1431.

Gunton, L. M., A. J. Gooday, A. G. Glover, and B. J. Bett. 2015. Macrofaunal abundance and community composition at lower bathyal depths in different branches of the Whittard Canyon and on the adjacent slope (NE Atlantic). *Deep Sea Research Part 1: Oceanographic Research Papers* 97: 29–39.

Haas, A., S. Hertwig, and I. Das. 2006. Extreme tadpoles: the morphology of fossorial megophryid larva, *Leptobrachella mjobergi*. *Zoology* 109(1): 26–42.

Hanlon, R. T., A. C. Watson, and A. Barbosa. 2010. A mimic octopus in the Atlantic: flatfish mimicry and camouflage by *Macrotritopus defilippi*. *Biological Bulletin* 218(1): 15–24.

Haygood, M. G. 1990. Relationship of the luminous bacterial symbiont of the Caribbean flashlight fish, *Kryptophanaron alfredi* (family Anomalopidae) to other luminous bacteria based on bacterial luciferase (luxA) genes. *Archives of Microbiology* 154(5): 496–503.

Hendrickson, D. A., J. K. Krejca, and J. M. R. Martinez. 2001. Mexican blindcats genus *Prietella* (Siluriformes: Ictaluridae): an overview of recent explorations. *Environmental Biology of Fishes* 62: 315–337.

Herring, P. J. 1977. Bioluminescence of marine organisms. *Nature* 267: 788–793.

Herring, P. J. 1990. *Bioluminescent Communication in the Sea*. Cambridge University Press, Cambridge, UK.

Herring, P. J. 2000. Species abundance, sexual encounter and bioluminescent signalling in the deep sea. *Philosophical Transactions of the Royal Society B* 355: 1273–1276.

Herring, P. J. 2007. Sex with the lights on? A review of bioluminescent sexual dimorphisms in the sea. *Journal of the Marine Biological Association of the United Kingdom* 87(4): 829–842.

Herring, P. J., A. K. Campbell, M. Whitfield, and L. Maddock. 1990. *Light and Life in the Sea*. Cambridge University Press, Cambridge, UK.

Heyerdahl, T. 1950. *Kon-Tiki: Across the Pacific by Raft*. Rand McNally, New York, NY, USA.

Hilton, E. J., C. C. Fernandes, J. P. Sullivan, J. G. Lundberg, and R. Campos-da-Paz. 2007. Redescription of *Orthosternarchus tamandua* (Boulenger, 1898) (Gymnotiformes, Apteronotidae), with reviews of its ecology, electric organ discharges, external morphology, osteology, and phylogenetic affinities. *Proceedings of the Academy of Natural Sciences of Philadelphia* 156: 1–25.

Ho, W. W., C. Cox Fernandes, J. Alves-Gomes, and G. T. Smith. 2010. Sex differences in the electrocommunication signals of the electric fish *Apteronotus bonapartii*. *Ethology* 116: 1050–1064.

Hodalic, A. 1997. Human fish—exposed. *Diver* 42(9): 32–36.

Hoffman, C. J. 1982. Associations between the Arrow Goby, *Clevelandia ios* (Jordan and Gilbert) and the Ghost Shrimp, *Callianassa californiensis* Dana in natural and artificial burrows. *Pacific Science* 35(3): 211–216.

Hoffman, J., and T. T. Sutton. 2010. Bathypelagic food web structure of the northern Atlantic Mid-Atlantic Ridge based on stable isotope analysis. *Proceedings from the 2010 AGU Ocean Science Meeting*, pp. 22–26. American Geophysical Union, Washington, DC, USA.

Hopkins, T. L., and T. T. Sutton. 1998. Midwater fishes and shrimps as competitors and resource partitioning in low latitude oligotrophic ecosystems. *Marine Ecology Progress Series* 164: 37–45.

Howes, B. G. 1888. Notes on the gular brood-pouch of *Rhinoderma darwini*. *Proceedings of the Zoological Society of London* 1888: 231–237.

Huang Q., Y. Cai, and X. Xing. 2008. Rocky desertification, antidesertification, and sustainable development in the karst mountain region of southwest China. *AMBIO: A Journal of the Human Environment* 37: 390–392.

Hubbs, C. L., and R. M. Bailey. 1947. Blind catfishes from artesian waters of Texas. *Occasional Papers of the Museum of Zoology, University of Michigan* 499: 1–15.

Hunn, E. S. 1977. *Tzeltal Folk Zoology: The Classification of Discontinuities in Nature*. Academic Press, New York, NY, USA.

Hunt, D. M., J. Fitzgibbon, S. J. Slobodyanyuk, and J. K. Bowmakers. 1995. Spectral tuning and molecular evolution of rod visual pigments in the species flock of cottoid fish in Lake Baikal. *Visual Research* 36(9): 1217–1224.

Hunt, J. C. 1999. Laboratory observations of the feeding behavior of the cirrate octopod, *Grimpoteuthis* sp.: one use of cirri. *Veliger* 42(2): 152–156.

Hutchison, V. H. 1956. Notes on the plethodontid salamanders *Eurycea lucifuga* (Rafinesque) and *Eurycea longicauda longicauda* (Green). *Occasional Papers of the National Speleological Society* 3: 4–24.

Hutchison, V. H. 1958. The distribution and ecology of the cave salamander, *Eurycea lucifuga*. *Ecological Monographs* 28(1): 1–20.

Idyll, C. P. 1964. *Abyss: The Deep Sea and the Creatures That Live in It*. Cromwell, New York, NY, USA.

Johnsen, S. 2005. The red and the black: bioluminescence and the color of animals in the deep sea. *Integrative and Comparative Biology* 45(2): 234–246.

Johnsen S., E. J. Balser, E. C. Fisher, and E. A. Widder. 1999. Bioluminescence in the deep-sea cirrate octopod *Stauroteuthis syrtensis* Verrill (Mollusca: Cephalopoda). *Biological Bulletin* 197: 26–39.

Johnsen, S., E. A. Widder, and C. D. Mobley. 2004. Propagation and perception of bioluminescence: factors affecting counterillumination as a cryptic strategy. *Biological Bulletin* 207: 1–16.

Jones, D. O. B., A. Walls, M. Clare, M. S. Fiske, R. J. Weiland, R. O'Brien, and D. F. Touzel. 2014. Asphalt mounds and associated biota on the Angolan Margin. *Deep Sea Research Part 1: Oceanographic Research Papers* 94: 124–136.

Jønsson, K. A., R. C. K. Bowie, J. A. Norman, L. Christidis, and J. Fjeldså. 2008. Polyphyletic origin of toxic Pitohui birds suggests widespread occurrence of toxicity in corvoid birds. *Biology Letters* 4(1): 71–74.

Kirtisinghe, P. 1957. *The Amphibia of Ceylon*. William Clowes and Sons, London, UK.

Kish, P. E., B. L. Bohnsack, D. Gallina, D. S. Kasprick, and A. Kahana. 2011. The eye as an organizer of craniofacial development. *Genesis* 49: 222–230.

Kittakoopa, P., J. Punyaa, P. Kongsaeree, Y. Lertwerawat, A. Jintasirikul, M. Tantich-
aroena, and Y. Thebtaranonth. 1999. Bioactive naphthoquinones from *Cordy-
ceps unilateralis*. *Phytochemistry* 52(3): 453–457.

Koestler, A. 1967. *The Ghost in the Machine*. Macmillan, New York, NY, USA.

Kubodera, T., Y. Koyama, and K. Mori. 2007. Observations of wild hunting behaviour
and bioluminescence of a large deep-sea, eight-armed squid, *Taningia danae*.
Proceedings of the Royal Society B 274(1613): 1029–1034.

Kubodera, T., and K. Mori. 2005. First-ever observations of a live giant squid in the
wild. *Proceedings of the Royal Society B* 272(1581): 2583–2586.

Kuhajda, B. R., and R. L. Mayden. 2004. Status of the federally endangered cave
fish, *Speoplatyrhinus poulsoni* (Amblyopsidae), in Key Cave and surrounding
Caves, Alabama. *Environmental Biology of Fishes* 62(1–3): 215–222.

Kupfer, A., H. Müller, M. M. Antoniazzi, C. Jared, H. Greven, R. A. Nussbaum, and
M. Wilkinson. 2005. Parental investment by skin feeding in a caecilian amphib-
ian. *Nature* 440: 926–929.

Lajovic, A. 1993. Johann Weichard Valvasor. *Naše Jama* (Our Caves) 35: 89–99.

Langecker, T. G., and G. Longley. 1993. Morphological adaptations of the Texas
blind catfishes *Trogloglanis pattersoni* and *Satan eurystomus* (Siluriformes: Ictalu-
ridae) to their underground environment. *Copeia* 1993(4): 976–986.

Latz, M. I., and J. F. Case. 1982. Light organ and eyestalk compensation to body tilt
in the luminescent midwater shrimp, *Sergestes similis*. *Journal of Experimental
Biology* 98: 83–104

Latz, M. I., and J. F. Case. 1992. Slow photic and chemical induction of biolumines-
cence in the midwater shrimp, *Sergestes similis* Hansen. *Biological Bulletin* 182:
391–400.

Ling, L. L., T. Schneider, A. J. Peoples, A. L. Spoering, I. Engels, B. P. Conlon, A. Muel-
ler, et al. 2015. A new antibiotic kills pathogens without detectable resistance.
Nature 517: 455–459. doi:10.1038/nature14098.

Longcore, J. E., A. P. Pessier, and D. K. Nichols. 1999. *Batrachochytrium dendrobatidis*
gen. et sp. nov., a chytrid pathogenic to amphibians. *Mycologia* 91: 219–227.

Longley, G. 1977. Status of *Typhlomulge* (= *Eurycea*) *rathbuni*, the Texas blind sala-
mander. Submitted to the United States Fish and Wildlife Service under con-
tract 14<H>16<H>0002<H>3727, pp. 1–45.

Lourenço, W. R. 1975. Preliminary studies of the scorpions of the Federal-District
Brazil. *Revista Brasiliera de Biologia* 34(4): 679–682.

Lourenço, W. R. 1978. Notes on the biology of *Acanthoscurria atrox* Araneae Thera-
phosidae. *Revista Brasiliera de Biologia* 38(1): 161–164.

Lyttle, T. 1995. Daring adventures in Peru: under the Amazonian canopy. *Psyche-
delic Illuminations* 1(4): 10–16.

Mace, R. E., R. Petrossian, R. Bradley, and W. F. Mullican III. 2006. A streetcar named
desired future conditions: the new groundwater availability for Texas. In: *The
State Bar of Texas 7th Annual The Changing Face of Water Rights in Texas*, chap. 3.1.
State Bar of Texas, Austin, TX, USA.

Mackie, T. T., G. W. Hunter III, and C. B. Worth. 1945. *Manual of Tropical Medicine*.
W. B. Saunders, Philadelphia, PA, USA.

Magnusson, W. E., A. P. Lima, and R. M. Sampaio. 1985. Sources of heat for nests of
Paleosuchus trigonatus and review of crocodilian nest temperatures. *Journal of
Herpetology* 19(2): 199–207.

Margat, J. 1994. Groundwater operations and management. In: J. Gibert, D. Danielopol, and J. Stanford (eds.). *Groundwater Ecology*, pp. 508–522. Academic Press, Salt Lake City, UT, USA.

Maruska, E. J. 1982. The reproduction and husbandry of salamanders in captivity with special emphasis on the Texas blind salamander, *Typhlomolge rathbuni*. In: *Proceedings of the 5th Annual Reptile Symposium on Captive Propagation and Husbandry*, pp. 151–161. Oklahoma City Zoo, Oklahoma City, OK, USA.

Maschio, G. F., A. L. C. Prudente, F. S. Rodrigues, and M. S. Hoogmoed. 2010. Food habits of *Anilius scytale* (Serpentes: Aniliidae) in the Brazilian Amazonia. *Zoologia* (Curitiba) 27(2): 184–190.

Mattingly, P. F. 1962. Some considerations relating to the role of *Culex pipiens fatigans* Wiedmann in the transmission of filariasis. *Bulletin of the World Health Organization* 58(3): 629–642.

McClain, C. R., A. G. Boyer, and G. Rosenburg. 2006. The island rule and the evolution of body size in the deep sea. *Journal of Biogeography* 33(9): 1578–1584.

McCosker, J. 1977. Flashlight fishes. *Scientific American* 236(3): 106–115.

McCosker, J., and R. H. Rosenblatt. 1987. Notes on the biology, taxonomy, and distribution of flashlight fishes (Beryciformes: Anomalopidae). *Ichthyological Research* 34(2): 157–164.

Mendelson, J. R. III, K. R. Lips, R. W. Gagliardo, G. B. Rabb, J. P. Collins, J. E. Diffendorfer, P. Daszak, et al. 2006. Biodiversity: confronting amphibian declines and extinctions. *Science* 313(5783): 48.

Métraux, A. 1946a. The Chiquitoans and other tribes of the Province of Chiquitos. In: J. H. Steward (ed.). *Handbook of South American Indians*, vol. 3, pp. 381–454. Smithsonian Institution Bureau of American Ethnology, prepared in cooperation with the United States Department of State as a project of the Interdepartmental Committee on Cultural and Scientific Cooperation. U.S. Government Printing Office, Washington DC, USA.

Métraux, A. 1946b. The Tupinamba. In: J. H. Steward (ed.). *Handbook of South American Indians*, vol. 3, pp. 95–133. Smithsonian Institution Bureau of American Ethnology, prepared in cooperation with the United States Department of State as a project of the Interdepartmental Committee on Cultural and Scientific Cooperation. U.S. Government Printing Office, Washington, DC, USA.

Milanovich, J. R., S. E. Trauth, and D. A. Saugey. 2007. *Plethodon albagula* (western slimy salamander): brooding defense behavior and oophagy. *Herpetological Review* 38(1): 67.

Mill, A. E. 1981. Observations on the ecology of *Pseudomyrmex termitarius* hymenoptera formicidae in Brazilian savannas. *Revista Brasiliera de Entomologia* 25(4): 271–274.

Miller, B. T., M. L. Niemiller, and R. G. Reynolds. 2008. Observations on egg-laying behavior and interactions among attending female red salamanders (*Pseudotriton ruber*) with comments on the use of caves in this species. *Herpetological Conservation and Biology* 3(2): 203–210.

Miller, D. J., and R. N. Lea. 1972. *Guide to the Coastal Marine Fishes of California*. University of California and California State Fish and Game, Sacramento, CA, USA.

Milton, K. 1994. No pain, no game. *Natural History*, September, pp. 44–51.

Miya, M., N. I. Holcroft, T. P. Satoh, M. Yamaguchi, M. Nishida, and E. O. Wiley. 2007. Mitochondrial genome and a nuclear gene indicate a novel phylogenetic

position of deep-sea tube-eye fish (Stylephoridae). *Ichthyological Research* 54: 323–332.

Miyake, T., H. Ikoma, M. Hoshima, E. Yamane, H. Hasegawa, and N. Arizono. 2004. Case of acute ileus caused by a spirurina larva. *Pathology International* 54: 730–733.

Moiseff, A., and J. Copeland. 1995. Mechanisms of synchrony in the North American firefly, *Photinus carolinus* (Coleoptera: Lampyridae). *Journal of Insect Behavior* 8: 395–407.

Moiseff, A., J. Copeland, F. Kubke, and L. Faust. 2001. Mating behavior of a synchronous firefly. *Bioluminescence and Chemiluminescence* 11: 153–156.

Moreira, C. R., M. E. Bichuette, O. T. Oyakawa, M. C. C. De Pinna, and E. Trajano. 2010. Rediscovery and redescription of the unusual subterranean characiform *Stygichthys typhlops*, with notes on its life history. *Journal of Fish Biology* 76: 1815–1824.

Moreira, L. A., D. B. Fenolio, H. L. R. Silva, and N. J. Da Silva Jr. 2009. A preliminary list of the herpetofauna from termite mounds of the cerrado in the upper Tocantins river valley. *Papéis Avulsos de Zoologia* 49(15): 183–189.

Morin, J. G., A. Harrington, K. Nealson, N. Krieger, T. O. Baldwin, and J. W. Hastings. 1975. Light for all reasons: versatility in the behavioral repertoire of the flash light fish. *Science* 190(4209): 74–76.

Murray, G. W., and D. Schramm. 1987. A comparative study of the diet of the wedge-snouted sand lizard *Meroles cuneirostris* Strauch and the sand diving lizard *Aporosaura achietae* Bocage lacertidae in the Namib Desert. *Madoqua* 15(1): 55–62.

Myers, C. W., J. W. Daly, and B. Malkin. 1978. A dangerously toxic new frog (*Phyllobates*) used by Emberá Indians of Western Colombia, with discussion of blow-gun fabrication and dart poisoning. *Bulletin of the American Museum of Natural History* 161(2): 307–366.

Neuwirth, M., J. W. Daly, C. W. Myers, and L. W. Tice. 1979. Morphology of the granular secretory glands of poison-dart frogs (Dendrobatidae). *Tissue and Cell* 11(4): 755–771.

Niemiller, M. L., M. S. Osbourne, D. B. Fenolio, T. K. Pauley, B. T. Miller, and J. R. Holsinger. 2010. Conservation status and habitat use of the West Virginia Spring Salamander (*Gyrinophilus subterraneus*) and Spring Salamander (*G. porphyriticus*) in General Davis Cave, Greenbriar Co., West Virginia. *Herpetological Conservation and Biology* 5(1): 32–43.

Niemiller, M. L., G. O. Graening, D. B. Fenolio, J. C. Godwin, J. R. Cooley, W. D. Pearson, B. M. Fitzpatrick, and T. J. Near. 2013a. Doomed before they are described? The need for conservation assessments of cryptic species complexes using an amblyopsid cavefish (Amblyopsidae: *Typhlichthys*) as a case study. *Biodiversity and Conservation* 22(8): 1799–1820.

Niemiller, M. L., K. Ziegler, and D. B. Fenolio. 2013b. *Cave Life of Tennessee, Alabama, and Georgia*. National Speleological Society Press, Huntsville, AL, USA.

Niemiller, M. L., and R. G. Graham (eds.). 2013. *The Amphibians of Tennessee*. University of Tennessee Press, Knoxville, TN, USA.

Nolan B. T., B. C. Ruddy, K. J. Hitt, and D. R. Helsel. 1998. A national look at nitrate contamination of ground water. *Water Conditioning and Purification* 39(12): 76–79.

O'Day, W. T., and H. R. Fernandez. 1974. *Aristostomias scintillans* (Malacosteidae): a deep sea fish with visual pigments apparently adapted to its own bioluminescence. *Vision Research* 14(7): 545–550.

Okeanos Explorer. 2014. Webpage of the National Oceanic and Atmospheric Administration. http://oceanexplorer.noaa.gov/okeanos/explorations/ex1402 /logs/apr24/apr24.html.

Omori, M., and D. Gluck. 1979. Life history and vertical migration of the pelagic shrimp *Sergestes similis* off the Southern California coast. *Fishery Bulletin* 77(1): 183–198.

O'Reilly, J. C., R. A. Nussbaum, and D. Boone. 1996. Vertebrate with protrusible eyes. *Nature* 382: 33.

O'Reilly, J. C., D. A. Ritter, and D. R. Carrier. 1997. Hydrostatic locomotion in a limbless tetrapod. *Nature* 386: 269–272.

O'Reilly, J. C., A. P. Summers, and D. A. Ritter. 2000. The evolution of the function of the trunk muscles during locomotion in adult amphibians. *American Zoologist* 40: 123–135.

Owens, H. L., A. C. Bentley, and A. T. Patterson. 2011. Predicting suitable environments and potential occurrences for coelacanths (*Latimeria* ssp.). *Biodiversity and Conservation* 21(2): 577–587.

Pacchioli, D. 2013. Getting to the bottom of the zombie ant phenomenon. *Penn State News*, July 9. http://news.psu.edu/story/277383/2013/05/21/research /getting-bottom-zombie-ant-phenomenon.

Peña, A. P. 2000. Importância dos termiteiros para a comunidade de pequenos vertebrados em uma área de váreza na região do Cerrado (Dissertação de Mestrado). Universidade Federal de Goiás, Instituto de Ciências Biológicas, Goiânia, Goiás, Brazil.

Pennisi, E. 1992. Pharming frogs. *Science News* 142(July 18): 40–42.

Peterson, B., and B. Fry. 1987. Stable isotopes in ecosystem studies. *Annual Review of Ecology and Systematics* 18: 293–320.

Pietsch, T. W. 2009. *Oceanic Anglerfishes*. University of California Press, Berkeley, CA, USA.

Poinar, J. O. Jr. 1975. Description and biology of a new insect parasitic rhabditoid, *Heterorhabditis bacteriophora* n. gen., n. sp. (Rhabditida; Heterorhabditidae n. fam.). *Nematologica* 21: 463–470.

Pomeroy, D. E., and M. W. Service. 1986. *Tropical Ecology*. Longman Scientific and Technical, New York, NY, USA.

Potter, F. E. Jr., and S. S. Sweet. 1981. Generic boundaries in Texas cave salamanders, and a redescription of *Typhlomulge robusta* (Amphibia: Plethodontidae). *Copeia* 1981: 64–75.

Poulson, T. L. 1963. Cave adaptation in amblyopsid fishes. *American Midland Naturalist* 70: 257–291.

Poulson, T. L. 2001. Adaptations of cave fishes with some comparisons to deep-sea fishes. In: A. Romero (ed.). *The Biology of Hypogean Fishes*. Kluwer Academic Publishers, Dordrecht, Netherlands.

Pouyaud, L., S. Wirjoatmodjo, I. Rachmatika, A. Tjakrawidjaja, R. Hadiaty, and W. Hadie. 1999. Une nouvelle espèce de cœlacanthe: preuves génétiques et morphologiques [A new species of coelacanth: genetic and morphologic proof]. *Comptes Rendus de l'Académie des Sciences* 322(4): 261–267.

Proudlove, G. S. 2006. *Subterranean Fishes of the World*. International Society for Subterranean Biology, Moulis, Italy.

Rabanal, F. E., and J. Nuñez. 2008. *Anfibios de los Bosques Templados de Chile*. Universidad Austral de Chile, Valdivia, Chile.

Raw, A. 1998. Relatório sobre número de insetos, a riqueza de espécies a aspectos zoogeográficos nos cerrados. Workshop *Açóes Prioritárias para Conservaçáo da Biodiversidade do Cerrado e Pantanal*. Conservation International/Fundaçáo Biodiversitas/Universidade de Brasília, Brasília, Brazil.

Reiserer, R. S., G. W. Schuett, and D. D. Beck. 2013. Taxonomic reassessment and conservation status of the Beaded Lizard, *Heloderma horridum* (Squamata: Helodermatidae). *Amphibian and Reptile Conservation* 7(1): 74–96.

Richards, W. J. (ed.). 2006. *Early Stages of Atlantic Fishes*, vols. 1 and 2. CRC Press, Boca Raton, FL, USA.

Rizzato, P. P., E. P. D. Costa Jr., E. Trajano, and M. E. Bichuette. 2011. *Trichomycterus dali*: a new highly troglomorphic catfish (Silurifirmes: Trichomycteridae) from Serra da Bodoquena, Mato Grasso do Sul state, Central Brazil. *Neotropical Ichthyology* 9(3): 477–491.

Robison, B. H. 2004. Deep pelagic biology. *Journal of Experimental Marine Biology and Ecology* 300: 253–272.

Robison, B. H. 2009. Conservation of deep pelagic biodiversity. *Conservation Biology* 23(4): 847–858.

Robison, B. H., K. R. Reisenbichler, J. C. Hunt, and S. H. D. Haddock. 2003. Light production by the arm tips of the deep-sea cephalopod *Vampyroteuthis infernalis*. *Biological Bulletin* 205: 102–109.

Robison, B. H., R. E. Sherlock, and K. R. Reisenbichler. 2010. The bathypelagic community of Monterey Canyon. *Deep Sea Research Part II: Topical Studies in Oceanography* 57(16): 1551–1556.

Robison, H. W., and R. T. Allen. 1995. *Only in Arkansas*. University of Arkansas Press, Fayetteville, AR, USA.

Romero, A. (ed.). 2001. *The Biology of Hypogean Fishes*. Kluwer Academic Publishers, London, UK.

Romero, A., Y. Zhao, and X. Chen. 2009. The hypogean fishes of China. *Environmental Biology of Fishes* 86: 211–278.

Samson, R. A., H. C. Evans, and J. P. Latgé. 1988. *Atlas of Entomopathogenic Fungi*. Springer-Verlag, Berlin, Germany.

Sasaki, T., T. Okutani, and K. Fujikura. 2005. Molluscs from hydrothermal vents and cold seeps in Japan: a review of taxa recorded in twenty recent years (1984–2004). *Venus* 64(3–4): 87–133.

Shattuck, F. C. 1951. *Diseases of the Tropics*. Appleton-Century-Crofts, New York, NY, USA.

Shtarkman, Y. M., Z. A. Koçer, R. Edgar, R. S. Veerapaneni, T. D'Elia, P. F. Morris, and S. O. Rogers. 2013. Subglacial Lake Vostok (Antarctica) accretion ice contains a diverse set of sequences from aquatic, marine and sediment-inhabiting bacteria and eukarya. *PLoS One* 8(7): e67221.

Slack, G. 1993. Magic frog leads anthropologist to new peptide. *Pacific Discovery*, Spring, p. 4.

Smith, D. C., and A. E. Douglas. 1987. *The Biology of Symbiosis*. Edward Arnold, London, UK.

Smith, J. L. B. 1956. *The Search beneath the Sea*, pp. 1–260. Henry Holt and Company, New York, NY, USA.

Sneegas, G. W., and D. A. Hendrickson. 2009. Extreme catfish. www.nanfa.org/aki-web/blindcats.html.

Spotte, S. 2002. *Candiru: Life and Legend of the Bloodsucking Catfishes*. Creative Arts Book Company, Berkeley, CA, USA.

Stebbins, R. C. 1972. *California Amphibians and Reptiles.* University of California Press, Berkeley, CA, USA.

Steinbeck, J. 1951. *The Log from the Sea of Cortez*. Viking Press, New York, NY, USA.

Stejneger, L. 1892. Preliminary description of a new genus and species of blind cave salamander from North America. *Proceedings of the United States National Museum* 15(894): 115–117.

Stejneger, L. 1896. Description of a new genus and species of blind tailed batrachians from the subterranean waters of Texas. *Proceedings of the United States National Museum* 18: 619–621.

Steward, J. H. 1946. The Witotoan tribes. In: J. H. Steward (ed.). *Handbook of South American Indians*, vol. 3, pp. 749–762. Smithsonian Institution Bureau of American Ethnology, prepared in cooperation with the United States Department of State as a project of the Interdepartmental Committee on Cultural and Scientific Cooperation. U.S. Government Printing Office, Washington, DC, USA.

Stickney, D. G., and J. J. Torres. 1989. Proximate composition and energy content of mesopelagic fishes from the eastern Gulf of Mexico. *Marine Biology* 103(1): 13–24.

Strong, R. P. 1943. *Stitts Diagnosis, Prevention, and Treatment of Topical Diseases*, vol. 2. Blackiston Company, Philadelphia, PA, USA.

Stuart, S. N., J. S. Chanson, N. A. Cox, B. E. Young, A. S. L. Rodrigues, D. L. Fischman, and R. W. Waller. 2004. Status and trends of amphibian declines and extinctions worldwide. *Science* 306: 1783–1786.

Sugawara, T., Y. Terai, H. Imai, G. F. Turner, S. Koblmüller, C. Sturmbauer, Y. Shichida, and N. Okada. 2005. Parallelism of amino acid changes at the RH1 affecting spectral sensitivity among deep-water cichlids from Lakes Tanganyika and Malawi. *Proceedings of the National Academy of Sciences USA* 102(15): 5448–5453.

Sutton, T. T. 2005. Trophic ecology of the deep-sea fish *Malacosteus niger* (Pisces: Stomiidae): an enigmatic feeding ecology to facilitate a unique visual system? *Deep Sea Research Part I: Oceanographic Research Papers* 52(11): 2065–2076.

Sutton, T. T., and T. L. Hopkins. 1996a. Species composition, abundance, and vertical distribution of the Stomiid (Pisces: Stomiiformes) fish assemblage of the Gulf of Mexico. *Bulletin of Marine Science* 59(3): 530–542.

Sutton, T. T., and T. L. Hopkins. 1996b. Trophic ecology of the stomiid (Pisces: Stomiidae) fish assemblage of the eastern Gulf of Mexico: strategies, selectivity and impact of a top mesopelagic predator group. *Marine Biology* 127(2): 179–192.

Sweet. S. S. 1976. *Eurycea*: spring and cave salamanders of the Edwards Plateau. *Texas Caver*, April, pp. 60–62.

Szamier, R. B., and V. L. Bennett. 1980. Ampullary electroreceptors in freshwater rays, *Potamotrygon. Journal of Comparative Physiology A* 138(3): 225–230.

Teal, J. M. 1971. Pressure effects on the respiration of vertically migrating decapod crustaceans. *American Zoologist* 11(3): 571–576.

Thomson, K. S. 1991. *Living Fossil*. W. W. Norton & Company, New York, NY, USA.

Timofeev, S. F. 2005. Bergmann's principle and deep-water gigantism in marine crustaceans. *Biology Bulletin* 28(6): 646–650.

Torres, J. J., and G. N. Somero. 1988a. Metabolism, enzymic activities and cold adaptation in Antarctic mesopelagic fishes. *Marine Biology* 98(2): 169–180.

Torres, J. J., and G. N. Somero. 1988b. Vertical distribution and metabolism in Antarctic mesopelagic fishes. *Comparative Biochemistry and Physiology Part B: Comparative Biochemistry* 90(3): 521–528.

Torres J. J., A. V. Aarset, J. Donnelly, T. L. Hopkins, T. M. Lancraft, and D. G. Ainley. 1994. Metabolism of Antarctic micronektonic crustacea as a function of depth of occurrence and season. *Marine Ecology Progress Series* 113(3): 207–219.

Trajano, E. 1997a. Population ecology of *Trichomycterus itacarambiensis*, a cave Catfish from eastern Brazil (Siluriformes, Trichomycteridae). *Environmental Biology of Fishes* 50(4): 357–369.

Trajano, E. 1997b. Synopsis of Brazilian troglomorphic fishes. *Mémoires de Biospéologie* 24: 119–126.

Trajano, E. 2001. Habitat and population data of troglobitic armored cave catfish, *Ancistrus cryptophthalmus* Reis, 1987, from central Brazil (Siluriformes: Loricariidae). *Environmental Biology of Fishes* 62(1/3): 195–200.

Trajano, E. 2003. Ecology and ethology of subterranean catfishes. In: G. Arratia, B. G. Kapoor, M. Chardon, and R. Diogo (eds.). *Catfishes*, pp. 601–635. Science Publishers, Enfield, NH, USA.

Trajano, E., and M. E. Bichuette. 2005. Diversity of subterranean fishes in Brazil. In: J. Gilbert (ed.). *World Subterranean Biodiversity*, pp. 161–163. Proceedings of an international symposium held on December 8–10, 2004 at Université Claude Bernard Lyon Villeurbanne, France (Lyon, France: Université Claude Bernard Lyon Villeurbanne).

Trajano, E., and M. E. Bichuette. 2007. Population ecology of cave armoured catfish, *Ancistrus cryptophthalmus* Reis 1987, from central Brazil (Siluriformes: Loricariidae). *Ecology of Freshwater Fish* 16(2): 105–115.

Trajano, E., N. Mugue, J. Krejca, C. Vidthayanon, D. Smart, and R. Borowsky. 2002. Habitat, distribution, ecology and behavior of cave balitorids from Thailand (Teleostei: Cypriniformes). *Ichthyological Exploration of Freshwaters* 13(2): 169–184.

Trauth, S. E., H. W. Robison, and M. V. Plummer. 2004. *The Amphibians and Reptiles of Arkansas*. University of Arkansas Press, Fayetteville, AR, USA.

von Cosel, R., and K. Olu. 1998. Gigantism in mytilidae: a new *Bathymodiolus* from cold seep areas on the Barbados accretionary Prism. *Comptes Rendus de l'Académie des Sciences Series III Sciences de la Vie* 321(8): 655–663.

von Rintelen, K., T. J. Page, Y. Cai, K. Roe, B. Stelbrink, B. R. Kuhajda, T. M. Iliffe, J. Hughes, and T. von Rintelen. 2012. Drawn to the dark side: a molecular phylogeny of freshwater shrimps (Crustacea: Decapoda: Caridea: Atyidae) reveals frequent cave invasions and challenges current taxonomic hypotheses. *Molecular Phylogenetics and Evolution* 63: 82–96.

Walter, M. R. 2007. Ancient hydrothermal ecosystems on Earth: a new palaeobiological frontier. In: G. R. Bock and J. A. Goode (eds). *Ciba Foundation Symposium 202: Evolution of Hydrothermal Ecosystems on Earth (And Mars?)*. John Wiley & Sons, Chichester, UK. doi:10.1002/9780470514986.ch7.

Wassersug, R. J., and W. F. Pyburn. 1987. The biology of the Pe-ret' Toad, *Otophryne robusta* (Microhylidae), with special consideration of its fossorial larvae and systematic relationships. *Zoological Journal of the Linnean Society* 91(2): 137–169.

Watson, M., E. L. Thurston, and J. A. C. Nicol. 1978. Reflectors in the light organ of Anomalops (Anomalopidae: Teleostei). *Proceedings of the Royal Society of London B* 202: 339–351.

Weinberg, S. 2000. *A Fish Caught in Time*. Harper Collins Publishers, New York, NY, USA.

Whitehead, D. L. 2002. Ampullary organs and electroreception in freshwater *Carcharhinus leucas*. *Journal of Physiology* 96: 391–395.

Widder, E. A. 2002. Bioluminescence and the pelagic visual environment. *Marine and Freshwater Behaviour and Physiology* 35:1–26.

Widder, E. A. 2010. Bioluminescence in the ocean: origins of biological, chemical, and ecological diversity. *Science* 328: 704–708.

Wikramanayake, E. D., and G. I. Dryden. 1993. Thermal ecology of habitat and microhabitat use by sympatric *Varanus bengalensis* and *Varanus salvator* in Sri Lanka. *Copeia* 3: 709–714.

Willis, L. D., and A. V. Brown. 1985. Distribution and habitat requirements of the Ozark Cavefish, *Amblyopsis rosae*. *American Midland Naturalist* 114(2): 311–317.

Wolfe, C. J., and M. G. Haygood. 1991. Restriction fragment length polymorphism analysis reveals high levels of genetic divergence among the light organ symbionts of flashlight fish. *Biological Bulletin* 181(1): 135–143.

Wollenberg, K. C., and G. J. Measey. 2009. Why color in subterranean vertebrates? Exploring the evolution of colour patterns in caecilian amphibians. *Journal of Evolutionary Biology* 22(5): 1046–1056.

Wright, J. W., and W. M. Mason. 1981. *Bipes* in Alta California. *Herpetological Review* 12(3): 76–77.

Xiao, J. H., and J. J. Zhong. 2007. Secondary metabolites from *Cordyceps* species and their antitumor activity studies. *Recent Patents on Biotechnology* 1(2): 123–137.

Xiu, L. H., J. Yang, and H. F. Zheng. 2014. An extraordinary new blind catfish, *Xiurenbagrus dorsalis* (Teleostei: Siluriformes: Amblycipitidae), from Guangxi, China. *Zootaxa* 3835(3): 376–380.

Yancey, P. H., M. E. Gerringer, J. C. Drazen, A. A. Rowden, and A. Jamieson. 2014. Marine fish may be biochemically constrained from inhabiting the deepest ocean depths, *Proceedings of the National Academy of Sciences USA* 111(12): 4461–4465.

Young, R. E. 1983. Oceanic bioluminescence: an overview of general functions. *Bulletin of Marine Science* 33(4): 829–845.

Zhao, Y., and Z. Chunguang. 2009. *Endemic Fishes of Sinocyclocheilus (Cypriniformes: Cyprinidae) in China*. Science Press, Beijing, China.

Zuanon, J., F. A. Bockmann, and I. Sazima. 2006. A remarkable sand-dwelling fish assemblage from Amazonia, with comments on the evolution of psammophily in South American freshwater fishes. *Neotropical Ichthyology* 4(1): 31–36.

In the acknowledgments, I mentioned only a few of the many people and organizations that have made this book possible. Here I provide a fuller, though surely incomplete, acknowledgment of all those to whom I owe a debt of gratitude. I sincerely apologize for any inadvertent omissions.

I thank the following people for their assistance: J. Albert, the Albrecht Family, D. Aldridge, N. Allen, N. Ananjeva, I. Anderson, J. Apodaca, J. Archer, S. Arias, N. Baiben, the Baker Family, R. Baker, the Balistreri Family, M. Barrett, C. Barrio, J. Barry, C. Bathie, N. Bendik, the Beninger Family, E. Bergey, G. Bernardi, M. Bichuette, D. Bickford, the Blackmore Family, R. Blackwood, R. Bonett, J. Bonnington, C. Braatan, V. Brahana, C. Brickey, B. Brock, T. Brockwell, S. Bros, A. Brown, S. Burghart, J. Burkhart, K. Busse, O. Cabezas, G. Cailliet, J. Caldwell, B. Castro, J. Cerepera, D. Chamberlain, D. Champ, A. Charrier, J. Chauvin, the Cheeseman Family, K. Chernoff, J. Clark, K. Coale, A. Cobb, the Colby Family, N. Cole Jr., R. Cole, J. Collett, M. Conner, J. Connor, A. Cook, E. Corfey, C. Cox, K. Crow-Sanchez, M. Crump, M. Da Costa, N. da Silva Jr., C. de la Rosa, P. de Vosjoli, S. Deban, C. Deen, C. Denton, R. Determann, M. Donnelly, V. Duncan, Q. Dwyer, J. Eberly, W. Elliot, J. Ettling, M. Fabry, B. and H. Fenolio, K. and K. Foose, A. Forsythe, H. Fortner, T. Frank, C. Franklin, W. Freed, T. Freitas, J. Fries, M. Fuhr, M. Fusari, C. Gables, R. Gagliardo, L. Ganser, J. Garcia Valdes, G. Gartner, J. Geller, M. Gerber, W. Gibbons, R. Gibson, A. Gluesenkamp, M. Godoy, T. Gorman, the Graening Family, A. Grajal, E. Gravel, the Greller Family, E. Griffith, the Grove Family, D. Grow, S. Haddock, M. Hagen, F. Hallé, S. Han, R. Hansen, C. Hanson, D. Harmon, K. Harris, R. Harris, C. Hass, D. Hendrickson, G. Hendry, L. Henry, S. Hensley, D. Hibbett, R. T. Hicks, R. Hill, J. Hood, K. Hovey, P. Howorth, J. Huang, E. Hudson, S. Humfeld, K. Hobson, S. House, B. and B. Howard, E. Howell, M. Howery, E. Hudson, F. Huey, R. Hurt, V. Hutchison, O. Inamura, the Inman Family, J. Jansen, R. Javitch, J. Jensen, K. Jessop, E. Jonasson, K. Jones, S. Jones, J. Justice, A. Kahn, A. Kardon, N. Keeney, K. Kelley, T. Kelley, D. Kendall, R. Kipp, D. Koehler, M. Kormanec, C. Kovach, E. Kowalski, J. Krejca, T. Kremer, B. Kuhjada, L. Kuhnz, S. Kyle, W. Lamar, S. Lamerdin, J. Lan, G. Lawson, C. Leary, G. Ledvina, J. Lee, K. Leidenfrost, J. Lemm, K. Lewand, G. Li, H. Li, T. Linbo, H. Liu, B. Lôbo, W. Loftus, B. Love, M. Lowman, O. Lucanus, J. Lundberg, T. Lynch, B. Macahuachi, B. Maher, the Mailloux Family, the Malfatti Family, J. Malone, the Mandica Family, B. Martinez, E. Martinez, M. Matheson, C. McAllister, K. McCarty, S. McCusker, R. McDiarmid, A. McKee, S. McKeown, E. McPhee-Shaw, S. McReynolds, L. Melde, J. Mendelson, E. B. Miller, H. Mitchell, P. Moler, A. Montalba, J. Moore, L. Moran, T. Morrow, M. Mortenthaler, P. Mudde, R. Muller, B. Muscher-Hodges, J. Nichols, M. Niemiller, J. Nuñez and lab, S. Okada, S. Opsahl, J. O'Reilly, N. Orlov, M. Osbourn, M. Osorno, L. Österdahl, T. Paine, C. Pelke, M. Pepper, L. Perrotti, L. Phillips, T. Pierson, T. Pietsch, N. Pitman, J. Plant, V. Poole, L. Porras, T. Poulson, W. Puckette, E. Quintana, G. Rabb, P. Radice, L. Rapp Py-Daniel, D. and M. Ready, E. Rekdal, R. Ribeiro, the Richter Family, B. Robison, H. Robison, A. Rockefeller, A. Romero, W. Roody, E. Rooks, R. Rozar, D. Ruland, M. Russell, F. Ruttenberg, M. Sanchez, M. Sasa,

G. Schlick, R. Scully, the Seah Family, D. Shapiro, D. Shepard, the Siegel Family, H. Silva, C. Simmons, J. Simmons, L. Simpson, R. Skylstad, the Slay Family, E. Smith, T. Snell, D. Soares, A. Solórzano, the Spooner Family, the Sprackland Family, J. Spratt Jr., P. Sprouse, J. Stabile, R. Stark, L. Sternberg, B. and B. Stine, the Stout Family, P. Stout, M. Sutton, T. Sutton, T. Tasmania, K. Thomas, M. Thomas, S. Tilley, L. Timm, E. Timpe, M. Tirado, X. Tong, J. Torres, K. Tosney, E. Trajano, M. Trefaut Rodrigues, T. Vandeventer, C. Vanskike, C. Vaughn, M. Vecchione, G. Veni, L. Vitt, B. Wagner, D. and M. Wake, S. Waldron, S. Walker, S. Wallace, M. Walvoord, B. Warner, P. Whitman, E. Widder, C. Widmer, M. Wike, M. Willig, B. Wilson, A. and B. Wolf, the Worall Family, R. Young, Y. Zhao, I. and E. Zimmermann, K. Zippel.

I thank the following organizations for their assistance: Alabama Department of Conservation and Natural Resources, Alabama Natural Heritage Program, Amazon Conservation Association, American Association of Zookeepers, American Museum of Natural History Theodore Roosevelt Memorial Fund, ANGAP (Madagascar), Acuario Río Momón (Peru), Arkansas Game and Fish Commission, Arkansas Natural Heritage Commission, Association of Zoos and Aquariums, Atlanta Botanical Garden, Bat Conservation International, Boston Mountains Grotto, California Department of Fish and Wildlife, Cave Research Foundation, Central Oklahoma Grotto, Cherokee Nation in Oklahoma, Chicago Board of Trade Endangered Species Fund, Chicago Herpetological Society, Chinese Academy of Sciences (China), Cisco Systems, CONAF (Chile), Dismals Canyon (Alabama), DEEPEND—Deep Pelagic Nekton Dynamics of the Gulf of Mexico, Dolphin Design (California), Dolphin Pet Village (California), East Texas Herpetological Society, Eglin Air Force Base (Florida), European Association of Zoos and Aquariums, Florida Fish and Wildlife Conservation Commission, Georgia Department of Natural Resources, George and Mary Rabb Foundation, GreenTracks Inc., GoMRI—Gulf of Mexico Research Initiative, Houston Zoo, IBAMA (Brazil), Instituto Nacional de Pesquisas da Amazônia (Manaus, Brazil), Kentucky Department of Fish and Wildlife Resources, Los Amigos Research Station (Peru), the staff of Madidi National Park (Bolivia), Madison County Land Trust (Alabama), Mark Twain National Forest System (Missouri), Middle Ozark Lower Earth Society, MINAE (Costa Rica), Missouri Department of Conservation, Missouri Speleological Survey, Monterey Bay Aquarium Research Institute, Moss Landing Marine Laboratories (California), Mushroom-observer.org, National Speleological Society, Naturae (Goiânia, Goiás, Brazil), Natural Investigations Company, The Nature Conservancy, Oklahoma Biological Survey, Oklahoma City Zoo, Oklahoma Department of Wildlife Conservation, Ornamental Fish Inc. (Florida), Ozark Subterranean Biodiversity Project, Pan-ocean (California), Radeau des Cimes (France), Russian Academy of Sciences (Russia), Saint Louis Zoo, Sam Noble Oklahoma Museum of Natural History, San Antonio Zoo, Sedgwick County Zoo (Wichita, Kansas), Servicio Agrícola Ganadero (Chile), Shared Earth Foundation, Sophie Danforth Conservation Biology Fund, Southern Nevada Herpetological Society, Tennessee Cave Survey, Tennessee Wildlife Resources Agency, Texas Department of Parks

and Wildlife, Texas Memorial Museum (Austin), Tree Walkers International, Tulsa Regional Oklahoma Grotto, Understory Enterprises, United States Fish and Wildlife Service Tulsa Field Office (Oklahoma), United States Fish and Wildlife Service Ozark National Wildlife Refuge (Luny Unit, Oklahoma), United States Forest Service, United States Geological Survey, United States National Park Service, Universidade Catolica (Goiânia, Goiás, Brazil), University of Arkansas (Fayetteville), University of California, Santa Cruz, University of Miami, Coral Gables, University of Oklahoma, University of South Florida College of Marine Science, Uozu Aquarium (Japan), USDA-ARS (Georgia), West Virginia Wildlife Diversity Program, Yale Institute for Biospheric Studies at Yale University, Zoológico Nacional de Chile, Zoo Med Laboratories, Zoo Atlanta.